ACROSS THE
ARCTIC OCEAN

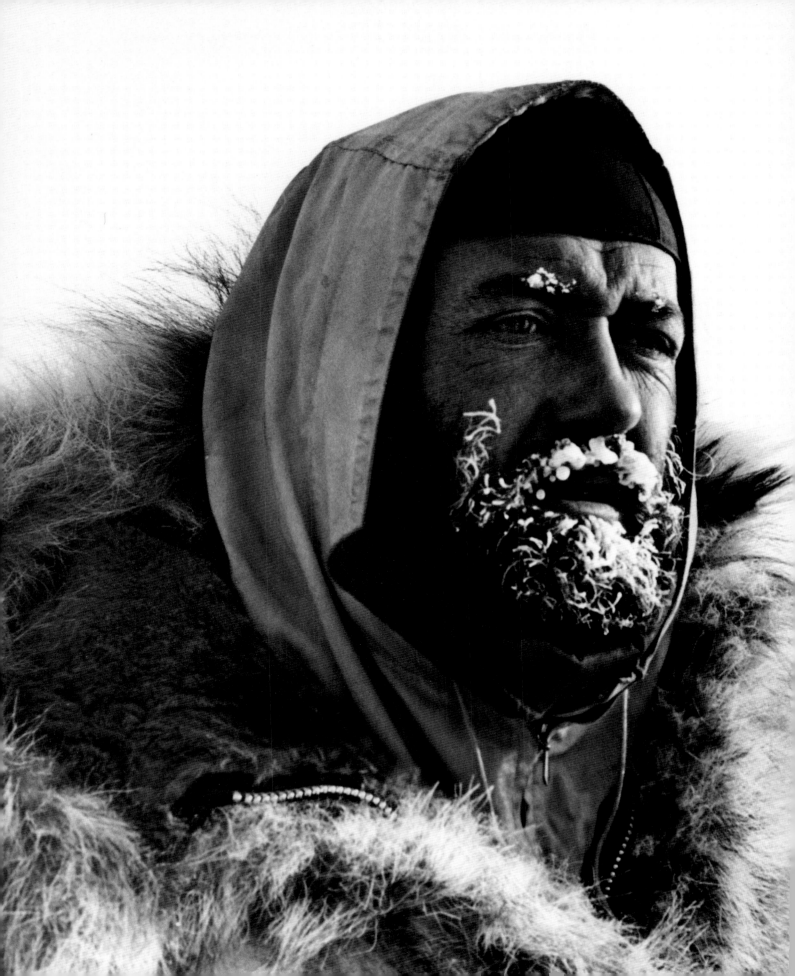

ACROSS THE
ARCTIC OCEAN

ORIGINAL PHOTOGRAPHS FROM
THE LAST GREAT POLAR JOURNEY

SIR WALLY HERBERT

AND HUW LEWIS-JONES

Thames & Hudson

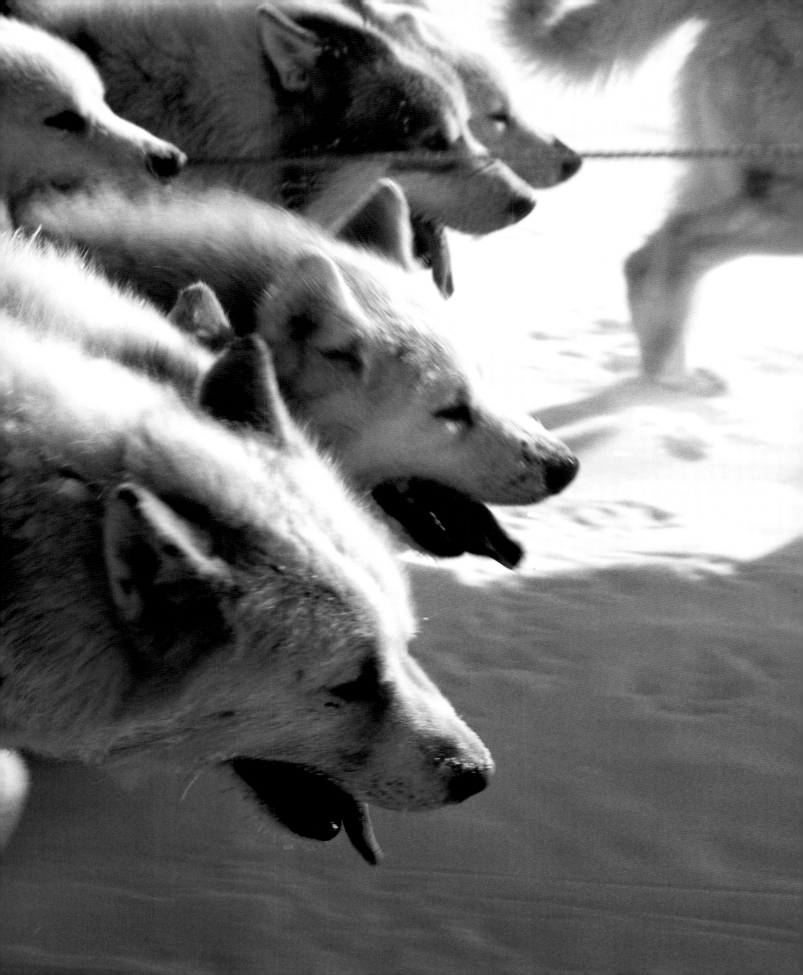

WITH PERSONAL REFLECTIONS FROM

VICTOR BOYARSKY

SIR RANULPH FIENNES

MARTIN HARTLEY

KARI HERBERT

ERLING KAGGE

PETER OTWAY

BØRGE OUSLAND

GEOFF RENNER

DMITRY SHPARO

CECILIE SKOG

For Nell. We hope that you'll come to enjoy Grandpa's special stories as much as we do; he would have loved to see you grow up. Soon we'll take you to the North Pole and we might even meet a polar bear or two.

Across the Arctic Ocean © 2015 Thames & Hudson Ltd, London

Designed by Liz House
Directed by Huw Lewis-Jones

First published in 2015 in hardcover in the United States of America by Thames & Hudson Inc., 500 Fifth Avenue, New York, New York 10110

thamesandhudsonusa.com

Library of Congress Catalog Card Number 2015932421

ISBN 978-0-500-25214-7

Printed and bound in Singapore by Tien Wah Press (Pte) Ltd

PAGES 2–3 Explorer Sir Wally Herbert was a man of huge achievement, yet his expeditions are largely forgotten. This is February 1968, in the early stages of his Arctic crossing.

PAGE 4 While billions of dollars of technological know-how were sending men skywards in rockets, the success of the Arctic journey would depend in large part on Inuit skills thousands of years old. Teams of Greenland huskies were at the heart of this adventure.

RIGHT Squadron Leader Freddie Church digs out the entrance to his radio shack at Barrow, on the north Alaskan coast. Every day for the next sixteen months he endeavoured to make radio contact with the expedition, their only link with the outside world.

PAGES 8–9 The Arctic Ocean is covered by a thin and brittle skin of ice, one of the most variable and unstable of all physical features on the Earth's surface.

PAGES 10–11 On 6 April 1969 four men stand at the North Pole, after more than a year of travelling across constantly moving sea ice. Yet the journey is not over. From left to right: Roy 'Fritz' Koerner, Ken Hedges, Allan Gill and leader Wally Herbert.

PAGE 12 Wally's 16mm ciné-film footage was used to create the BBC film *Across the Top of the World*. 'An epic 3,800-mile march across the frozen polar sea ends in triumph … the longest, loneliest walk in the history of exploration, like conquering a horizontal Everest', declared *True Magazine*.

PAGE 14 Wally Herbert and Kevin Pain descend Mount Fridtjof Nansen, then the highest unclimbed peak in Antarctica. The peak was named in honour of Nansen, whose expeditions would later inspire Wally's own Arctic journey.

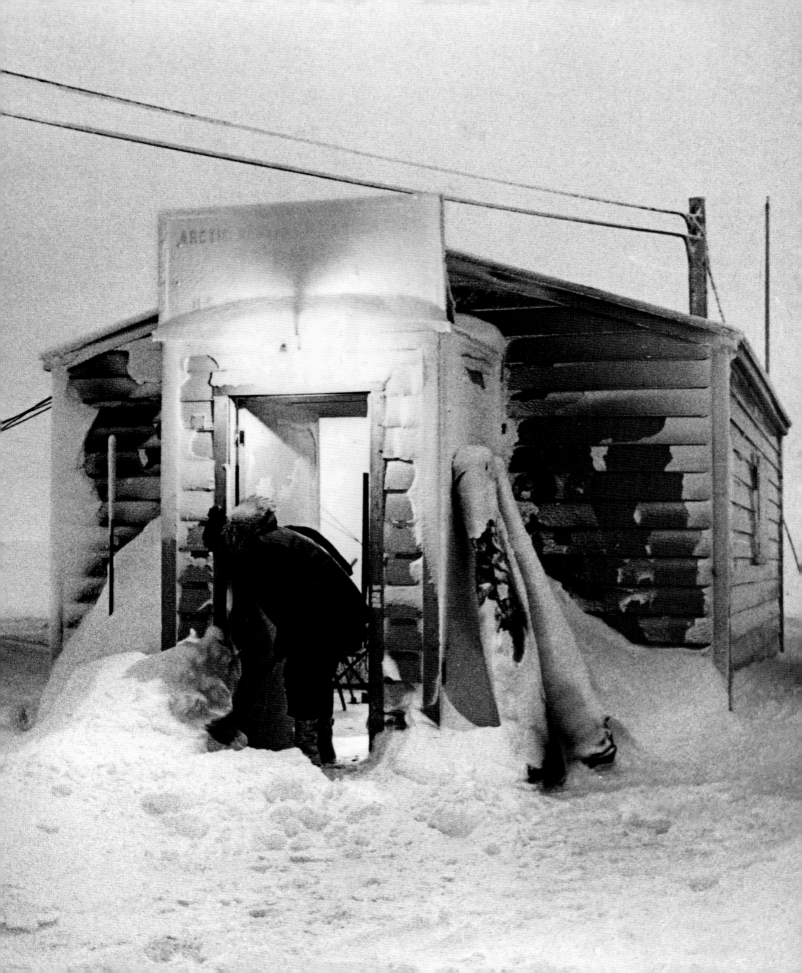

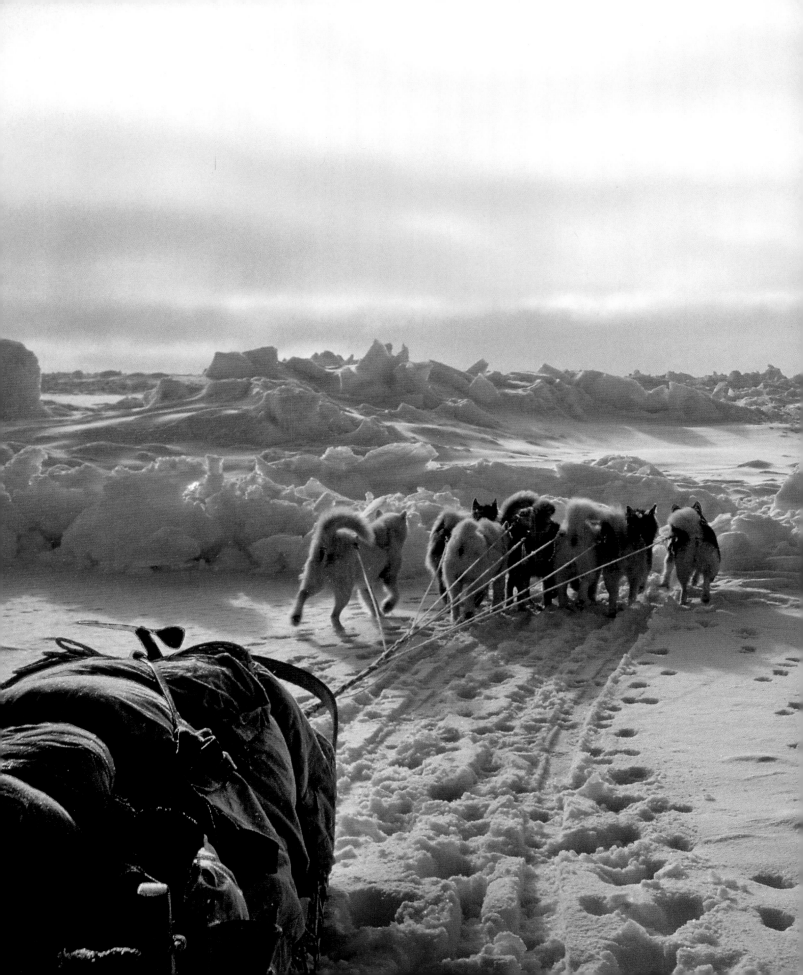

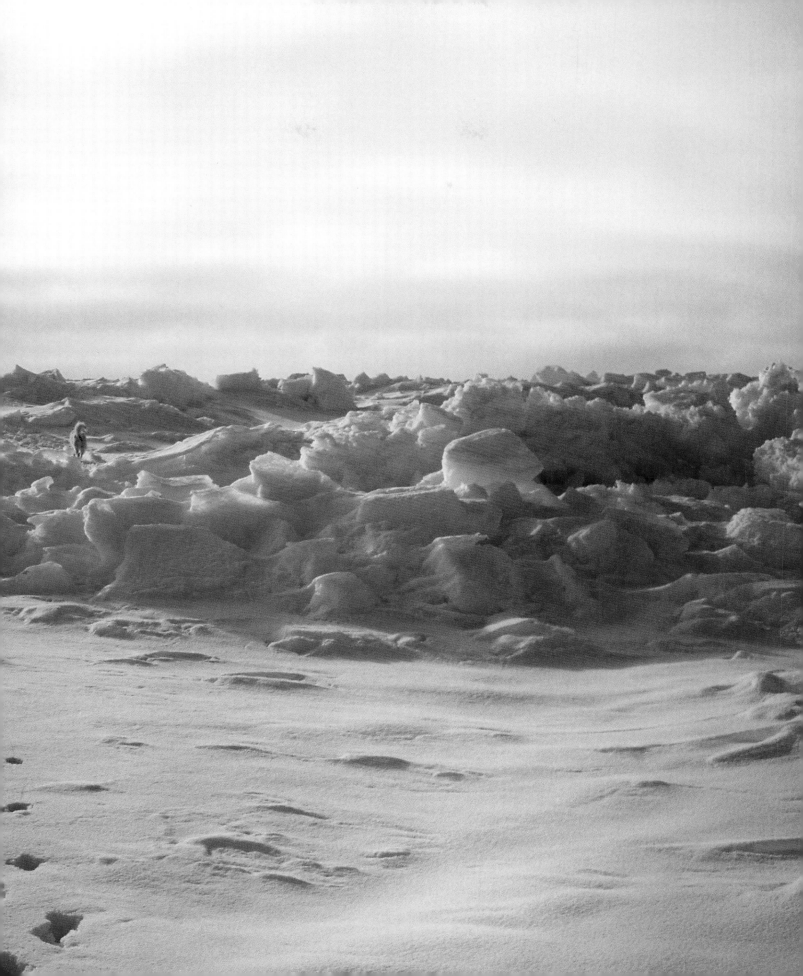

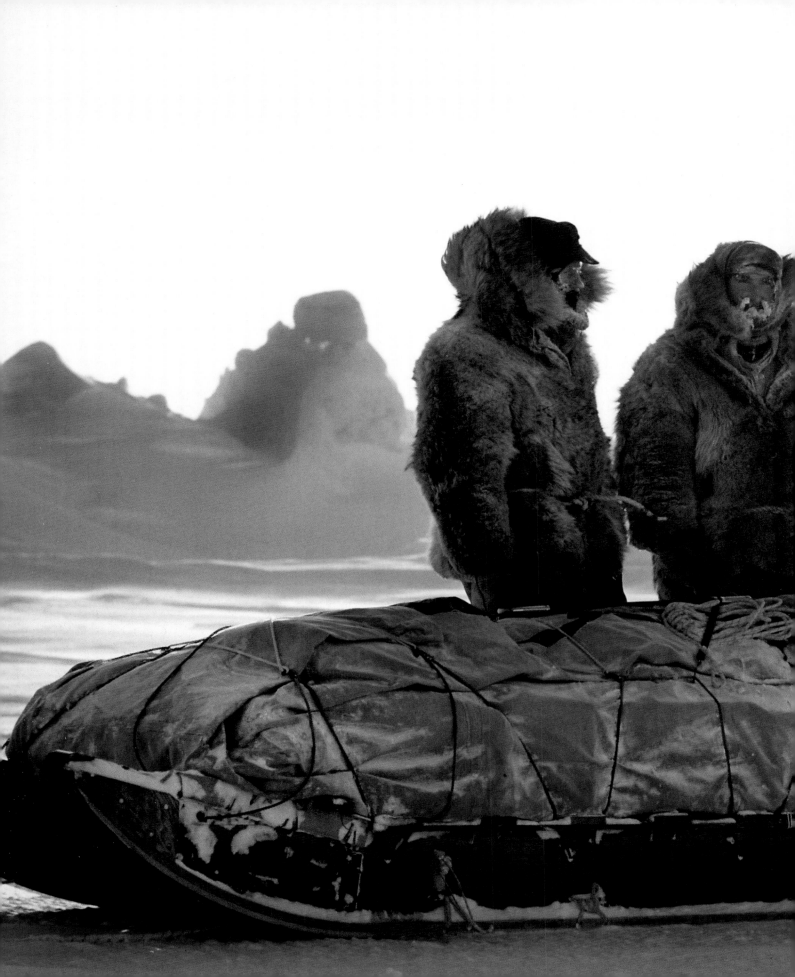

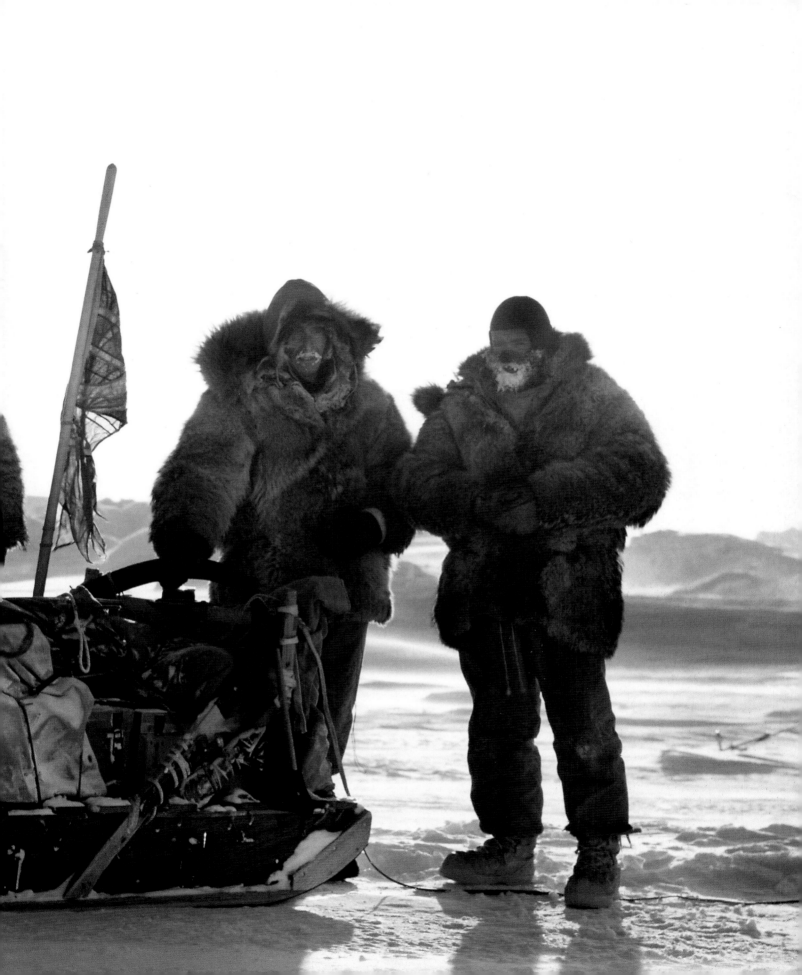

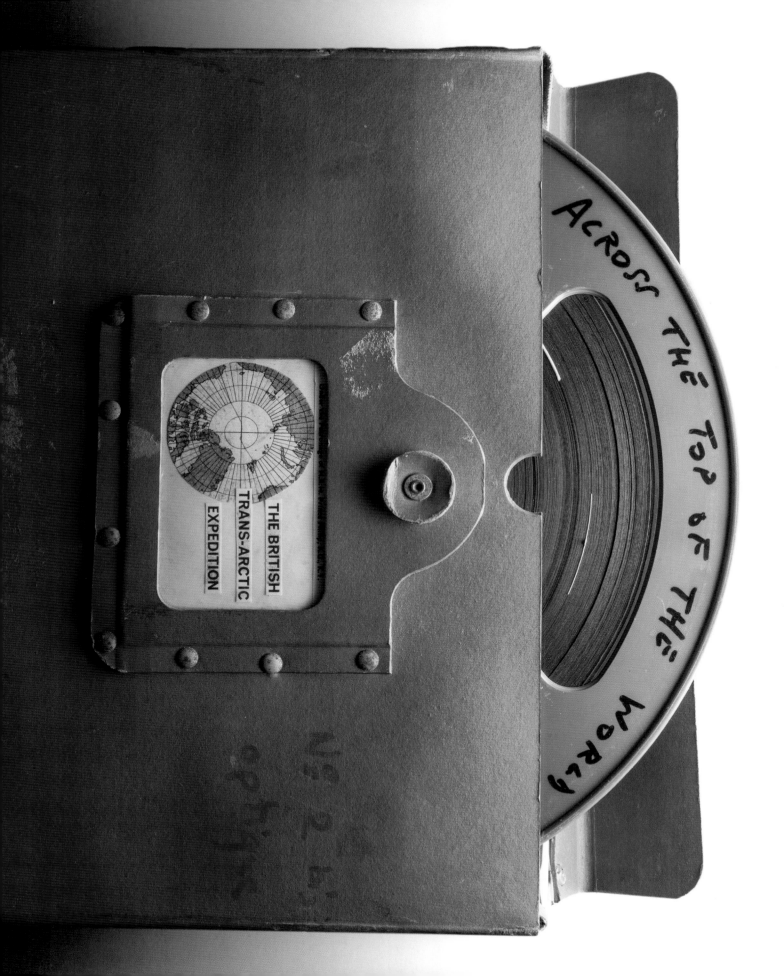

THE BRITISH
TRANS-ARCTIC
EXPEDITION

ACROSS THE TOP OF THE WORLD

CONTENTS

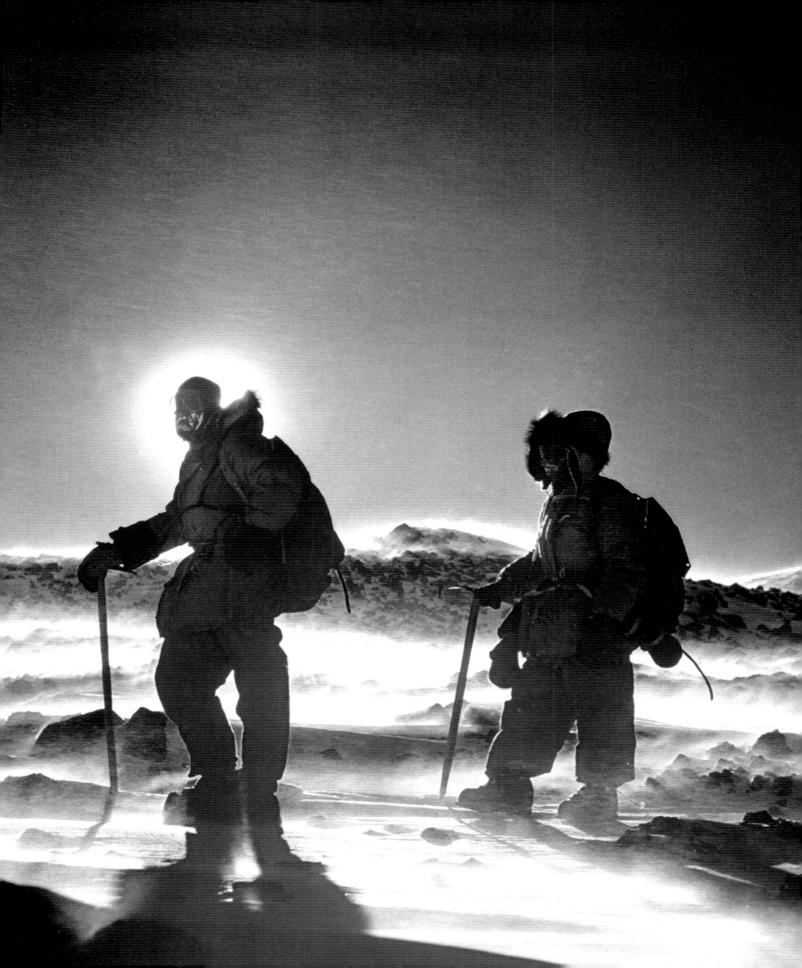

Men go out into the void spaces of the world for various reasons. Some are actuated simply by a love of adventure, some have the keen thirst for scientific knowledge, and others again are drawn away from the trodden paths by the 'lure of little voices', the mysterious fascination of the unknown.

Sir Ernest Shackleton, 1909

*There is always a risk
in being alive,
and if you are more alive,
there is more risk.*

Henrik Ibsen, 1880

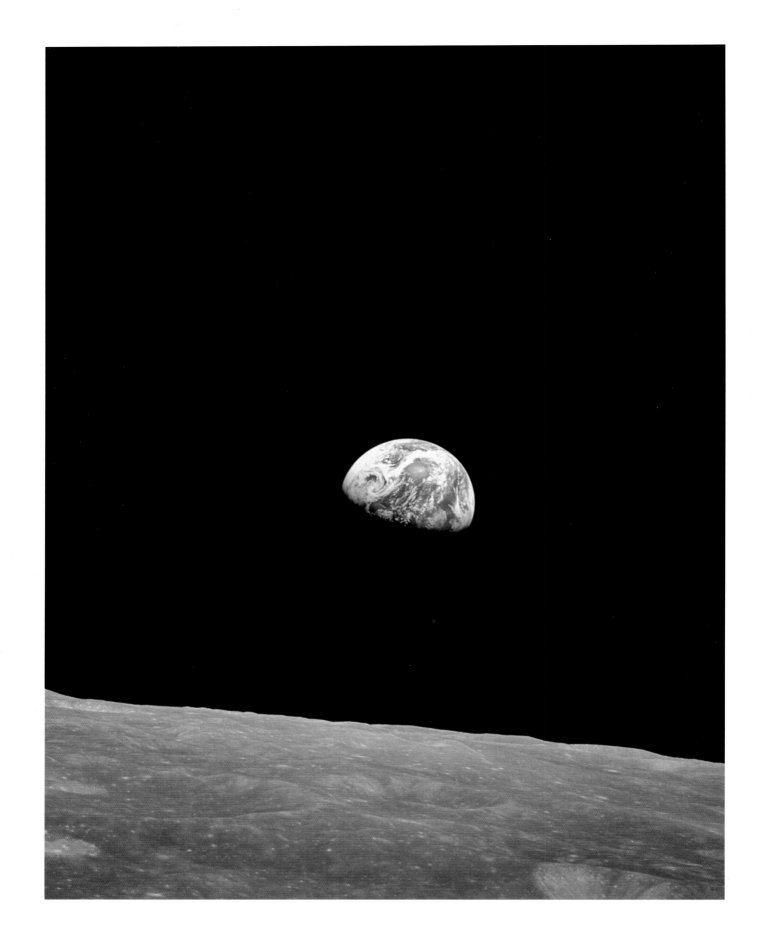

IN THE SHADOW OF THE MOON

HUW LEWIS-JONES

O n Christmas Eve 1968 three men are floating in an aluminium capsule on the far side of the moon. The first lunar voyagers in history – Apollo 8 astronauts Frank Borman, Jim Lovell and Bill Anders – emerge from behind the moon for the fourth time and witness an incredible sight: the Earth is rising over the barren horizon. They reach for their cameras.

That evening, as they orbit the moon for a ninth time, the astronauts hold a live broadcast from their spacecraft to show images of the fragile Earth and share first impressions of the wonders they've just experienced. Borman describes 'a vast, lonely, forbidding expanse of nothing'. Lovell echoes his words: 'The vast loneliness is awe-inspiring and it makes you realize just what you have back there on Earth'. They end the transmission taking turns reading from the book of Genesis. The world is listening – their message becomes the most watched television programme ever.

As pioneers voyaging into the unknown, their goal was to photograph and survey potential landing sites on the moon. Almost a decade in the planning, the Apollo 8 mission lasts just 6 days, 3 hours and 42 seconds, but the knowledge they take home greatly assists Apollo 11 in its sublime touchdown on the lunar surface on 20 July 1969. A global excitement, a technological breakthrough, a defining moment in the story of mankind, Apollo 11 is an act of exploration without parallel. All this and they bring back 22 kg (48 lb) of lunar rocks too.

Just as the astronauts of Apollo 8 capture one of the most famous photographs of all time, back on Earth a team of four men is floating on a frozen sea through the darkness of the polar winter. A padded tent serves as their home in the perpetual night; beneath their feet the ice is in continual motion and the prospect of death is a constant companion. They are halfway through an epic sixteen-month journey where none have gone before, but the worst still lies ahead. In a few months time, as light returns, they will hitch their dogs to their sledges to continue north across the floes. Contact with the outside world is fleeting, and rescue – should they need it – nigh on impossible.

Splashdown in the warm blue waters of the Pacific signals success and a safe return for the astronauts of the Apollo missions. For explorer Wally Herbert and his team, elation comes at last in their first sight of land for 464 days. Proof of their landing takes the form of a small lump of granite from the shores of the Arctic island they reach and in the tales they have to tell of their remarkable survival. They return to England to a heroes' welcome, but for a generation looking to the heavens in a blaze of rockets and TV screens, the ways of these explorers are old-fashioned, out of step; something perhaps of a bygone age. Already their great journey is cast in the shadow of the moon.

❧

LEFT Earth appears to rise above the lunar horizon, 24 December 1968. Shot on a 70mm Hasselblad by Apollo 8 astronaut Bill Anders, this has become one of the most influential images in photographic history. The perspective it gave of our place in the cosmos is said to have begun the environmental movement. One of Wally's favourites, when it was taken he was camped on the frozen Arctic Ocean, floating through the long darkness of the polar winter.

Now it is time to share their story again. In previous books I have worked with George Lowe, a man greatly admired and a member of two of the other great triumphs of twentieth-century exploration – the first ascent of Everest and the first crossing of Antarctica. It's rare to have such opportunities in life to meet explorers who were part of the history that you read and care about. Wally Herbert, clearly, was another of these special men.

I was still at Cambridge, finishing off my doctorate and in the throes of writing a first book. Each day at the Scott Polar Research Institute a bronze bell is proudly rung, summoning staff and guests to gather for a cup of tea. Though a historian really ought not to ignore the ship's bell from Captain Scott's *Terra Nova*, it was a ritual I mostly avoided, especially when I was trying to write. But that morning, for whatever reason, I was desperate for a brew and ran downstairs to find the museum empty save for one man, standing in the middle of the hall, chuckling to himself. It was Wally.

I knew instantly who he was – for those of us in the polar community his achievements were legendary – but I'd never had the chance to meet him. Before the hordes descended in a clatter of china cups and coffee pots, we spoke together in the quiet gallery. Naturally, we talked a little about Scott and his poignant final letters, displayed there beside us, but with the same gentle intensity he told me stories of the polar winter, of new artworks and old charts, the state of his woollen socks, the perils of life as a writer. He smiled, recognizing me as a young man with interests after his own and we commiserated with one another about the 'joys' of deadlines.

We laughed, too, I remember, about the rash of little signs that had just gone up in the museum, encouraging people to 'kindly turn off all mobile phones'. It was a relatively new thing back then, the thought that someone would carry a phone into a museum, but it was all the more remarkable as inside another glass cabinet, in fact, was Wally's huge radio set from the Trans-Arctic expedition of 1968–69. It's extraordinary to think that he'd carried this and so much more all the way across, when nowadays people pull a satellite phone from their pocket to summon rescue in an instant. It was an implausibly tough expedition back then, of that there's no doubt.

Some years later I was lucky enough to curate an exhibition of Wally's paintings. From London the show travelled up to Dundee, appearing alongside Scott's ship *Discovery*. Wally loved Scotland and loved that ship, but he would not live to see his art enjoyed there. He died suddenly in 2007, a quiet and sensitive man yet the greatest explorer of his generation. In Cambridge, his wolfskin parka and huge oak sledge used to be on display too, before a museum overhaul consigned them

RIGHT Wally's original lecture slides on the lightbox. Despite the tough conditions and huge distances, the team created an impressive visual record of the expedition. Many of these images are published here for the first time.

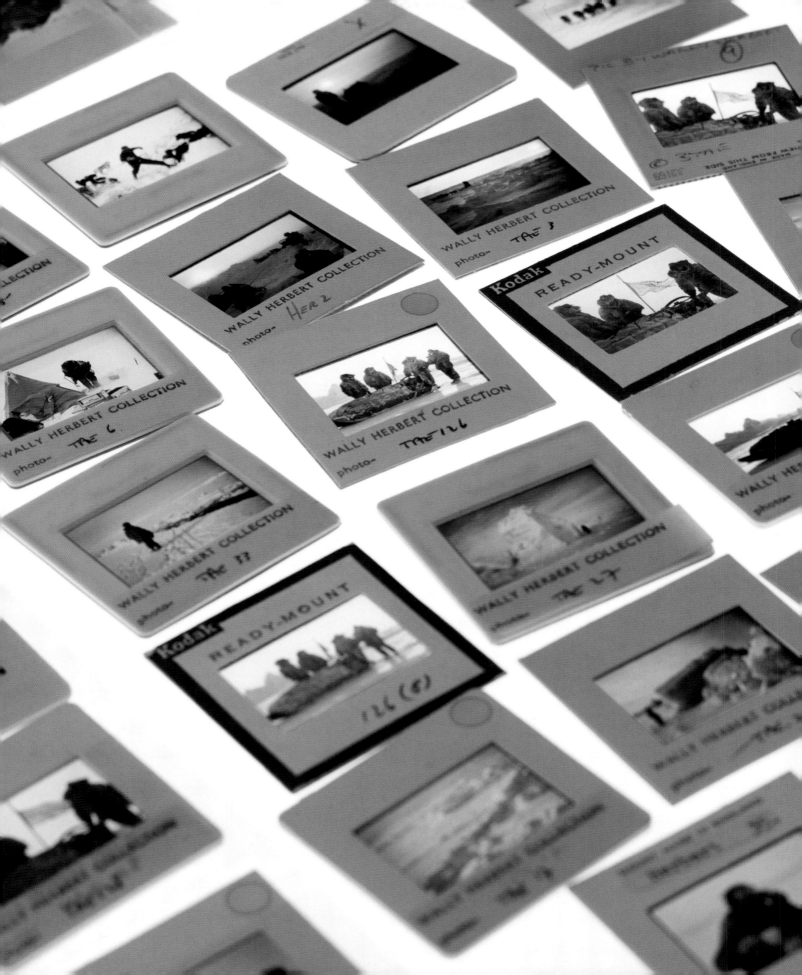

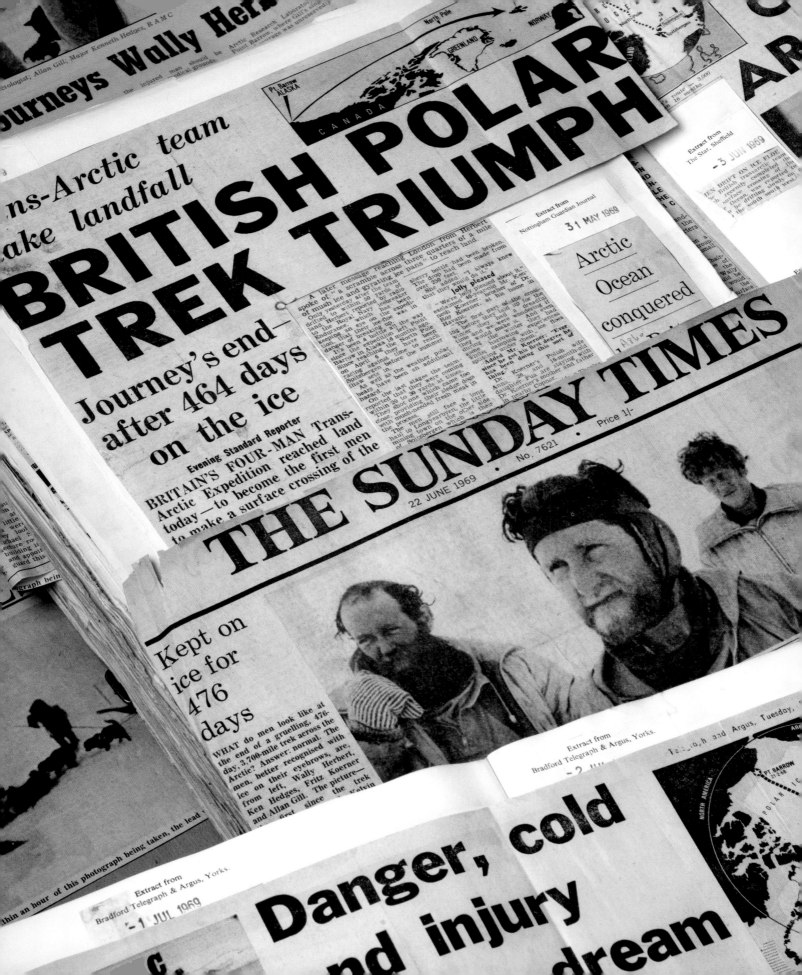

ns-Arctic team

ake landfall

Journeys Wally Herb.

...ologist, Allan Gill, Major Kenneth Hedges, R.A.M.C...
...the injured man should be ... Arctic Research Laboratory ... Point Barrow, where Gill's ... medical grounds. ... trage was unreservedly

BRITISH POLAR TREK TRIUMPH

Journey's end— after 464 days on the ice

Evening Standard Reporter

BRITAIN'S FOUR-MAN Trans-Arctic Expedition reached land today —to become the first men to make a surface crossing of the

A later message reaching London from Herbert spoke of "a scramble across three quarters of a mile of mush ice and gyrating ice pans" to reach land.

Only yesterday after the team drifted to within 50 yards of land Herbert reported by radio to the Royal Navy icebreaker *Endurance*, which has been keeping an eye on the expedition, that their ice-floe had been breaking up.

Goteborg, a bottle of champagne since the expedition left Point Barrow in Alaska 16 months ago.

Since reaching the North Pole in April, they have been racing against time to reach Spitsbergen before the summer thaw sets in.

As well as the weather, polar bears have been an additional hazard.

On the last stages the team reported that they were coming within 20 to 30 yards at times. They shot one which came too close, providing their sledge dogs with much-needed fresh meat in the process.

The men still face a long haul to Longyearbyen, the little mining town on the other side of Spitsbergen, which is their

sherry bottle had been broken. The drop from over 250 feet.

She added: "I always knew that she would do it."

Jolly pleased

"We're jolly pleased about it," exclaimed 40-year-old Mr Ken neth Koerner, brother of Dr Roy Koerner, at his home in Havana.

The first part of the cross ing before they had a dreadful time and they had wonderful time and they were wonder they would make it and even doing, camping with wonder splashing under them.

Added Mr Koerner: "Ever since he got his first degree he's been doing this sort of thing."

Dr Koerner's Polish, 26-month-old wife Anna, 26 and their little daughter Eva are staying with Dr Koerner's mother and father in nearby Copnor.

31 MAY 1969

Arctic Ocean conquered

Extract from Nottingham Guardian Journal

Extract from The Star, Sheffield
— 3 JUN 1969

...EN DRIFT ON ICE FLOE... British transarctic team... recently completed the... surface crossing of the... Ocean, was reported in... be drifting slowly on... the drifting south-west...

THE SUNDAY TIMES
22 JUNE 1969 No. 7621 Price 1/-

Kept on ice for 476 days

WHAT do men look like at the end of a gruelling, 476-day, 3,700-mile trek across the Arctic? Answer: normal. The men, better recognised with ice on their eyebrows, are, from left, Wally Herbert, Ken Hedges, Fritz Koerner, and Allan Gill. The picture trek...

...within an hour of this photograph being taken, the lead...

Extract from Bradford Telegraph & Argus, Yorks.
— 1 JUL 1969

Danger, cold ...d injury ...dream

Extract from Bradford Telegraph & Argus, Yorks.
— 2 JU...

to the basement. I hope that soon – as the fiftieth anniversary of his great expedition approaches – these everyday but immensely special objects will come out again, alongside the jumble of journals and letters, pipes and snow-goggles, the sacred symbols of the other explorers he so admired.

∾

Wally first went to Antarctica as a young man in 1956, spending two winters at Hope Bay and learning to navigate by the sun and stars. He mastered the art of sledging with dogs and was leader of the team that made the first crossing of the Antarctic Peninsula. During his first Antarctic season on the Ross Sea side he would map 10,000 square miles of previously unexplored country. As leader of his own field party in 1962 he covered 21,500 square miles of the Queen Maud Range, with his geologist securing the richest collection of plant-fossils yet found on that frozen continent. As surveyors, they opened the gateway to the Pole, retracing Amundsen's route through the mountains down to the Ross Ice Shelf. They came home with a string of records and first ascents but – most important of all – they returned with the maps they had made. This was real exploration.

Four years later Wally led an arduous 1,500-mile training expedition over the most difficult terrain in the Canadian Arctic. After years of grinding preparation work, he then set out, in February 1968, with three others, to attempt that impossible dream, the first surface crossing of the Arctic Ocean – a surface as unstable and unsafe as anywhere on Earth. There would not be a day when the floes on which they travelled or slept were not drifting in response to currents and winds. There would be no rest, no landfalls, no safe haven, no certainty and no precedent.

On 6 April 1969 they finally reached the North Pole. Two exhausting and perilous months later, Wally and his team completed their journey, some 3,720 route miles in all. Their success was hailed by British Prime Minister Harold Wilson as a 'feat of courage which ranks with any in polar history', and, in the opinion of HRH the Duke of Edinburgh, as 'one of the greatest triumphs of human skill and endurance'. As time passed, however, public interest and attention naturally fell away, and it is only now that the significance of this journey is coming back into focus.

Yet Wally always believed in deeds not words. 'No amount of dreaming', he once wrote, 'will shift a seated man.' He felt that the urge to respond to a challenge is one of the finest attributes, and to discourage such things in people is to ignore our innate sense of curiosity, the wellspring of discovery. All this might not seem that much to people with no interest in the ice, but it isn't

LEFT The *Sunday Times* announced Wally's plan on 9 July 1967 as: 'The Longest, Loneliest Walk in the World'. For the next two years there was an almost constant stream of stories charting progress. Yet afterwards attention soon faded and the expedition's achievements were forgotten.

hard to see the magnitude of his achievement. He made his time on Earth count and he left his mark in his lifetime. He was a good man, a man of wild deeds yet wise and meticulous, careful, confident of his own skills and generous in sharing them. He did not waste his days and he was brave enough to live with the consequences of a calculated risk. Perhaps he was too good, too competent; thankfully there were no disasters on his many expeditions, but tragedy seems to be the only thing to guarantee the notoriety of lasting news. Yet, he would not have wanted this fame anyway. His deeds should be remembered because he earned his place in the history of this wide, eternal sea *the hard way*.

<div align="center">☙</div>

In the years that have passed since 1969, several astronauts have walked on the moon and hundreds of adventurers have sledged, skied or snowmobiled by the shortest routes to the North Pole. As the sea ice retreats, the Arctic is on the brink of a scramble for resources. It is a playground for the imagination as much as for very real geopolitical concerns. At the South Pole a new generation of people are kiting, trucking and tourist-trekking their way towards their personal goals in ever greater numbers, while sacred Mount Everest has been climbed over five thousand times since Hillary and Tenzing made the first ascent in 1953.

And yet, in spite of all this record breaking and glory seeking, nobody has ever repeated, or even attempted to repeat, Wally Herbert's journey across the longest axis of the Arctic Ocean. Few now would be willing to endure sixteen months of extreme isolation and constant danger drifting on the polar pack. These days we seem to be breeding a different type of polar traveller – men and women who love adventure, but who insist their journeys should be as fast, and as 'hardcore', as they can contrive to make them. You'd be excused for thinking that they don't enjoy themselves at all.

Wally would have chuckled at this. For all the hardship he experienced on the Arctic Ocean it was, without doubt, one of the happiest times in his life. Perhaps modern adventurers can see the writing on the wall – that every journey to the North Pole must now be done at breakneck speed as global warming is seriously reducing the amount of ice that is afloat. Or is it that, realizing the explorable blank spaces on the map have all but vanished, they push to find new ways of doing what has already been done?

PAGES **24–25** Some of Wally's expedition kit from the Arctic crossing, including his Rolleiflex 3.5F and Nikon F2 cameras, two Brunton 'Pocket Transits', a Barker M73 prismatic compass, a large Smith & Sons sextant, a Weston light-meter, snow-goggles, a Kern DKM1 theodolite, and one of many pipes.

Following in the footsteps of others, the goal of the modern media 'explorer' is merely to *appear* to be doing something new. But, of course, so much of this is neither new, nor innovative, despite what their sponsors are led to believe. Much is mirage. So it's important to distinguish all this activity from those genuine firsts of men like Wally, or a Nansen, an Amundsen, or a Shackleton. The true achievements stand the test of time.

It's something our contributors have first-hand experience of too. Some knew Wally well, a few travelled with him, many have been inspired by his journeys and for most, having gone on their own expeditions across the ice, their admiration for Wally has soared. These voices can provide another testament to his legacy as an explorer with the vision to act out a dream.

But you don't need to be a polar explorer to appreciate this story. It's a tale of four men and forty dogs, the genesis of a great adventure, a message of human daring and the simple willingness to give it a go. But why did they do it? For the love of adventure, and to satisfy our human curiosity? For the rich promise of scientific discoveries, for deep friendships, for experiences that reach a little closer to the meaning of life? All of these things, perhaps, and this too: for holding a small piece of rock in their hands and knowing, at last, that the journey thought impossible was done.

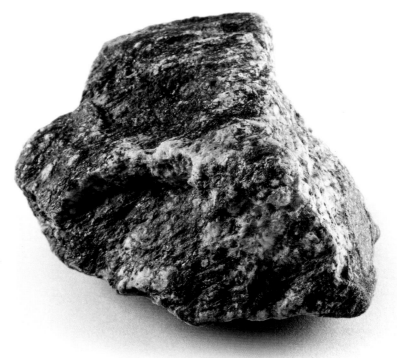

RIGHT A small lump of granite was the simple reward after sledging over 3,600 miles. 'At that moment', recalled Wally, 'it was more precious to me than anything.' Here was proof at last that man could cross this vast frozen ocean.

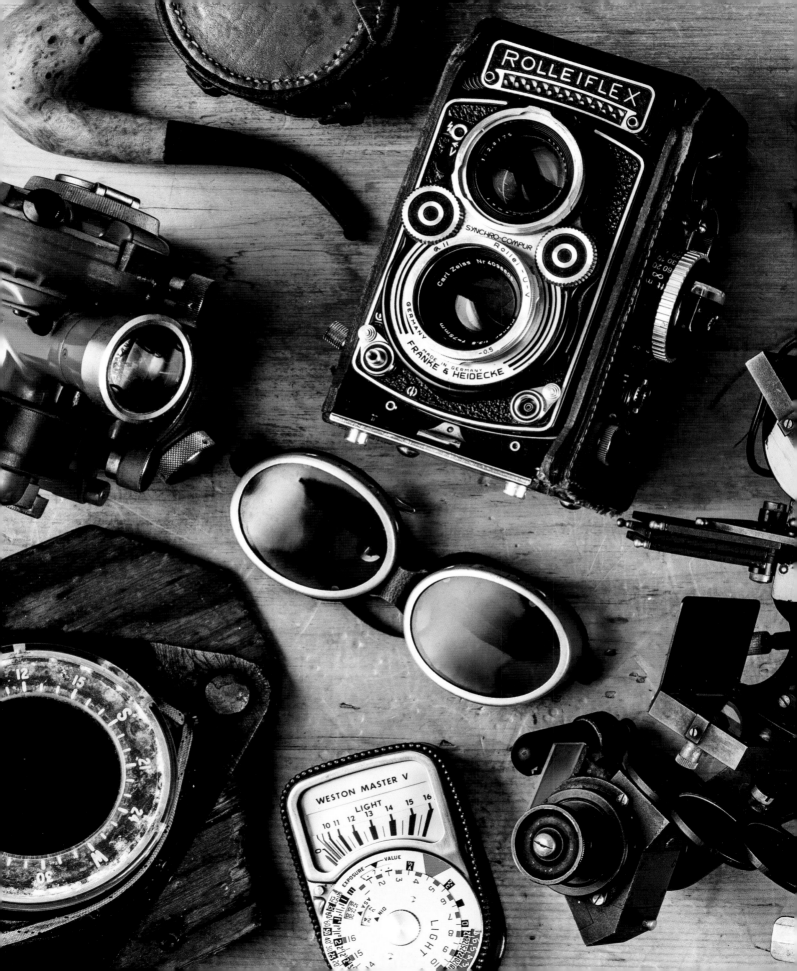

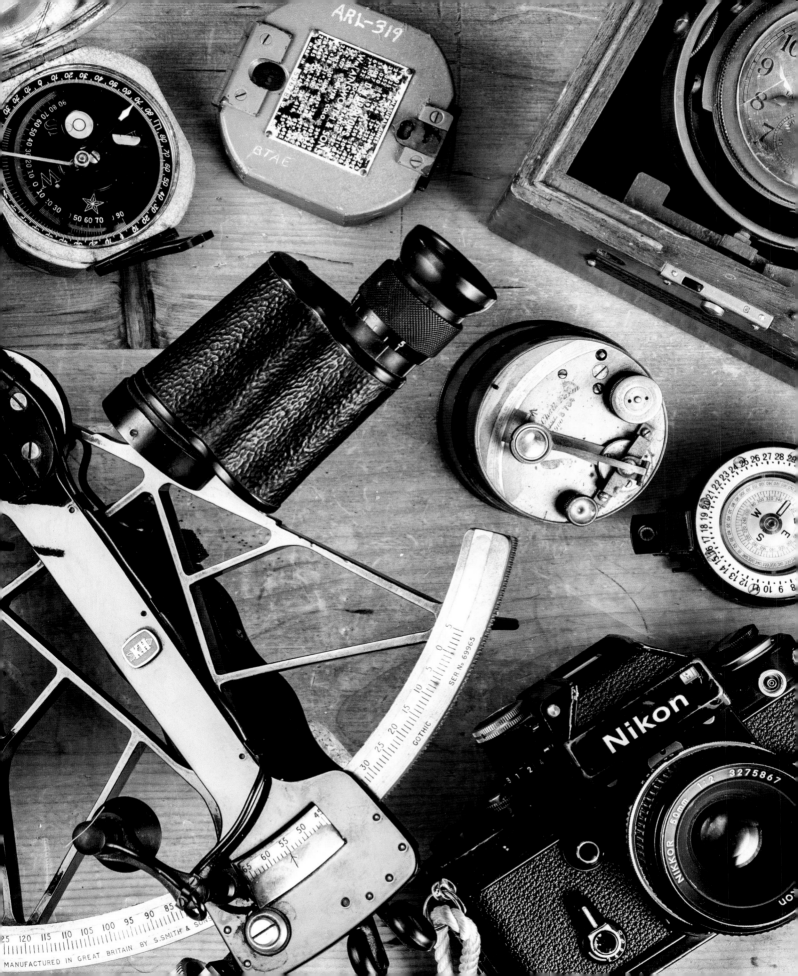

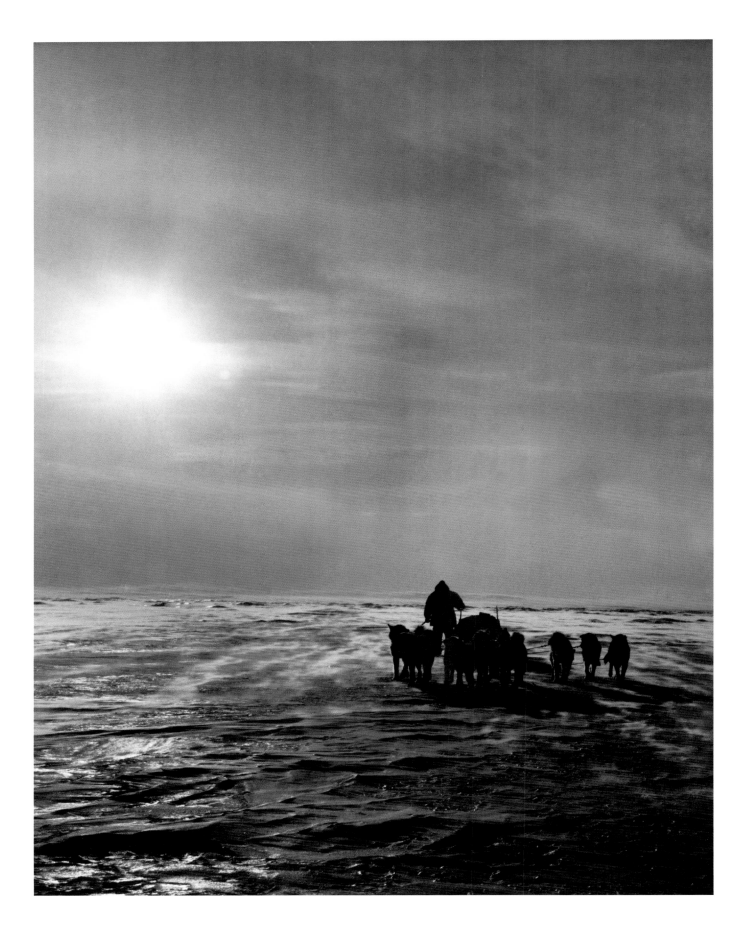

TRUE EXPLORATION

SIR RANULPH FIENNES

What compels a man to risk everything on a dream? Why would anyone put themselves through hell and back all for the sake of walking across a frozen ocean? In these pages you'll discover *why* and *how* something as formidable as this challenge was achieved for the very first time. Sir Wally Herbert was the man who did it and rightly earned his place in history. It's an elemental story of men chasing their ambitions over the polar horizon and travelling into the unknown. These were true explorers.

Fly over the Arctic Ocean today and you might wonder what all the fuss is about. From anywhere above 200 ft or so the uneven nature of the ice is lost in the overall white glare. It looks serene. And where it is white, it appears safe; further deception. Below this height, and if your aircraft is going slowly enough, you begin to see what looks like an endless succession of small fields enclosed by tiny hedges, broken by large areas of rubble, split by endless streams and a few great rivers. Grab your parachute and jump out. If you should strike lucky you'll land in a soft drift. It might be so soft you sink to your armpits. But you might land on solid ice, angled and sharp, full of cracks and cavities. All around will be walls of ice, from 5 to 30 ft in height, a disorientating maze of thick blocks, rearing like the ramparts of a castle wall. These were the tiny hedges you saw from the window, and to progress you will need to cut through or climb them. For mile after mile it will be the same.

If fate is kind you might come across a newly frozen lead, once a narrow canal and now looking like a deep, smooth river. If you're really fortunate it might run due north for a while, but before long your progress will be stopped by further icy chaos. It's getting cold, bitterly so. Night is falling and the temperature will soon plummet even further. The wind is picking up. The ocean beneath you moves with the currents and the natural swell of the sea, and the winds act on the ice ridges like sails, causing them to crack and buckle, and then your troubles really begin. You feel your cheeks beginning to freeze, perhaps your eyelids too. Urgently, you must find somewhere to camp. It had all looked so much easier from the window of your aircraft.

It is easy to describe how tough a proposition it is to cross the Arctic Ocean. It's *extremely* difficult. Full stop. Only a handful of humans have ever risked the journey, and those who have done so recently have mostly gone the shorter way – from Russia to Canada. Only Wally Herbert and his team went the hard way, the longest way possible, from Alaska to Spitsbergen. And they were the first to do it. That's the significant thing. This was back in 1968. Just as mankind was looking skywards into space, Wally was setting his sights on a great terrestrial journey yet to be achieved,

LEFT Like 'astronauts who tread for the first time on some virgin planet, the British Trans-Arctic Expedition marched across a wasteland never crossed by man', wrote *True Magazine*. 'Against incredible odds, four brave men walked across the top of this planet.'

a page in the history of exploration that was still an appealing blank. I say appealing, but very few people thought it so: to venture across the frozen ocean was surely madness?

Sir Wally Herbert was the last of the truly great explorers. Measured by any standards, he is right up there with the most famous names of all: Amundsen, Nansen, Mawson, Scott and Shackleton. The major difference with Scott, of course, is that Wally won through to the end. He stayed alive and managed to come home. The major difference with Shackleton is that Wally actually achieved his goal. On the now famous *Endurance* voyage, Shackleton wanted to be the first to brave a crossing of Antarctica overland, but he didn't even manage to set foot on the continent.

Wally shared Shackleton's vision for a truly ambitious, record-breaking journey and in doing so realized his life's goal. He crossed the Arctic Ocean on its longest axis, stepping off the safety of land to make real his dreams. There was little hope of rescue; even turning back and retreating would have been difficult, for the ice was ever shifting. Once they set out there was no option other than to push on through to the other side. This was a journey of total commitment.

<p style="text-align:center">જી</p>

As a young man, I hoped one day to have the chance to lead my own expeditions to the ends of the world. It was 1973 when my wife had the first outlines of what would be, arguably, our most ambitious expedition scribbled on a piece of paper. We called it the 'Transglobe Expedition'. It seemed to me one of the few great adventures left – to circumnavigate the world, crossing both the North and South Poles. No one had tried it before. And therein lies the challenge that faces anyone attempting something genuinely new. There is only so much that can prepare you for something that has never been done. That's what makes expeditions like these the hard ones. That's what kept me awake at night.

In the beginning most thought us crazy, but a few kindred souls understood our dream. Wally was one of the few. He was mentor to me in those early days and became a dear friend in later life. He exemplified the can-do spirit. He was always happy to give me advice; it was always good and it was always wanted. He encouraged me to use dogs only if I was prepared to spend a couple of years learning how to handle them. We simply didn't have the time to reach his skill level so we chose snowmobiles.

When I started planning expeditions I wanted to emulate Wally. I had read his books and coveted his experiences. I longed for my own journey of true exploration in a land where no man had ever been, a geographical goal not as yet reached. Sir John Hunt's expedition, with Ed Hillary and Tenzing in the vanguard, had ascended Everest; Chichester had sailed solo around the world; Wally had crossed the Arctic and endured a winter floating on the ice; Bunny Fuchs had forged across Antarctica and into the history books. Priority was the key.

In those early days I needed a training expedition to convince our backers that my companions and I were up to it. We could also do with a little convincing ourselves, so we opted for a recce to northern Greenland, where we spent a summer humping heavy loads across remote glaciers, slogging blindly over crevasses and camping in blizzards for the first time. That was fine enough, but a bigger journey was called for and we set our sights on the North Pole. It was 1977. I had never set foot on the Arctic Ocean, but I reassured myself that every journey, no matter how difficult, has to begin with a first step. Or, in our case, throwing ourselves in the deep end of things. We had to give it a go or we were nothing, our hopes just fanciful dreams.

That first major Arctic expedition of ours almost cost me my life. But it would also change my life forever. There had been obstacles on earlier adventures, but all the rapids, whirlpools, avalanches, deserts, swamps, communist bullets and faulty parachutes could not have prepared me for the challenges I would face out on the Arctic Ocean. Nowhere else had I encountered so hostile and uncertain an environment. It proved to be the toughest couple of months of my life to date.

❧

The sea ice felt spongy at first, then more like rubber. Without warning it began to move. A few feet ahead black water gushed up and spread rapidly over a wide area. I stopped at once, but the water rushed past me, covering my boots and, perhaps because of its weight or my involuntary movements, the whole mass of new ice began to rise and fall as though a motor boat had gone by. The undulating movement of a swell approached in slow motion and as it passed under me the ice rind broke up beneath my feet and I began to sink.

Fearing to disturb the ice further, I remained rigid like a mesmerized rabbit. As the water closed over my knees the remaining layer of crust broke, and I sank quietly and completely. My head could not have been submerged more than a second – the air trapped under my wolfskin

acted as a life jacket. At first I had no thoughts but to get out at once. But the nearest solid floe was 30 yards from me. Instinctively I shouted for the others before remembering they were a good half-mile away on the other side of many slabs and ridges. I leant both arms on the new ice that hung suspended under two or three inches of water, then kicked with my boots to lever my chest up on to this fragile skin. I succeeded and felt a rush of hope. But the thin skin broke beneath me and I sank again.

I tried several times. Each time I clawed and crawled until half out, and each time I sank I was weaker. My mind began to work overtime, but not constructively. Perhaps a passer-by might see me and throw a rope? Realization hit like a bombshell of course. There would be no passers-by. Was it deep? A vivid picture of the Arctic Ocean's floor mapped in the *National Geographic* magazine flashed to mind and gave me a sort of watery vertigo. Yes, it was deep. Directly under my threshing feet was a cold drop to the canyons of the Lomonosov Ridge, perhaps 17,000 ft below. I vaguely remembered that sailors on the Murmansk convoys in the Second World War reckoned on surviving in the waters of the North Sea for about one minute before the cold got them. And this thought brought back the words of an old SAS instructor: 'Never struggle. Don't even try to swim. Just float and keep as still as you can. Give the water trapped in your clothes a chance to warm up a bit, then keep it there.'

So I tried doing nothing except paddle my arms to keep afloat. But, at a great distance it seemed, I sensed a numbness in my toes. My inner boots filled up, my trousers were sodden. Only in the wolfskin could I 'feel myself'. Inside the gloves there was no sensation in my fingers. And all the while, my chin, inside the parka hood, was sinking slowly lower as the clothes became heavier. It might work in the Mediterranean or even in the North Sea but not here. I felt a rising panic. I *must* get out now or never. I smashed the ice with one arm, while the other thrashed wildly to keep my head above water.

The seconds seemed like minutes and the minutes like hours. The precarious platform of ice rind was too strong to smash with one arm. Only with the weight of my chest could I crack it, a few inches at a time, and my strength was draining quickly. My arm slapped down on a solid chunk, inches thick, suspended in the skin like a layer of clay in quicksand. I levered my chest on to it. It held. Then my thighs, and finally my knees. For a second I lay gasping on this island of safety, but once out of the water the cold and the wind zeroed in. It was minus 38°C that morning with a seven knot breeze. At those temperatures dry exposed flesh freezes in less than a minute.

RIGHT A modern Arctic Ocean adventurer man-hauls a plastic pulk (sledge) among pressure ridges, photographed by Martin Hartley. An expedition to the North Pole must cross many thousands of obstacles like this.

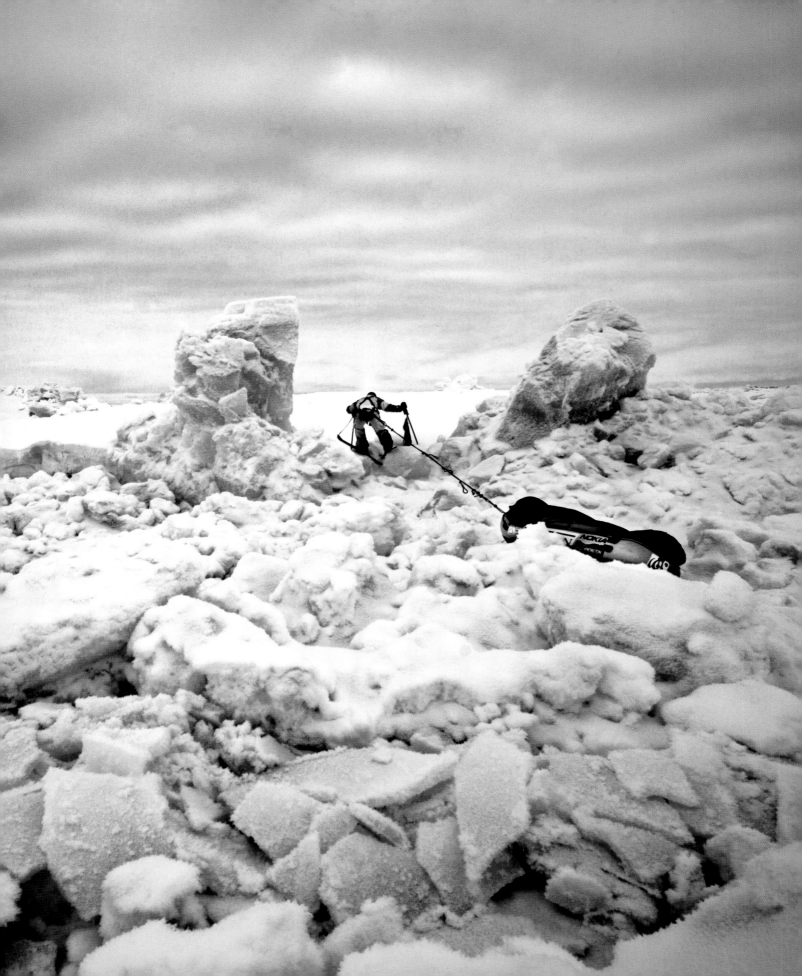

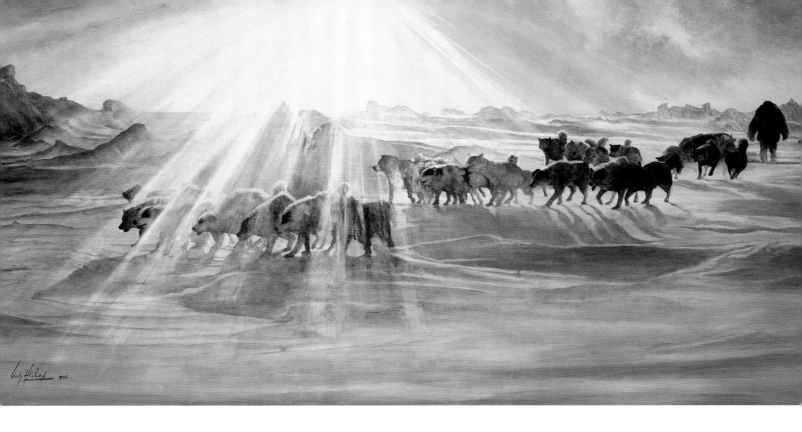

Moving on my stomach and wriggling legs and arms like a turtle in soft sand, I edged to the nearest floe, with the newly formed ice bending and pulsating beneath me as though it was alive. Standing up I watched the water dribble out of boots, trousers and sleeves. When I moved I heard the trousers crackle as they froze. The shivering began, and I could not control it. I tried press-ups but five had always been my limit at the best of times. I slumped over to my skidoo and the air movement was bitter on my face and legs. It would be foolish to walk back to the others. My skidoo had stalled. I couldn't start it again without removing my thick outer mitts. This I couldn't do anyhow: the leather had gone rigid and shrunk.

For about twenty minutes I plodded round and round my skidoo with a sodden heavy jog, flapping my arms in wheeling windmills and shouting all the while. When, finally, one team-mate, Oliver, arrived on the scene he could see things were not well. After that, all was action. I got on the back of his skidoo and we went slowly to where Charlie was stopped with an overturned sledge. Quickly they erected the tent, started the cooker, cut my boots and wolfskin off with a knife, and between them found bits and pieces of spare clothes to replace my soaked ones. Soon the wet items were strung dripping above, while tea brewed and Oliver rubbed the blood back into my fingers and toes.

I was lucky to be alive: few survive a long dip in the Arctic Ocean. I'd learnt a lesson, but the Arctic is no place to learn lessons because all too often, by the time you've absorbed them, it's too

ABOVE This magnificent oil painting by Wally was based on three frames from the 16mm ciné-film he shot on 6 April 1969 as the expedition crossed the North Pole.

late to take advantage of the hard-won knowledge. Your expedition is over. If you're not already dead, it's time to get out of there and head for home.

❧

Even on this first foray on the Arctic Ocean – just a 'training exercise', we consoled ourselves – success always hung in the balance. Every day we feared an accident. Every day involved a succession of knife-edge decisions. Was the ice safe to cross on? How and where? One wrong decision and we could lose a man together with all his kit. There were leads that moved fast and evenly, humming like bees or hissing with whispers that warned of too-new slush. Others ground together with the sound of chomping horse teeth, spewing green blocks from between their closing jaws. We worked hard, spoke little, slept rarely, lost a great deal of weight and strength. It became a nightmare world: no land, no night, just a blanket of white, ice, snow, water, sky.

On 7 May 1977 at 87°11'N, some 167 miles from the North Pole, we finally came to a halt in a region of swirling mush. Had we crossed earlier we might have made it. Temperatures rose, our chances disappeared. If we took a risk now and flunked it, we'd not get another opportunity. I thought of Shackleton who had been within easy reach of the South Pole some years before Amundsen claimed it. Like us, Shackleton had been on the Pole side of 87° latitude. But, running out of food, he had decided to save his men and turn back. The floes were breaking up for us; we would turn back too and live to fight another day.

On 16 May our Twin Otter was able to land on the moving ice and rescue us. We loaded our equipment and headed home. Now safe in the warm aircraft, the view out of the window returned to a mere featureless waste. Below us the miles flashed by, the ice as smooth as ivory. How could it have been so hard? Drifting into sleep, I thought, 'I will never write a book about this place. What can I say? There is nothing to describe. No history, no buildings, no animals, no birds or people. No scenery even. Just the ice, the snow, the water. People want to read about places they might like to visit one day, somewhere inviting and fun.' Yet, deep down, I knew I would return.

Two messages greeted me as I stepped off the aircraft and landed on solid ground. One, from HRH the Prince of Wales, informed us that he'd agreed to become patron of the main circumpolar expedition, and the other was a note from Wally Herbert. 'You beat the farthest north of Nansen and should feel rightly proud of your achievement. Warmest congratulations. It was a

truly great effort – Wally.' I'll never forget that simple note. It encouraged me to pick myself up and look forwards, not back. I resolved immediately to try again.

The Arctic Ocean had humbled me: my first expedition failure. But, if you want to get on in the world of polar challenges you can't lick your wounds for long. As cruel an experience as it had been, we soon realized how useful it was. We reassessed everything: clothing, food, camping gear, skidoos, ice conditions, the act of survival. Frostbite and implausible cold still posed problems, but at least we knew now what we were in for. We would still aim high, but we'd go with caution. Failure sparked in my mind a whole host of new questions and I determined not to make the same mistakes again.

The next time I attempted the North Pole, during the Transglobe Expedition, Wally was there to encourage me. As a traveller he was redoubtable and strong, but he was a kind man and funny too. The night before we left, a radio message came through from Wally. It finished with these lines:

With my very best wishes for the final dawn.
I send tips to help win the fight:
Beware of the calm that follows the storm
And the floes that go bump in the night.
Never trust ice that appears to be dead,
And if you want peace of mind,
Steer well clear of the bear up ahead
And cover that bear behind.

Under azure blue skies on Easter Day 1982, with the temperature hovering at minus 30°C, my companion Charlie and I finally reached the North Pole. We became the first men in history to have travelled over the Earth's surface to both Poles. We were too tired to celebrate and too apprehensive about what lay ahead to enjoy our achievement. We unfurled our flag and took some photographs. We made radio (Morse code) calls to our loved ones and sat for a while in silence. All around was ice. Our ship was still many hundreds of miles and many cold wet months beyond our horizon. It would be a race against time for us, drifting south as the ice broke up before we'd have to take to the sea ourselves. Wally would have understood how we felt. The job was not yet done.

RIGHT The multitude of hazards on the Arctic Ocean include more than just treacherous ice. Add in the inhuman temperatures, the long periods of total darkness and the bears that can hunt you down, day or night, and you might wonder why anyone would dare to go there at all.

Map labels:

C I F I C
O C E A N
SOUTH SHETLAND ISLANDS
Elephant I.
Shackleton
Gibbs
King George I.
Admiralty B.
Bridgeman I.
Nelson
Greenwich I.
Livingston
Bransfield Strait
Smith I.
Snow
Deception
Trinity I.
Astrolabe I.
Trinity Pen.
d'Urville I.
Joinville
James Ross I.
Snow Hill I.
Brabant I.
Melchiors
PALMER ARCHIPELAGO
Anvers I.
BISCOE ISLANDS
Victor Hugo I.
Argentine Is.
GRAHAM LAND
C. Alexander
Jason I.
Robertson I.
Mt. —
Larsen
Ice Shelf
Francis I.
WEDDELL SEA
VIEW POINT
Nordenskjöld
old hut.
EN Adelaide I.
MT. —
Debenham I.
Stonington I.
Marguerite B.
C. Agassiz
Hearst I.
MT WAKEFIELD 9400
Biggs
ALEXANDER
LAND
KING GEORGE VI St.
BATTERBEE
MTS
MT ANDREW
JACKSON 10,000
SEWARD
MTS
MT TRICORN 5200
C. Mackintosh
I C
SCALE

"Preparations for fine sledge journey to base
from View Point (with pony milkar propeller ?)"

be able to have a free run on James
Ross Island _____. I have an idea that the
new base leader, who is a surveyor, wants
to go on the plateau attempt — and I feel
that two surveyors on one journey is a
terrible waste of one surveyor. I have
therefore proposed to our authority that either
I or Lee has a go at James Ross.
Lee wants me to go with him on the

After many more weeks of effort we found a solid floe to base ourselves on and began our slow drift. Nineteen bears visited our tent over our 99 days on the floe. Only one was aggressive and he was warned off by a bullet through the shin as he attacked. On 3 August we abandoned our refuge and, using two small canoes on detachable skis, made a dash for safety on a compass bearing. We hauled like madmen and finally spotted two tiny matchsticks to the south, the masts of our ship the *Benjy B*. I think that was the single most satisfactory moment of my life. For hours we heaved, tugged, paddled and often lost sight of the ship, but soon after midnight we climbed on board. The circle was complete. On 24 August Prince Charles brought the ship back to her starting point in Greenwich, almost three years to the day since we had set out. Thousands of cheering people lined the banks of the Thames. Our journey, for a while at least, was over.

છ

In this tremendous book you can discover a little more of what it means to be a polar explorer. As a writer and polar guide, historian Huw Lewis-Jones understands what drives men like Wally and also knows a thing or two about being in this world. Here fine words are matched with original photographs that touch the soul of this great expedition. But though a gifted historian, Huw's views on Wally are, clearly, unashamedly biased. Let me reveal all! You see, Huw is married to Wally's daughter Kari. They have a little daughter who will grow up with the stories of Wally's exploits. Young Nell has a grandfather to be proud of. So, it is my duty to set out the unvarnished facts: Wally Herbert was a phenomenal explorer and a great human being. That's not a biased opinion. It's the simple truth.

For those of us who have travelled in the polar regions, the desire to keep going back is inescapable. At times it is bitterly miserable, horrid, relentless, exhausting, dangerous – yes – but the Arctic Ocean also offers a series of experiences that are closer to the finest of all feelings: being truly alive. I have often cursed for having wilfully placed myself in some icy predicament and sworn that, should we emerge unscathed, I would never return to such cold places. But I am addicted. As was Wally. Why do it? People often ask. There are many answers to the question of what is the point of all of this, but the truest is surely Wally's: 'And of what value was this journey? It is well for those who ask such a question that there are others who *feel* the answer and never need to ask.'

LEFT Wally was an explorer, surveyor, author and artist: a modest man of huge achievement. These are some of his original sketches and journals from his first expeditions in Antarctica.

annuation AM... ...ion-
the Final exa... ...
of Chartered Su... ...ed Auc-
tioneers and Estate ...
 Applicants are requir... ...state whether
or not they desire the Council to provide hous-
ing accommodation.
 Further particulars may be obtained from
the undersigned, to whom APPLICATIONS
must be delivered by MONDAY, 26th SEPTEM-
BER, 1955.
 R. G. LICKFOLD. Town Clerk.
Town Hall, Weston-super-Mare. 5th Sept. 1955

EXPEDITION TO ANTARCTICA.
 THE FALKLAND ISLAND DEPENDEN-
CIES SURVEY which maintains isolated land
bases in the Antarctic, requires SURVEYORS.
Salary according to age in the scale £400
rising to £540 a year with all found including
clothing and canteen stores Candidates.
SINGLE, must be keen young men of good
education and high physical standard who have
a genuine interest in Polar research and travel
and are willing to spend 18 or 30 months
under conditions which are a test of character
and resource. They must be competent to
carry out surveying operations in the Antarctic,
including plane tabling and astral fixing. Un-
qualified candidates who have had experience
with the Ordnance Survey or R.E. Survey
would be considered for training. Salary in
this case would be £330 rising to £420 a
year.— Write to the Crown Agents, 4, Mill-
bank, London, S.W.1 State age, name in block
letters full qualifications and experience and
quote M3B/35407/DA.

MAURITIUS
 WOMEN EDUCATION OFFICERS quali-
fied in (a) General Science; (b) Mathematics;
(c) English; (d) Domestic Science, are required
Posts are permanent and pensionable or tem-
porary appointment can be arranged. Exist-
... superannuation rights can be safeguarded
...ry scale for graduates £562 to £1,291
...annum; for non graduates £549 to
...6 plus appropriate cost of living allow-
... Free passages. Candidates must be
... graduate teachers with a teaching
... and/or experience or for ...
... diploma ...

UNI...
Limited accommoda... ...
15,000-mile 9 weeks' ...
as follows: November 1... ...
(Cabin), February One ...
 1st Class. April O...

 First Class ...
One Class (Cab...

 Apply your Tr...
3. Fenchurch Stree...

SOUTH AFRIC...
 NEW Z...
†CERAMIC (1st class o...
*DOMINION MONARCH...
†Gothic (1st class only...
†Via Panama to New Z...

 SHAW SAV...
11a. LOWER REGE...
 WHItehall 1485...

THE WE...
VOYAGE OF...
 by the s...
calling at Barbad...
Curacao. Jamai...
Leaving TILBUR...
Returning from NA...
 SINGLE ...
 RETU...
 Also special rou...
ber, January and ...
in conjunction w...
 Ask your TR...

 SWE...
Marlow House.

SUNSH...
Make sure of ...
ing a holida...
M./S. "Vent...
bord" tab...
at 5...
of ...

1 | KEEN YOUNG MEN

Here's to the long white road that beckons,
The climb that baffles, the risk that nerves;
And here's to the merry heart that reckons
The rough with the smooth and never swerves!

Seaforth Mackenzie, 1907

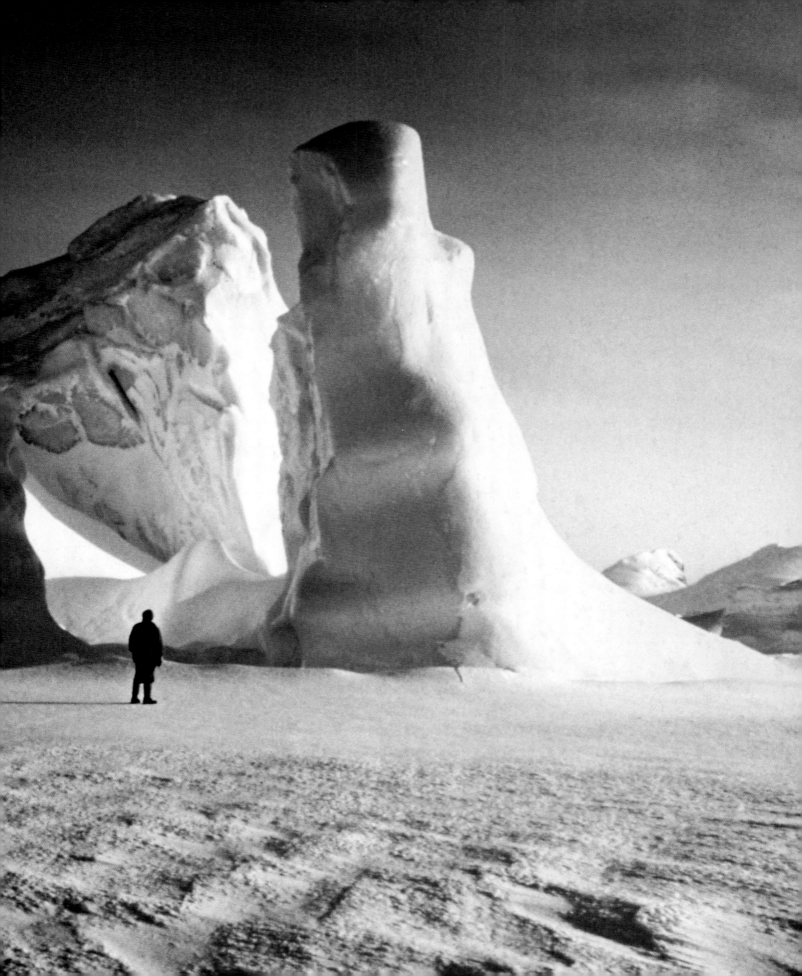

A blue-grey fog was tumbling softly round a dead camp fire when I awoke, cold and stiff, on the morning of 18 June 1960, rolled out of a hollow in the spongy tundra, launched a canoe and resumed my journey along the fjord. In the past three days I had paddled 80 miles through breaking seas along a coastline aproned in scree and scarred by rushing melt streams, and beneath towering cliffs with curtains of nesting birds. It was a race against time – to catch a ship due to sail south from Longyearbyen on the Arctic island of Spitsbergen.

A month before, I had made my escape from England in an old Austin van, driving up the coast of Norway, deep into the heart of Lapland, and then on by ship to Spitsbergen. Yet my stay on the island had been a short one. During the past four weeks I'd been a member of a small expedition whose object had been to carry out physiological experiments to see if humans could adapt to an abnormal length of day. Relaxing in the sunshine, without any great stress, hardship or isolation, or time for discontent, it was not so much an expedition as a holiday. I was, however, obliged to return to England ahead of my companions because I had been invited to join the New Zealand Antarctic Expedition as a surveyor, and had also agreed to make a trip to Greenland to buy dogs from the native hunters and transport them to Scott Base in Antarctica's McMurdo Sound.

Fog muted everything that morning; even the canoe made only a dull thud as it plunged into the waves. By evening, as I drew in to the coast alongside a cluster of derelict shacks on the side of a small tributary fjord, I was fatigued and frozen to the core. Though it was only 2 miles across from there to Longyearbyen, I had no reserves of energy to cover even that short distance. The ship was not leaving until the following day,

so I decided to doss down in some sheltered nook among the deserted mine workings of Moskushamn.

A wiry, strained-faced man appeared, strode to the water's edge, greeted me in English and lifted the canoe high above the beach. We picked our way through the debris of broken-down buildings and rusted engines to a warped three-storeyed warehouse. Most of its windows were shuttered and the groaning door flapped gently on its hinges. Inside, it was dark. Pit props supported a sagging ceiling. The whole building seemed to be listing, and the rotting staircase creaked as we climbed to the attic.

My host was the only inhabitant of Moskushamn, a recluse who had spent the two previous winters on the north coast of Spitsbergen hunting polar bear. He was gathering stores and equipment for another trip, and the squalid attic was his temporary retreat until autumn, when he would ship by sealing vessel up the coast, occupy his tiny hut, bait his traps, set his fixed guns and wait for the bear to come. He was a man with a stare in his eyes; a man who wintered alone by choice – a nocturnal man who awakens at sundown and prowls around in polar darkness.

Several hours passed before I felt at ease in his company, for he was intense and, seemingly, a nervous man. We came from different worlds, he and I, and yet we talked away the hours of sleep while the wind moaned past the windows. We spoke of his life as a hunter. We talked about the polar bear and about the Arctic Ocean and its currents that had carried driftwood from Siberia to the rocky coast outside his hunting cabin. 'Why is it,' he asked, 'that no one has ever attempted to sledge across the Arctic Ocean?'

'Because it is not feasible,' I replied, without much thought.

<center>☙</center>

Three years were to elapse between my meeting with the hunter and the realization that the journey we had talked about was not only feasible but probably also the most challenging journey left to man on the surface of our planet. I cannot claim that during those three years I nursed a dream of launching a great Arctic expedition – I really wanted to map virgin mountain ranges instead, maybe even sledge to the South Pole too – though I do remember the first time my plans began to formulate.

Back in England a chart of the Arctic Ocean soon absorbed my attention. On it were plotted the tracks of several Russian scientific stations that had been set up on the drifting floes in the 1950s. I added to it the tracks of the new American drifting stations and the 1895 course of *Fram*, the ship of my hero, the Norwegian explorer Fridtjof Nansen. I was intrigued to find that the ice circulation formed a pattern that broadly divided into two currents. One, evidently slow-moving, drifted clockwise in the western half of the Arctic Ocean; the other, faster-moving, seemed to flow over the North Pole and out of the Arctic Ocean between Spitsbergen and northeast Greenland. I thought I could work with nature, moving with this stream of energy, following the drift of the frozen sea.

The more I studied that chart, the more reasonable it seemed to me that a party of men and dog teams could set out from Point Barrow, Alaska, and sledge via the North Pole to the other side, perhaps even Spitsbergen or the Russian coast. I had not taken into account in those first rough calculations that the 1,850-mile route taken by airlines from Alaska to northeast Greenland, for example, would, over the polar pack, be increased dramatically, both by the continuous twisting and turning, which would mean threading our way back and forth over frozen ramparts, and the daily movement and drift of ice underfoot. Nor had I at that time really studied the harrowing records of previous explorers who had attempted to reach the North Pole, to say nothing of giving thought to how I might raise the money for such a venture.

Perhaps it is just as well, for had I realized how much hard work, frustration and disappointment lay ahead I might never have become involved in the dream. To the exclusion of all else, this expedition was to occupy more than seven years of my life. And thinking about it now, the journey had actually begun even a few years before this, when, as a young man of just twenty, I was sitting on a bus, bored. It was 1955. I remember it clearly, as if it were yesterday. That morning would change my life forever.

But before that let's go back a few more years. I actually remember very little about my childhood. I had been told, of course, of various events to which I had made some contribution during the first few bruising years of my life. But so few of these appear to have registered, I think I must have come to the conclusion quite early on that being a boy was a waste of time – I wanted to grow up and achieve something.

Any psychologist worth his salt would probably have considered some of these events of interest, such as my first serious adventure of walking across a frozen river on ice that was barely thick enough to support the weight of a boy of twelve – the very first 'triumph' of my life that I can recall. I remember especially returning home and boasting proudly about what I had done and of my parents' angry reaction. My mother wept and my father grew into an alarming rage as, just returned from the Second World War, he didn't really know whether his role as a father and a military man gave him the right to beat me. In retrospect, I suppose it's a little ironic that my final thrashing as a boy should have been for the very act of walking on ice, something that would so come to dominate my adult life.

My father had been born into a family in which every male member during the past four hundred years or so had served his country as a soldier, and he was particularly proud of his military heritage. His own father had died at the early age of 39 while serving in South Africa, where the family was living at the time. So at just nine years old my father had been sent back to England with a label sewn on to the front of his jersey saying 'deliver this boy to the Duke of York's Royal Military School at Dover'. At the age of thirteen he was enlisted into the Royal Regiment of Artillery.

He never spoke about his courtship of my mother, but from her I learnt that his proposal of marriage had been written on a note that he pushed under the door of her room as he set off to join a troop ship bound for China. There he was to serve for the next four years, climbing slowly through the ranks, and my parents married on his return to England. I was born on 24 October 1934 in a tiny terraced house in the City of York. I'm often talked about as a Yorkshireman, although in truth I was only there for about two months before being taken on a troop ship to Egypt. Shortly after the outbreak of the Second World War my mother, baby sister and I were evacuated out of the 'War Zone' on a ship heading south through the Suez Canal. Along with several other soldiers' families, we were put ashore in South Africa and told to fend for ourselves until the War was over.

It was there, on a ranch in the Drakensberg Mountains, that I spent a solitary childhood in a wild and remote region. I had no male adults to discipline me, or offer me any encouragement. My sister and I did not meet the stranger who was supposed to be our father until after the war had ended, and it was difficult for all of us to adjust. For many years I resisted the collective pressure from my father and two of his surviving brothers that I should join the army when I left school. This, they had assured me, was as close as I could ever get to becoming an explorer. I had been given the same advice by the careers service in my final year at school. And so, naively, at the age of seventeen I was marched off to the nearest Army Recruiting Office escorted by three officers in uniform and signed up for 22 years.

True, my contract gave me an option to leave the army after serving only three years, but the advantage to me of being a 'career soldier' was that I would be eligible for special courses – such as those at the School of Military Survey, which would give me a grounding in cartography and navigation. This is pretty much the way it worked out. After a year studying surveying I was posted out to Egypt and there, in a tented camp in the Suez Canal Zone, I spent the next two years producing maps of Kenya from aerial photos and counting the grains of sand in the desert.

Unfulfilled, I eventually managed to persuade the Colonel that I had more to offer life as a civilian. He agreed, and so I was able to leave the army in Egypt and hitch-hike back to England, drawing portraits for my board and lodging and, as often as not, sleeping rough. From Cyprus I took a nightmare steerage passage on a stinking old ship across to the coast of Turkey. Then through Greece and Italy I made my way from one scrape straight to another – a stream of adventures in the space of five months that aged me by as many years.

Actually, that ageing process was to work distinctly to my advantage sooner than I could have imagined, although for the first few months after my return I could see no glimmer of light at the end of a black tunnel – there seemed to be no possibility whatsoever of becoming the explorer I yearned to be. I took a job as a cartographer with an air survey company on the south

coast of England, often working a night shift so that I could enjoy the summer sunshine during the day – and I lazed away my free hours dreaming.

Then one morning in 1955, chance offered a timely hand. I will never forget that moment. It was a blustery day, and the lurching bus taking me to work was dank with the odour of steaming raincoats. I had paid my fare, lit my pipe and had just closed my eyes when there was a rush of wind, and in my lap landed a newspaper that had fallen from the luggage rack. It was opened at the appointments page, and two advertisements caught my eye almost simultaneously. 'Surveyor required in Kenya', one said; 'EXPEDITION TO ANTARCTICA', announced the other:

> …THE FALKLAND ISLAND DEPENDENCIES SURVEY which maintains isolated land bases in the Antarctic, requires SURVEYORS…. Candidates, SINGLE, must be keen young men of good education and high physical standard who have a genuine interest in Polar research and travel and are willing to spend 18 or 30 months under conditions which are a test of character and resource….

I jumped off the bus, ran past the boat yards, over the bridge and along by the mud banks. I arrived at work in a glow, borrowed a pen, secluded myself in the smallest room and wrote an application for each of the jobs. I was in an agony of excitement as the days went by. Then I was summoned to London for an interview for the second job. I should have had answers for all the simple questions that came up, such as: 'Why do you want to go to Antarctica?' A searching question if ever there was one,

and yet all I could splutter on the spur of the moment was, 'Because I've always wanted to go there.' I felt very foolish.

From the time I was a smooth-skinned choirboy, my hero and role model had been Norman Gurney, who, when a young curate fresh from college, had sailed to the Antarctic on the three-masted schooner *Penola* in 1934, the year I was born. Years later he would enthral us choirboys and his congregations in his Sunday sermons with tales of his ship battling through the massive waves of the Drake Passage on her way south to the ice. Another member of the crew had been Duncan Carse, who at the time of my youth had been a household name as the radio actor who played the role of 'Dick Barton Special Agent'. In my formative years these were the two men I most greatly admired, and I had read every book about their adventures I could lay my hands on. Why had I, at the very least, not mentioned them?

'If you were tent-bound for ten days or more, how would you keep your tent mates amused?' That one completely beat me. But why did I not, there and then, tell them of some of the amazing adventures on my journey home from Egypt? 'I'm sorry, Mr Herbert, but we really don't think you are suitable', the man in the grey suit said, and my heart sank with a thud. And they were just about to draw a line through my name on their list of applicants when I boldly demanded to know their reasons. They all looked up from their pads with surprise. 'Well, Mr Herbert, it's like this: we are interested in what a man has done – not what a man says he would like to do. You haven't done very much with your life so far, have you?'

'No Sir, I suppose not', I said, totally crestfallen. I tried to be polite and say 'Good Morning', but the words stuck in my throat, and so I simply stood up and walked out. I was still only twenty years of age and had no professional qualifications, facts

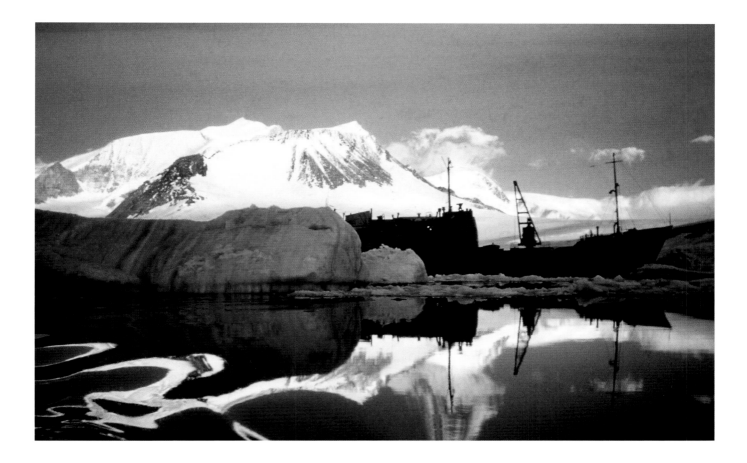

that struck me hard when I returned to the waiting room where the other applicants were seated. All of them had degrees and looked at least five years older than me, but not one of them, I thought, had done anything with their lives to prove that they had spirit and a powerful sense of destiny. I had both, but had failed to point it out – or so at least I thought. For a commissionaire was sent after me as I was walking away from the ordeal with the message that I was to go right away to Harley Street for a medical.

So, clearly, to my surprise, I had come through, and I was overjoyed. Two months later I sailed for Antarctica on the research ship *Shackleton* on a cold and rainy day, 27 December 1955. We were following a few weeks in the wake of the Commonwealth Trans-Antarctic Expedition ship *Theron*, but no sirens or church bells bade us farewell as they had for that departure; only a few friends and relations were waving their

handkerchiefs tearfully as they stood on the quay, mirrored in puddles of water.

In the Falklands I joined the old *John Biscoe* for passage to Hope Bay at the northernmost tip of the Peninsula, which was to be my base for the next two years of dog-sledging and mapping. We sailed all day through the pack ice on our fifth day south from Stanley around the coast to Duce Bay, where we were going to land the building materials at View Point for a four-man hut we would erect later in the year. That evening a curtain of cloud was drawn across the sky, leaving only a chink of brilliant light along the western seaboard, and a tantalizing first glimpse of Antarctica. To the east, night had already settled, and by the time we reached Duce Bay, it was dark.

No ship had ever been in that bay before, and the Captain reluctantly broke a channel through the old ice towards the

ABOVE For our crossing of the Antarctic Peninsula in 1957 we laid a depot on the coast using the ship *Shackleton*. On either side of us smooth snowfields dipped steeply into the bay. The floating ice was drifting by and sunbeams played in the water among the chunks of brash.

chosen site for the hut on View Point, which we strained to see even with the searchlight trained on it. We were divided into two working parties: one would move the stores from the hold to the deck of the ship and then into the scow, while the other would work ashore, off-loading the stores on to a rocky headland about a mile and a half from the hut site. I was detailed to go with the shore party. By this time the night was almost pitch black.

The scow bucked in the swell and scraped on the rocks – mooring lines tightened and then went slack, tripping us up as we struggled with the cumbersome loads. We crawled like ants over the greasy boulders, supporting each other, or formed a chain to pass the sandbags and heavy crates. Occasionally all of us came together to handle an awkward load across slippery planks bridging the surging tide between the scow and

the sea-sprayed rocks. The ship's searchlight would feel its way along the coast, find us and then wander away. For a moment we would recognize each other, then in darkness again we would fumble about. After a few more hours work we were back onboard and heading round the coast to our main base at Hope Bay. But what a dramatic first night it had been, to have stepped foot on the Antarctic continent at last!

My task for the next few years was to map the Plateau, coasts, mountains and glaciers from Hope Bay to Portal Point, some 10,000 square miles. We actually spent the entire first year laying depots of food and fuel to support the journey we would make – the first crossing of the Antarctic Peninsula – and we had no aircraft to help us. We were four men with two teams of dogs, and in fifty days we achieved what many had thought impossible. Seldom have I ever been so sharply aware of the

ABOVE No building has ever meant so much to me as our hut at Hope Bay, with bunks head-to-toe around the walls and a stove in the centre. We spent our evenings reading and writing letters home, fixing things – here a sledge harness – dreaming of new adventures perhaps, or playing chess or darts.

narrow margin between safety and disaster, whether enduring blizzards confined to our small tent, or crossing precarious ridges as clouds surged over our route. Once we had started, we had no choice but to continue on.

For a month, at journey's end, we survived in a small refuge hut until the *John Biscoe* returned to pick us up. Soon I was hitch-hiking my way home once more alone overland through South America, dreaming of expeditions that would, many years later, culminate in the first crossing of the Arctic Ocean. But this time here in Antarctica in 1957 was certainly one of my happiest. We saw a paradise in snowscapes and heard music in the wind, for we were young, mastering the art of driving dogs and full sledges, travelling by compass, sextant and the stars – learning the art of surviving, yet also having the time of our lives.

<div align="center">ᐧᔦ</div>

My next journey to the Antarctic was a completely different experience from that first voyage south; for one thing it was on a flight in a US Navy Globemaster packed to its limit with boxes of all sizes and shapes, and twelve dog crates. It took just a few hours of flying time to reach our destination compared with several days of stormy seas when crossing the Drake Passage. But the most stunning experience was flying over the Ross Sea, and seeing, far below, the unmistakable coastline of McMurdo Sound and the winter quarters of Scott and Shackleton. I had read about this area with avid interest when I was in our hut at Hope Bay on the other side of Antarctica, but at that time had never dreamt I would actually get to see it.

Following my late-night conversations with the hunter in Moskushamn, then a journey across to northwest Greenland to buy the dogs, and many flights later I was now stepping foot again in Antarctica at New Zealand's Scott Base. It was 1960, another year that would shape my future path. I was leader of a four-man team of surveyors in the blank wilderness and our task was to map the mountains that lay to the south, the very 'Gateway to the Pole'. I would spend the next two years sledging with our dogs among majestic ranges and formidable glaciers, following in the footsteps of our heroes Shackleton and Scott. Towards the end of this programme of surveying and collecting geological specimens, on 16 January 1962 – exactly fifty years after Scott and his companions learnt that they had been preceded at the South Pole by Roald Amundsen's team – we managed to make the first ascent of Mount Fridtjof Nansen in the Queen Maud Range.

'Great God! This is an awful place', Scott had written of the South Pole in his diary in 1912, 'and terrible enough for us to have laboured to it without the reward of priority.' Those immortal words were singing in my ears for the seventeen hours we were on the 13,350-ft mountain, cowering in a stabbing wind, struggling to carry out our survey, stopping every few minutes to blow into our gloved hands and massage our stiff bodies. The misery and exhaustion we suffered dug deeply into our reserves, and the long, long trudge back down to camp almost claimed the four of us. It was less windy down below and the sun was soothing; in spite of the risks of resting we were compelled to lie down every few yards.

Nearing the end of the expedition, we now had to find a route off the Polar Plateau in order to be picked up for our return home. We scorned the radio message suggesting we retreat back around the fringe of the Plateau and instead drove our teams to the head of the Axel Heiberg Glacier. The sledge flags drummed in a stiffening breeze from the south, while we

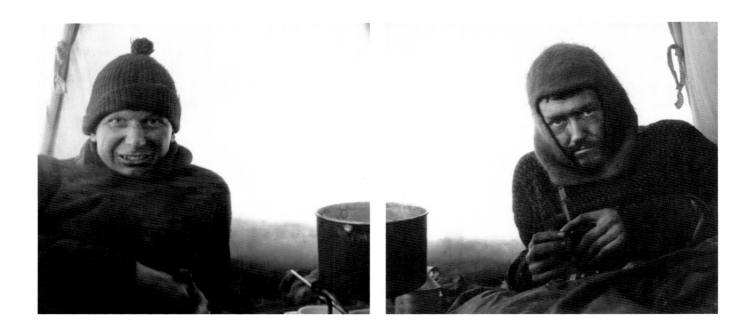

assessed our chances of safely descending the route Amundsen had taken up the glacier on his journey to the Pole. In one way at least Mount Fridtjof Nansen had been good to us, for from its eastern side we had been given a glimpse of part of Amundsen's route. The icefalls of the glacier we could not see, but the top terrace and the run off at the bottom looked crevasse-free. The evening we reached that spot was glorious. The smooth, soft Plateau sank gently towards the brink of a bowl of cloud. Two ice-caked mountains rose on either side, catching the sun on their slipping faces scarred with crevasses and gaping chasms.

We had a copy of Amundsen's book *The South Pole*, and we had read passages from it to each other every night. We handled it with reverence and I had re-read it until I knew by heart his

account of the ascent and descent of that magnificent glacier. But we found many ambiguities, for the narrative of his journey had not been intended as a guide for future travellers. He had made no maps, left no route sketches. He had taken only two photographs and neither showed the icefalls. We had no choice but to re-discover a route down the Axel Heiberg ourselves.

Amundsen's ascent of the Axel Heiberg Glacier had been a triumph of courage, experience and good sportsmanship. His return down after reaching the Pole seems so uneventful and straightforward that it barely gets a mention in his book, and yet by reading between the lines of this master of understatement I can see how breathtaking that trip down must have been. He covers the crux of the descent with no more words than these:

ABOVE Lee Rice arrived as the new leader of Hope Bay on my first trip to Antarctica and he became a good friend. I took him on long journeys across the sea ice and he joined my team on the first crossing of the Peninsula. When this picture was taken in 1957 it was the third day of being trapped in our tent by a blizzard. Outside the temperature was minus 28°C.

On the ridge where the descent to the glacier began we halted to make our preparations. Brakes were put under the sledges, and our two ski-sticks were fastened together to make one strong one; we should have to be able to stop instantly if surprised by a crevasse as we were going. We ski-runners went in front. The going was ideal here on the steep slope, just enough loose snow to give one good steering on ski. We went whizzing down, and it was not many minutes before we were on the Heiberg Glacier. For the drivers it was not quite such plain sailing: they … had to be extremely careful on the steep fall.

For our attempt I decided we would first try a lightly equipped reconnaissance of the route, as we dared not commit ourselves to the glacier with our full loads in case we met an impasse and had to return; nor could we risk an accident on the glacier, for we had not yet been given permission to make the descent. And it had to be done in less than four days. We had no intention of taking the heavy radio, and four days off air was the mute clarion call for search and rescue to begin. So we had to flag a route through the icefalls and be back on the Plateau by 7.30 p.m. on 24 January. The brink of the first drop could not be seen, but we could feel it waiting to swallow us. Amundsen had called it the 'severe, steep slope' and I skied towards it to judge it for myself, while my companions sorted out the gear we would take with us on our reconnaissance.

We fastened the Norwegian flag I had made out of bits of bunting and torn handkerchief to the front of the leading sledge, prepared the rope brakes, called to the dogs and lurched forward along my sledge tracks. We over-braked the sledges and began to descend in perfect control, not taking the slightest risk that would jeopardize our success. We felt squeezed by crumbled buttresses of ice, sun-soaked and shadow-smudged, that towered on either side. Struggling through the deep snow of the top terrace, our shouts profaned the silence, our tracks scarred the soft surface. After the first day our tents went up on a ledge, with mist swirling around us. Six inches of snow fell on our outward tracks. Time trickled away.

At this point two of our four-man team volunteered to make their way back up to the Polar Plateau, leaving me and Vic McGregor with the rest of the food. We skied off the ledge and down a 1,000-ft drop on to a smooth table of snow which reached out towards the icefalls. At the corner of the table the ground fell away in a gaping precipice. Before us was a turbulence of ice – I had never seen anything to surpass the power, the beauty of that scene of turmoil and chaos. Into the cwm fell thundering, grumbling avalanches, with snow exploding in white cushions, curling, settling, churning the floor with debris. We stood transfixed and stared in horror at the glacier far below. The knives of nature had slashed that valley with such viciousness that mere man – so insignificant – could surely not creep through. But Amundsen and his men had done so fifty years before.

Which way had they gone? We studied the icefalls through binoculars for almost an hour trying to imagine a route, but it was impossible to judge the scale – we were still at least 2,000 ft above the chaotic ice that was the crux of Amundsen's route. We could see no hope of finding a way, but in order to get some photographs among the spectacular icefalls we set off and free-skied down a switchback fall on to the middle terrace. Roped together, we probed our way towards the head of the bottom icefall. Swishing over small ice-bridges with yawning crevasses on one side and chasms on the other, we descended, and in the

cold grip of fear hurtled towards the yawning mouth of a chasm, coming to a trembling stop at its edge. We picked ourselves up and as we dusted off the snow we felt the leaping pride of having safely negotiated the vital stage of Amundsen's route.

At the bottom a meandering course began. We went up and down and around the lips of monstrous pits and chasms until we came to a comparatively undisturbed tract, followed by another region of awful pits. At 6.30 a.m. we were through the worst of the icefalls. Ahead we could see a clear route on to the main stream of the glacier. We stuck in a marker flag at the only spot near at hand where there would be enough room to span out two teams of dogs and erect a camp. We were now 6,000 ft below our depot on the Polar Plateau and we had to get back up.

On our return journey up the icefalls we stuck in marker flags at every distinct change of direction, so that on the descent with the dog teams, should the weather be against us, we would be able to feel our way between the crevasses by taking a straight line route from one flag to the next. The next day we reached the Plateau with the good news for our companions that we had found a route. However, permission had still to be granted for us to make the actual descent in order to be picked up from the ice shelf. Surely, we thought, this permission would be forthcoming, since there were no suitable aircraft landing sites on the Polar Plateau within a hundred miles of our camp. All four of us were getting very tired, we were running low on food, the weather had been bad for weeks and the temperature had begun its autumn plunge. By this time the Plateau had become an awful place. Our faces were sheets of ice, our hands and feet seized up as fatigue slowed our progress to a halt. Frozen fingers switched on the radio, disgust twisted our faces as we heard more excuses – 'they are still in conference'. At last we were given permission to go.

On 5 February we contacted the base with the news that we had safely descended the glacier. We were just a short distance from where Amundsen had camped after his descent, exactly 50 years earlier. Our last day's sledging was pure delight. Relief after all the anxiety and the glorious warmth of lower altitudes restored our spirits. A few miles further along the coast we found a perfect landing site on the vast ice shelf that stretched out for hundreds of miles to the north.

We spent two lazy days waiting for the aircraft to reach us. We sorted our gear, repacking with great care the 150 lb of geological specimens and fossils we had collected – we had carried many of those rocks almost 800 miles and to us they were more precious than diamonds. Our survey observations filled several notebooks with cold spidery figures, computations and sketches, each one part of a gigantic scheme that would provide the information for a map covering over 22,000 square miles of the Beardmore Glacier and the Queen Maud Range. It had been a successful season and the glow of its climax developed into deep gratitude as I watched my companions relax and laugh easily once again. Our tracks had converged on a glacier in Antarctica. We had met in spirit at the head of it and had descended together. We would now each voyage on alone.

The plane finally came like a noisy bird. We fed it with dogs and sledges and gear. In less than half an hour we were lifted into the air and into the warmth of our own thoughts. Then came the safety of Scott Base, a first good wash and a fried breakfast, but my heart was already heading elsewhere. My years in Antarctica were crucial to my future success; we were living our dreams almost every day, but also preparing ourselves for journeys we had yet to dare to imagine. To the south lay my past – and now, to the north, I saw my future.

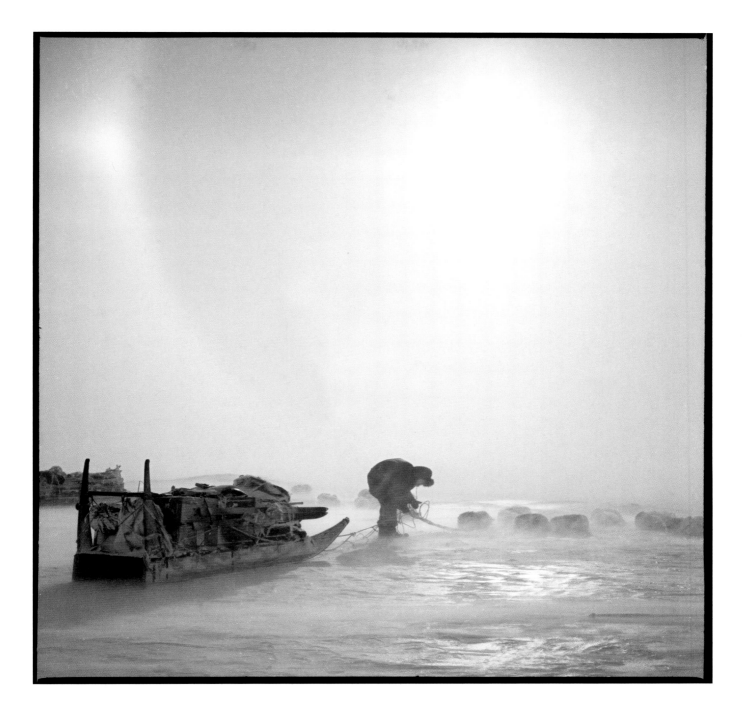

ABOVE Original medium-format film positive from our Arctic training expedition in 1967, before setting out on the crossing itself. It was, without doubt, the most difficult journey of my polar career up to that point. But as a training exercise it was essential. Now we truly knew the weaknesses of our equipment and ourselves.

PORTFOLIO

KEEN YOUNG MEN

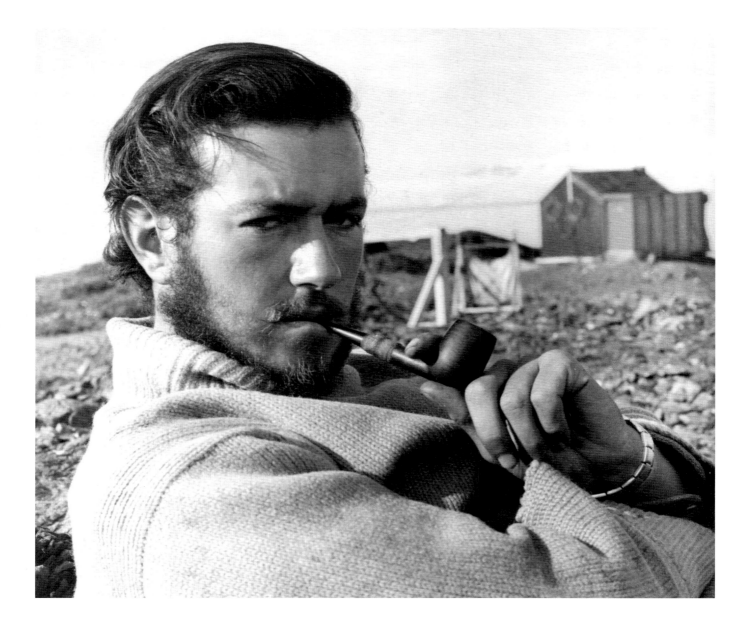

ABOVE I was just 21 years old when I first sailed for Antarctica. My formative years were at Hope Bay and my favourite memories are from my time there, as one of twelve men around a bunkhouse fire, or two men in a tent, or alone in the solitude of summer-warmed hills. It was a hard but carefree way of life, and over too soon.

RIGHT At extreme temperatures a cup of boiling water thrown in the air will explode into a bursting cloud of minute ice particles. This little trick gave us no end of pleasure. In this shot it was about minus 50°C and it was worth the cold to get a good photograph. We tried many times.

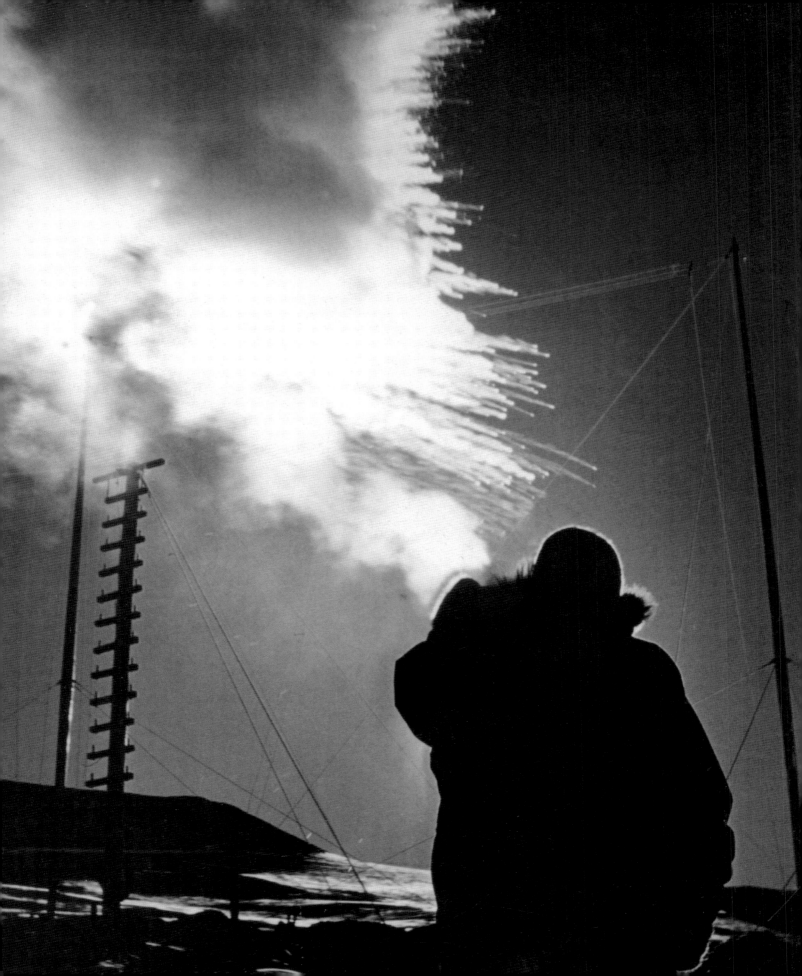

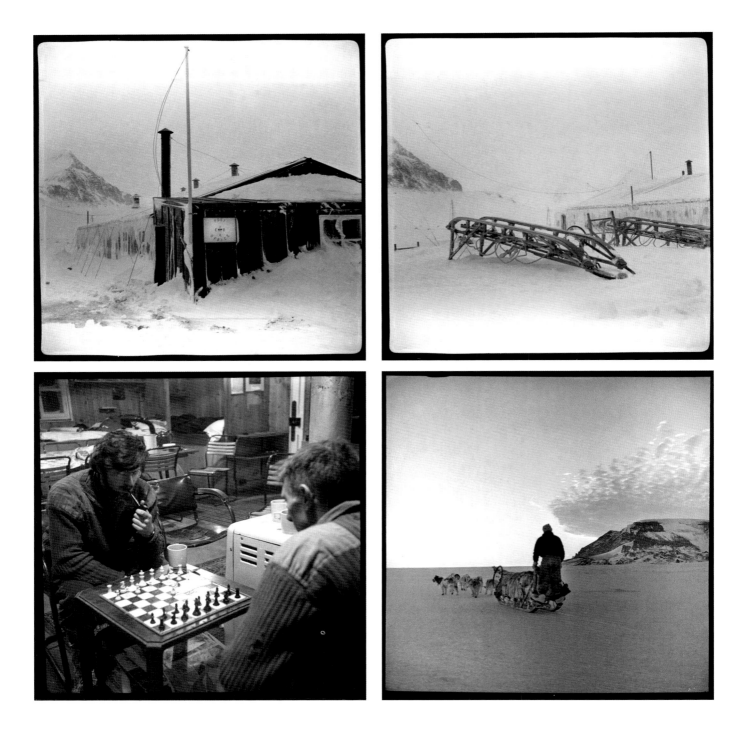

ABOVE Our hut at Hope Bay was a shell of pine timbers that creaked and groaned in gales, with guy wires to anchor it to the solid rock. The rows of upturned sledges outside gave the hut the distinctive character of a British polar base. We sat out the winter storms, but when light returned we were off into the wilds.

RIGHT My task on this first Antarctic expedition was to map the whole area from Hope Bay to the Reclus hut at Portal Point – approximately 10,000 square miles. We had to spend the entire first year laying depots of food and fuel to support our one-way journey – we had no aircraft to resupply us, as they have today.

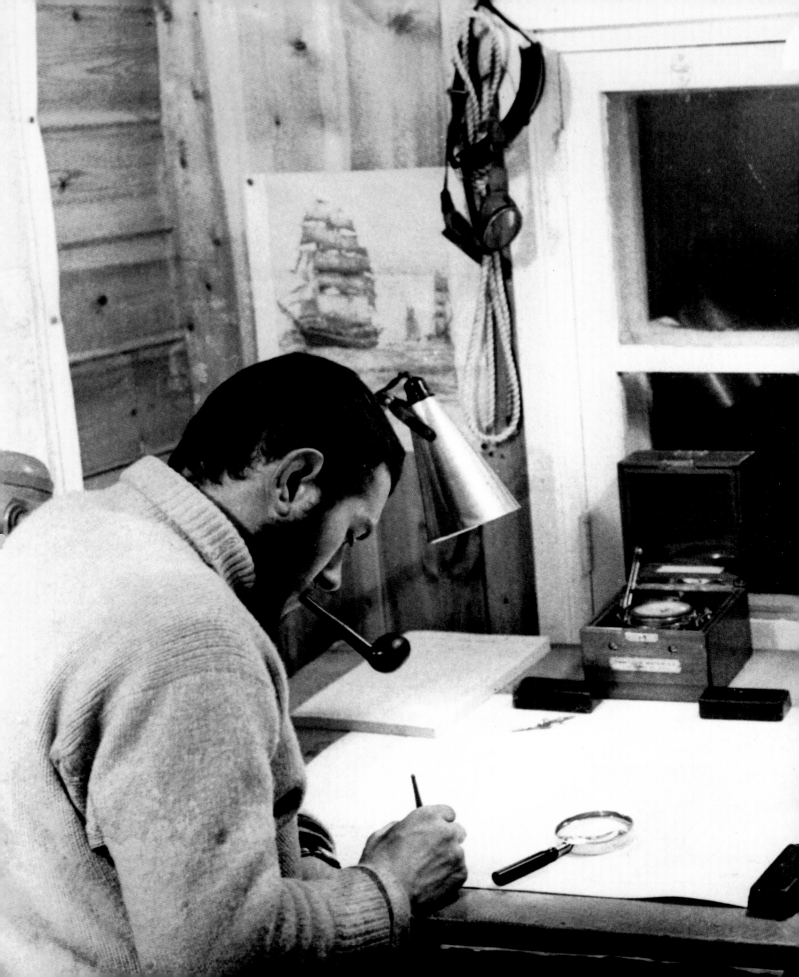

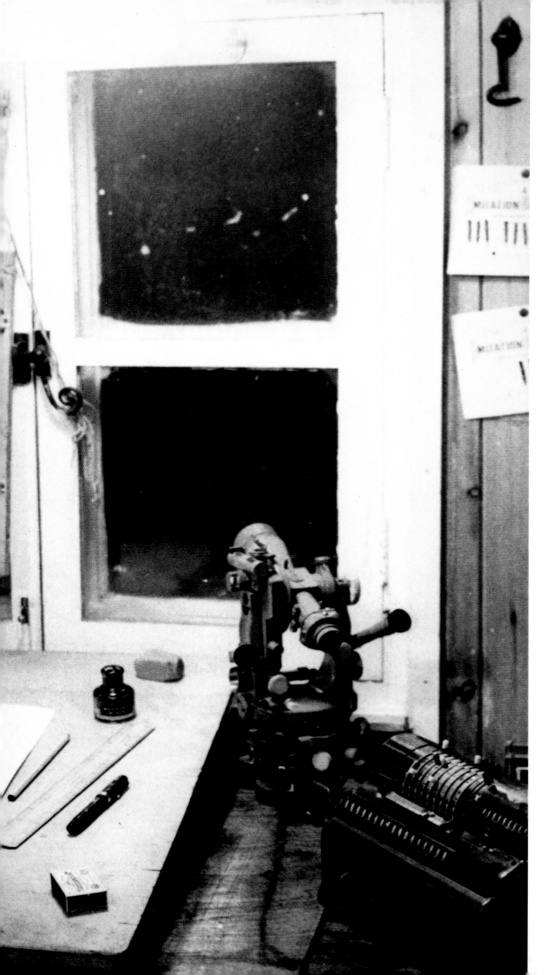

LEFT The hut door opened into a narrow room aromatic with sledging smells of linseed oil and beeswax. In a small corner I began to make our maps and soon my drawings covered the walls. Although I made it as snug as I could, my inks still froze during the winter. I would look out of the window at night and see the blizzards streaking across the beam of light.

PAGE 58 On 9 October 1957 we left base and after two hard weeks of sledging took the first steps up on to the Peninsula ridge. Climbing that escarpment was a gruelling experience in drifting snows. It was a desolate world, a desert of ice. Day after day we recorded our progress as a line drawn on an almost completely blank map.

PAGE 59 Man-hauling sledges is a self-imposed hardship. We would use our skills and knowledge to be wise and careful in our passage, not to battle nature needlessly. Teams of tough dogs were the answer.

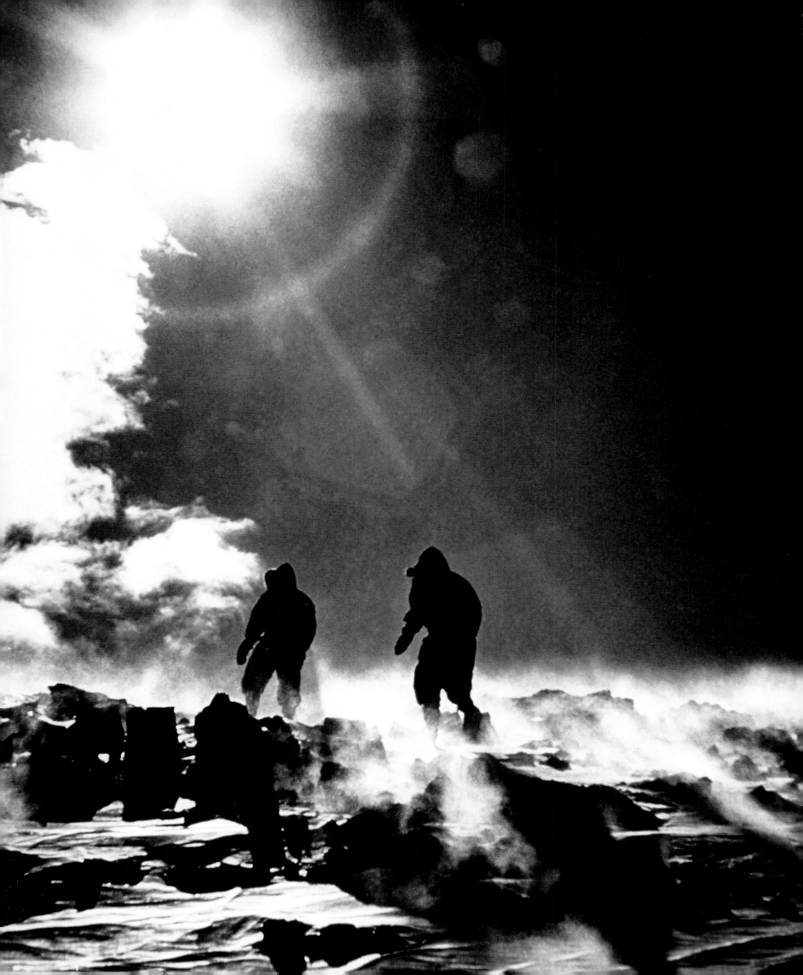

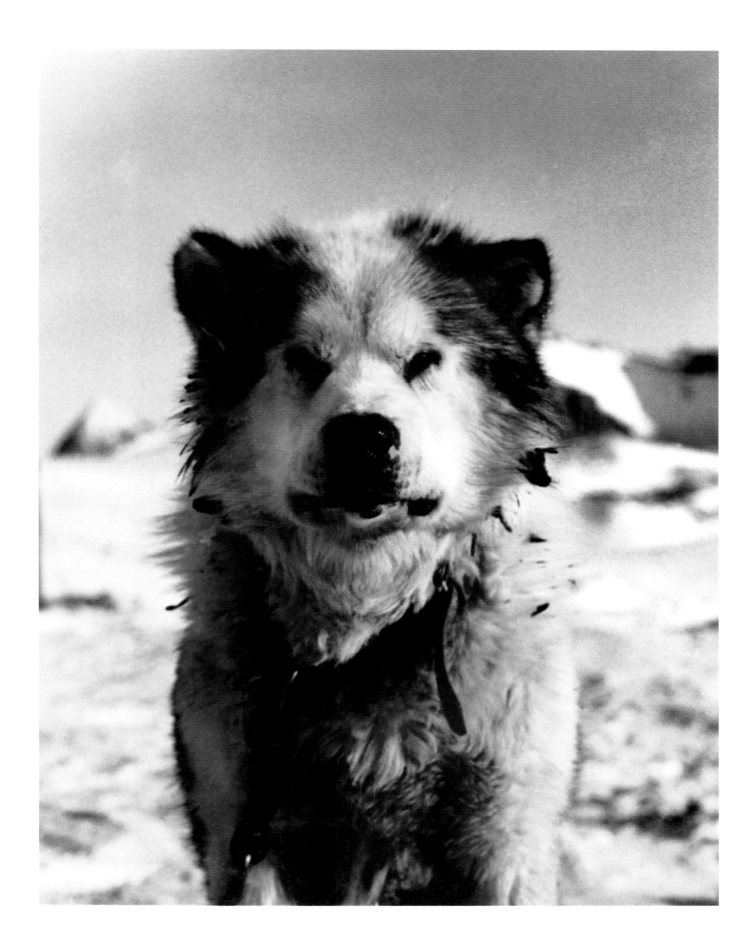

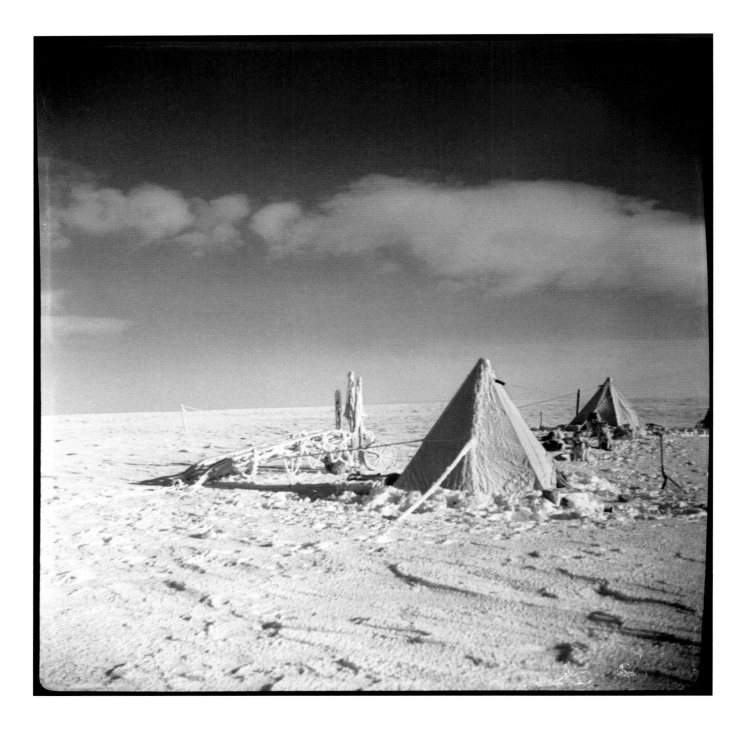

ABOVE As snow fell continuously on my 23rd birthday, 24 October 1957, we were confined to the tent reading *Woman's Own* magazines. In one box of pemmican the packers at Bovril's had tucked in copies – a nice gesture of goodwill. That evening we had a party in the tent – the highlight was the opening of a precious tin of pineapple.

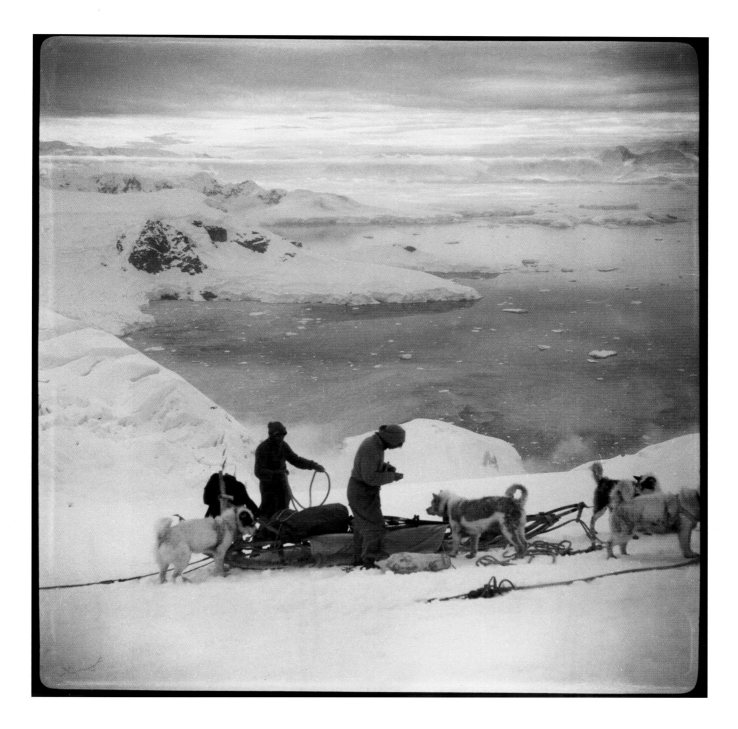

ABOVE Our 50-day mapping journey has never been
repeated. Our aim was cross the Antarctic Peninsula from
east to west, and find refuge at the tiny Reclus hut at Portal
Point. The plateau edge was a sheer drop of several thousand
feet. It was not a safe area along which to travel for 3 miles,
let alone 300, but we made it.

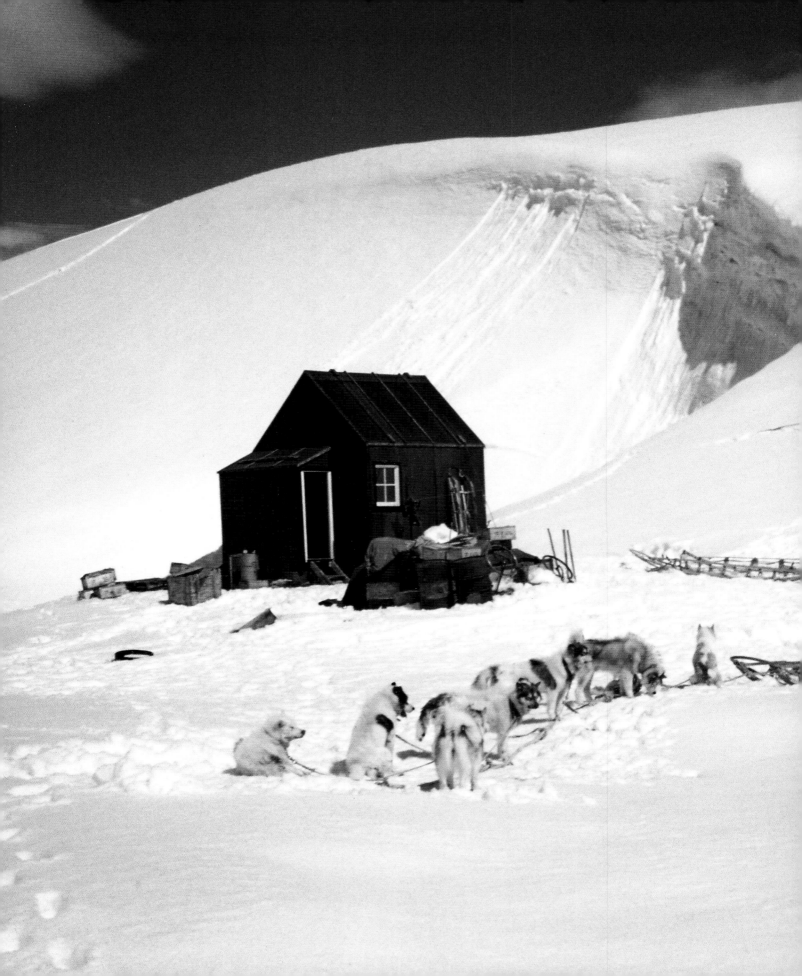

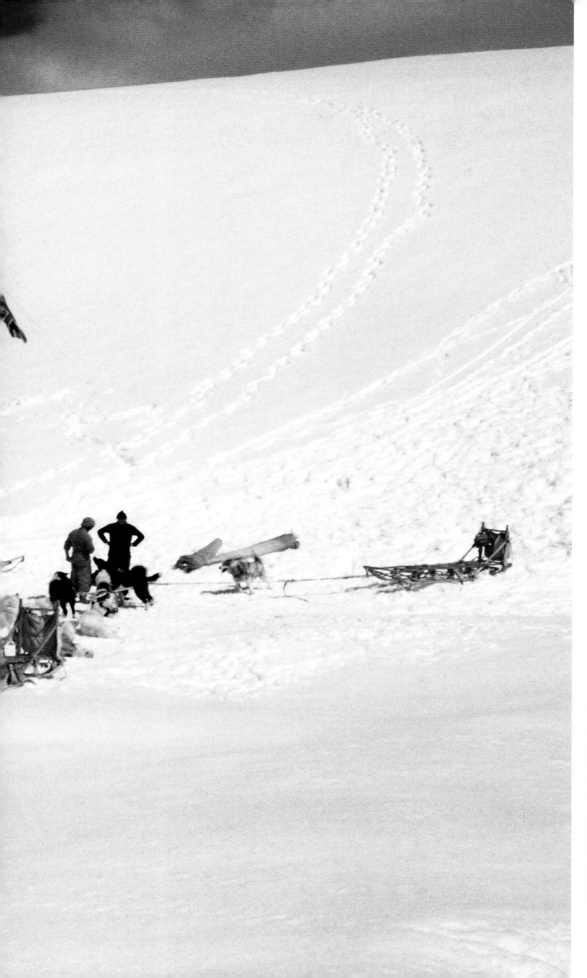

LEFT The Reclus hut was no more than a box – steeply roofed, with two windows, a door and three primus stoves. There were bunks, a table, a bench, two chairs and a gramophone. The *Shackleton* was due to relieve us but hit an iceberg; she limped back to South Georgia for repairs. We were stranded for a month. To feed the dogs we built a raft and paddled out to sea to catch seals. We fed ourselves on penguin and baked bread in an oven made from an old flour tin. Eventually, on 28 December 1957, the *John Biscoe* rescued us. The hut is now proudly displayed at the Falkland Islands Museum.

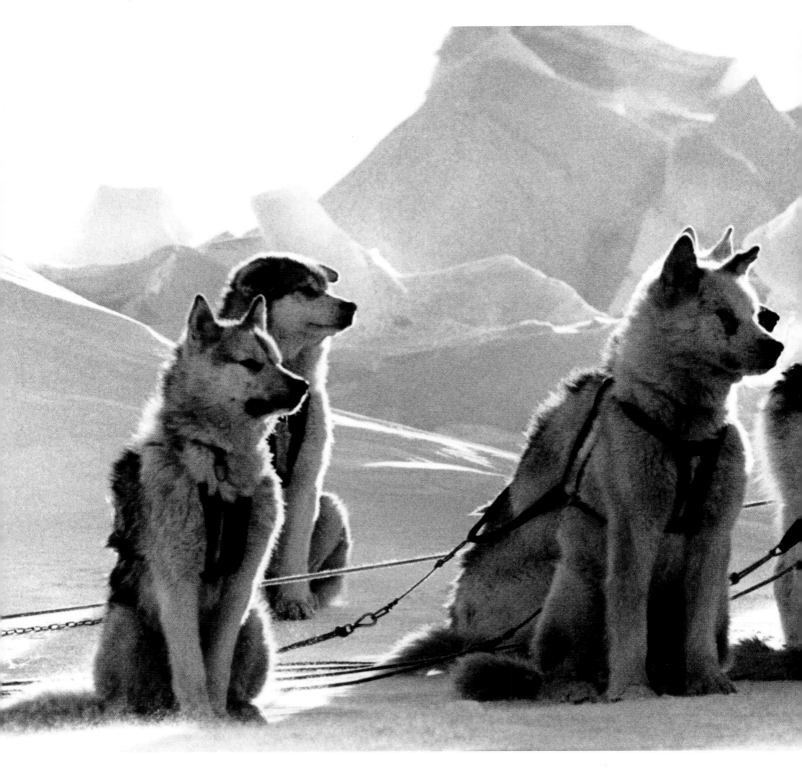

ABOVE In the summer of 1960 I had to scour the west coast of Greenland for dogs – 'Operation Husky', as the press called it – and persuade the Inuit hunters to sell them. Next I had to get the dogs all the way to McMurdo Sound in Antarctica. This time in Greenland was my first experience of the Inuit and I came to admire them greatly.

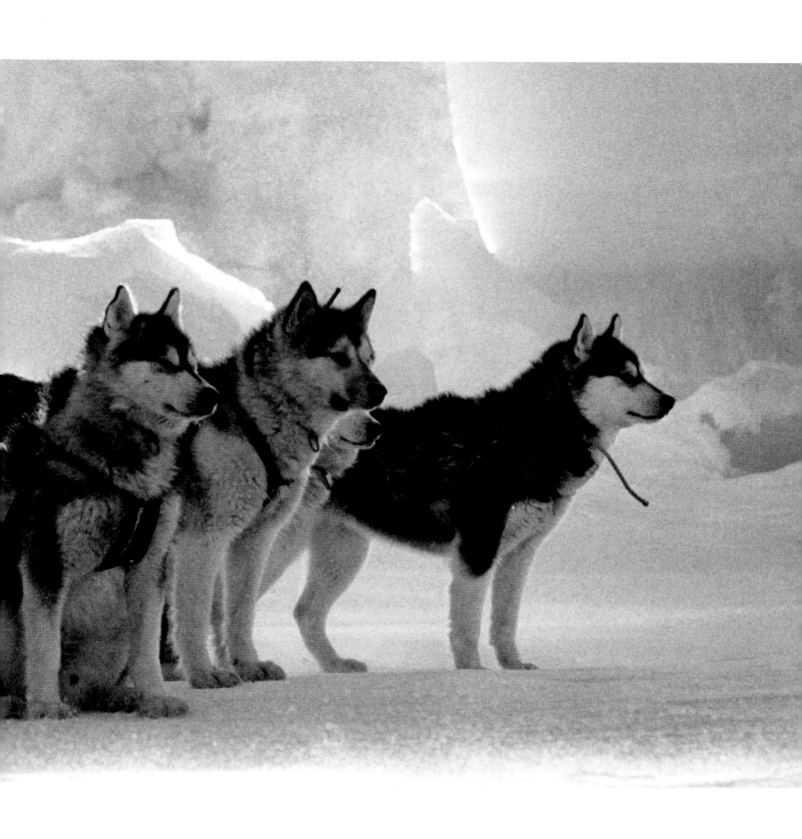

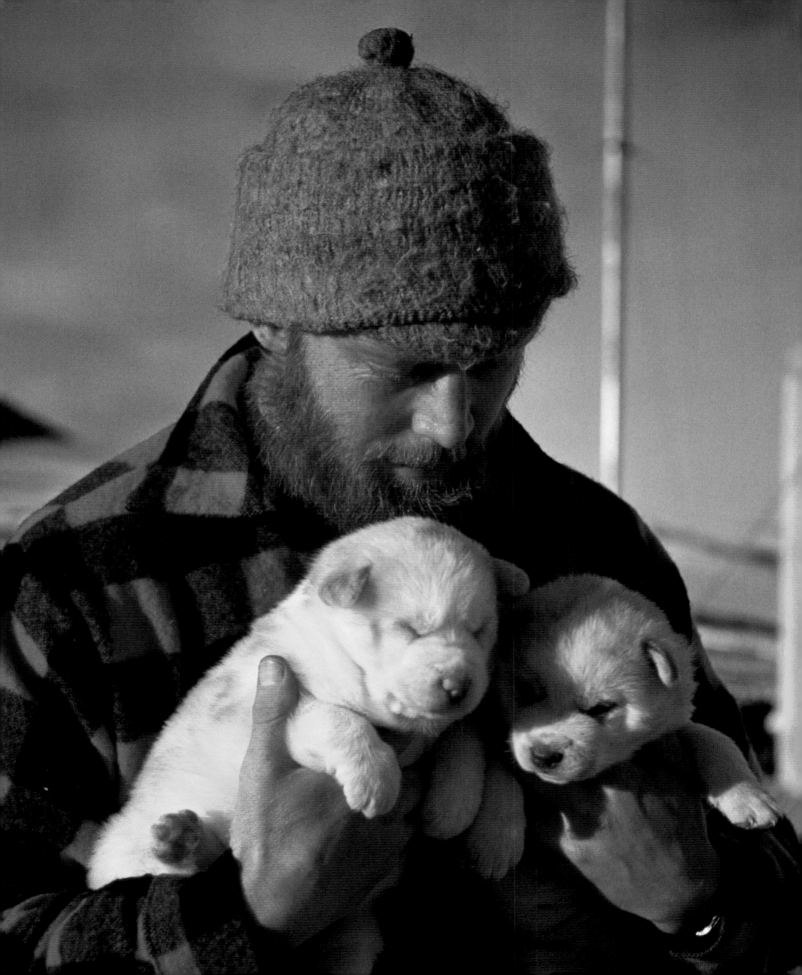

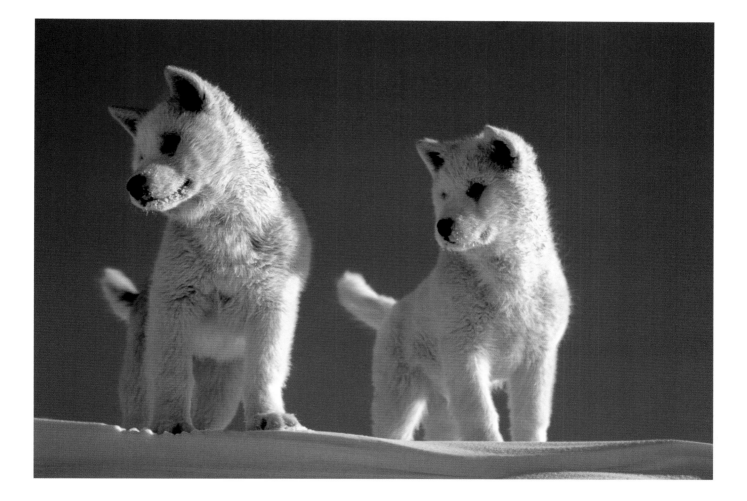

LEFT Scott Base, Antarctica, in 1961: just six weeks old, husky pups Castor and Pollux would later become excellent sledge dogs. I took them on training runs along the Barne Glacier, discovered by Scott and named by Shackleton. It was a thrill for us to be following in the footsteps of such great men, but our real work lay much further south.

ABOVE These two young husky pups are now five months old and keen to explore the sea ice near Scott Base. We named them Ursa and Virgo – the bear and the maiden.

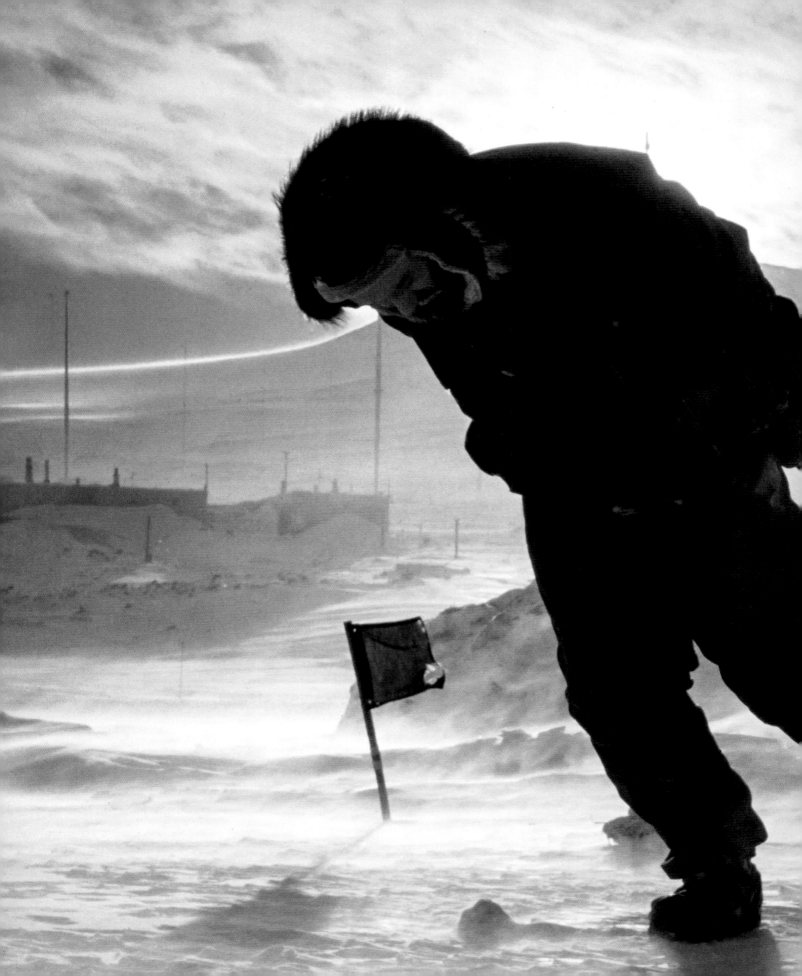

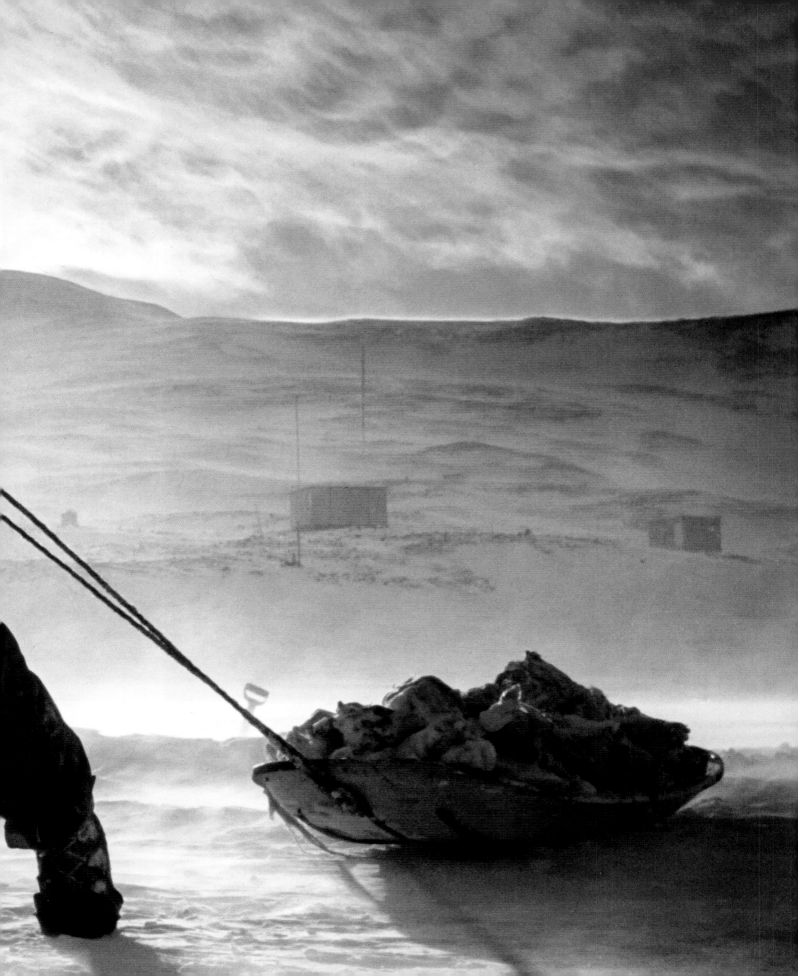

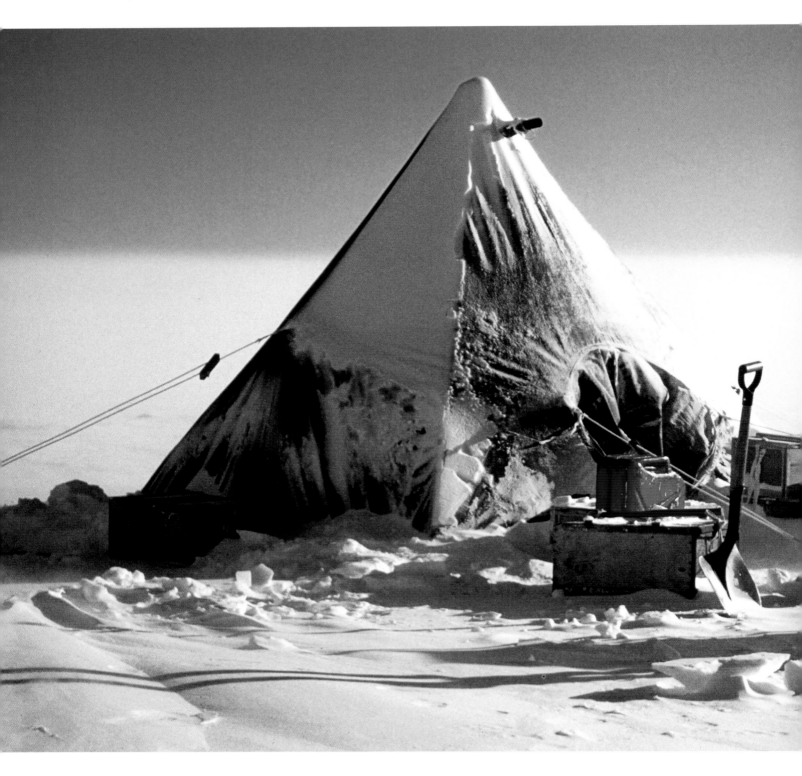

PREVIOUS Dinnertime for the dogs and I'm hauling hunks of
frozen seal at Scott Base. Taking care of the huskies became a
fundamental regime, and when winter darkness descended, it was
a dangerous but vital chore in the pitch black. We needed the dogs
fit and healthy to begin our survey as soon as the light returned.

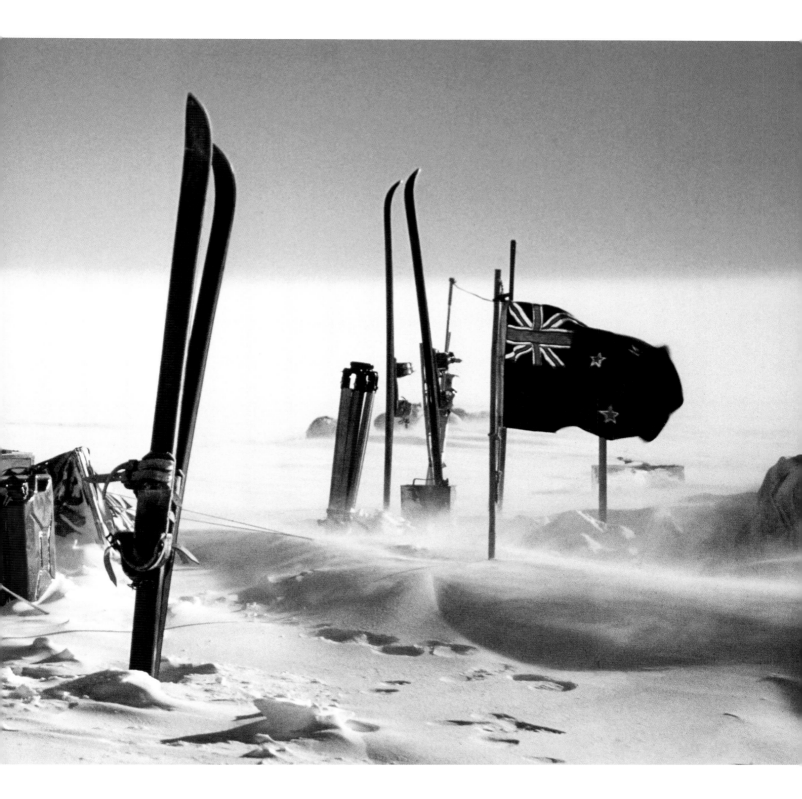

ABOVE This is our first camp in November 1961 at the start of our 95-day sledge campaign south of the Beardmore Glacier. As the New Zealand 'Southern Party' we were tasked with mapping as much new country as we could in the three months of austral summer. It was a season of high climbs in strong winds and bitter weather, accumulating notebooks full of data. We were sledging for the first time where our heroes Scott and Amundsen had been, but also surveying far beyond their routes.

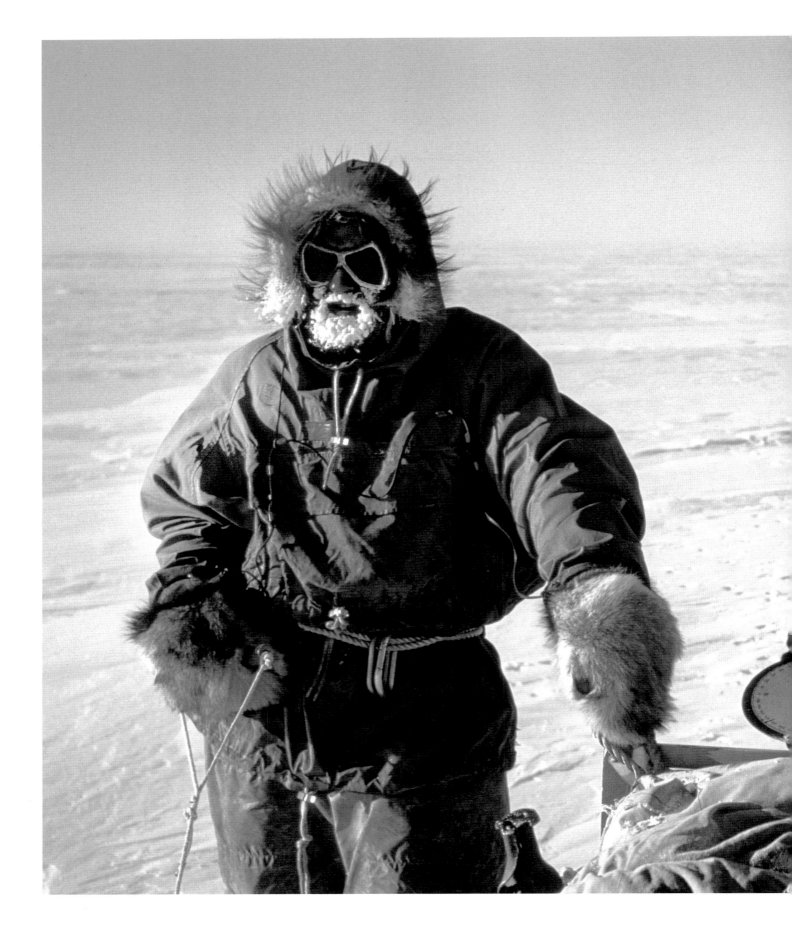

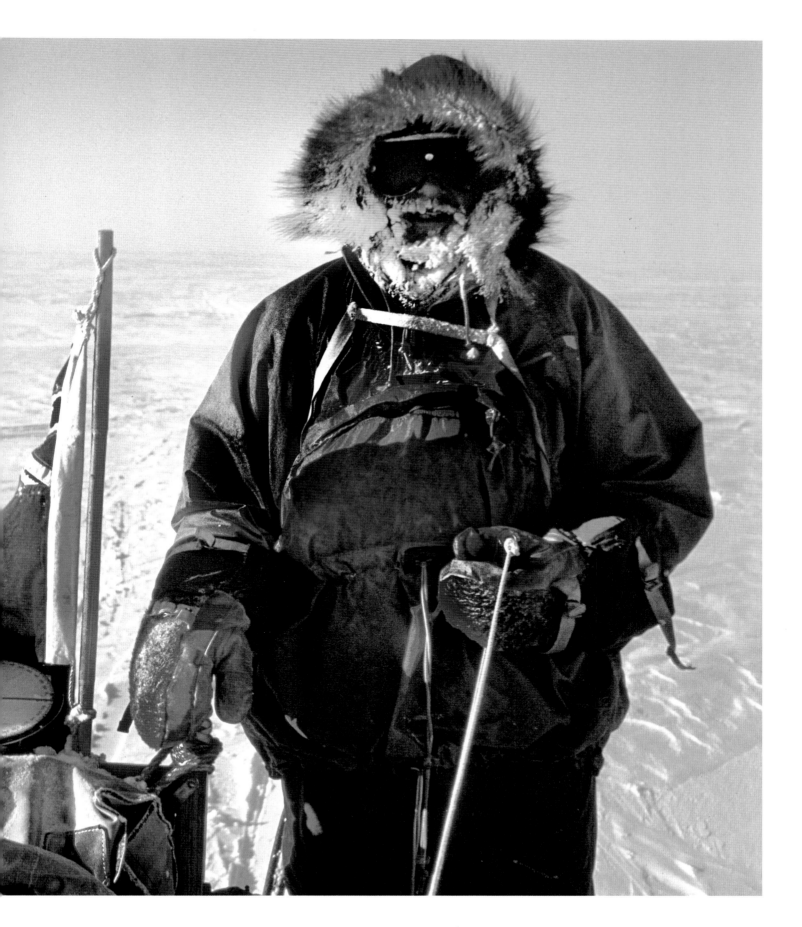

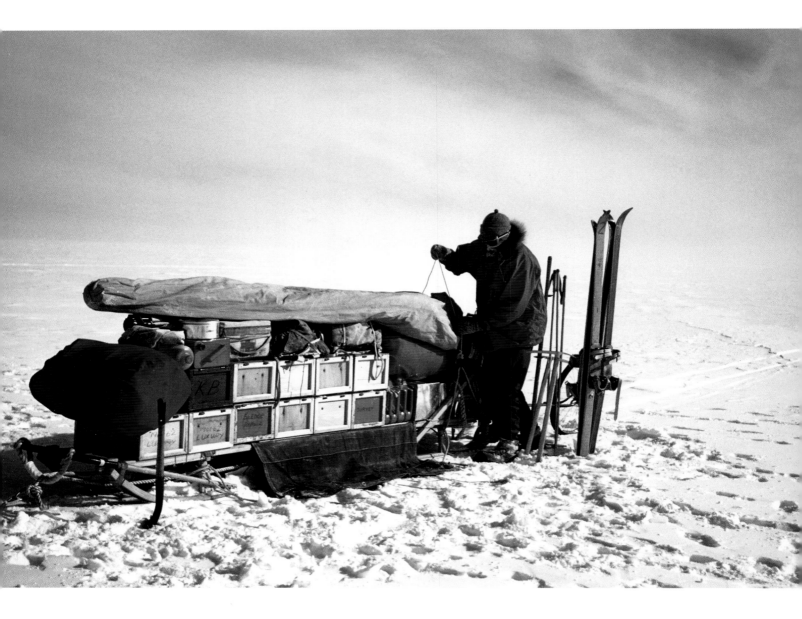

PREVIOUS This is what we looked like after a fine Midsummer's Day on the Polar Plateau in minus 30°C. We became accustomed to these temperatures even though it was supposed to be summertime.

ABOVE Peter Otway loading a Nansen sledge with food and surveying gear. Our ration boxes were packed with New Zealand butter, sugar, packets of biscuits (which could only be broken with a mallet), tins of pea flour, dried onions, oats, a tin of fat bacon, tea, cocoa and milk powder, thick tiles of pemmican and bars of milk chocolate. Basics, but it all tasted delicious after a long day's sledging.

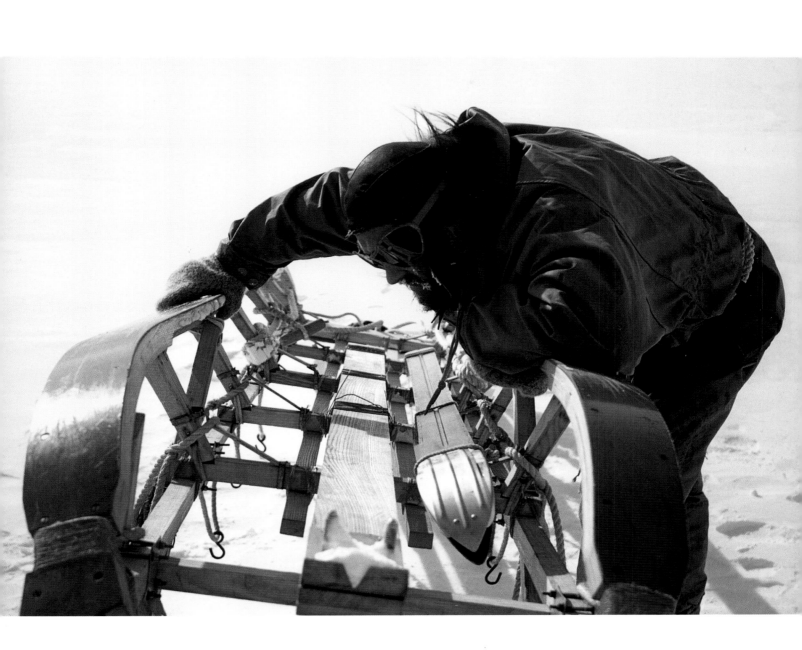

ABOVE I'm checking the sledge runners. The freedom of open country lay ahead. In comparison to the previous expedition to the Peninsula, and to my later trips on the Arctic Ocean, sledging here was easy. It was a summer of broad, pure terrain and sweeping mountain ranges under a dome of blue sky.

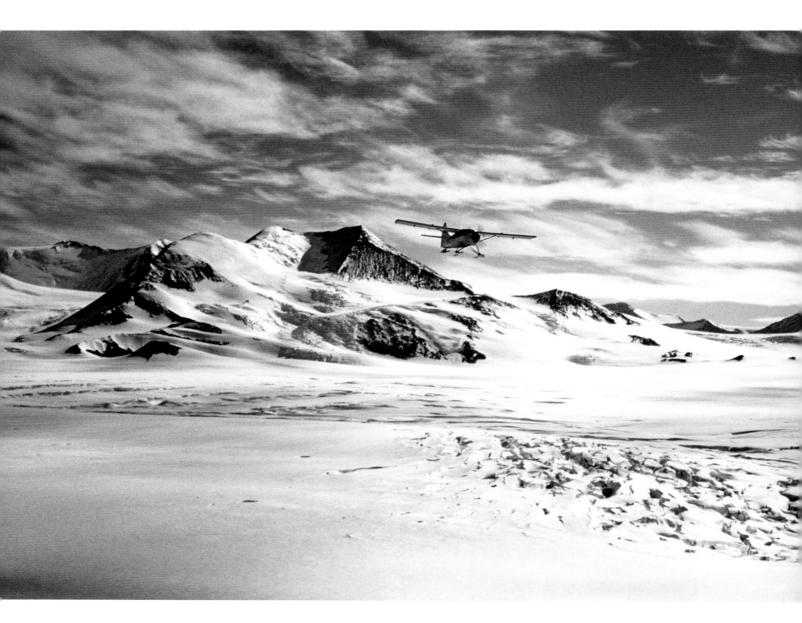

ABOVE Our Otter soars over the Byrd Glacier in the summer of 1960–61. Air support on this expedition was absolutely vital to resupply our surveying parties if worthwhile mapping was to be achieved. Admiral Byrd flew over these mountains on his way to the South Pole in 1929. 'If ever I saw the inadequacies of words I did then', he wrote. 'Cones, summits, peaks, flanks, ridges, turrets – scramble them all together, add a dash or two of adjectives, and one has, at best, an approximation.'

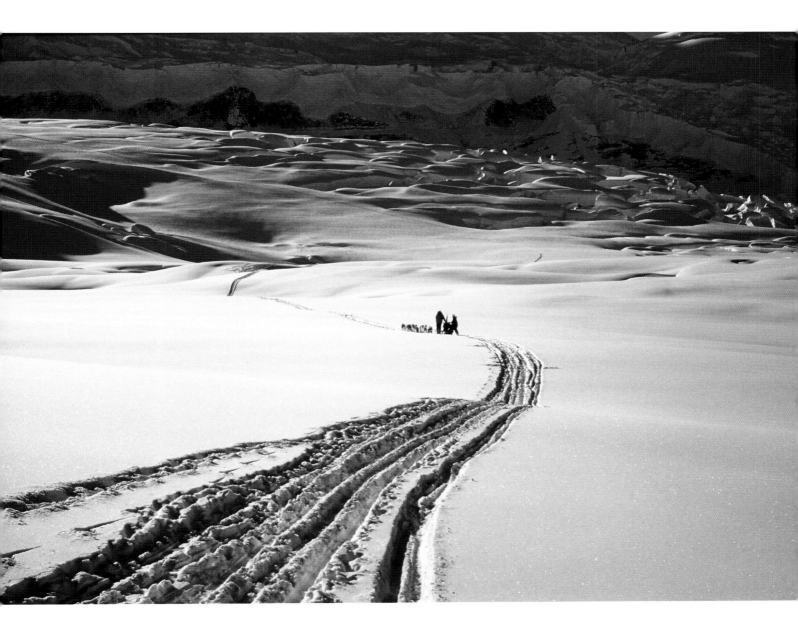

ABOVE Amundsen did little surveying on his race to the South Pole and most of the area between the Beardmore and Axel Heiberg glaciers remained unmapped until 1961. It was to this vast swathe of ice and mountain that we directed our attention; ours was the privilege of filling in these gaps.

FOLLOWING PAGES The climax of this expedition was following Amundsen's route down the Axel Heiberg Glacier with dog teams on the 50th anniversary of his journey. I took this shot just as we were about to start the full descent in February 1962. Mount Engelstad looms in the background.

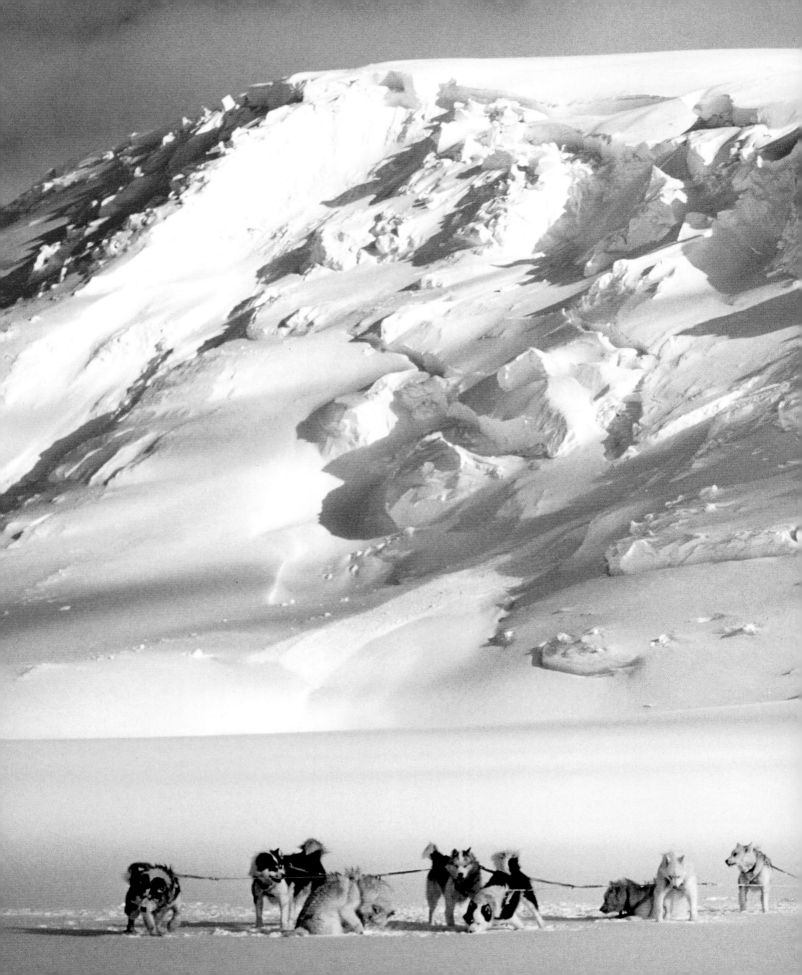

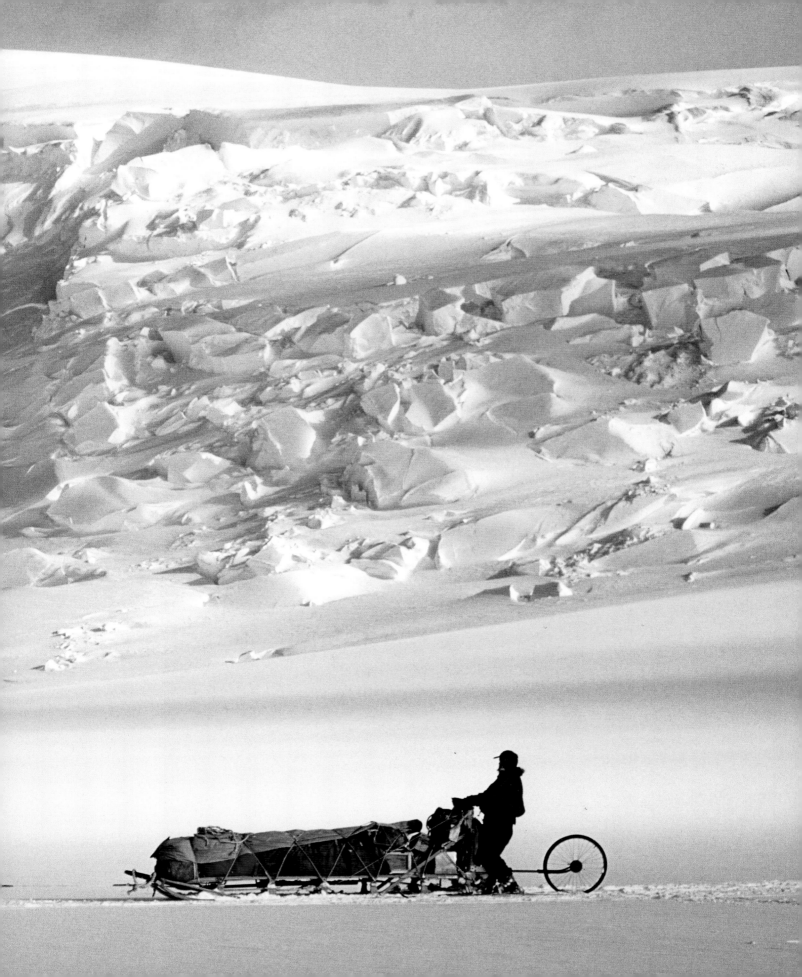

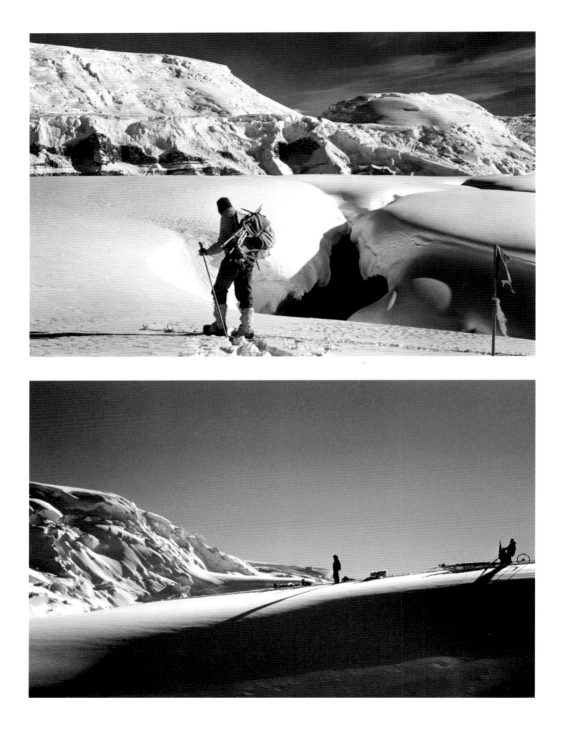

ABOVE On our descent of the Axel Heiberg we first flagged a safe route to the bottom on skis, and then had to climb back up. Rejoining our companions at the top, we came down once again with sledges and dogs. The glacier was a labyrinth of hazardous crevasses, giant blocks of marble ice, chasms and snow bridges.

RIGHT Our dogs surfed through deep snow as we blazed the trail down on 4 February 1962. In just a few days we would be on the Ross Ice Shelf, a white horizon stretching northwards to the safety of Scott Base.

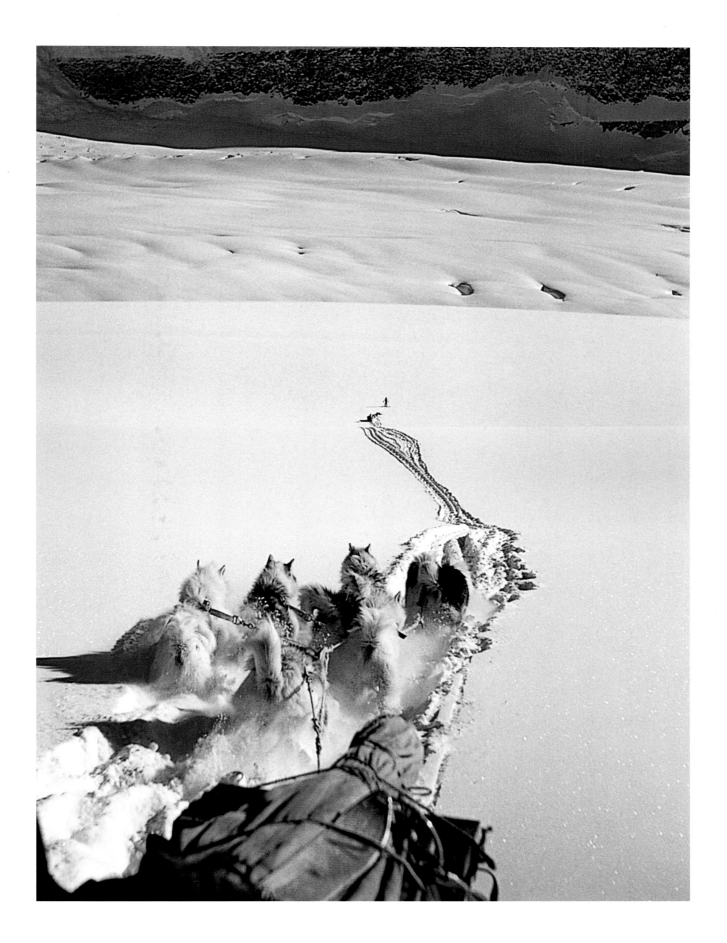

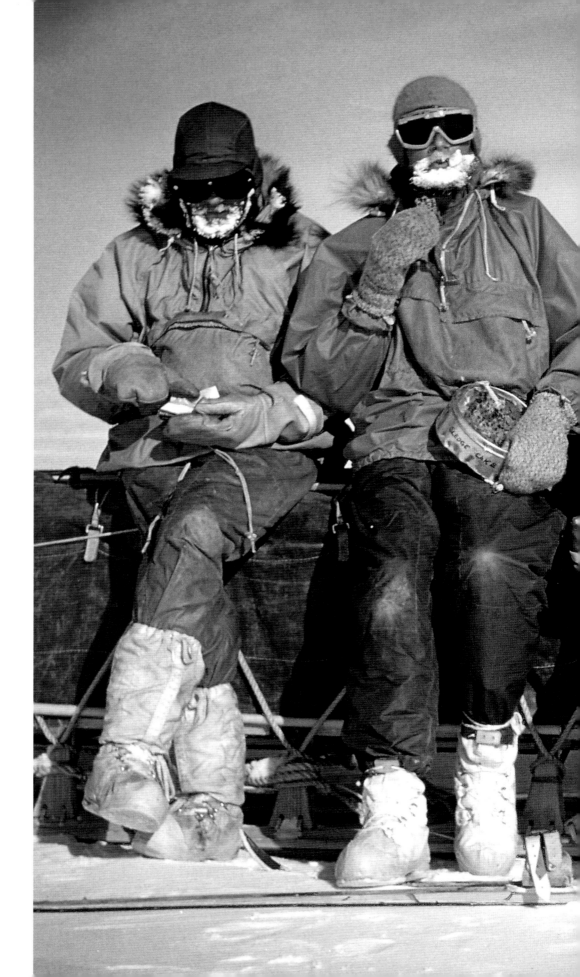

RIGHT The 'Southern Party', from left to right: geologist Vic McGregor, surveyor Peter Otway, field assistant Kevin Pain, and me, the surveyor-leader. We were all still young men, but I suppose we had become Antarctic veterans. I knew now I didn't want to return or repeat anything that had already been done. I wanted to pioneer a journey of my own: something new and something difficult. The Arctic was calling.

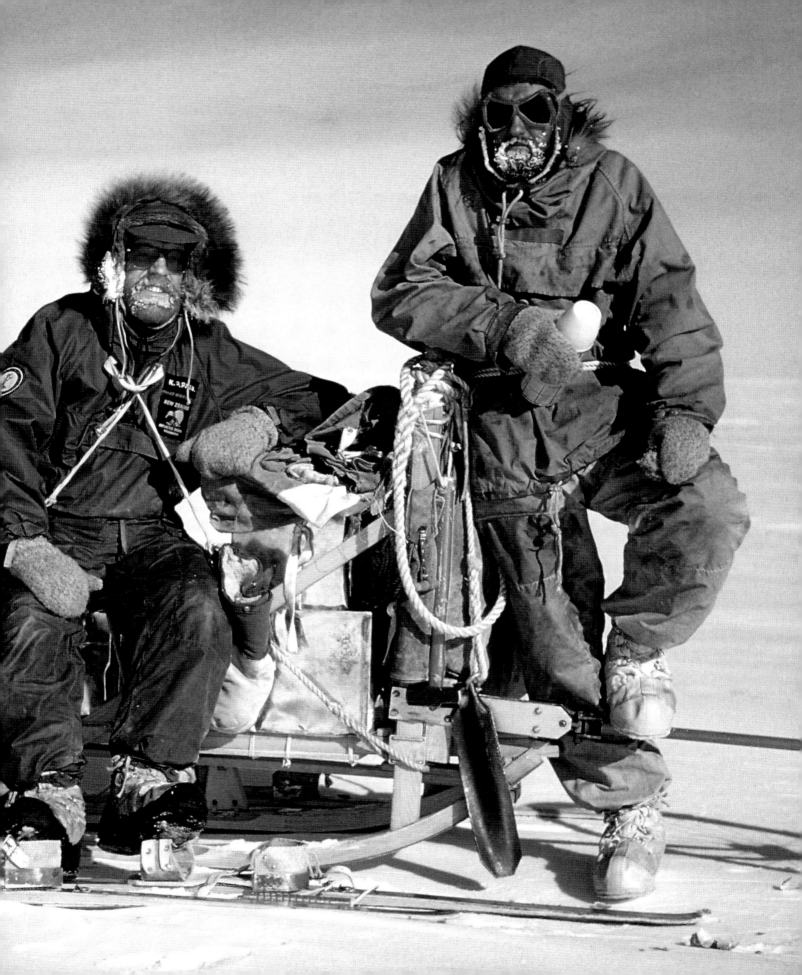

2 | THE FROZEN SEA

Deep was the silence. Then, in the dawn of history, far away in the south, the awakening spirit of man reared its head ... and gazed over the earth ... the limits of the unknown had to recede, till they made a stand in the north, at the threshold of Nature's great Ice.

Fridtjof Nansen, 1901

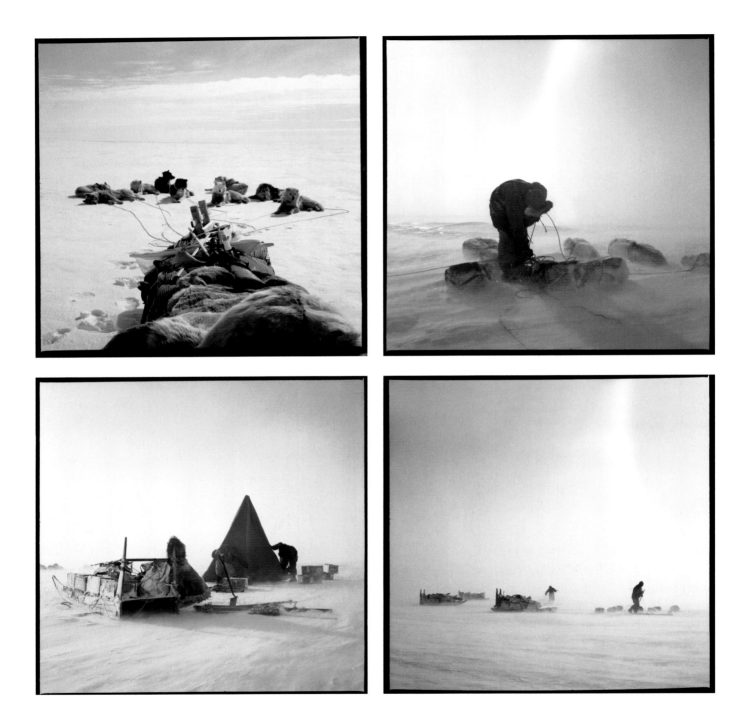

L ondon was a busy place in the late 1960s, full of competing attentions and technological breakthroughs. The social revolution was passing me by. I felt a stranger back at home and I longed to return to the wilderness. However, my idea of making the first crossing of the Arctic Ocean provoked a range of responses, from incredulity to downright hostility: 'Why risk your neck doing something so worthless?', was a typical reaction. Polar exploration was, surely, an activity from a bygone age?

It was in this sceptical environment that I tried to earn my place as a pioneer. Though the North Pole had already been reached, the Arctic Ocean itself was still a vast unknown: 5 million square miles of bleak nothingness. Yet it was a region that had captivated the minds of men throughout many centuries. The American explorer Robert Peary had battled close to the North Pole in 1909 across the ice, after countless others had struggled to reach the prize. Since then, from Arctic drifting stations manned by Russian and American scientists in relays over the years, the nature of the basin had become a specialized study. Classified charts of the Arctic Ocean were webbed with the flight paths of possible missile attacks and peppered with strategic targets; beneath the drifting ice cruised submarines with their lethal cargoes, while above patrolled the nuclear bombers. But all the while, no human had dared a crossing over its surface. And why would they?, so many people would ask. This chaos of shattered floes was not a place for the living.

By the end of July 1965 I had completed a 20,000-word plan of action – the result of two years' work and a tour of the major centres of polar research in North America and Scandinavia, where I had discussed my rough ideas with many of the world's leading authorities. My premise was that 'there is only one ocean left uncrossed – a challenge to which man must respond'. Late in 1913 Sir Ernest Shackleton had proposed the first surface crossing of the Antarctic continent for basically the same motives, arguing that a Trans-Antarctic expedition was the last great journey that could be made, since the South and North Poles had both been reached. Shackleton's journey would have been a bold first indeed, but it was a dream he never fulfilled; as for the crossing of the Arctic Ocean, it was considered impossible by everyone.

I saw our expedition as a journey by dog sledge from Alaska across the longest axis of the Arctic Ocean to Spitsbergen, via the North Pole – a route that I calculated would take sixteen months. The sheer distance involved was staggering. The shortest possible route from the northernmost tip of Alaska to the northernmost point of land in the Spitsbergen group is 1,670 nautical miles (1,920 statute miles) – which in practice would be around 3,800 route miles, for it is seldom possible to travel more than a mile across pack ice without having to make a detour to avoid some form of obstruction. The ice of the Arctic Ocean is in continual movement, drifting sometimes as much as 10 miles a day, fracturing, pressuring, gyrating. Once our journey had started there would be no going back – our escape routes would melt into thin air. We would have to push on.

There would be three periods of sledging, when we would be able to counter any adverse drift of ice, and two periods – the height of summer and the long polar night – when we would be completely at its mercy and would have to establish a base camp. The success or failure of the expedition depended on how accurately I could predict the drift and how closely we could keep to the schedule. Throughout the period of continuous darkness, while still drifting, we would conduct a programme of scientific research.

LEFT In 1967 we embarked on a tough 1,500-mile practice journey from Greenland across Ellesmere Island, sledging over sea ice, up uncharted glaciers and into deep canyons. We ran out of food and at times were so tired we could barely stand. Yet on an easier journey we would have learnt nothing; we swore never to repeat our mistakes.

PREVIOUS This little shot sums up the reality of life as an explorer. It's 1965 and I'm in England, having just come home from Antarctica. Now setting my sights on the Arctic, it would take many years of planning, and thousands of letters, to secure the funds and the support I needed.

Hauling heavy boats across the ice, as attempted by William Parry in 1827 and George Nares in 1876, was clearly impractical. The ocean could be crossed only by a combination of the oldest techniques of Arctic travel with the most advanced form of logistical support: dog teams and sledges in concert with Morse code messaging and radio reports. Moreover, from a broadly scientific point of view, I believed that by walking across the top of the world we could learn far more about the environment than we would by flying over it, submerging under it or stationing ourselves in a heated observatory on the ice.

The earliest date on which the expedition could set off from Point Barrow in Alaska was 1 February; the latest, 21 February. Those are the only three weeks of the year when there is a chance that the wide belt of fractured young ice along the coast might be packed tightly enough to form a 'bridge' to the heavy polar pack drifting slowly past the coast about 80 miles offshore. We would have to cross this ice bridge at the coldest time of the year when there was very little daylight. No wonder this had never been attempted before! And no wonder, I suppose, that nobody has tried it since.

♁

By November 1965 my first plans had been rejected by the Royal Geographical Society (RGS), whose support I needed to make my dream a reality, on the grounds that the scientific dividends were not clear. Crushed, but still determined, I began typing hundreds of letters. Slowly, I amassed a private army of supporters from among the world's foremost explorers and travellers, all of whom recognized the plan's daring and were prepared publicly to say so. Eight of them came together to form a Management Committee

under the chairmanship of Sir Miles Clifford, a former Governor of the Falkland Islands and its Antarctic Dependencies. I would need all of their diplomacy and skill to help secure some £50,000 – the bare minimum we estimated was required to launch my venture, with its near-implausible logistics.

I also needed a team. Roy 'Fritz' Koerner was a glaciologist I'd spent a month with at the end of my first spell in the Antarctic. Our paths crossed again in a climbers' hut in the English Lake District on a black, wild night in the spring of 1964. I remember telling him, on our way back to the hut from a pub, of my ambition to cross the Arctic Ocean. The invitation to join me was in the tone of my voice, the setting, the secrecy to which I had sworn him. What had impressed me about Fritz was that he had that rare combination of a brilliant scientific mind and a spirit of adventure.

It was on Fritz's recommendation that I met Allan Gill. Allan, like the rest of us, had started his polar career on British bases in the Antarctic. I remember very well my first impression of him: a deeply creased, parchment-faced, wiry individual – the scruffiest man in the American institute where we first met. A master of temporary repair and ingenious contraptions, Allan had already spent three winters in the Antarctic, one in the Canadian Arctic, and two on the Arctic Ocean at the American scientific drifting station T-3. In addition to gravity measurements and magnetics, he had been involved in several other pioneer projects for the Lamont Observatory, to which he could apply the infinite patience for which he was renowned. He had made seismic measurements of waves transmitted through the ice, and experimented with a lethal piece of apparatus for measuring the ocean bed. He had taken core samples of the mud and dredged the abyssal plain with a bucket to collect ooze and microscopic shells.

With Fritz and Allan I now had the basis for an expedition of considerable scientific value. The variable extent of the Arctic pack ice was seen by many scientists as a sensitive climatic instrument – one of the key elements in the complex system of atmospheric circulation. By that stage much work had been done on the properties of sea ice, but no one had ever made a profile of its thickness over any appreciable distance that took into account the age of the ice. Nuclear submarines have now collected invaluable data, and the ocean has been mapped by subsurface profiles of the pack; ice-observation flights are made regularly and the polar-orbiting satellites provide excellent information. But at the time I presented my new proposal to the RGS there was still much that a glaciologist could do to extend our knowledge of the pack-ice environment – if one could be found who would be prepared to walk right across the top of the world, observing and measuring as he went. We had just such a man in Fritz Koerner.

Our scientific plan was inspired by Nansen, who also had attempted to use the drift of the pack, although we would not be stuck in the ice as his ship *Fram* was, and so we would be able to measure a wider range of ice conditions throughout the seasons. Fritz's work would end up providing the scientific community with the base-line against which all measurements these days are still made when discussing the rate of ice decrease on the Arctic Ocean as a result of climate change. That alone is a brilliant legacy from this crazy journey of ours.

I remember entering the conference room of the RGS on 18 April 1966 in a defiant mood. But the atmosphere was sympathetic. Two days later the official letter of confirmation arrived. We were on our way.

૮ა

A training expedition in northwest Greenland was a vital part of the plan, to test not only all our gear but also ourselves over a course that would exaggerate any weaknesses. By then my crossing party would have amassed a total of 20 winters and 41 summers in the polar regions. In terms of sledging experience, we would be one of the strongest parties ever to have set out on a polar expedition from Great Britain; even so, there was still much that could be learnt. I proposed that we would live and hunt with the Inuit during the winter of 1966–67. We would then make a challenging 1,500-mile journey the following spring with dog sledges from Qaanaaq to Canada, retracing a route pioneered by Frederick Cook across Ellesmere Island to the shores of the Arctic Ocean, then south over unexplored lands to the small settlement at Resolute Bay.

It would be just Allan and I for now, as Fritz was already committed to another expedition. By everyone else's standards, Allan and I were experienced dog sledgers, but we were still regarded by the Inuit as no more skilled than their children. We had not yet learnt to relax in a polar environment, for on all our previous expeditions we had been keen to overachieve, to be intrepid and daring. An Inuk isn't like that; he's far too clever to risk his life doing something unnecessary. For the first time in my polar career I began seriously to question my motives: why was I strangely drawn to the privations of expedition life? Was it just my ambition that had driven me to try to chart a line across this convenient blank?

For the first part of our training trip we arranged to go with a brilliant young hunter named Peter Peary – the Inuit grandson of Robert Peary, the American Arctic explorer who claimed he had reached the North Pole on 6 April 1909 – and an Inuit hunter named Kaungnak. We would travel with them and their

wives for the first 200 gruelling miles, trading lightweight dog food known as pemmican in return for their guidance.

We set out on 26 February 1967, working our way up the coast to Etah then out across Smith Sound to where the Norwegian explorer Otto Sverdrup had wintered over during his immense exploration of 1898–1902. We continued on to Alexandra Fjord. There our arrangement with the Inuit came to an end; but before parting they each marked a cross on our map where they believed we would die! The first cross was a point about 20 miles away where there was a narrow strait with a strong sea current flowing under dangerously thin ice. Sure enough, at that place the dogs were actually putting their feet through the ice, which on the surface looked perfectly safe. The second cross was at the col midway across Ellesmere Island in what is known as the Sverdrup Pass.

The Pass had been discovered by Sverdrup on one of his exploring journeys and had been re-traced by Cook nine years later. Since then only one party had been on that route, but none had followed its full length. We only just came out of that canyon with our lives, and finally reached Resolute at the end of June after the most harrowing few months I had ever experienced.

What had I learnt from this ordeal? Well, keeping our beloved dogs healthy would be the major challenge. Short of killing and feeding them to each other – which Amundsen did willingly, but was something we desperately wanted to avoid – we'd have to shoot seals and also lay a trail of dog food from the air all the way across the Arctic Ocean. We'd use the Inuit-type sledge, but made of the finest oak. We must also have reserve sledges on hand at Barrow and Resolute that could be flown out to us in an emergency; and reserve tents, sleeping bags, primus stoves, food – reserves of everything. Each sledge would

be a completely self-contained unit down to the smallest item of essential gear. We'd need robust radio sets with power enough for ranges of up to 800 miles. We would have furs, but not caribou; they must be Alaskan wolf, properly tanned. But most important of all, we must think like the Inuit, move like the Inuit, relax like the Inuit, yet drive ourselves with the spirit of men obsessed with a goal on which our lives depended. The hardship of our training journey had not put Allan off. As I boarded the plane back to London, he simply said with a nod: 'See you in September.'

⁓

Wearing a sun-bleached beard, a pair of khaki slacks and an Inuit anorak, I arrived back in London at the end of June 1967. I felt fitter than I had in years and it was just as well: we had less than six months to launch the expedition and there was still so much to be done, and so much money to be raised.

Fortunately by this time I had the essential support of the Management Committee. Now well-scrubbed and more neatly dressed, I reported to them in the office of explorer Sir Vivian 'Bunny' Fuchs. Their main function, they told me, was to 'guide, council, encourage, and temper my enthusiasm', and to use their far-ranging influence in the City to ease my workload. Bunny Fuchs became a very useful ally in this landscape of patronage and connections, a terrain as precarious as any ice floe I'd have to walk across. Most of our sponsors thought it a fine idea but a financial gamble; I needed the committee's help urgently and I was grateful for it. We gained the full support of the RGS, the patronage of HRH Prince Philip and the vice-patronage of two doyens of polar exploration: Sir Raymond Priestley, who

had been geologist with Shackleton and Scott, and Launcelot Fleming, Bishop of Norwich, who had been on the *Penola* expedition of 1934–37, the last to go to the Antarctic under sail. It was an exhausting process, but suffice to say we finally raised sufficient funds, ordered and shipped 70,000 lb of equipment to the two staging depots in the Arctic, and transported 40 huskies from northwest Greenland to Alaska, all within the space of a few frantic months.

The logistical support, so vital to the expedition, had been promised by the Canadian Air Force and the Arctic Research Laboratory at Point Barrow, and we carefully scheduled all the airdrops. The Royal Air Force flew our equipment to our staging depots where the expedition gear for each of the seven drops was carefully labelled, weighed and stored. The hut in which we had spent the winter training in Greenland was flown to Resolute, where it was kept until it was needed. The last piece in this immense puzzle of diplomacy and logistics was the Royal Navy, who agreed to schedule HMS *Endurance* for standby duty in Spitsbergen waters to cover the closing stages of our journey in June 1969.

There was one final decision to make: who would be the fourth man? The choice was a very close thing. High on our shortlist – drawn from the many applicants who had responded to a newspaper article headed 'EXPLORER WANTED' – was Geoff Renner, a geophysicist who had a similar background to Allan, Fritz and me, and who later became a dear friend. He had spent two and a half years at Hope Bay in the Antarctic and had dog-sledged many thousands of miles. Ken Hedges, on the other hand, was a doctor, and also an outdoorsman, a sailor, a military parachutist, a frogman and had seen active service. Geoff was my instinctive choice, but he was still writing up the results of his Antarctic work. The committee made it clear that it was essential to have a doctor and so Ken was given the role.

On 19 November, with Allan dressed in one of my suits, and Ken, Fritz and our radioman Squadron Leader Freddie Church all looking very smart, we drove to Buckingham Palace to meet our Patron, Prince Philip. It was a breezy, informal, stand-up meeting – all over in ten minutes – but we carried his good wishes and our memory of that occasion many thousands of miles.

Allan and Ken left London on 12 December bound for Greenland, where they would collect our dogs and fly on to our rendezvous point in Alaska. The last three weeks at Barrow before we set out were the most testing of my life. For Fritz and his heavily pregnant wife, Anna, now both at home in Ohio, those same three weeks were also stressful and anxious. Then, on 31 January, Anna gave birth to a girl; two days later Fritz joined us for the final few days of nervous anticipation.

Starting too early would be suicidal. For a number of weeks, I had made reconnaissance flights looking for a route across the fractured young ice that drifts along the desolate north Alaskan coast, and each time I had returned dejected, having discovered a belt of sea ice far more open and active than expected. We had flown over wave after wave of pressure ridges, and soared with the engine roaring as narrow leads had opened alarmingly into smoking seas of open water. We had circled high above sea ice impossible to traverse – ice that was drifting at two knots or more and working itself into angry lines of friction.

Finally, on 20 February 1968, I was able to signal to the pilot beside me with a nod. He eased the plane into a turn and we took one last look northwards. The vast expanse of drifting ice was awesome – limitless. To the south, weak rays of sunlight pierced the clouds and scattered the ice with patches of

light. Cracks and open leads caught the sun like molten silver before turning into jet-black scars on the skin of the frozen sea. It was a moment of profound relief – the moment of decision. Tomorrow, four men and four teams of dogs would finally step off the land.

Our proposed route, the longest axis of the Arctic Ocean, would be a pioneer journey – some would say a horizontal Everest – that would mark each one of us for life. Our beds, most nights, would be on ice no more than 6 ft thick, and often very much thinner; ice which might at any time split or buckle. There would not be a day during the next sixteen months when the floes on which we were travelling, or sleeping off our fatigue, would not be drifting with the currents or driven by the winds. There would be no end to the movement: no rest, no landfall, no sense of achievement, no peace of mind, until we reached Spitsbergen. And, most importantly, there was no turning back.

ↄ

The day before we left I received a parcel from home containing a Union Jack and a simple note from my father that read: 'You forgot your flag son, good luck'. That last night at Barrow I remember well. I was physically sick with fear and the weight of the trust that my three companions had placed in me. Danger and responsibility: which of these two pressures was the greater, I still don't know, even writing this many decades later. I unlatched the huge doors of the warehouse and opened them wide. The night was almost over. It was calm, clear and very cold. My sledge moved over the floor on rollers, bit the snow and slid forwards, out into a deserted street smoke-grey in the twilight. I left it facing northeast at the end of two rows

of streetlights. There was not a breath of wind to dissipate the plumes of vapour that hung over each box-like building; the settlement was still and sleeping.

And so the scene was set on 21 February 1968 for the final farewells, and the start of a journey that would define us as men. But even from the very first day we were fighting to stay alive. During those first weeks each moment we were at risk of foundering – moving over fractured ice, sometimes by the light of the aurora, sometimes in moonlight, but most of the time in pitch darkness. We were too preoccupied with what we were doing to be amused or irritated by the odds of four to one against our success that were being offered in the bars in Fairbanks.

We were using techniques of travel regarded as obsolete by all but a few Inuit, in an environment which even to them is completely unknown. We hacked our way north from winter into early summer across an ocean where none had gone before – and where none have been since – across vast areas of ice barely thick enough to support the weight of a sledge, and at other times across icescapes so chaotic it was hard to believe that beneath our feet the sea was 10,000 ft deep.

Our day's toil on 20 March was mostly across thin ice. A typical day like the many before it: tough, unrelenting struggle. We were 400 statute miles behind schedule, and 1,170 miles from the North Pole. The following day, at the Pole the sun would rise for the first time in six months. Each day for the next three months it would be spiralling higher; quickly at first, but slowing down as it approached its highest altitude at the solstice of 21 June. It would then start to lose altitude until, at the equinox of 23 September, it would set and then rise at the South Pole. But even if we were to maintain an average of 60 nautical miles a week in our trudge northwards, it would be a

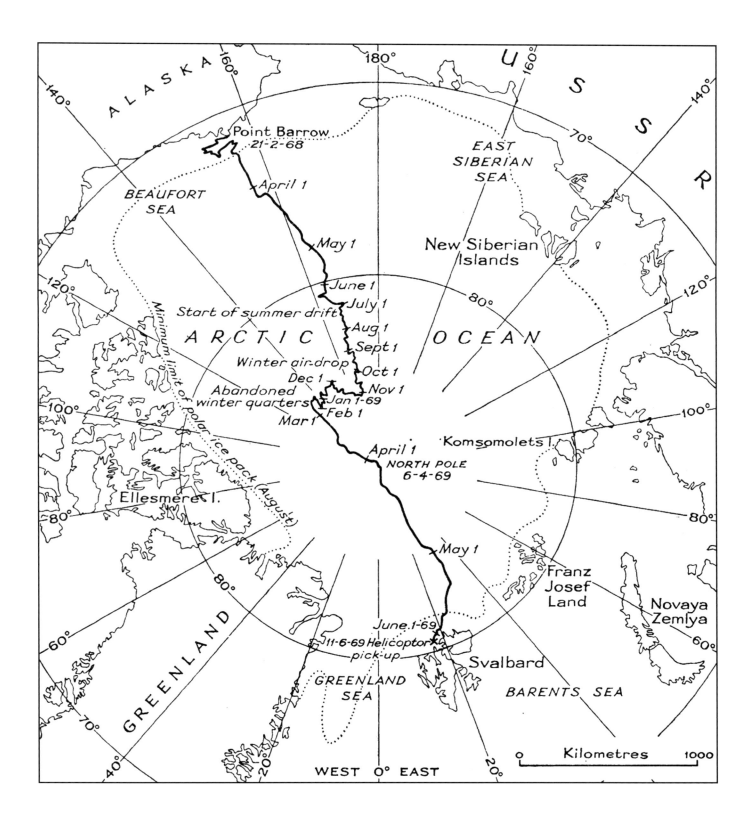

Point Barrow
21-2-68

ALASKA

140°

160°

180°

U.S.S.R.

160°

140°

70°

EAST SIBERIAN SEA

BEAUFORT SEA

April 1

May 1

New Siberian Islands

120°

80°

June 1

July 1

Start of summer drift

A R C T I C O C E A N

Aug 1

Sept 1

Winter air-drop

Oct 1

Dec 1

Nov 1

Minimum limit of polar ice pack (August)

Abandoned winter quarters

Jan 1-69

Feb 1

Mar 1

100°

100°

April 1

Komsomolets I.

NORTH POLE
6-4-69

Ellesmere I.

80°

80°

May 1

Franz Josef Land

Novaya Zemlya

60°

June 1-69

GREENLAND

80°

60°

11-6-69 Helicopter pick-up

Svalbard

BARENTS SEA

70°

GREENLAND SEA

40°

20°

WEST 0° EAST

20°

Kilometres

0 1000

ABOVE As man had crossed all the deserts, climbed the highest mountains and begun to make the first cautious probes into the oceans and space, there was only one pioneer journey left to be made on the surface of the planet: across the top of the world. The Arctic Ocean is the middle sea of a circumpolar landmass, some 5 million square miles of shifting ice. This chart shows the meandering track of our expedition, 1968–69.

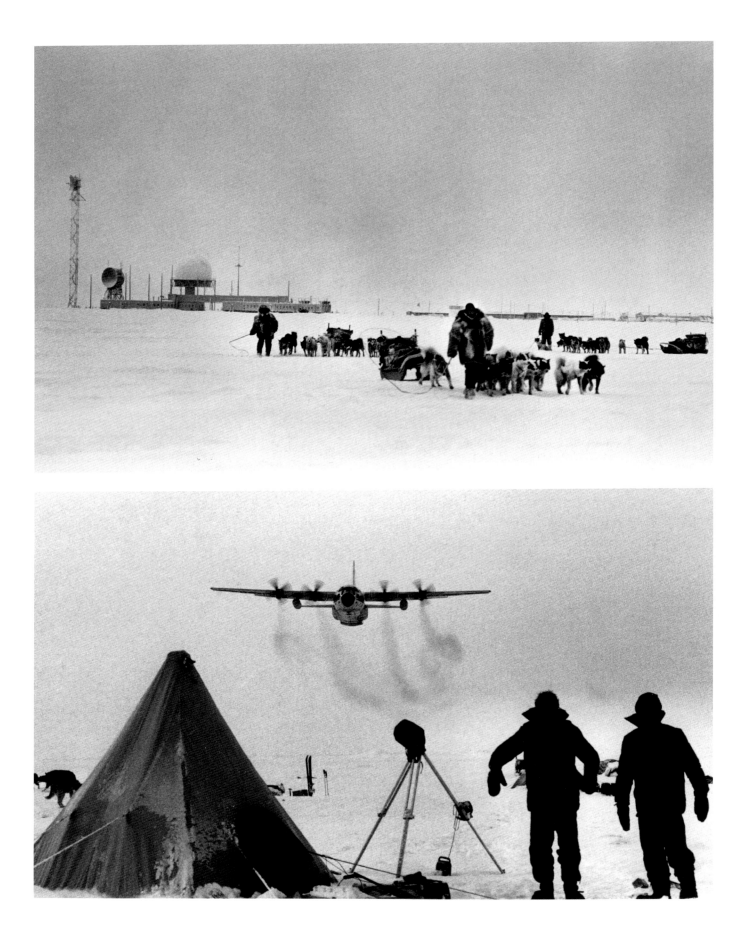

few weeks yet before the sun would remain above our horizon for 24 hours a day, and by that time in all probability it would be hidden by fog.

The chart obviously showed no features along our chosen route between Barrow, the North Pole and Spitsbergen. We could expect to find nothing but ice – 5 million square miles of irregularly broken floes constantly on the move, responding to the winds and the currents: a monotonous, frozen desert. Here on the Arctic Ocean we were faced with a problem I had never known on such a scale – we needed targets, anything that would break down the enormous distance. Happily, cartographers had provided them, for our chart was precisely divided with radiating circles of latitude described for each degree. We could get a good latitude fix from the sun if the sky was clear; all we needed to know was the number of degrees and minutes the sun was north of the Equator at local noon and the amount by which we should correct our theodolite observation of its altitude. I would make my computations on the snow, scratching the figures with the tip of a ski stick.

In time those imaginary lines of latitude were to become as real to us as if they had been painted on the ice, and the crossing of them more exciting than any distance we calculated we had sledged. We became as impatient approaching each new latitude as children on the eve of a birthday – and, like children, dejected the morning after at realizing that little had changed. Such was the feeling on 22 March when we woke to find the day overcast and all colour drained from the scene. We were 57 nautical miles from our next line of latitude; the sledges were in need of minor repairs, and Fritz, who had been bitten by one of his dogs the night before, was feeling dizzy. With patience, a nervous dog can sometimes be reassured, but a dog that attacks its owner must be shot. Fritz put the biter down that night, and Ken shot the oldest dog in his team the next day.

We had now lost three dogs since leaving Barrow, and dogs of course were the topic of conversation in our camp that night – that is, until the wires connecting the battery to our reserve transmitter snapped off at the socket. We were now without radio, cut off from the outside world. It took Allan a full day to fix it, using a heated clasp-knife as a soldering iron. I joked with him, promising to buy him a new clasp-knife when or if we ever got off the Arctic Ocean. He just shrugged and suggested I pack a soldering iron next time we went on an expedition together.

Temperatures were still in the minus 30s and the fractures and leads in the ice were healing quickly; old floes were becoming more numerous, and the action of the drifting more predictable. The splitting of floes, the heaving, groaning walls of ice, the sinking feeling of sledging over ice which in the early days of the journey we would have considered too thin to bear the weight of a loaded sledge – we now regarded all this as normal.

'Sea ice is flexible like plastic', we had been told by the Inuit. We had taken their word for it and ventured out only on to ice that would take three hefty blows of the ice axe – ice about 8 in thick. Now we found we could take loaded sledges across ice only 4 in thick, which would bend as much as a foot from its normal plane as the sledge, pushing a bow-wave before it, rode the ice like a ship. We took in our stride pressure ridges that were still moving – even the dogs were getting accustomed to scrambling over walls of ice rubble heaving under their paws.

On 16 April the resupply aircraft was on its way out from Barrow, and by 3 p.m. was circling low on the horizon and coming in for its first pass. For a second or two we were only a few hundred feet from old friends from the Arctic Research

LEFT ABOVE About a mile north of Barrow, the road ended and the trackless waste began. It is 21 February 1968. I suppose there was no better place to leave land on our journey into the unknown than this rocket-launching site. I had lived with this dream for so long, now it was time for take off.

LEFT BELOW In Antarctica we could lay supply depots in advance, but this was not possible on the Arctic Ocean's constantly shifting skin of ice. For a journey of this distance there simply was no other way than using airdrops. We were way out on a limb.

95

Laboratory. We could see Dick Dickerson at the controls of the Dakota and caught a glimpse of Randy, Frenchy and Bill Beck as they kicked the boxes out of the door. They made two more runs over our dropping zone and a low pass of the camp before the roar of the engines died away and we were left once again alone. During those sixteen months on the roof of the world we never did get used to that mixture of relief and isolation which descended over us immediately after an aircraft had gone, or the sight of foreign objects on the floe with parachutes streaming like spinnakers, straining to haul them away from us across the ice.

Morale in the party was high, but on 19 April, when crashing through some very rough country, my sledge split a runner. I did a temporary repair on it and we pushed on for another seven hours before camping. We lost a day and a half as a result, for to make a strong repair we were obliged to rig a canvas tarpaulin to protect us from the wind. The ice that had formed in the split we thawed out with primus stoves. We sealed the crack with an epoxy resin, bolted six metal plates across it, and, as an extra precaution, 'stitched' the runner in three places with bearded seal hide. We had learnt this technique of repairing a sledge from the Inuit. The shelter we had rigged up was another of their tips, and the harpoons that served as uprights for the tent had been given to us by them.

The going was very rough over the next few days as we met heavier ice, fractured and pressured in tighter fields. We occasionally broke free on to larger floes or stretches of new ice, but seldom got a clear run of more than a mile before meeting a sheer wall of ice or a large expanse of fractured pack ice moving at a rate of knots. Sometimes the sea was a stew of smaller pieces with clear patches of black water, and then a growler of ice, a sizeable sea-eroded block, would rise up with water pouring off

its green, gnarled sides and flop back into the stew. For a while it would heave and plunge as it sought to find its new equilibrium.

We inched wearily into a milky world of shapeless shadows, for we were now in May, the month of mists and overcast skies. Daylight diffused by the multiple reflections between snow and cloud bleached out all contrast, all horizons, and we could no longer judge size. Mountains of ice shrank into knobbles as we approached, and pressure ridges loomed then faded into ghostly forms. We followed dogs and sledges over hummocks we could not see and fell into invisible holes. Gone were all the daydreams, gone those quiet smokes at the back of the sledge when we sat cocooned in fur, soaking in the warmth of a low Arctic sun. We had breathed deeply then, knowing that it would be many months before the air would be as clear again; it was now thick with fog or falling snow, and seemed clammy and close. Our world had become a stagnant mist, a set of tracks and voices of speakers near but seldom seen.

We were soon faced by a lead that barred any further progress north. An alternative route east or west was out of the question, for it would have taken at least six days with such heavily loaded sledges to carve a detour through the deep sticky snow that had just fallen. And it would be as many days before the ice on the lead was thick enough to bear the weight of a sledge, for the air temperature was now only a few degrees below freezing. The time had come to convert our sledges into boats.

I had looked forward to this moment ever since I had drawn up my designs for a sledge that would convert easily; we were, after all, a maritime expedition. Nowadays it is all plastic, but back then I devised a light duralumin frame, over which a waterproof tarpaulin could be stretched. I'd tested a prototype on a frozen lake in Norfolk in 1967, which eventually sank – not

ideal preparation for the Arctic Ocean perhaps. Anyhow, now we simply had to do it, and so, on 13 May, the time had come.

We lashed harpoons and skis across an unloaded sledge, pushed it on to a tarpaulin which had eyelets at 1-ft intervals around the edge, and stitched this up with parachute shrouds that crossed from one side to the other. Our 'parcel' when it was ready for launching looked not unlike a boat; indeed, but for the handlebars of the sledge which stuck up at the stern, it had a certain quaint grace about it. There was a skin of grease ice on the surface of the lead which had to be broken before we could start ferrying gear and dogs across, so Ken and I made the maiden voyage to cut a channel through to the far bank.

It was a really slow job, as we had to reach over the bow and break every foot of the way. Allan and I made a second trip with the sledge-boat loaded up with boxes of food and three reluctant dogs. We got across without much difficulty, but in the meantime the floe had deformed and the ice was on the move. There was no choice but to return and wait for things to quieten down, and in order speed things up, Fritz and Ken towed us back with the line. The three dogs had been too scared to move during the outward journey, but on the return they became restless. They shifted and tilted the craft and it started taking on water; we reached the home shore just as it sank. The sledge and the gear lashed to it took several hours to fish out.

The few weeks before setting up summer camp at latitude 81°33'N were physically the hardest of the whole journey. We drove the dogs out of their depth in wet snow and meltwater pools, and had to drag them across one by one. Each day the pools were deeper and the dogs more reluctant to plough their way through dragging a sledge. We were fighting a losing struggle with the drift – a hopeless effort to travel northwest in search of a safer area where we could sit out the summer melt when progress would be impossible.

Since leaving Barrow we had covered 1,180 route miles, sledging further from land than any others in history. We'd measured floe thicknesses and snow densities almost every day and kept logs of wildlife, and the type and ages of the ice across which we had travelled. We recorded weather data, which we coded and transmitted daily to Freddie Church at Barrow; he in turn passed it on to the US Weather Bureau and the British Met Office. But by 4 July the floes were so flooded with water we could go no further. The Canadian Air Force flew out our summer supply drop and we set up camp.

❧

I knew all along that two of the most difficult decisions would be when and where to stop and set up the summer camp, and the even more critical choice of the floe on which to establish our winter quarters for the five-month drift through the polar night. Both are gambles. You know nothing of what lies ahead. What were our chances of survival if we missed our airdrops? The Arctic explorer Vilhjalmur Stefansson believed that man could survive by hunting on the Arctic Ocean. We had not been convinced, for Stefansson had not sledged far enough from land to put his theory to a proper test. We had to rely not on game but aircraft support – and it was well we did. Though we had seen both polar bear and fox tracks frequently during the journey, the animals kept out of our way for now; and the total of twelve seals we had sighted in the previous five months, together with four gulls, a little auk, two long-tailed jaegers and a flight of ducks, would hardly have made three respectable feeds for our 36 working dogs.

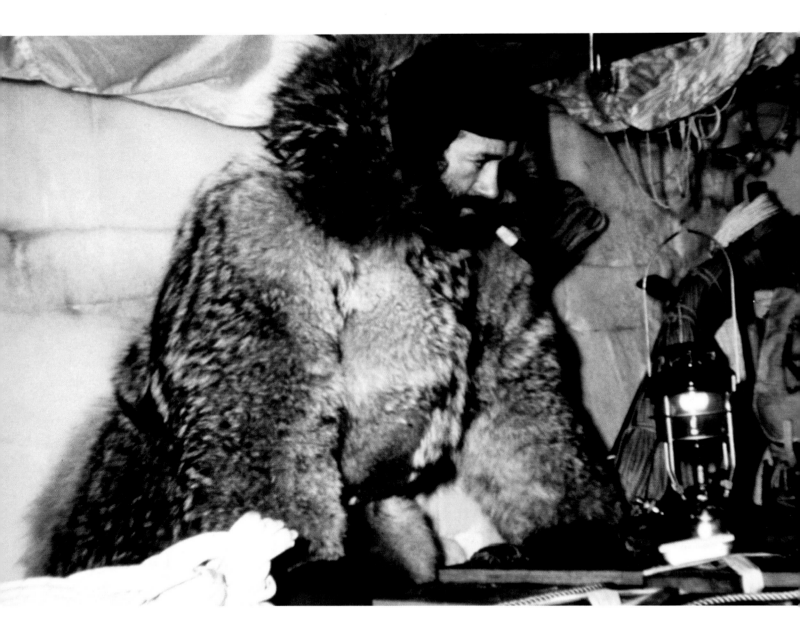

ABOVE During the long winter drift we each had to rebuild our heavy sledges in our snow-block workshop, with its false ceiling of parachutes held up with skis, listening to classical music on a cheap cassette player. The temperature outside was minus 45°C, with snowdrift surging across the floes.

Thankfully, over the next month our planned resupplies went well. Of the 9,000 lb of food, fuel and equipment dropped, the only loss was one batch of kerosene jerry cans. A vast array of scientific apparatus was safely unpacked and made ready for use. My typewriter even survived the drop, as did Ken's wet suit, sent out so he could do some underwater photography. Fritz was now by far the busiest of the four of us. First up every morning and last to bed each night, he worked for seventeen hours a day. He seemed almost continually to be on the move across the floe from one delicate instrument to another, measuring temperature profiles through the 15 ft of ice below us, and the minute changes in the wind, temperature and humidity in the air column 15 ft above the melting surface of the floe.

Meanwhile, I was erecting a work tent, a place where we could sit at a table, stretch, stand up, swing an imaginary cat. The frame was made out of skis, ski sticks, poles from the mountain tents we carried as reserves, and harpoons, guyed and anchored with dog-pemmican boxes. I made a floor platform out of cargo pallets and built shelves and tables from packing crates and empty boxes. It was rough, crude carpentry, but the furniture, although not attractive, was functional. Ration boxes were placed around the table to serve as seats, and some of the parachutes that a few days earlier had rained down on us were stretched over the frame and weighted down around the sides with more boxes. Meltville – the world's most isolated and insecure village – had been established.

For the first time since leaving Barrow, we sat that night at a table and ate our evening meal of meat-bar stew in a civilized manner. There was something of a party atmosphere in that bright, airy shelter; it was the first of many pleasant evening meals during the next few weeks. As a work tent it had its limitations: it was big and therefore cold, flimsy and draughty, so I did most of my writing in the small pyramid tent that I had shared with Allan. Now that the weather was warmer, he much preferred sleeping outside on his sledge. He spent his working day either puttering with his gear, repairing sledges and broken instruments, helping me with the computations for position and floe gyration, or assisting Fritz.

Fritz and Ken were still sleeping in the other pyramid tent, but after breakfast each morning Fritz would go the rounds of his instruments. Ken spent some of his time brushing up on his navigation and sorting out the psychological questionnaires prepared by the Ministry of Defence. Such data would provide information on the interaction of men in isolation and under stress that would be of great value to the military, they said. There were also interesting parallels between our expedition and lunar explorations that might yield data of use to those responsible for the selection of astronauts for the longer space missions.

July was misty, miserable and very sticky – the relative humidity was generally above 90 per cent. We saw the sun through a screen of drizzle; everything was limp and wet. The dogs lay on the tops of hummocks, yawning with boredom and scratching off their moulting fur. They looked around the horizon and seeing nothing went back to sleep. I envied them. Every day I turned the hand generator for two hours to recharge batteries and spent six more writing, while the mists closed in and retreated, lifted and fell, like some enormous lung, with odours of decay and sodden fabric clinging to us like a film of grease.

My breakfast conversations with Allan in the parachute tent as a rule started with a grunt and became more intelligible with each successive cup of tea. Next we'd refill the buckets with fresh water from one of the nearby melt pools, then pick up one of

our three rifles and go for a walk to check the ice. On this occasion, Fritz had reported a new fracture about a mile from the camp that was in places several yards wide, and we had wanted to see for ourselves. I remember it as one of the happiest moments during the entire summer, for it was one of those rare, relaxing days on the Arctic Ocean, with the temperature a few degrees above freezing and not a breath of wind. Allan and I talked and shared jokes under a clear blue sky – the sort of day when working dogs with no work to do lay sprawled out like rugs.

On 2 September, the sun found a hole in the clouds and lit the floe for a moment; the first snows of winter had settled on our camp and had transformed the scene into a dazzling wilderness. But we could not stay there. We had to move on and find another floe on which to set up our winter quarters before the onset of the polar night, for the floe on which we had spent the summer was too far east to pick up the transpolar drift stream which we hoped might carry us closer to the Pole.

We abandoned our summer camp on 4 September and set out with heavily loaded sledges. Four days later we suffered the biggest setback of the whole journey: running beside his sledge, Allan stumbled and fell. His injury proved to be a slipped disc. Ken advised immediate evacuation. Fritz and I, deeply depressed by the seriousness of Allan's injury, spent a long time discussing the situation. Not only was Allan one of our closest friends, he was also an essential part of our crew. We hoped for a miraculous recovery, and felt sure, knowing Allan, that within a couple of days he'd let us know if we should risk him staying through the winter. We had no choice but to return to our summer base for it was the only sizeable floe we had seen for days.

Ken felt it was his responsibility as a doctor to safeguard the well-being of his patient and would resign if he didn't get his way; Allan was determined to stay, and my feeling was that we should listen to Allan and allow him the chance to recover. Ken's offer of resignation was hypothetical, for everything depended on whether or not an aircraft could actually reach us and make a landing. If there was no aircraft, there could be no formal showdown; but the damage had already been done. Ken's demonstration, sincere though it was and admirable from an ethical stand-point, had shown him to be a determined man of the highest principles, but one who was lacking in one important consideration: the instinctive acceptance of calculated risk.

Every journey Allan, Fritz and I had ever made had been a calculated risk. We thrived on such risks. The Trans-Arctic expedition was the greatest and most carefully calculated risk we had ever taken – justified because it was the last great pioneer journey that man could make in the polar regions. To give up while there was a chance of success or to be evacuated while there was a hope of Allan's recovery were out of the question. This was not a case of sentiment getting the better of sound judgment; it was the judgment of highly motivated men, men determined to go on. And men who realized that any attempt at rescue would be fraught with dangers for all involved, particularly the pilots. We would simply not allow it. We had to take the responsibility, and the risk, on our shoulders alone.

That night Ken handed me his medical report. In it he stated that Allan had an acute prolapsed intervertebral disc, gave details of his examination, and that he strongly advised that Allan should be evacuated and should not spend the winter on the Arctic Ocean. Duty bound, I transmitted this message to Freddie. That same night I received confirmation that an attempt would be made by Weldy Phipps in the Twin Otter to land on the ice.

The wind blew all the next day and built up drifts of snow around the tent as I wrote, and that night I transmitted the result of my efforts: a short article for the *Sunday Times* and also a message to the Committee, in which I set out both the great risks of an air evacuation and the prospects for Allan's health, recommending that no attempt be made until the ice improved or until the return of the sun.

Allan by this stage had taken fresh air, hobbling around near the tent talking to his dogs. He was out again the next day for a short walk, and later I took him on a ride on a sledge that we'd fitted up with a padded seat. Fritz joined us and together we explored the floe. It had split and we were now cut off from the old summer campsite. It was a depressing day. I had expected the support of the Committee, but they were insisting Allan leave. It had been impossible to give them my recommendations in great detail, for every word had to be transmitted 4,800 miles. Surely there was no need for me to give more than a brief and direct opinion; I was the leader of the expedition, the man in the field, the man directly responsible. Nevertheless, it was indiscreet of me on the night of 22 September to confide to Freddie over the radio what I thought of the Committee's directive: '…they don't know what the bloody hell they are talking about'.

Every day for the last seven months I had spoken on the radio with Freddie. Night after night he had sat in his radio shack at Barrow, jamming his hands over his earphones like a man with a migraine, listening for my signals through the raucous noise caused by ionospheric storms on the off chance that I might have an important message to pass. If all else failed, he would try again later, switching from voice contact to Morse and probing through the crackle to pick up signals so weak at times that he sometimes suspected they were more imagined than real.

Freddie and I had passed our comments on each day's events as between friends, though guarding our remarks to protect the interests of the expedition, our Committee and sponsors. Only on this one occasion did I make a criticism and, wouldn't you know it, a reporter had been eavesdropping.

My comment hit the headlines of most of the national newspapers in England on 25 September. The *Daily Mail* was typical of the response:

A row broke out last night over the four-man British Trans-Arctic Expedition, which is now about 330 miles from the North Pole. The organizers in London issued a statement in response saying that the leader may be suffering from 'Winteritis'. This is a condition 'which clouds the judgment and can become a danger', but the leader, Mr Wally Herbert … hit back with fierce criticism of the Organizing Committee.

I had little idea then what kind of press sensation my short message had provoked. Nor, I expect, did our Committee appreciate the pressures we were under. But, these were problems of our own making and dangers of our own choosing. In no time at all, we hoped, this particular storm would pass.

On 26 September we received our massive winter supply drop from the Canadian Air Force. The two C-130 Hercules peppered the floe chosen as suitable for it with 70 parachute loads of supplies for men and dogs totalling 28 tons – and the only loss was a dozen bottles of HP sauce! We had come to hugely appreciate the Canadians and their positive thoughts for our survival. We sensed this encouragement in the care taken to check our equipment, the many thoughtful gifts – magazines,

cakes and fruit – and the shouts of the airmen standing in the open cargo door at the rear of the aircraft as they made their final low passes over the camp.

I still had to make the vital decision: whether to send Allan out or go against the Committee's directive by keeping him on the ice. I spoke to veteran pilot Weldy Phipps, who told me he would need a minimum of 2 ft of ice before he could risk putting the Twin Otter down on a frozen lead. Allan was by now up and about and carefully active, but was resigned to being forced to leave. He made one last effort, however, in cahoots with Fritz: the pair of them came over, rather sheepishly I thought, and suggested that Allan should ski off and hide. Hilarious though the thought was, they were dead serious and wanted to know if I would be in trouble if they did it! After a three-day wait, the attempt in the Twin Otter was called off. White-out conditions on 4 October also spoiled the efforts of the press to get more than a fleeting glimpse of us as they roared overhead in the Arctic Research Laboratory's Dakota. Ken aside, the rest of us were delighted of course that we hadn't been reached.

With the issue resolved for now, we turned our attentions to the more pressing problem of surviving the winter. With Allan's injury we had no hope of correcting course and getting ourselves to a position to benefit from the transpolar stream. So there we were in the middle of the Arctic Ocean, as the sun was retreating for the start of five months of darkness, on ice that was moving about 3 miles a day and constantly fracturing, opening into smoking leads, or building into great walls of pressure. There is no surface on the face of the Earth more unstable than the drifting pack ice, nor any place more desolate and hazardous than a camp at 85°N at the start of the long polar night.

It was at that latitude, on 6 October, just as the sun disappeared, that we officially established our winter quarters. Our base was to be the same prefabricated hut that we had used in Greenland during training. It was known as a 'Parcoll Housing Unit' – simply a padded tent, 16 ft square, with a kerosene-burning stove in the middle – not quite as romantic as the clutch of snow houses that had been my original plan. Yet with some optimism and improvisation, making the best of our grim predicament, it proved to be cosy. Charts of the Arctic Ocean mounted on plywood boards were strapped to the sloping ceiling; rifles hung near the door; drying woollens, anoraks, wolverine mitts, wolfskin parkas and pressure lamps hung from the roof's ribs. It was a hut soon aromatic with the smell of newly baked bread and noisy with the clatter of carpentry.

We had enough food and fuel and ample reserves to see us through the winter, but this precious supply had to be laid out in depots all around the floe just in case it cracked up – which sure enough it did some three weeks later. The floe was by then about a mile across; the nearest fracture cut through the camp only 25 ft from a team of dogs and separated us from two of our supply piles. We dismantled our hut in a hurry and had to shift all 28 tons of food, fuel and equipment, including all of the furniture we had made out of packing crates and odd bits of wood, some 3 miles to a safer place. As wind and snow lashed our faces, the light from our hurricane lamps was all we had to guide us in the dark. We had no time to be fearful. Our survival depended on securing our hut as quickly as possible.

Looking back on it now I shudder at the thought of what we went through. There is nothing easy about moving house in the depths of an Arctic winter. Imagine four sledges rattling through the night, our tiny lamps casting weird light on an ever stranger

cargo of desks, shelves, beds, tables, stove and stovepipes. We were like the victims of some terrible earthquake, refugees at the mercy of the elements. And like refugees we could not help wondering how many times during the next few months we would have to move on, always escaping into the darkness, always the same skeletal rattle of possessions, the same pathetic junk worth more to its owner than its weight in gold.

A corner of the hut was allocated to each man, who furnished it according to his needs and temperament. An upturned packing crate served as Ken's writing desk and, with shelves hammered inside, a storebox for clothes and personal gear. For a scientist, Fritz's furniture was surprisingly unsymmetrical, while my own was a robust-looking piece of carpentry incorporating a writing desk and a set of shelves built around four radios, two tape recorders, cameras, books and navigational tables. There were only three beds in the hut, however, for Allan, in spite of his back, preferred to sleep in a tent outside. Also outside, the dogs kept their own territories and slept happily, picketed in lines, curled up and cocooned by the drifting snows.

We established a good winter routine. We would rise at 8 a.m. and start work at 9, each absorbed with our individual projects until 10 p.m., when we'd enjoy the luxury of reading until midnight. Each man would take his turn at cooking: one day on, three off. He would make a fresh batch of bread rolls every lunchtime, and one loaf a day. The cook would be expected to show some imagination in his menus. There was no excuse not to: we had 4,334 lb of provisions consisting of 1,540 assorted cans as well as freeze-dried foods, frozen foods, vegetables and eggs that had been fresh on 24 September, and of course dehydrated foods. All one needed was time, enthusiasm, and patience with the tin oven that balanced precariously on

a primus stove. And all the while our fragile home floated on through the endless night.

Every night I would lie in bed gazing up at a chart of the Arctic Ocean hanging above my bunk and fret over the adverse drift that was robbing us of the miles I had hoped we'd collect from the transpolar stream. Now we were heading south, unable to counter the drift and helpless to ignore it. For most of the winter the ice around us creaked and groaned incessantly. There were times in our hut when even the roar of three primus stoves and four pressure lamps could not drown out the crunching, creaking sounds of advancing ice ridges.

Sometimes I went for walks alone along the thin ice of a fracture that had split our floe. It was a black lane, with high ice hedges on either side, petrified and magical in the swinging yellow light cast by my hurricane lamp, crowded with moving shadows and faces that disappeared a fraction of a second before I looked in their direction. I imagined bears creeping stealthily towards me. I would look back at our base, afloat in the centre of an ocean, its one light like a jewel piercing the darkness.

On Christmas Day I finally finished building the snow house that was to be our workshop, and over the next few weeks we each took turns in that cramped space to reconstruct our heavy sledges. It was a period I look back on now with great nostalgia: that snow-block room with its tarpaulin roof and false ceiling of parachutes held up with skis; the warmth that rose from the primus stoves on the floor; those cassette tape-recorder concerts – Bach Suites 1 and 2, Berlioz's *Symphonie Fantastique* and a cappella classics from the Swingle Singers, the only three items of music we had. I remember those days wrapped up in fur, our breath vapour hanging in a swirling cloud. Inside it was just below freezing, but outside it was minus 50°C, and

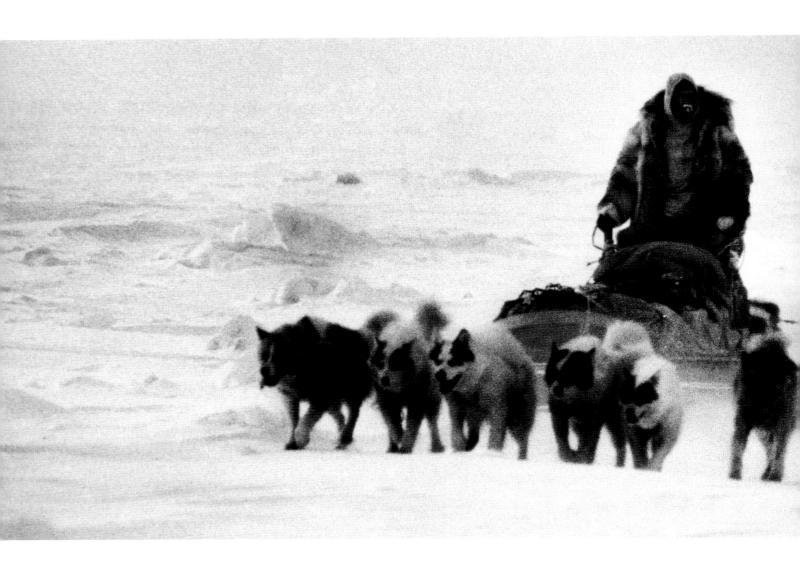

ground drift was slithering like snakes across the floe and licking the shelter walls.

On 2 January 1969, in the light of a moon, we noticed what appeared to be a water sky to our east and northeast and on investigating found that the floes had drifted apart – a vast expanse of open water now separated us and our first winter quarters. We quickly hitched up the dogs and shifted two of our depots nearer to our hut. The floe's greatest width was now less than half a mile. An awareness of what lay ahead was also now beginning to tighten the muscles. I was sensing this most in the evenings after I had

turned in for the night; it was an exciting feeling which I knew from past experience would build until, by the eve of departure, I would be practically screaming inside for action.

On 3 February at midday the temperature was minus 45°C. Vapour from the chimney was rising vertically and feeding a thin canopy of mist that hung above the hut. To the southeast, and low in the sky, Venus was like a pearl. To the north the moon was full and cold. The whole icescape was awash with an ethereal winter light. But overnight everything changed; the sky clouded over, a strong wind got up, and at 4 a.m. the floe split in two.

ABOVE We are about a mile from the coast on the first day of the expedition. Ahead lay thousands of miles where nobody had gone before. There would not be a day during the next sixteen months when the floes over which we were travelling were not drifting with the currents or being driven by the wind. There would be no end to the movement; no rest, no landfalls, no sense of achievement, no peace of mind, until we reached Spitsbergen.

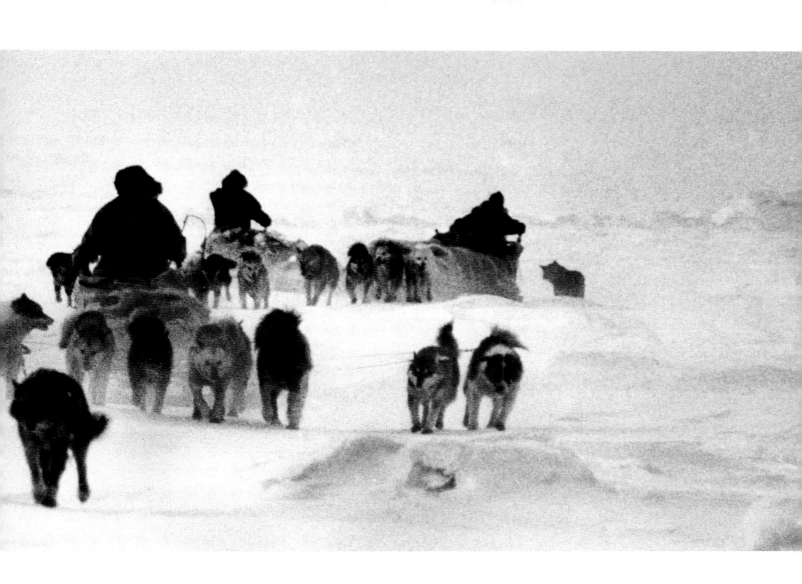

We were now 350 miles behind schedule and only halfway to our destination. The journey ahead seemed formidable. To reach Spitsbergen we would have to travel the same distance in 100 days as we had to date covered in almost a year. The polar night was being rolled back almost too quickly for eyes grown accustomed to the darkness. The sun was climbing faster than man and dogs could run; we knew it would start melting the thin skin of ice that covers the Arctic Ocean long before we caught sight of our destination. We still had to sledge 1,700 route miles. What possible hope was there of covering such a distance?

By 23 February a hard-packed lead wound towards the northern horizon – a trail that crossed crests and troughs of the hummocked ice floes and swept gracefully over frozen sea lakes to the chaos of ice beyond. By then every instinct was straining, every fibre tense, every dog harnessed, every sledge ready to receive its load. Early the next morning, the floe cracked like an eggshell and the whole area started to gyrate. The nearest fracture had split the floe only 10 ft from the hut. We abandoned it and in semi-darkness scrambled around rescuing dogs and sledges as the ice pans heaved under our feet. It was now surely time to go.

PORTFOLIO

THE FROZEN SEA

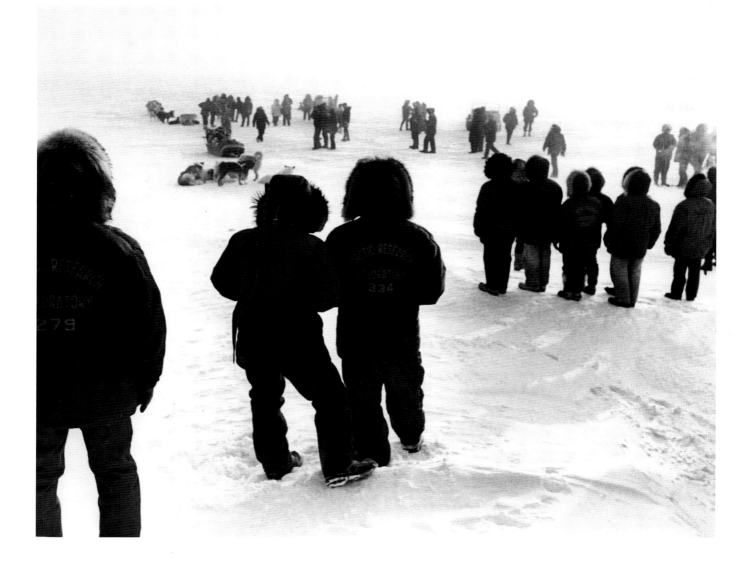

ABOVE On our departure from Barrow a crowd from the Inuit village and nearby research base gathered to wave us off. Most wore parkas with enormous fur hoods. At last we were off! After years of effort, it was an immense relief finally to get going.

RIGHT For the entire night before we set out, I felt sick. There was nothing left in me except fear. It was not so much the personal risks, but the weight of responsibility for the lives of the men who had chosen to share in my dream. So how did I feel as we left? Absolutely brilliant.

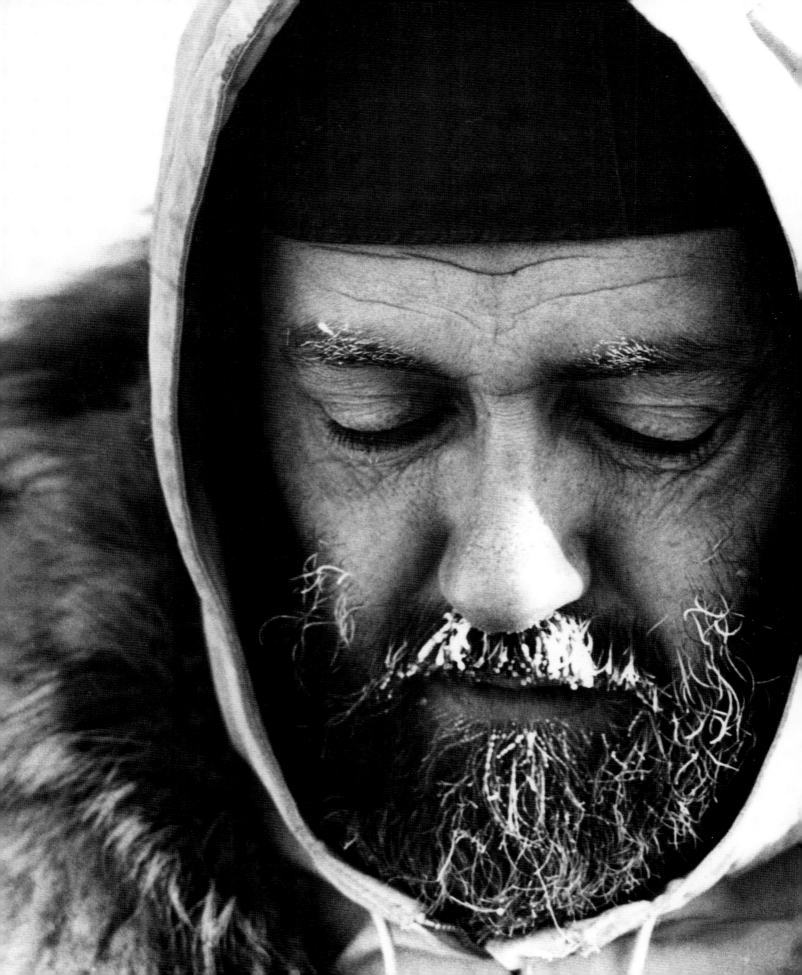

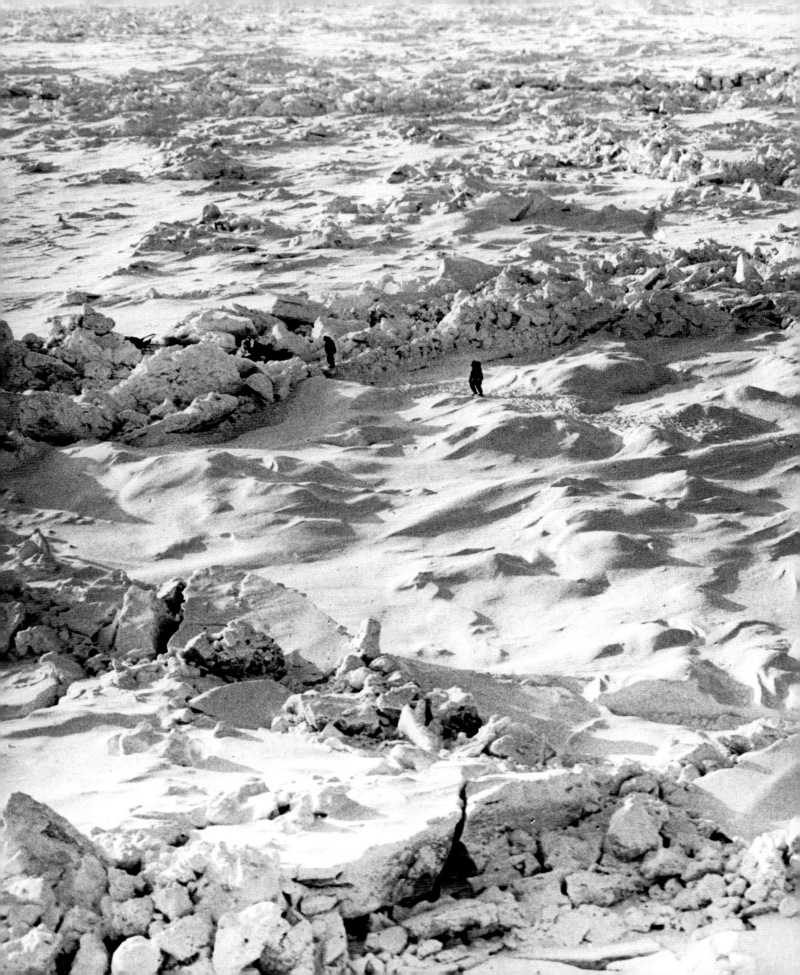

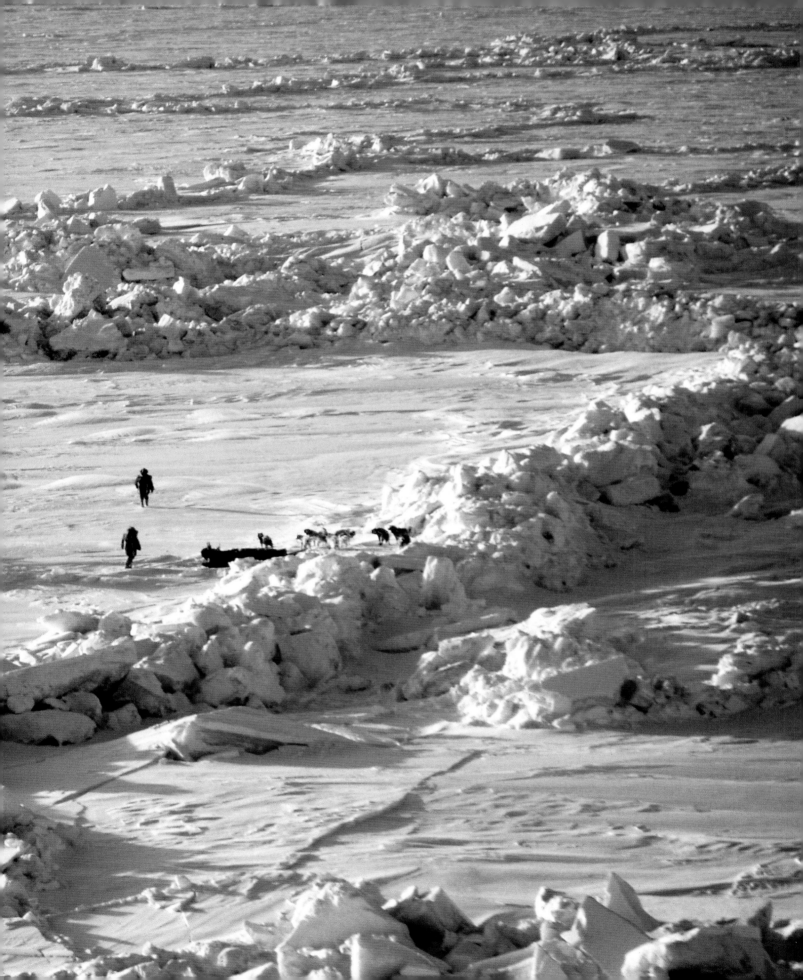

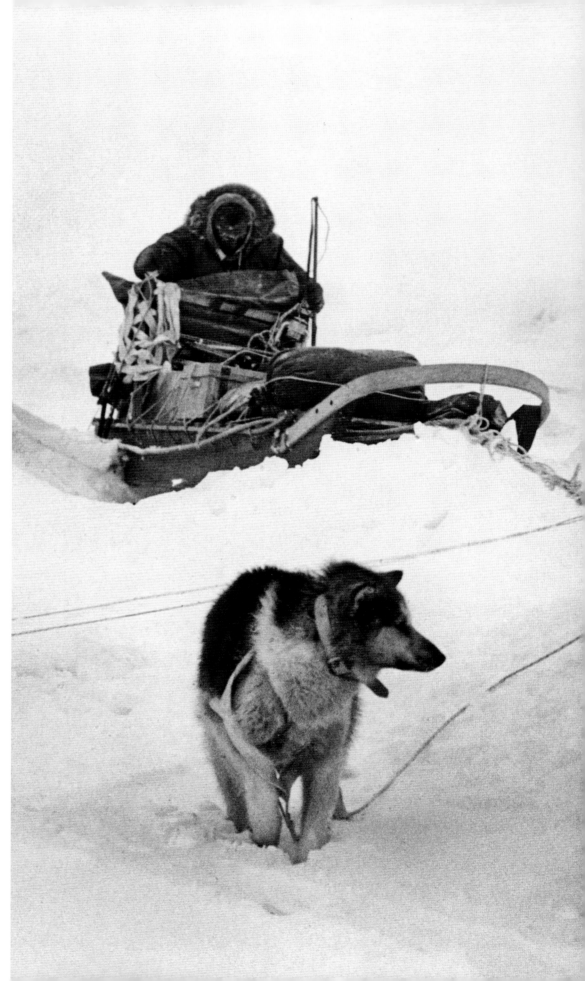

PREVIOUS The frozen surface we travelled over was a tracery of complex fractures caused by winds that drove the ice in confusion against the sea currents. This is the sea we had to cross, hidden beneath a skin of ice that could crack apart instantly or melt into treacherous drifting slush.

RIGHT Allan Gill and his dog team are tackling a pressure ridge. We scanned the horizon, but as far as the eye could see ahead was just a volatile, churning mass of moving ice that wouldn't bear the weight of a man. It took us a full three hours to get all four sledges over that first pressure ridge.

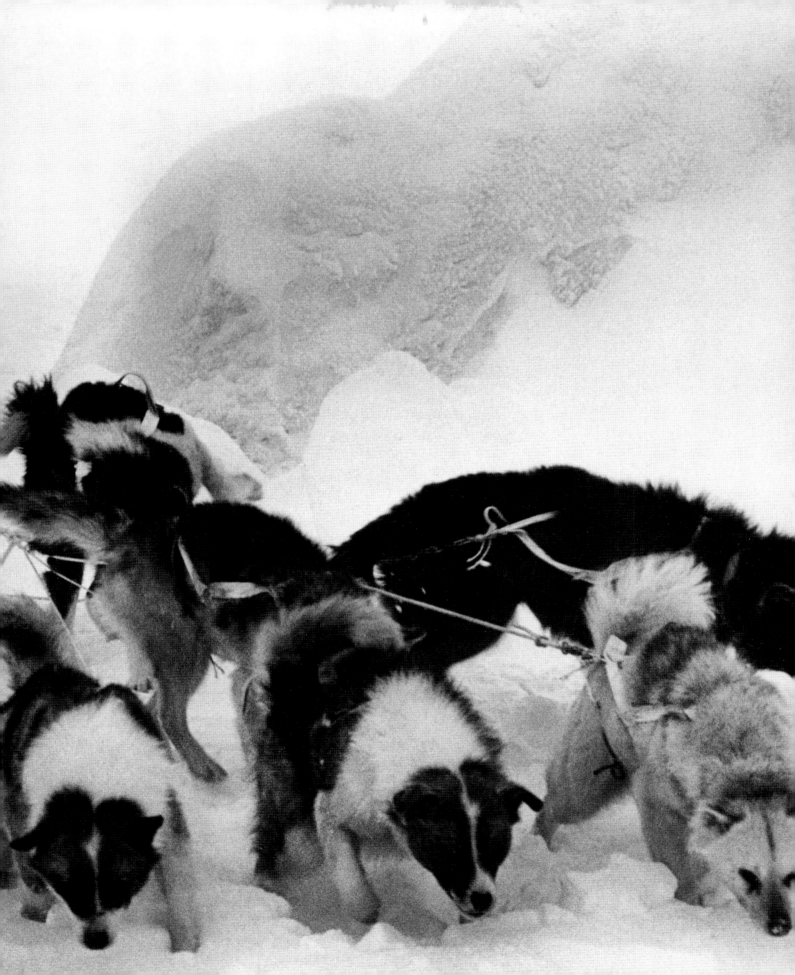

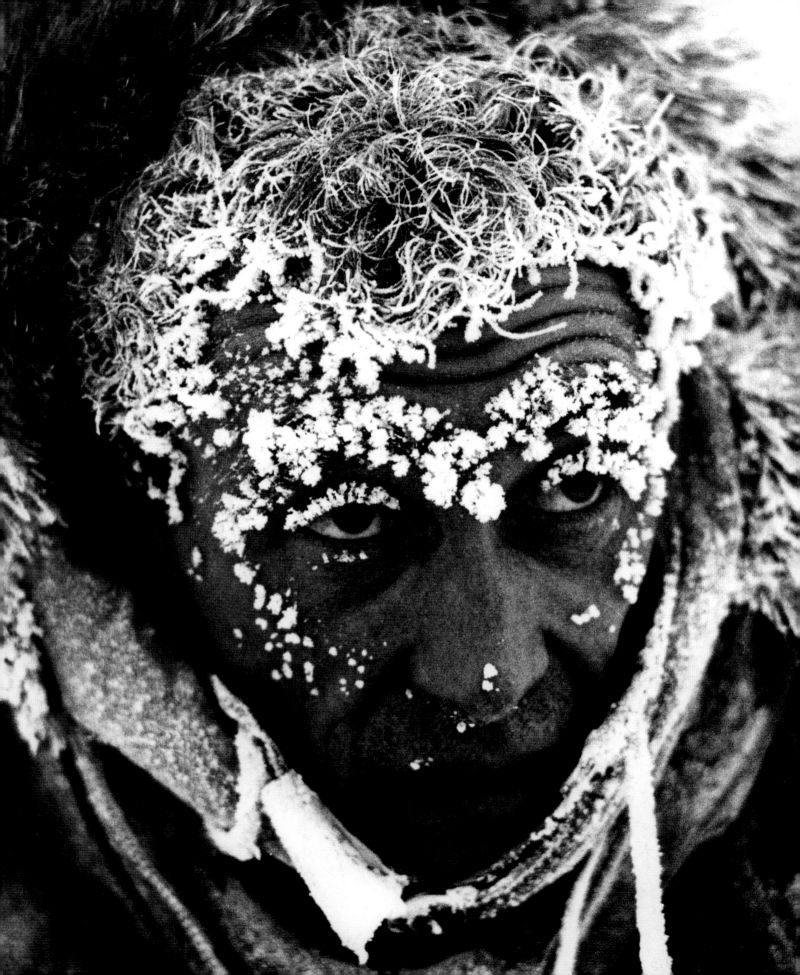

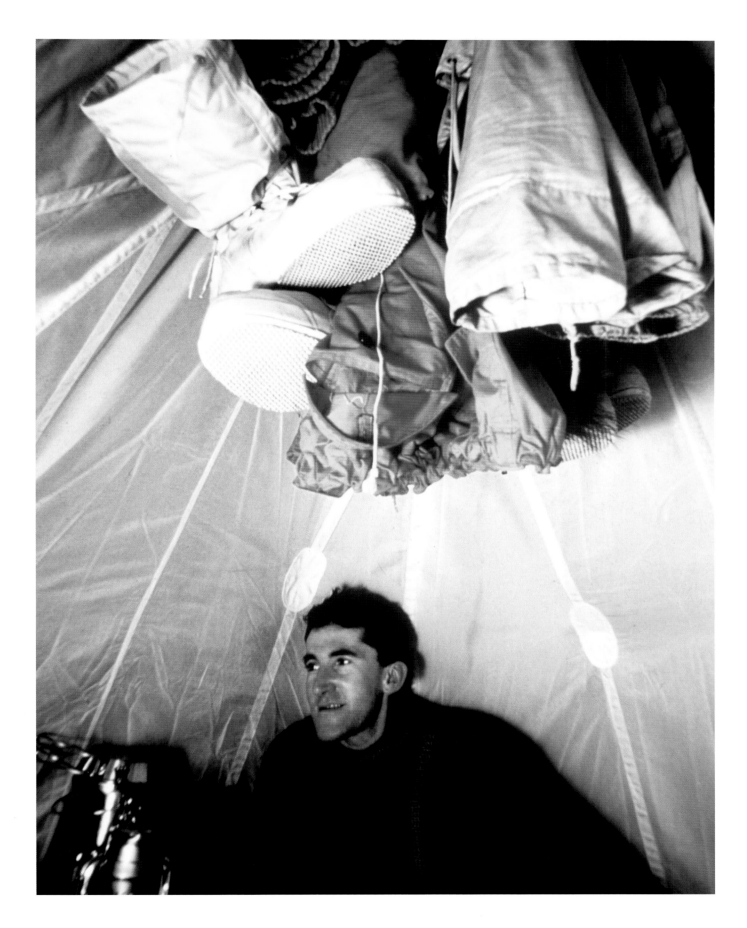

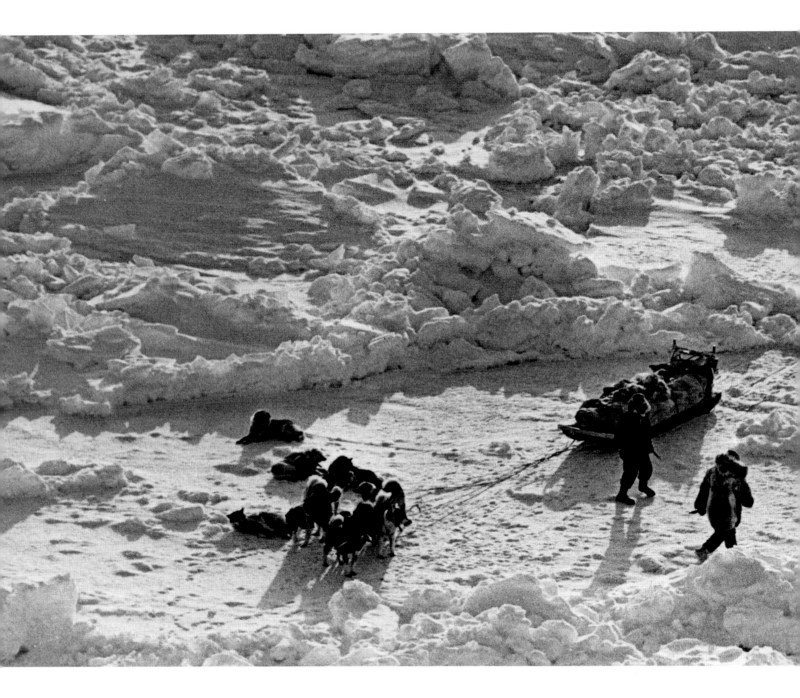

PREVIOUS LEFT Allan was someone who simply loved sledging with dogs. He was a man of very few words, but loyal, strong and a tremendous friend to me. It was minus 50°C that day. In this sort of cold if you touch bare metal you burn your fingers, and if you face the wind, white dead patches appear on your cheeks and nose.

PREVIOUS RIGHT After a day on the ice the only refuge was a tent, with the tiny flame of the primus the means for survival. Frost and ice still formed everywhere. Clothes hung in the apex of the tent to dry out froze solid by morning. Ken Hedges was the medical officer of our party; he had spent most of his time in the jungle and hot deserts and really didn't enjoy the cold.

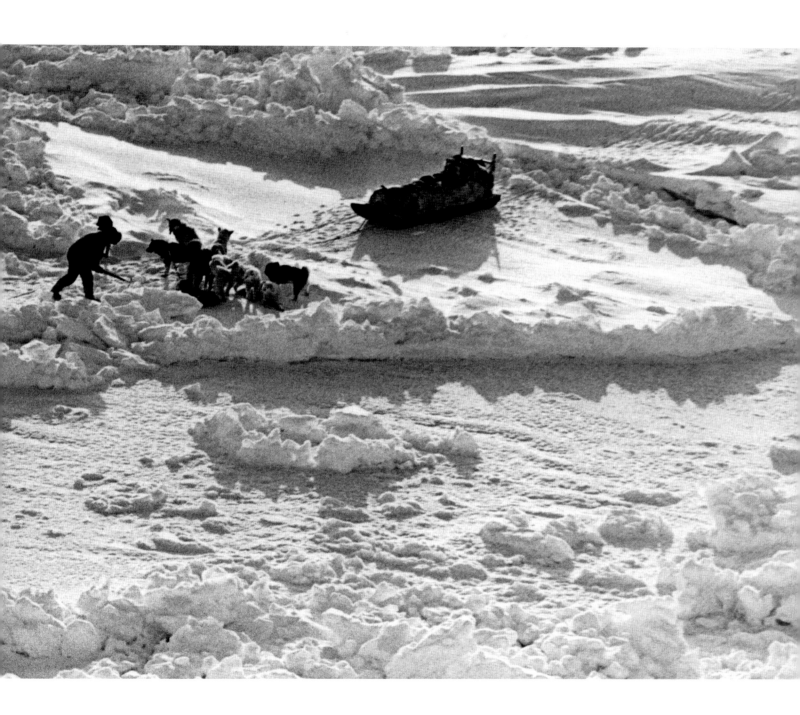

ABOVE We are about 60 miles out to sea off the Alaskan coast when this photo was taken from a Cessna full of press. It shows typically heavy going on the frozen surface. Soon it would be night. The temperatures plummet. You must find somewhere safe to camp in this barren icescape.

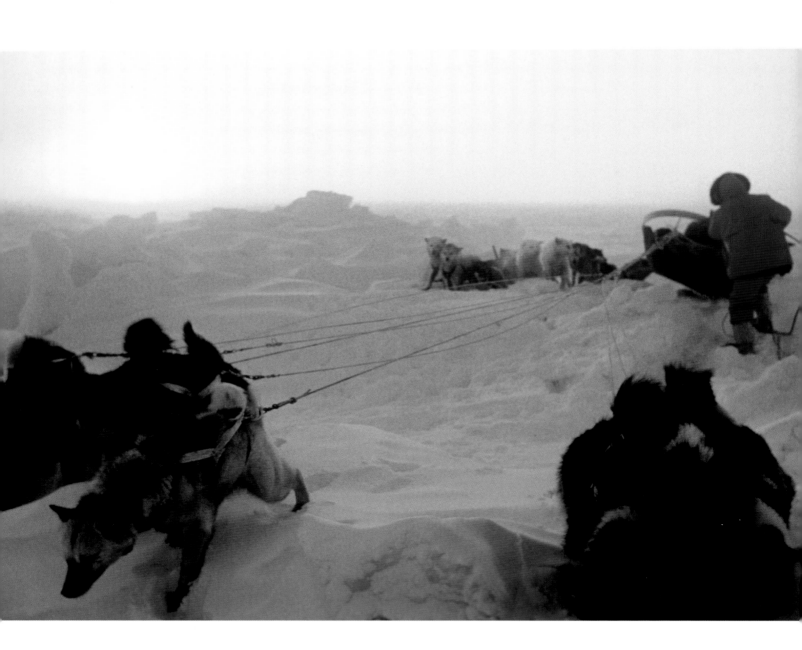

ABOVE As we headed into March the sun rose ever higher. With the ice still hard and the days longer, this was a time for good sledging. But each day we were stopped by pressure ridges and mush ice in this frustratingly insecure pack.

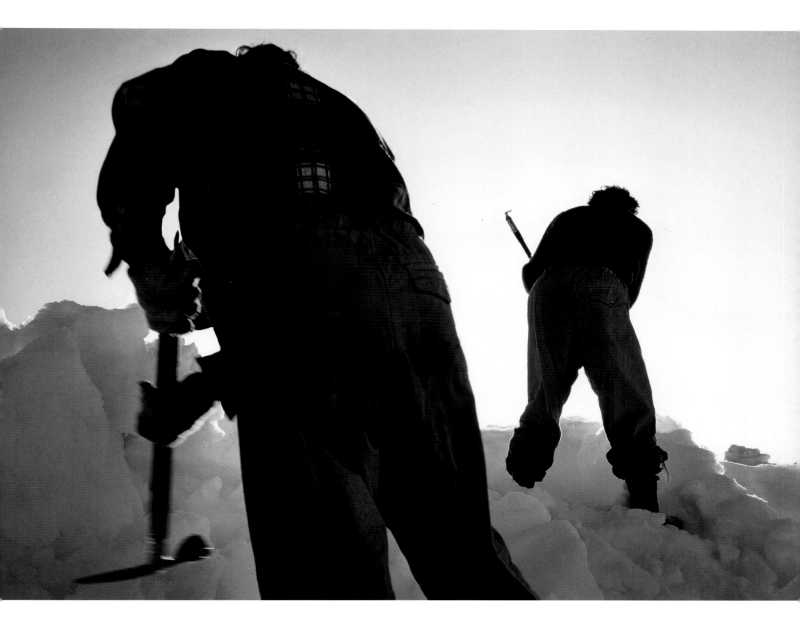

ABOVE All the time as we hacked our way north through the rubble of ice, the sea beneath our feet was 10,000 ft deep and ink black in the leads. Sometimes we were jumping from one piece of ice to the next, with the only light from the aurora.

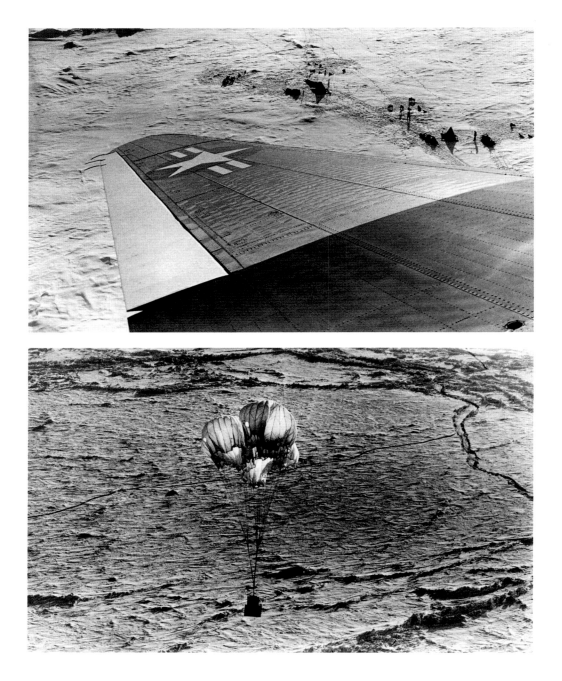

TOP AND RIGHT Our camp on the ice as seen from the Arctic Research Laboratory Dakota aircraft. It had been a day of particularly heavy going through smashed floes and crossing severe cracks; we were mere specks in this vast wilderness of ice.

ABOVE Our first two supply drops were performed by the American Navy and it was no easy task. The shadows cast by the pressure ridges were much longer than those of our two tiny tents, so we had to tell the pilots exactly where we were. They showed real skill and bravery.

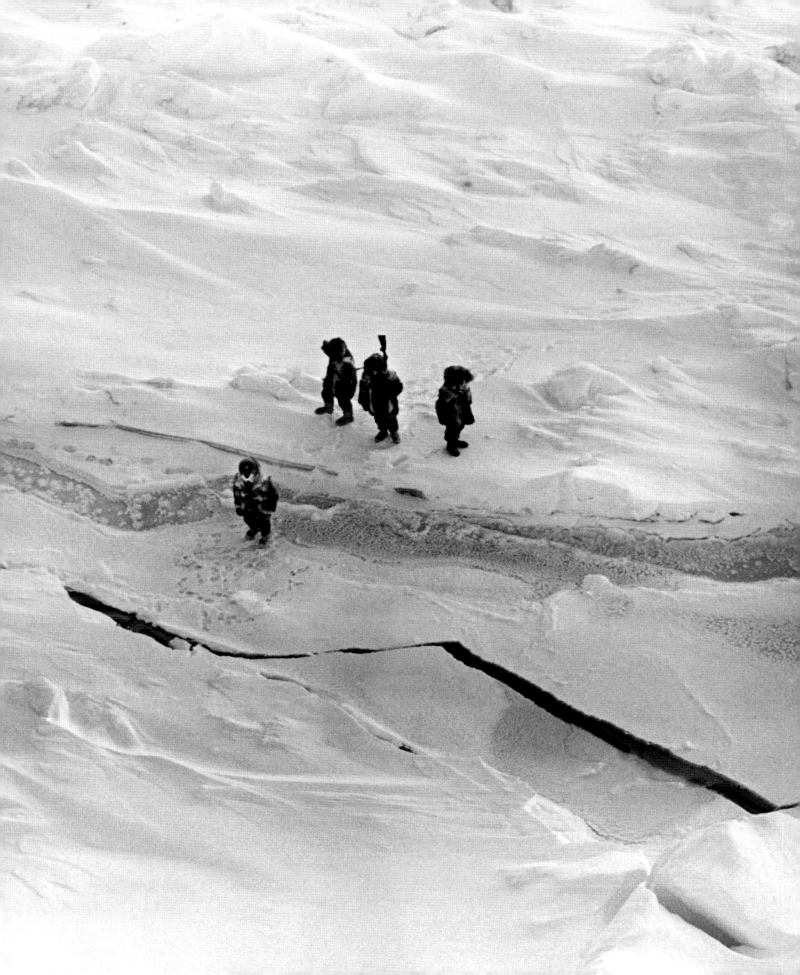

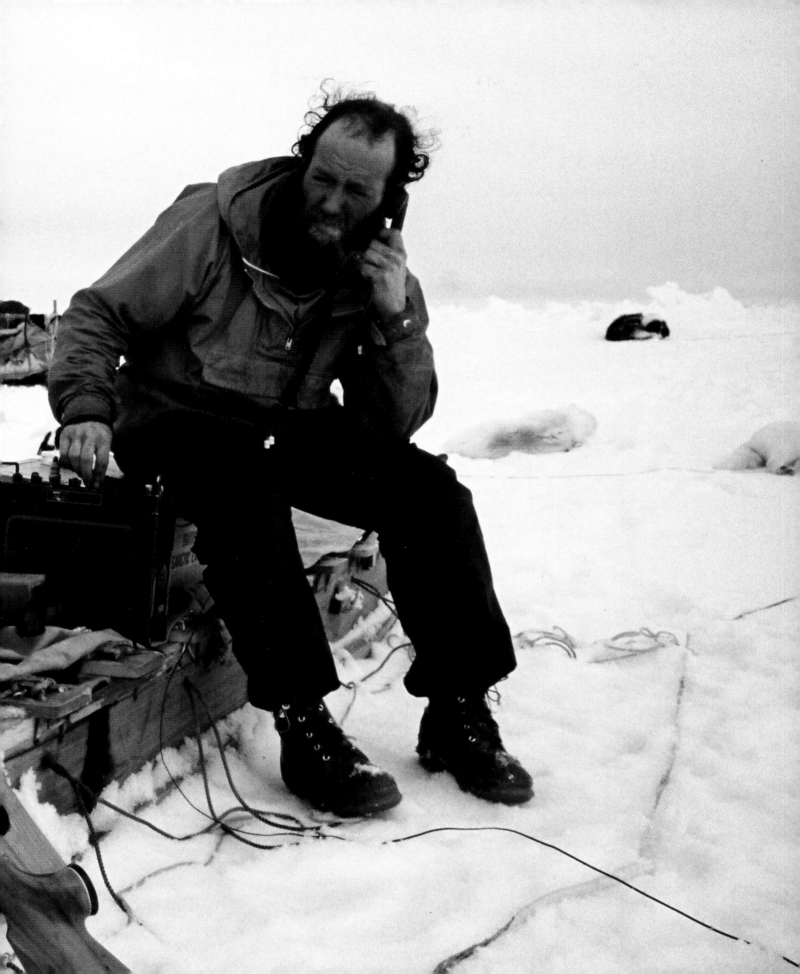

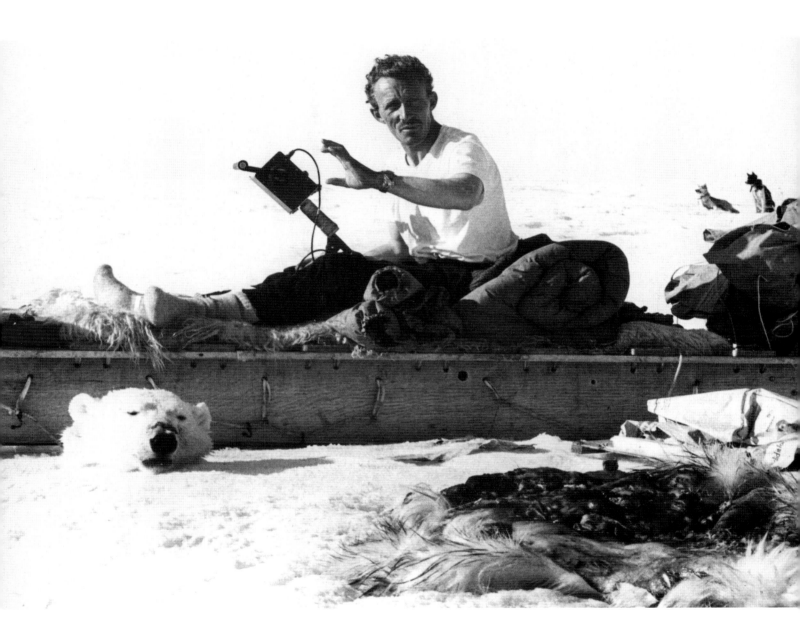

PREVIOUS The radio set was our sole link with the outside world and we made contact whenever conditions allowed. This shot was taken a few months into the journey, with the weather unusually calm. Five hundred miles away in his small shack on the Alaskan coast, our radio officer Freddie Church relayed our messages back to London.

ABOVE Allan turns the hand generator, providing power for our radio. The remains of a polar bear lie nearby, which we reluctantly had to shoot. On the few occasions we had to kill a bear we chopped it up to feed the dogs. It was hard work, but not to do it would have been a truly callous waste. Bears often approached our tents at night; mostly we could scare them away.

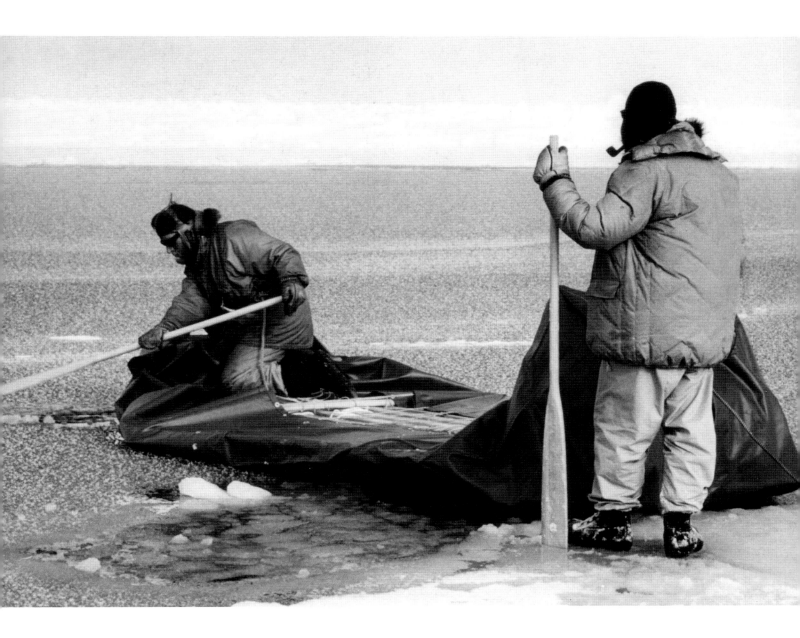

ABOVE We converted our sledges into 'boats' by wrapping them up in a waterproof tarpaulin. Our first effort on 13 May was a disaster. The sledge sank and most of the gear, even though fished out, was ruined. We eventually refined our technique and slowly but surely we could ferry ourselves and our equipment across most open water.

ABOVE By Midsummer's Day the sun was circling constantly overhead. The ice was melting into large surface pools and the floes were splitting apart. We were travelling on borrowed time. We finally found a floe big enough for us to sit out the summer melt. The Royal Canadian Air Force flew out a supply drop and we set up camp on a hummock.

RIGHT Allan is repairing a broken sledge runner. The tent is rigged up over it to gain some protection from the wind, a trick we learnt from the Inuit. Our wolfskin parkas were also essential. It looks like a sunny day, but it's deceptive. Even when the sun is shining the invisible winds are frigid.

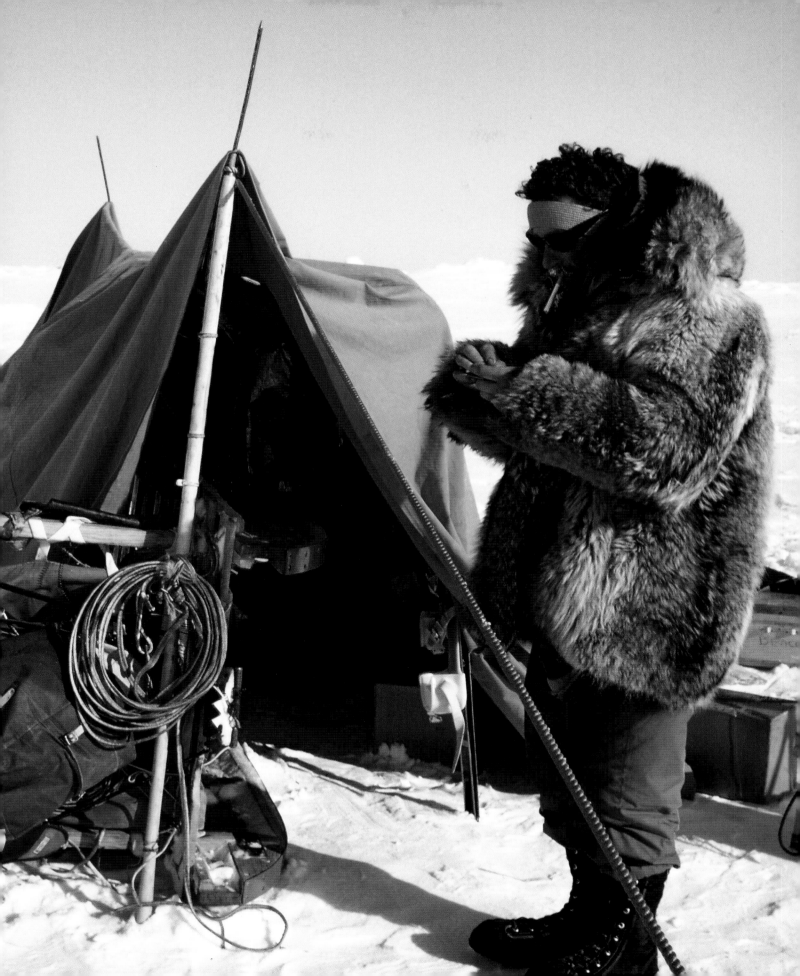

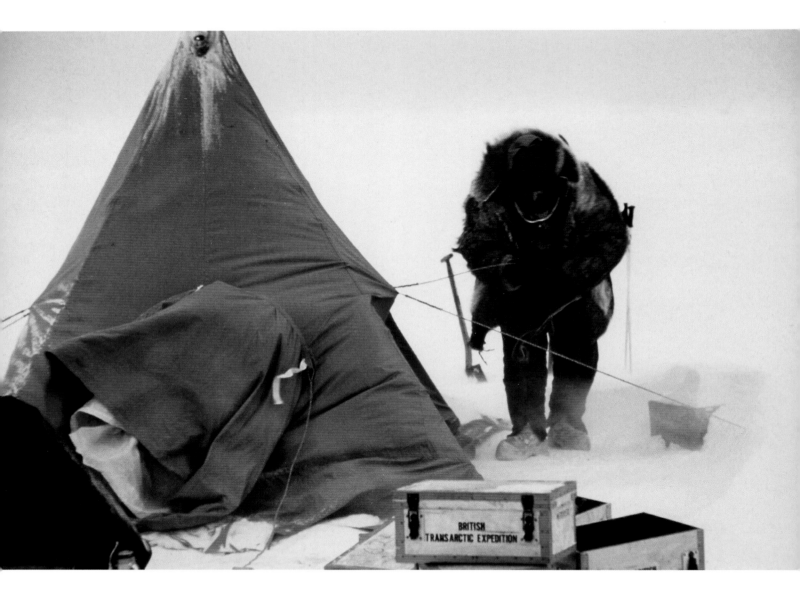

ABOVE Surviving on the Arctic Ocean is all about finding a rhythm. You travel hard until you feel tired, then you stop, have a meal and try to sleep despite the wind howling outside. The day is divided into these three basic sensations: working hard, the need to eat, the need to sleep. I think it was this very simplicity that made it so satisfying.

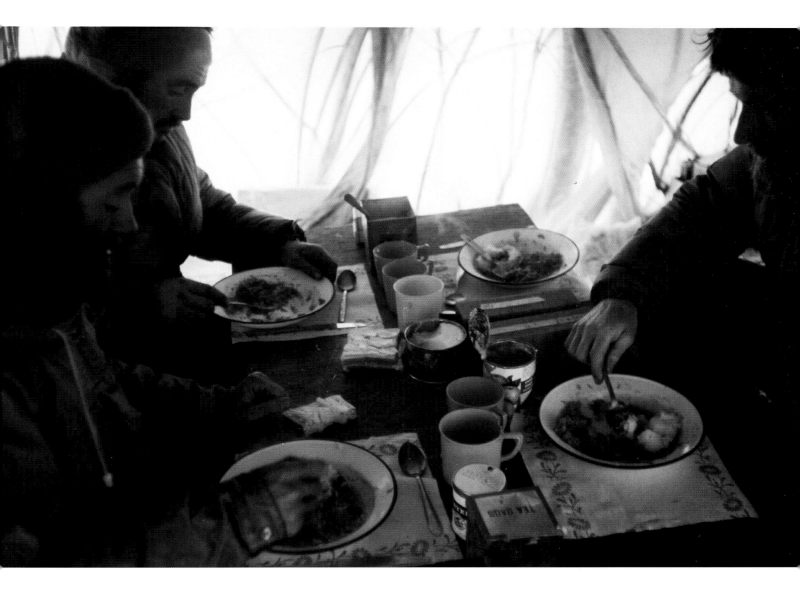

ABOVE By 4 July the floes were so flooded we could go no further, and we set up camp. In a makeshift mess tent we sat down to eat together at a table for the first time in over five months, with sledge ration boxes as seats. What I remember most vividly was waking up on our first morning there. For the first time since leaving Alaska we didn't have to go anywhere. It was wonderful.

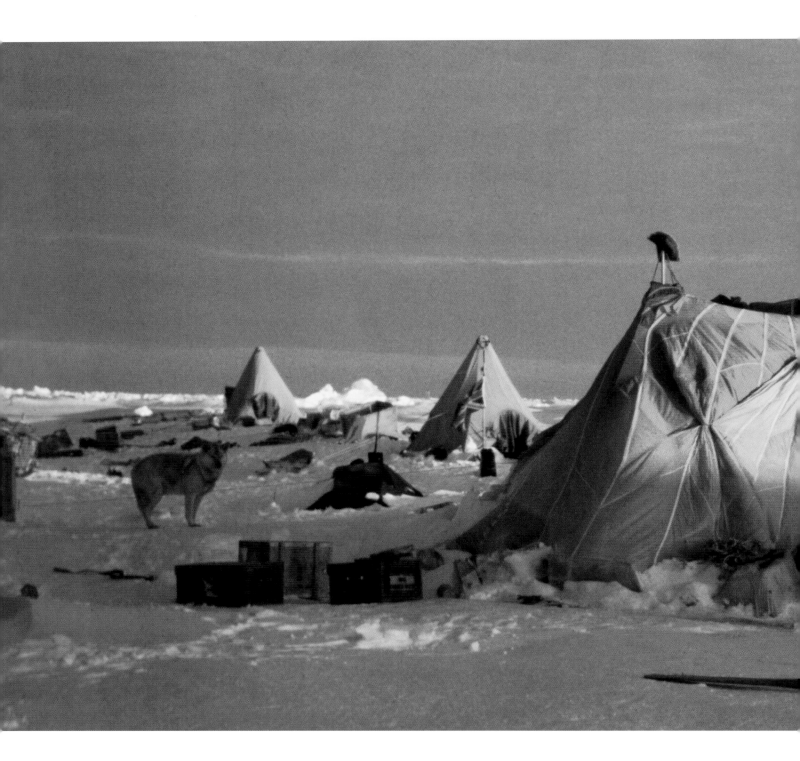

ABOVE 'Meltville' was our insecure summer hamlet of two pyramid tents and a large mess tent fashioned out of parachutes. Roy 'Fritz' Koerner was our expedition glaciologist. First up every morning and last to bed at night, he worked for seventeen hours a day in that camp. To him the mists, the melting ice, the freshwater layer on the surface of the sea were all subjects to be measured or recorded.

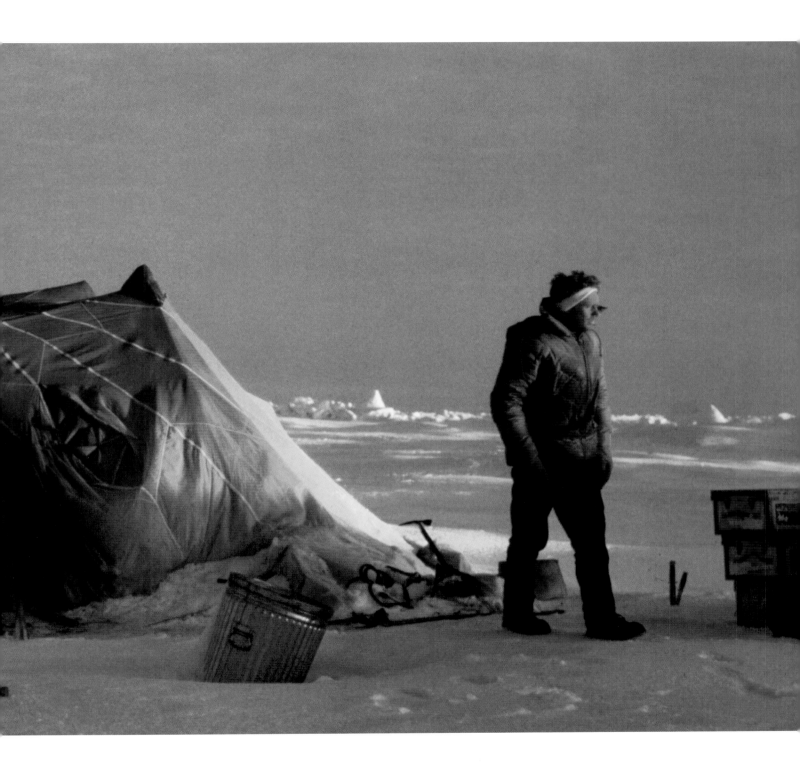

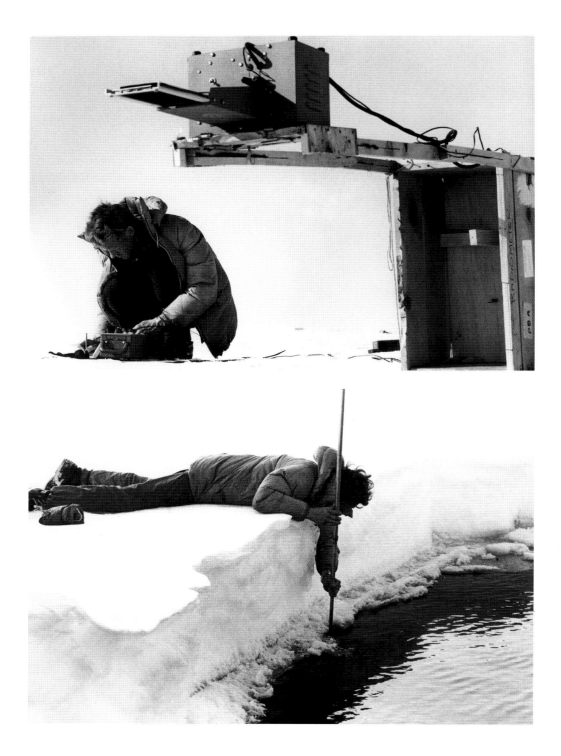

ABOVE AND RIGHT Fritz seemed to be almost continually on the move from one instrument to another. A true pioneer, he hoped his work would provide insight into the total ice production of the Arctic Ocean at a time when its influence on world climate was only just beginning to attract scientific interest. At the top, Fritz is recording incoming and outgoing radiation; above he is measuring the thickness of the floe; and opposite he is studying temperature gradients at his anemometer mast. Extra instruments were flown out to us and the airmen also slipped in some welcome bottles of beer.

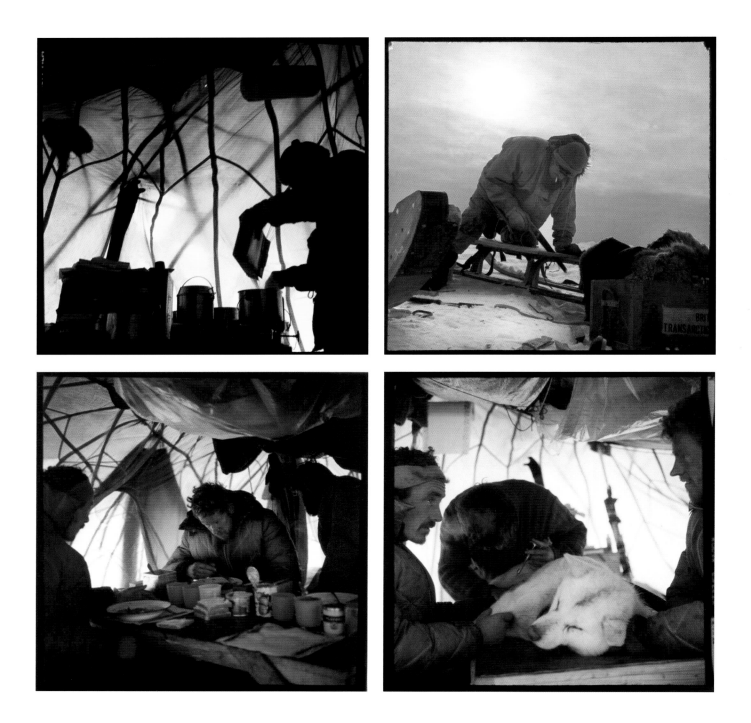

ABOVE The rhythm of our daily lives changed at Meltville. During the day we did some rudimentary cooking and eating, and made repairs to the sledges. With some careful bolting and lashing cracks with seal hide, we kept them moving. Each man had his own team of dogs, and of 40 we only lost four during the whole crossing, despite the tough conditions. We could ill-afford to lose any and a little careful surgery was sometimes required.

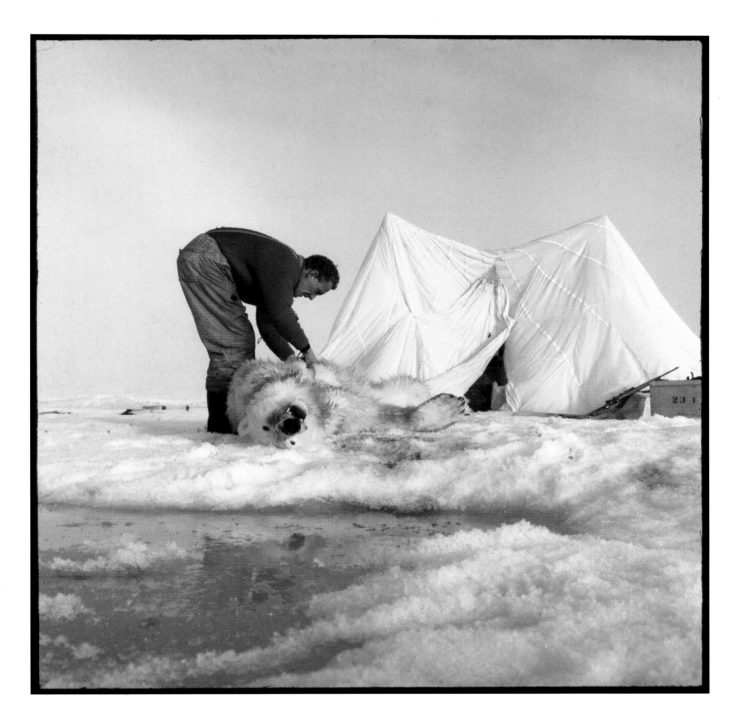

ABOVE Allan had a nasty scare with a bear that suddenly emerged from the water. Another time when a bear appeared, Ken's rifle jammed and, reluctantly, I made the shot. We resolved we would only kill a bear when it was certain that a dog's life was in danger, or if it was coming at a man. Once I had to shove my rifle down my trousers in a last-minute effort to thaw it out.

FOLLOWING In his researches Fritz even donned a wet suit to measure the underside of floes. Despite our jokes he went back in frequently. He also conducted auroral observations through the long polar night and an air-sampling programme that collected particle fallout in this remote area – some of lunar origin.

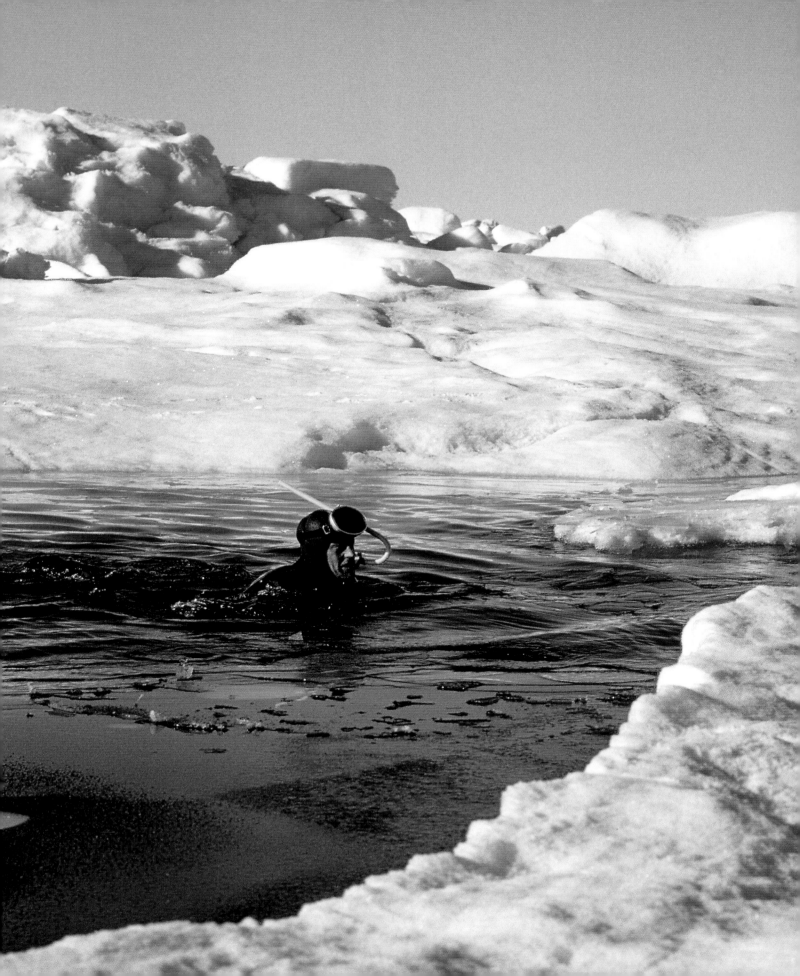

ABOVE Fritz fixing his sledge: many of his scientific colleagues regarded his decision to abandon his career and join our 'crazy adventure' as irresponsible. But he proved them wrong. He would count and measure thousands of pressure ridges and bored over 200 holes through the pack ice as part of his study covering areas of the Arctic Ocean never visited before or since.

RIGHT Twenty-eight tons of food, fuel and equipment, including our prefabricated hut, are dropped by parachute from a Canadian Air Force C-130 Hercules: everything we would need to get through the following five months of winter darkness. It was a huge relief to see all the boxes that I had carefully packed by hand in London being delivered.

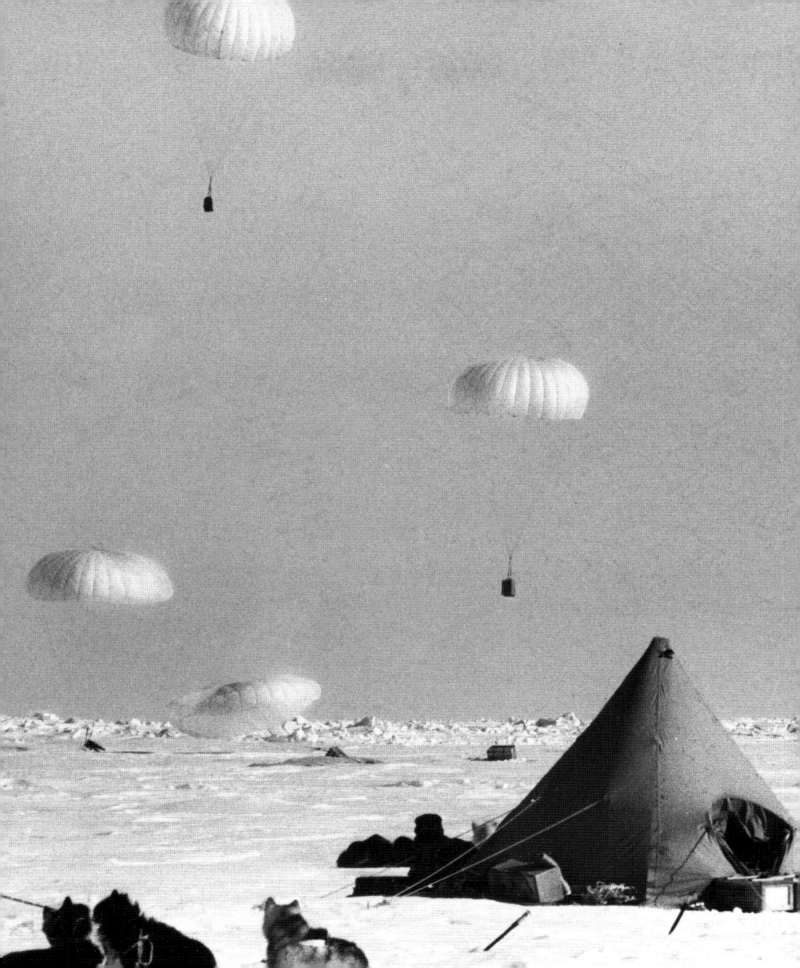

RIGHT During the winter we were cocooned in our hut, drifting through constant darkness. We built bunks out of packing cases and I fashioned a table for plotting charts. I kept all the radios near to hand as I had to send back regular reports of our progress to my London Committee, and updates for the *Sunday Times*, all written in code and tapped out in Morse.

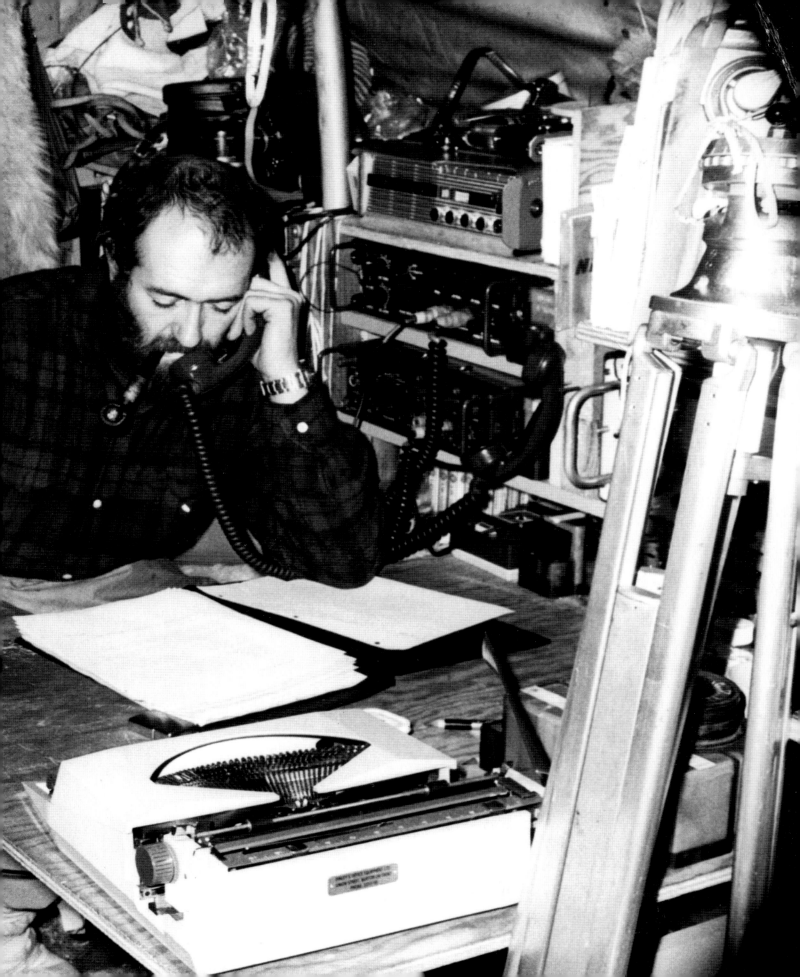

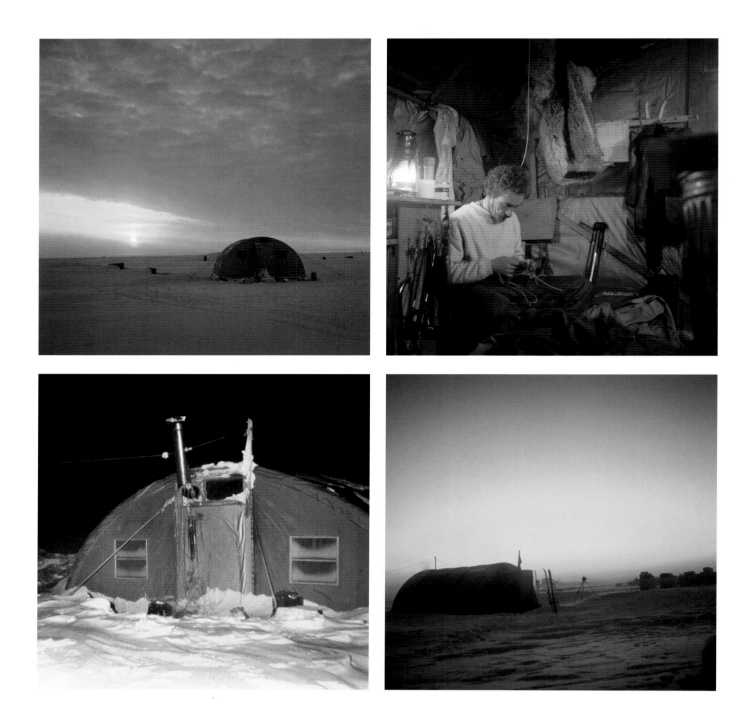

ABOVE Our winter hut was basically a frame covered with padded blankets, with two windows at each end and a door leading to a small porch. It was cramped, but we didn't want too much space that would be difficult to heat. Although injured, Allan was still playing an active part, including taking navigational fixes. In the still of those starry midwinter nights after all the stoves and lamps had been turned out, I would lie awake for hours listening to the groans and crunching of the moving ice.

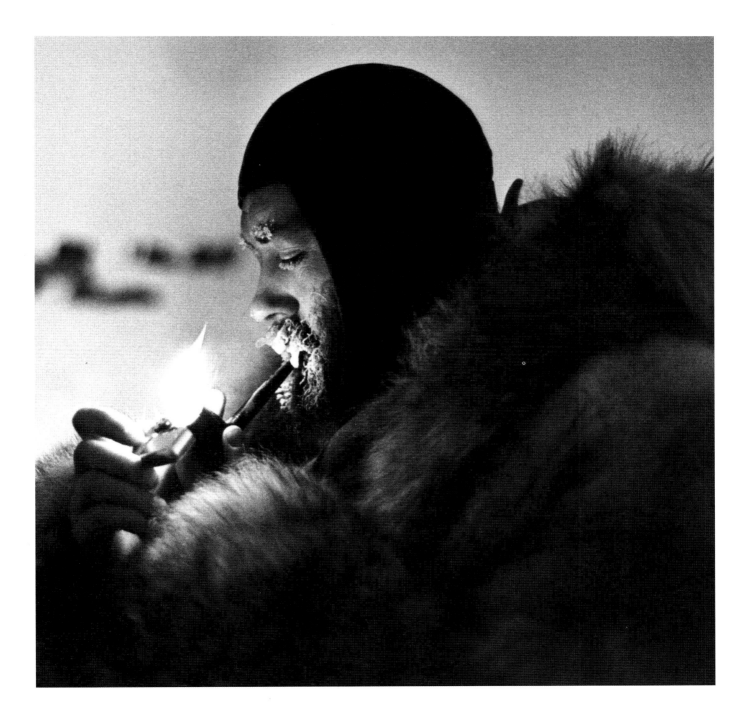

ABOVE Navigation was a difficult task in winter, peering through the theodolite trying to pick up a few stars in temperatures of minus 45°C. We did this twice a day and we also had to go out every few hours to check the ice floe for fractures. Smoking was my winter comfort. Usually I snapped off the stem of my pipe, so that the warm smoke had less time to condense and freeze. A short pipe is the sign of a polar smoker.

3 | A PIONEER JOURNEY

A week ago it was the marvels of space travel that held us all enthralled.
Now a remarkable achievement in a more traditional form of
exploration. This is the first surface crossing of the Arctic Ocean.
Their trek deserves to be honoured first as an achievement of physical
courage and endurance. But it is more than that. The real justification
of the exploration lies not in particular additions to knowledge
but in the achievement for its own sake. Even in this calculating
age it is the spirit of romance that has been fed, and it is
the sense of adventure that should be honoured.

The Times, 1969

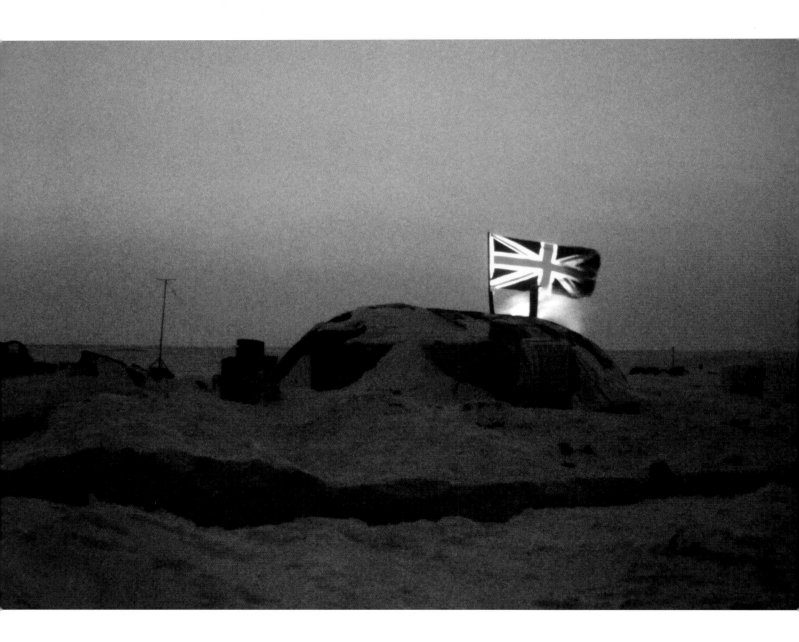

We were lucky to be alive. Early that morning, without warning, everything beneath our feet had started to move. One of the tents collapsed into the water. Pressure was building in some places and leads were opening in others. At any moment the jagged fracture might shift and set off a series of cracks and drop the hut, sledges and dogs into the bottomless, ink-black waters.

We dared not go back into the hut together that perilous morning on 24 February. Allan stood watch while we rushed in to save what each of us felt to be our most vital possessions, and hurled them outside in piles. I grabbed a big waterproof bag and stuffed it with anything that came readily to hand: the navigation almanacs off the shelf, my journals, theodolite, camera, bullets, film – all the loose things I had been intending to pack carefully that morning. Our four breakfasts were still sitting on the table uneaten. We kept our sheath knives ready in case we had to cut our way out.

Ken's and Fritz's dogs were near at hand, but the other two teams were widely scattered, and in the semi-darkness we eventually rounded them up and hitched them to the sledges. We furiously loaded up and took a last look at our old winter quarters with the vapour from the chimney still rising up into the sky. We sledged north towards the darkest part of the horizon with only Venus as a guide – a wilderness in monochrome through which the sledges weaved and rattled, groping our way once more into the unknown. We camped that first night having only covered 5 miles. But at least we were on the move again.

At the time we abandoned our winter quarters we were 322 statute miles from the Pole and soon found ourselves on very active ice. We had to make several detours to get round new cracks and leads, and on the second day entered another maze of pressure fields. There were only about four hours of twilight and we made little progress. By now Allan was in pretty good shape; apart from his back he was probably fitter than any of us. The first real crisis occurred on the third day out when we noticed that Allan's sledge had split along the whole length of the runner. We stopped to make repairs – a miserable job as the temperature was about minus 45°C. We had to rig up a shelter as a windbreak and use two lamps, since it was too dark to see our hands in front of our faces. The following day Fritz's sledge also cracked, then mine, and within a period of a week all four sledges had major splits, caused no doubt by a combination of the tremendous hammering they were receiving and the very low temperatures which made the wood brittle. We bored holes right through the runners, fixed metal plates, inserted bolts and lashed them up with rawhide. All four sledges got this treatment now and, thankfully, they lasted for the rest of the journey.

We were still navigating by Venus; the stars had all faded and neither the sun nor the moon was up, but by 9 March clouds were finally catching the sunlight. The temperature was about minus 50°C. We were travelling eight hours a day, and the fatigue and cold were crippling. The alarm would wake us at 6 a.m. and the man whose turn it was to make breakfast would ease himself out of a frozen shell of warmth and fumble in the dark for a match. After a sharp scratch and a spurt of light, a flame would grow that would always snuff itself out as it reached the lamp. At the second or third attempt it would catch and the tent filled with yellow light. The burning match lit the fuel in the priming cup of the kerosene stove. Hoar frost hung like fleecy beards from the clothing in the apex of the tent, and trembled as breath vapour floating in curls drifted up on a rising draft of warmth.

LEFT We logged our winter drift by taking observations of the stars. Because we were drifting on the sea we were an official weather station with a ship's call sign. This is a few days before we abandoned the winter hut as the floe cracked like an eggshell. In the semi-darkness we scrambled around rescuing dogs and sledges as the ice pans heaved under our feet.

PREVIOUS I fixed this little wooden plaque to my sledge for the Arctic crossing, a pilgrim's prayer carried across the roof of the world. The Tibetan inscription, 'Om mani padme hum', is the mantra of compassion: 'Hail the jewel in the lotus.'

A leg, stiffened with morning cramp, would shake loose a cascade of delicate ice crystals that would settle like spiders' webs on our faces. The man on duty would release two arms from the warmth of his sleeping bag, wipe the melting frost evenly over his face and poke his fingers into his ears. His morning ablutions done, he would pump the stove, which would splutter and fire. The pot, which the night before had been filled with water now frozen solid, was placed on the stove; heated by the flame the ice contracted with pings and cracks.

Few words were passed at that time of the day, for not until the stove had been burning for half an hour would the temperature in the tent have risen from minus 45°C to a tolerable minus 35°C. We started each day with a cup of tea, followed by porridge with as much butter as we could afford chipped off its frozen block and buried in the simmering goo. Sugar and milk were added, but, at that stage in the journey, never enough. Two more cups of tea would complete the meal and we would pack up and go. By 8 a.m., with our wolfskin parkas frozen as solid as suits of armour, we were on the move.

We were at that point on a well-balanced but inadequate diet of 5,200 calories a day. There could be no question of carrying more food or fuel; already the dogs were hauling maximum loads of 1,300 lb and we had four-and-a-half weeks to go before our resupply drop. We could keep warm only by moving, but the harder we worked the more hungry we became, and the hungrier we became the less resistance we had to the cold. There was no alternative: we had to suffer for our miles.

By 10 March we started to overtake the records of some of our greatest predecessors, and our spirits lifted immeasurably. We sledged through Nansen's then Peary's positions and were approximately at latitude 87°15'N. The 110 nautical miles we had covered since leaving winter quarters had been extremely testing to nerves and bodies. On three occasions we had to break camp in a hurry and escape as the floes cracked up, and the strain was beginning to show.

Allan, the emotional anchorman of the party, was quite miserable, for the arrangement still stood that a relief operation might yet be attempted after the return of the sun. We had learnt from Freddie that Geoff Renner had been flown out from London and was waiting in Barrow. Ideal as Geoff was as a replacement, it was upsetting Fritz almost as much as it was Allan that the evacuation plans were still afoot. Ken and Fritz had an argument over this. It was by no means the first nor the last heated discussion on this subject, and I racked my brains to find an acceptable solution.

On 12 March we saw the sun for the first time since October. It was blood-red and beautiful – a living, pulsating thing, slowly drifting on a sea stained with its glow. It was a moment of joy on the exhausting haul towards the Pole. On 16 March I was at the rear of the line. The others were out of sight, hidden in the rough pack. What made me look around I'm not sure; I heard no sound, but I sensed something following me, and sure enough there was a polar bear shuffling heavily along our tracks just 200 yards away. Between the four of us we had three rifles, but at that time only one of them was in perfect working order, and that was on Fritz's sledge at the front. The rifle on my sledge had not been adequately degreased and in temperatures below minus 30°C had a tendency to jam. During the bear season we always kept the rifles loaded, but we hadn't seen a bear since the previous summer and hadn't expected any this far north. I always carried a few rounds in the pocket of my anorak, but on that day of all days I was not wearing it – it was buried in the front of the sledge load under the tarpaulin.

I screamed at the dogs and drove them as hard as I could in the hope of catching up with the rest of the party, but the polar bear was closing on me all the time. I dared not stop, so I kept the dogs going while I worked my way along the top of the moving sledge. By the time I had fished the anorak out, the bear was less than 50 yards away. Sitting astride the sledge I fed four rounds into the rifle. But the rifle would not fire, and the bear was intent on getting an even closer look. I urged the dogs forwards while turning back towards the bear as the sledge sped on like a runaway train. For what seemed an eternity, I snatched at the trigger until, in frustration, I hit the bolt with the palm of my hand and the rifle fired into the air. To my surprise and relief, the noise stopped the bear in his tracks, and he disappeared among the pressure blocks.

Bear sightings so close to the North Pole are rare I suspect only because visits of people to these regions are rare. Polar bears are well equipped for survival in this environment. Inveterate wanderers, they are capable of going for long periods without food, moving freely across the floes, taking to the water only when they have the need. They don't as a rule dive beneath the ice; they can stalk their food, the ringed seal, on the surface – or, if the seal is basking on the edge of a floe, approach it unseen by swimming underwater before surging in to attack. At times near Spitsbergen it felt as though we were being hunted, and I'm sure we were.

For now, bears were the least of our problems. Most important were logistics and a contingency plan to cover the final stage of the journey. We'd need more supplies, smaller sledges and an inflatable boat should we fail to reach Spitsbergen's north shore before the summer melt. It would be far too risky for us to sit out another season drifting south into the Greenland Sea.

I spent my days navigating a maze of unanswered problems and mentally drafting messages and articles.

Three days later we received the first scheduled airdrop of supplies of 1969 from the Canadian Air Force. This provided us with enough food and fuel to last 25 days. There were 23 boxes of dog pemmican, five man-ration boxes and six jerry cans of kerosene, plus 20 lb of potato powder and 24 lb of chocolate. With the sun warming us and with a diet adequate to our tremendous appetites we were now able to put in much longer days. The surface was improving too; for the first time during the journey we were consistently travelling across hard snow, packed down by the wind and polished into sharp-edged waves. The sledges hardly left a track.

Long and distinct shadows were stretching out ahead of us at local noon by the time we had reached the 89th parallel. Our wolfskins were much heavier for they were matted with frozen condensation, as were our beards within half an hour of setting off each morning. By the end of each day we were always dead beat. But there was no longer the agony of doubt about Allan. He had come through the hardest and coldest part of the journey, and we were now steadily crawling up the final slopes towards the summit of the world.

❧

Our position at the end of an exhausting day's travel on 30 March was latitude 89°14'N. But by the end of the following day, not one of us had any feeling left in our hands or feet, nor energy enough for another step. Day and night were fused together and now all seemed part of a recurring dream from which I had just awakened. There was no longer shade or

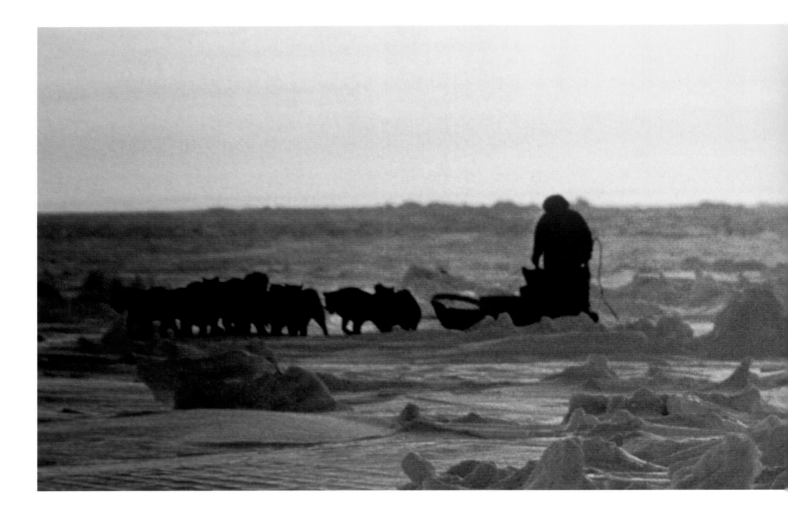

subtlety; no longer any humour, only an overwhelming desire to reach the Pole. On 2 April Ken ran into trouble when a fracture across which half his team had jumped widened and swallowed five of his dogs. I was at the back of the column, and by the time I had caught up, Fritz and Ken were fishing the dogs out of the water. Huskies with their thick coats for protection can survive for several minutes in icy water; but this particular fracture was choked with ice debris like a thick soup of sludge in which the dogs in their panic were soon locked together in a fight.

I then went ahead, leading the dogs across the fracture at a narrow point, and drove them hard for the rest of that day – a good day's travel, at a guess about 24 miles. Fritz led off the

next day and ploughed a way north across rough country into an area of dense fractures. The frustration of this, so close to the Pole, was almost unbearable. All that night and right through to 2 p.m. the next day, a fierce wind drummed the tents and flying snow reduced visibility to a few score yards. There was no question of breaking camp. This seemed as good a moment as any to change over to Greenwich Mean Time. We had been keeping time with Alaska, which was eleven hours behind GMT, for the convenience of being in phase with Freddie on the radio in Barrow. Now, only a few miles from the source of all meridians in the Northern Hemisphere, it seemed more sensible to use GMT. At 1 p.m. on our old time routine my three companions

ABOVE On 12 March, for the first time in five long months, the sun returned – seeming almost to explode out of the sea. It renewed in us what we had lost in hope and energy. I was out in the lead and could see three sledges behind me, with breath vapour streaming from the dogs. Jumbled ice was stained pink in the low rays of the sun. It was a moment of joy on the exhausting haul towards the Pole.

turned in to bridge the eleven-hour time difference with some sorely needed sleep, while I stayed awake poring over figures in an effort to determine our dead-reckoning position.

Our last fix had been five days before. Our latitude then had been 89°14'N. Factoring in drift and surface currents, and calculating the distances we'd covered, I thought we now must be near 89°59'N, barely a mile from the Pole. While my companions were sleeping the sky cleared, and on 5 April I was able to get five extra observations. I couldn't compute these new fixes at the time as Allan had all the tables in his tent and I didn't want to wake him – there would be time enough later that morning to confirm our position, and if necessary sledge

the extra mile or so to that invisible, mathematical point on the Earth's surface. At 6 a.m. I woke Ken and told him the results of my dead-reckoning calculations and we had breakfast. It was a very relaxed occasion, almost festive. I switched on the radio to make contact with Freddie. I sent a few short messages by Morse; the first was to the Queen:

I have the honour to inform Your Majesty that today, 5 April, at 0700 hrs Greenwich Mean Time, the British Trans-Arctic Expedition by dead reckoning reached the North Pole 407 days after setting out from Point Barrow, Alaska. My companions of the crossing party,

Allan Gill, Major Kenneth Hedges, RAMC, and Dr Roy [Fritz] Koerner, together with Squadron Leader Church, RAF, our radio relay officer at Point Barrow, are in good health and spirits and hopeful that by forced marches and a measure of good fortune the Expedition will reach Spitsbergen by Midsummer's Day of this year, thus concluding in the name of our Country the first surface crossing of the Arctic Ocean.

No sooner had I tapped out that message than the sun came out and we were able to get another fix on our position. Allan came across with the computation results just as I finished transmitting. There was a strained expression on his face as he poked his head through the tent door. 'Aren't you coming in?' 'No … er, well you see, we're not quite there', he said apologetically. 'How far short are we then?' I asked. 'About seven miles…'.

Seven miles! That's bloody impossible I thought, though I knew our dead reckoning had been out a few times. What a damn silly thing to announce that we had reached the Pole; it was just asking for trouble. It was now 9 a.m. and so we had to break camp and travel in a great hurry the extra miles in the hope of getting to the Pole before the date changed! We hitched up the dogs and moved off across the polished snow surface. We were leaving behind us a trail of vapour but scarcely a mark on the wind-packed snow. Was it not the same with this entire expedition, I wondered: what mark are we leaving on history? The Pole now meant little to me, I had in a sense left it behind. But, for all our sakes, we had to make sure.

Navigation in close proximity to the Pole is filled with possible errors. If your calculation of the longitude is slightly out, or if, as in the case of American explorer Robert Peary, you don't take one observation during the whole journey, then the time you calculate the sun will cross your meridian – in other words, the time at which you think the sun is due north – is wrong. Errors in the dead-reckoning of your longitude increase progressively until, confounded by the mystery of it all, you set up your theodolite once again and take a precise observation.

With Spitsbergen as our goal and still three weeks behind schedule, it was a temptation to abandon that search for an imaginary point; but we could not do so with a clear conscience, especially since we had told the Queen that we had reached it. After yet more measurements, we set off again and travelled on a precise azimuth. We chopped through every pressure ridge that came our way, cutting ourselves a dead-straight road due north. At first we were hardly making any progress at all, and after about four hours had come less than a mile.

In desperation, we off-loaded the sledges, laid a depot and took on with us only the barest essentials. It was a risk, but it paid off. With the lighter sledges we made faster progress, and after about three hours estimated that we must surely be at the Pole, possibly even beyond it. So we stopped, set up our tents, and did a final observation which put us at 89°59'N, 1 mile south of the North Pole on longitude 180°. In other words, we'd crossed the Pole about a mile back along our tracks. The time was 0345 GMT on 6 April 1969.

The North Pole, where two separate sets of meridians meet and all directions are south; it had been an elusive spot to find and fix. Trying to set foot upon it had been like trying to step on the shadow of a bird that was hovering overhead, for the surface across which we were moving was itself moving on a planet that was spinning about an axis beneath our feet. Too tired to celebrate we set up our camera and posed for some pictures – 36

shots at different exposures. We tried not to look weary, tried not to look cold, four fur-clad figures in a pose that was vaguely familiar – what other proof could we bring back that we had reached the Pole?

By the time we left, the pad marks of our Greenland huskies, the broad tracks of four heavy Inuit-style sledges, and four sets of human footprints no longer marked the spot where we had been when we took our final shots. For all the while we had been slowly drifting; and, by the time we had reloaded our sledges a few hours later and set course for the island of Spitsbergen, the Pole lay north in a different direction.

∾

We began our journey south straight down the Greenwich meridian – and you can't aim more precisely for London than that; but I felt so weak through lack of sleep that all I can remember of that day is a blurred impression of ice hummocks and ridges moving towards me and sweeping past. Over dinner I fell asleep. I fell asleep again later in my tent over the messages I was trying to draft in time for the radio call with Freddie, and did not wake until Fritz stuck his head in to say the other tent had caught fire! I crawled out and slithered across the wind-packed snow with my hands tucked under my armpits to protect them from the breeze. Allan was scratching among the charred remains of clothing that lay scattered around; the tent's four blackened ribs projected from the hole at the apex like the bones of a carcass. The snow all around was streaked black with soot.

I shrugged, shivered and went back to my warm tent and switched on the radio. I could hear Freddie quite well and from time to time he could hear me, but we were now at the limit of my transmitter's range. Within a few days he would be moving his relay station. There was a message from the Queen:

I send my warmest congratulations to you and the other members of The British Trans-Arctic Expedition on reaching the North Pole. My husband and I are delighted that you are well and wish you the best of luck for the rest of your journey.

There was also a message from the Prime Minister, Harold Wilson: 'Yours is a feat of endurance and courage which ranks with any in polar history. My colleagues and I send you heartfelt congratulations and our best wishes for a safe and triumphant completion of your journey.' That's all very well, I thought, but Allan has just burnt his tent down. We were to receive a stream of messages over the next few days, but that night I could do nothing but collapse wearily into my sleeping bag. The emotional exhaustion of the past few months had finally caught up with me.

By 8 April we had only 60 days left in which to cover an absolute minimum of 600 nautical miles. Men and dogs were broken as a result of the gruelling sledging of the last six weeks in regular temperatures of minus 40°C on a dwindling diet. We arranged for the next Canadian Air Force resupply to drop 500 lb of red meat for the dogs, and in order to compensate for this extra weight we jettisoned all unessential instruments and gear. I also had real pleasure in radioing the Committee that we would proceed to Spitsbergen with Allan in company.

Heading south, I now had the feeling that I was, in a sense, descending from the summit. But it was only by forced marches that we could reach Spitsbergen before the summer melt began; and then came the mists, the broken floes, the ordeal of

fifteen-hour marches, the anxieties and the fatigue. Since latitude 89°N on the other side of the Pole, I had been averaging only five hours sleep a night and travelling in a kind of dream. At the end of each day's long journey there was an hour's hand-generating to provide battery power for the radio transmission of messages and plans, which I would stay up late to write. It went on like this through to the end – there was no other way. Every contingency had to be anticipated by a plan. I could not write while on the move, although often enough I tried; the evening was the only time, after my tent-mate had turned in.

On and on I had to urge team-mates and dogs alike. There was no goal more attractive than solid land 600 miles to our south. It had become a race we could only win by driving ourselves and our dogs to the very limit of physical endurance – and against all the odds, our efforts were rewarded. By 10 May we were at latitude 83°N – the point at which we were to turn and head for land. On that same day we received our last airdrop from 435 Squadron – a brilliantly executed mission. We brought them in by listening for the sound of their engines and passing directions by radio. They descended to 250 ft in fog and, roaring over us, dispatched their load in two passes. We could not have seen the aircraft for more than five seconds each time. The captain of the aircraft caught only a split-second glance of his target, but the chutes all landed within 100 yards of the dropping zone.

Through the mist on 14 May I saw what I thought to be a man standing alone about 300 yards off to the east. An uncomfortable feeling ran through me. I knew it couldn't be one of my companions, for all three sledge tracks swept away to the west, and it was too dark to be a bear. Not until I got closer could I make out a log, ice-crusted on one side and sticking out of the floe almost vertically. It could only have come from one of the

Siberian rivers that drains into the Arctic Ocean. Caught up in the transpolar drift stream, it had probably been a few years or more on its passage to the Greenland Sea. I had been fascinated by this before, in 1960, that first time I'd walked the shores of Spitsbergen and seen the driftwood that gathers there. Fridtjof Nansen had been so inspired by logs drifting long distances that he constructed the *Fram*, a ship that would survive the ice pressure that squeezed its hull and be carried across the Polar basin. Though he had failed to reach the North Pole, I admired him greatly. On that log I scratched Nansen's name.

By 16 May we were 110 miles from landfall in an area where there were many pressure ridges and cracks. A little auk flew over us that day, and the following morning when we awoke we saw a snow bunting pecking around in the snow among the sleeping dogs. Small things like this lifted our hearts immeasurably, even though we knew the final stage of our journey would be a desperate scramble across broken ice.

The sky was now our surest guide. Dark streaks and patches on the undersides of clouds indicate open water directly beneath; it was like having a mirror suspended above us. By staying on longitude 30°E as far south as latitude 83°N, I had judged that we would be making our final approach parallel to the major fractures. This the sky confirmed – we were sledging beneath a striped canopy which indicated the presence of major leads on either side of us. We had for several days now been travelling through the night and sleeping outside on the sledges during the heat of the day when the temperatures rose to about minus 5°C. By 20 May the ice was slushy, and for the first time since the summer of 1968 we could actually smell the sea.

Wildlife suddenly became abundant: little auks, fulmars, ivory gulls, king eiders and terns. Perhaps this all had something

to do with the upwelling of water near the edge of the continental shelf; perhaps we were on the southern dispersal edge of the ice pack – we did not really know, but the excitement we were now beginning to feel was intensified. We sighted seals and a school of six narwhal, and, on 22 May, fresh polar bear tracks. Soon we would see the bears themselves, dozens of them. They had probably been following us unseen for miles.

The next day was perfect, with an empty blue sky save for a few wispy cirrus and a roll of cloud low on the horizon directly on our heading. 'They've got to be land clouds', I called to Allan, who had stopped at a new fracture in the floe. 'Sure they're land clouds.' There was a long pause while I waited for another comment. He lit a cigarette, took a couple of draws and moved up to the front of his sledge. 'Shall we go on then?' he asked with a broad smile. I'll always remember that simple moment: one of the happiest in my life. We were almost there!

Later that bright night I climbed a great hummock. Into the summit I stuck a harpoon against which I steadied my rifle, peering through the sight I took aim on the cloud base directly ahead. A mountain climbed out of the horizon into the cloud rolls – a grey-and-white wall of land, hazy with distance. Words can't come close to describing how I felt at that sight. Relief, joy, happiness, exhaustion all merged into one; I was too cold to cry and too tired to shout. Eventually, I lowered my gaze very slightly to the pack ice. I could see all three sledges in line ahead but widely separated. They were dead on course. I sent out a short message that night which, I suppose, gives little sense of my jubilation:

Herbert to Church. Land sighted directly ahead 2055 GMT 23 May 459 days out from Barrow. Present position 81°13'N, 22°00'E – 29 nautical miles NNE of Phipps Island.

A truly memorable day. It was also the first time we were seriously bothered by polar bears. From this moment onwards we encountered them all the way to landfall. They were a menace. As we waded through slush, suddenly a bear would appear from the sea. Often they'd sniff around for an hour or more, amble off to bide their time, before returning after we had camped on a small floe. We would picket the dog teams to guard us on the perimeter, but your sleep is always shallow.

We killed three during those three days; three more than we'd have liked, but increasingly it was becoming a case of them or us. At times they would come downwind, but usually they stalked us from behind. There is no way of knowing how close they'll charge before they turn round and walk away – if they do walk away. Fritz was trying to cross a stretch of very weak ice when one bear emerged. The dogs took off and dragged the sledge into the water. The other dog teams were going berserk and it was absolute chaos. But the bear just kept walking towards us, casually, purposefully, without fear. You realize then that you're being hunted. We couldn't take any chances and dropped this bear with two clean shots, just 15 ft away. That's as close as I ever want to be to a hungry polar bear.

⁊

HMS *Endurance* called me on the radio early on 24 May, giving their position as 'Norwegian Sea – estimating northwest tip Spitsbergen twenty-seventh'. Our position at that time was a patch of ice only 16 inches thick, constantly moving and with many cracks in it; it's no wonder we felt little cause for celebration. I decided to go for the nearest group of islands. I guessed we would be able to scramble ashore at some point along the

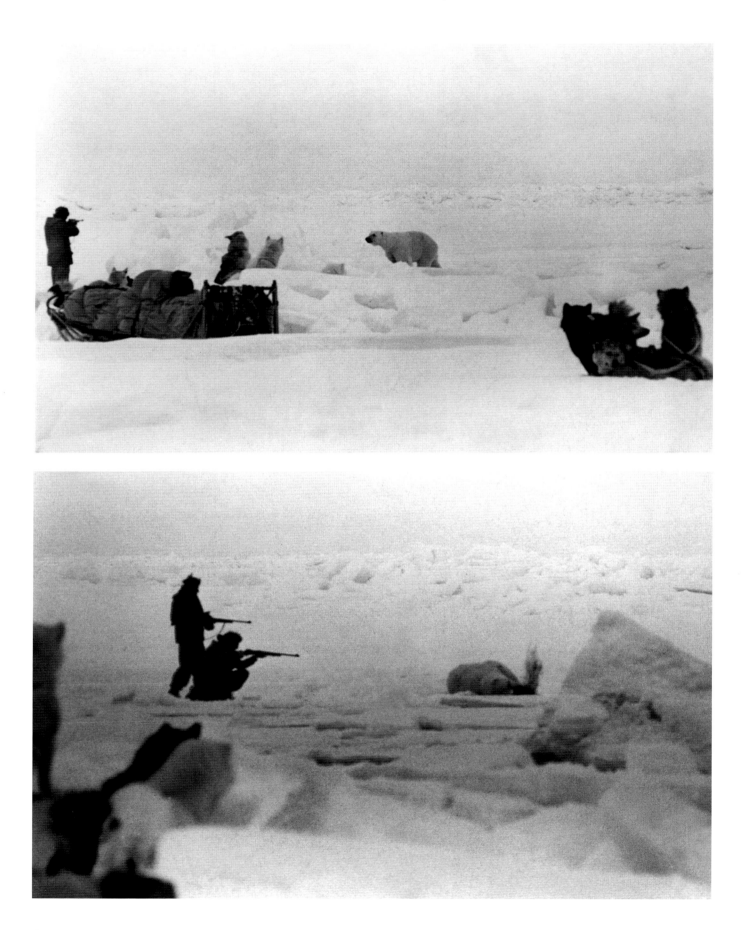

coast as the ice drifted past it and make landfall. It would be risky, but it would be worth it, for once that landing was made our crossing of the Arctic Ocean would be historic fact.

My original intention of triumphantly sledging all the way into Longyearbyen overland had long since been abandoned. Clearly the ice conditions were not good enough. We were now weaving a tortuous track around small cracks, fractures and ridges, but none of them slowed the steady rhythm of the dogs. The cloud cover had thickened and hung heavy above us in a frontal system that ended in a line just short of the Sjuöyane Group. Beyond, the sky was clear and of the deepest blue; warm sunlight soaked the islands – there was never a sight more beautiful to men who had been so long at sea.

At about midnight we came upon a huge barrier ridge which stretched east–west across our line of advance, but we went to work immediately to hack a way through. There could be no other course – we were only 8 miles from land. We got the dogs over the first ridge and found a trail of blood where a polar bear had killed a seal and dragged it up the next ridge and over. With such a spoor the dogs needed little encouragement, and once over we found ourselves on a vast floe that seemed to reach right to the very base of the land ahead. For 3 miles there was barely a ripple in the surface, and the longer we sledged the more convinced I became that we were at that very moment breathing the air of success. Allan was in the lead, Ken behind him; two tiny specks in the distance. Fritz and I were sledging alongside each other, chatting. It was joyous.

But within minutes, our floe transformed into a floating mass of ice rubble simmering like some vast cauldron of stew. The sledges jammed in the pressure, or lurched as the ice relaxed or heaved. At one point my sledge turned completely turtle over

a 6-ft drop and landed upside down in a pool of meltwater. In a box strapped to the top of the sledge were our cameras, plus all the unexposed film and some of the exposed stock. Our two Nikons, a Rolleiflex, and two 16mm Bell & Howell ciné cameras and the total visual record of our efforts were now underwater. I had carried this box on the top of the sledge so that, should we break through the ice I could cut it free and swim with it to the ice edge. Fortunately, we'd sealed it with rubber, and all the contents were in polythene bags; nevertheless, I was lucky to get the sledge out without loss.

We concentrated all our efforts in getting on to the biggest floe we could find and set up camp, though it became alarmingly obvious that we were drifting at something over half a knot past the island. We ate a meal and turned in – sleeping as usual on the sledges to be able to move quickly in an emergency. But I was unable to sleep. Each time I looked at the towering black cliffs, it was a part of the rocky coastline I had not seen before. In the eight hours between dinner and breakfast we drifted almost 4 miles and closed on the island, but between our small floe and the coast there was a broad strip of open water. There was no way off the floe in any direction.

We drifted to within a quarter of a mile of the northern tip of Phipps Island, then the direction of drift changed and we started shifting slightly northwest. Finding we were still marooned on the floe, we set up camp again. We broke camp a second time at 0300 hours on 29 May, for by then it had become clear that we were about to drift between Phipps and a much smaller island. That island is a rugged granite rock about 1,000 ft high, a spectacular cliff from some angles. I told Captain Buchanan on the *Endurance* that there was no chance of getting across Spitsbergen as our route south was barred by a great stretch of open water.

LEFT By May, ice conditions were extremely hazardous and the polar bears menacing. We had three guns; on this occasion I had the camera. This polar bear charged and was shot just 15 ft away. To kill a bear you have to shoot it before it is close enough to knock you down. We always tried to scare them off first, but sometimes they just kept on coming. You can't run away or you'll soon become the bear's lunch.

We would therefore head straight to rendezvous with the ship, though it too was locked in the ice and still more than a week of hard sledging away.

Later, however, we found that an eddy had held the ice in tightly to that small rocky island and we had one more chance of getting across to it. The island was still less than a mile from the camp. The mush ice had widened though, and was moving all the time, vacillating, shifting, churning. At that moment the ice was fairly quiet, but the whole thing was delicately poised: held together by the floe pushing the ice rubble against the land, there was just sufficient pressure to hold it tight – just tight enough to bear the weight of a man. It needed only to slacken off a couple of inches and it would be impossible to cross.

Fritz elected to stay on the edge of the floe. I went to help Allan and Ken, who had spent some time trying to chop steps down a steep ice drop on to another pan of ice. I then told them both to go ahead as I patrolled the ice. Fritz came across to me when we saw them finally climb on to solid land, scrambling up the rocks on the other side of the Arctic Ocean from where our journey had begun. They were there for just a few moments before jumping back in the water and up on to the ice.

I set off across the mush to meet them and immediately there was more movement in the treacherous ice: a deep lurching groan. The risk of us all making a second trip to the island to take some pictures was too great. Just as Allan and Ken rejoined me Fritz started yelling that the ice was seriously on the move. We had to race on my sledge to get back to his floe. No sooner did we reach it than the sea broke through. It was some moments before the full significance of what Allan and Ken had done sank in. 'We brought you a small bit of the island', they said with broad smiles as they pressed a chunk of granite into my hand. That modest piece of rough, wet rock was worth more than anything on this Earth at that moment. We were almost finished.

I crawled into the tent and drafted out a message for Freddie to pass to London. It rang with all the triumph we felt:

At 1900 hrs GMT 29 May a landing was made on a small rocky island at latitude 80°49'N, longitude 20°23'E, after a scramble across three-quarters of a mile of mush ice and gyrating ice pans. This landing, though brief, concluded the first surface crossing of the Arctic Ocean – a journey of 3,620 route miles from Point Barrow, Alaska, via the North Pole. The four members of the crossing party on their 464th day of drifting ice are now heading across broken ice pack toward a rendezvous with HMS *Endurance*.

Although in many ways that final scramble marked a simple end to our journey, we were still nowhere near safety. The ice was literally melting away beneath our feet and polar bears followed our every step. Despite all this, 29 May 1969 was a supremely happy day – that it was the anniversary of the day Hillary and Tenzing had reached the summit of Mount Everest back in 1953 was only something we had chance to reflect on years later. We were elated, exhausted, and our lives on the ice still hung in the balance. Fritz and I had stayed in command of the dogs and sledges, watching over our escape route across the ice, guarding with guns at the ready in case polar bears arrived on the scene. But that small lump of rock meant so much to me. It had completed the trilogy of the last three great geographical firsts on our planet: namely, the first ascent of the highest mountain, and the first journeys across the ice at the ends of the Earth.

The bear situation was now just desperate. With only 30 rounds between us, we could no longer afford to fire warning shots over their heads. Without weapons, the hazards of sledging, already huge, were almost unthinkable. We were trying every method we could come up with to drive them off: throwing ice axes, banging shovels, even approaching the advancing bear. Once was enough to teach us that advancing on a bear only closed the gap faster; on one occasion Fritz hurled one of my snow boots at a bear who promptly tore it to shreds. At least in Antarctica you don't have to worry about being eaten alive. I can cope with any amount of cold, but you're never a match for a polar bear.

We were committed to a further ten days' travel, and more than 100 route miles, before we were able to reach HMS *Endurance*. Some time later, after Fritz, Allan and Ken were carried in helicopters to the ship, I was left alone on the ice with my team of dogs. I sat on the sledge and had a smoke. For the first time in sixteen months I was on my own. I was overcome by a sense of presence and contentment – neither sad the journey was over nor excited about what lay ahead.

The helicopters came back and the stillness and purity of the Arctic was shattered. People were shouting at me, laughing, yelling. I had to rush. I had to lift dogs, push them into the helicopters. Lift sledges. Crawl in after the dogs and pacify them during the flight – poor creatures, wondering what the hell was going on. Occasionally I would glance out; the ice below was a broken mess. Patches of deep blue ocean would flash silver in the sunlight. The helicopter banked and I could see the ship framed in the window. The hangar on the flight deck was crowded with sailors.

We hovered over the deck for a second or two, then settled. The doors were flung open and the noise flooded in. I pushed the dogs out of the helicopter door. Their legs were kicking before they hit the deck and they took off as soon as their claws scratched the steel; sailors grabbed them. I jumped down on to the deck. Bloody hell, it was hard – the thud resonated all through the ship. Yes, we were still afloat, but for the first time since Alaska it felt like being on solid ground. There was a great sea of faces – a huge crowd of strangers. I could hear congratulations and feel my hand being shaken. I was confused, dazed, swallowed up in a crowd; everyone was speaking now, but I no longer heard what they were saying.

From land to land our journey had taken us 464 days, and yet, oddly enough, its climax was not the sight of land, nor even the landing on the island, or reaching safety. The best moment of all was the sight from the ship northwards, across the vast expanse of ice over which we had come. I had for months sensed this distance at my back, sensed the tiredness of all those miles in my limbs, the longing for the other side and the release of my burden – a total commitment to success, without which six years of my life would have been wasted. What a journey it had been. But never, never again!

'The ice and the long moonlit polar nights', Nansen had written not long before his death, 'seemed like a far-off dream from another world.' And so, I suspected, it would seem with me. Almost ten years had passed since my fateful meeting with the hunter in the deserted mine of Moskushamn, and now, at long last, the journey so many thought impossible was accomplished.

❧

We returned to our normal lives changed men, enriched by an experience that would define much of our future. Life would

never be the same again, but then our lives were not that normal in the first place! However hard it had been at the time, the siren song of the Arctic ice kept calling.

For Allan it was a very personal adventure. He had been attracted by the idea not so much because it was a first surface crossing of the Arctic Ocean, but because it was an opportunity to spend sixteen months with dog teams in an environment he loved. For Fritz, on the other hand, it was a sort of monument – a monument of achievement in life of which he was proud. He would not have come if it had not been a first, nor if he couldn't conduct a credible scientific programme. Ken had joined the expedition with an open mind, not knowing really quite what to expect. The whole experience for him had been a struggle, not only with the elements, but also in the company of three men with whom he had little in common. But, many years later, I know he looked back with huge pleasure in the part he had played.

As with many old sledging companions, Allan and Fritz became my lifelong friends. We had come through hard times, and through long periods of uncertainty during the expedition, but that is exactly what made it a great adventure. Without their loyalty and their complete trust in my overall plan, without their optimism and their endurance, we could never have got through.

Some years later Allan and I mounted another expedition, this time to make the first circumnavigation of Greenland. We were not able to pull this one off and although I hadn't realized it at the time, the moment when we gave up was the end of my active polar career. I returned to the Arctic several times – even taking my family there, living with my Inuit hunter friends – but I never went back to make a pioneering journey. I did go again to the North Pole with Allan, to produce a film, and I even made another crossing of the Arctic Ocean; but this time the

easy way, as a lecturer on a Russian icebreaker with a hundred paying passengers onboard who would variously declare each night over cocktails that 'they had always wanted to take part in a truly great adventure'. I'd slip away most evenings to a quiet spot on the outer deck and, with a cool breeze on my face, find comfort in my own thoughts.

I also went back to the Antarctic for ten southern summers on various cruise ships as a guest lecturer. This was an absolute luxury compared to the expedition life I had known. I got to see many places I'd been unable to visit as a surveyor, and it refreshed my memory of those scenes that were such an important part of my early exploring life. It also eventually led to the discovery that I had a talent for painting – and this opened up a whole new world to me.

A pioneer has an unspoken responsibility to bring back something of value from his or her travels – a map, a unique discovery, or specialist knowledge that can contribute to the understanding of our planet. Every explorer has to start somewhere. And every exploration has its end. Some of you reading this might have been lucky enough to experience the thrill and the joy of going into the wilderness, others I hope will be encouraged to plan a first adventure of your own. The question I've been asked most over the years is this: 'how do I become an explorer too?' I've never really had a good answer to that, but if I were to try and distil everything I've learnt from my strange life of adventure into a guiding piece of wisdom or advice, or a philosophy of travel even, I would struggle to find any words better than those scribbled at the head of a ream of dusty papers found in one of my old expedition cases. It's the draft of a talk that I hoped to give if I made it home safely after my first winter in Antarctica.

I guess this is where it all began for me. I felt sure then that I'd found a message – 'youth is glorious, don't waste it, get out and achieve' – but I was increasingly unsatisfied with just speaking about what I had then done. I longed to go out and do more myself. It burned within me. It's all very well to stand at a lectern in a suit and tie and deliver a message of 'take to the hills', but the response would always be 'how?' And I had no answer, save only the feeling within me that said 'GO!' I'd whisper this word to myself at night, and alone in the morning. I'd shout it to my dogs as we plugged up a slope of virgin snow; I'd scream it to the wind as it tore at our tents.

The first time I said it at a lecture it resounded like a cannon explosion round the rafters of the hall. I said it again, and again. Speaking in schools and youth clubs, in tearooms and concert halls, I let this precious word escape in them all. I said it once giving a talk at a prison and it almost caused a riot. To me, the birth of adventure, the meaning of exploration, is no more complex than this. It's about lighting the fuse of your imagination and having the courage to start something new. The word became my favourite. What a splendid word to end a lecture with, or, better still, a word with which to begin. Try it for yourself. Don't think too hard. Just GO.

ABOVE Safe at last! This shot was taken just as we gathered on board *Endurance*. I remember the final moments, standing with a pipe on deck, leaving the Arctic Ocean after such an effort of survival. It now seems a lifetime away. For me the climax was the sight not of land but of the expanse of ice across which we had come.

PORTFOLIO

A PIONEER JOURNEY

ABOVE AND RIGHT Allan and Fritz scan the horizon as we break camp. The alarm would wake us at 6 a.m. and that first hour of the day was always the worst. The cold was intense and the best thing was just to get up and go. We would load the sledges, untangle the dogs and hitch them up, and with our wolfskin parkas frozen as solid as suits of armour, we were on the move. Of the four of us, Allan seemed to have the greatest resistance to the cold. It was nearly always he who was called on to help others pull mitts off at the end of the day, when hands had seized up and lost all feeling. Allan, like the Inuit, could work bare-handed for long stretches; he thrived in this world.

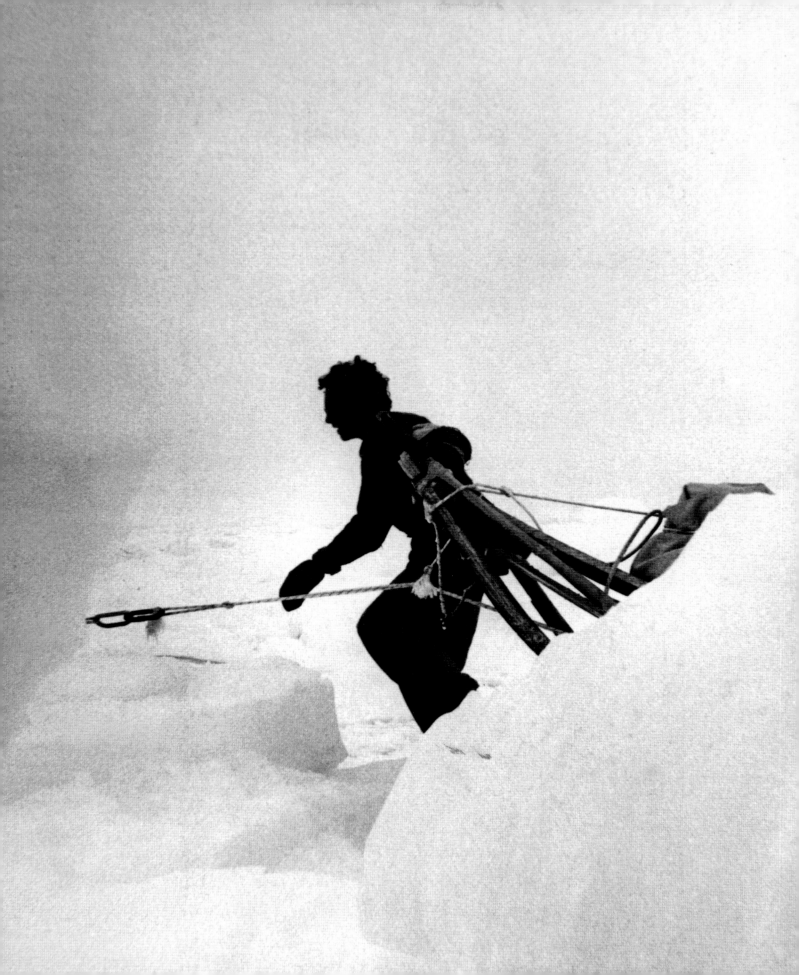

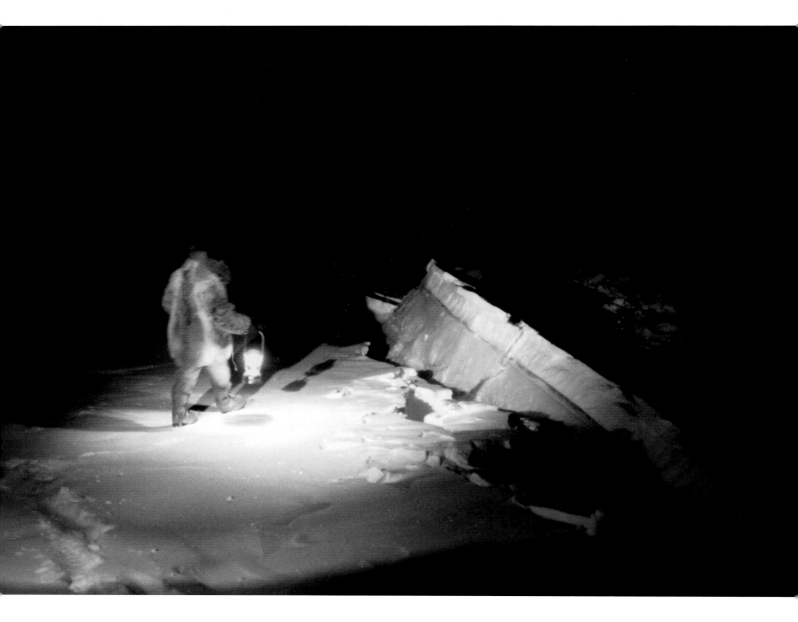

ABOVE Throughout the long winter darkness the floes still drift
a few miles each day and can fracture as pressure builds. It is
totally unpredictable. Even the biggest floe could be smashed into
matchsticks in an instant. On clear nights I could see the ridges
around us like monstrous breakers chewing up the floe on which
we drifted helplessly.

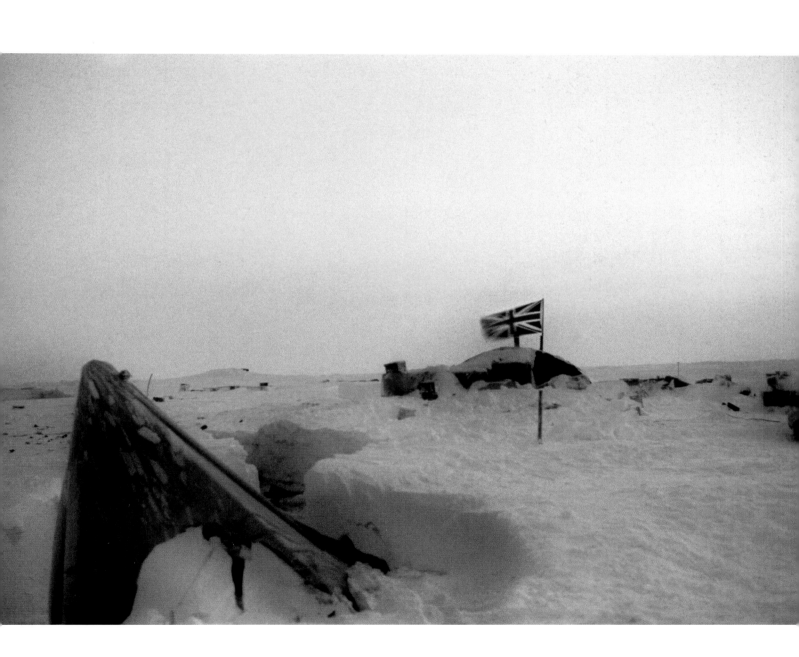

ABOVE A month after the sun had set in 1968 the floe on which we had established our winter quarters shattered, and we had to dismantle the hut and move it in darkness to another floe. This too broke up as we left on our journey north for the Pole on 24 February 1969. We were eating breakfast and the fracture missed us by only 12 ft, swallowing our stores tent.

FOLLOWING Navigating by the moon and Venus we headed north, hundreds of miles behind schedule and with the temperature hovering at minus 45℃. Closing in on the Pole, the focus of our efforts was on one spot. Just at the time we needed a good strong sun, it disappeared behind the clouds and the ice began to crack. And then the blizzards returned. It was maddening.

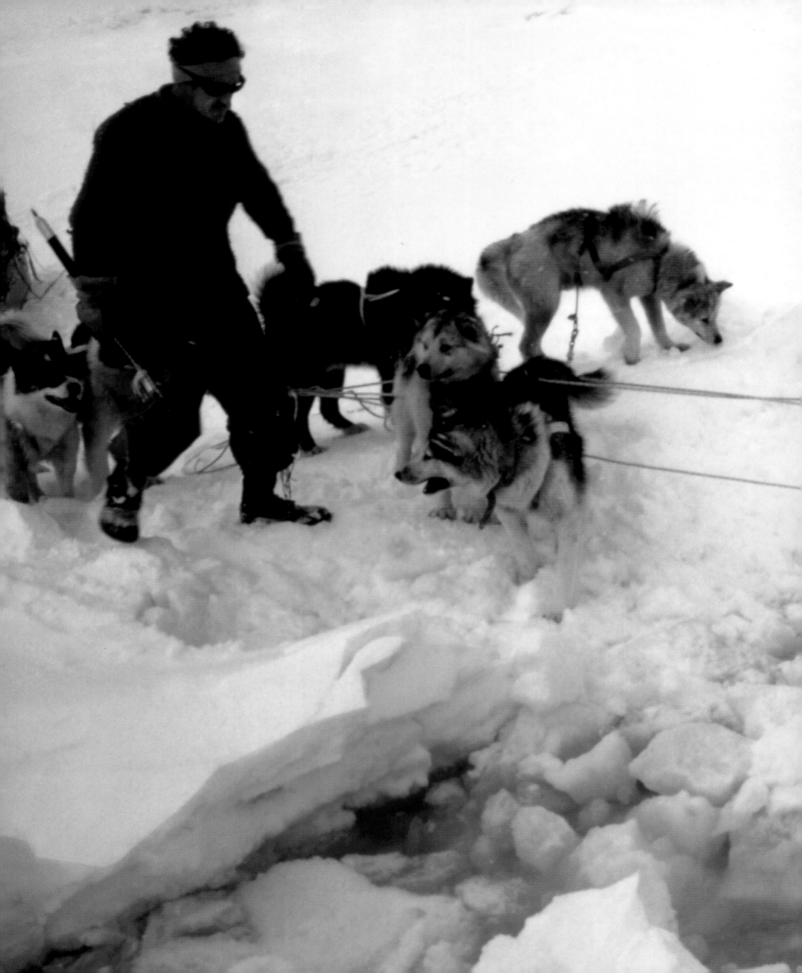

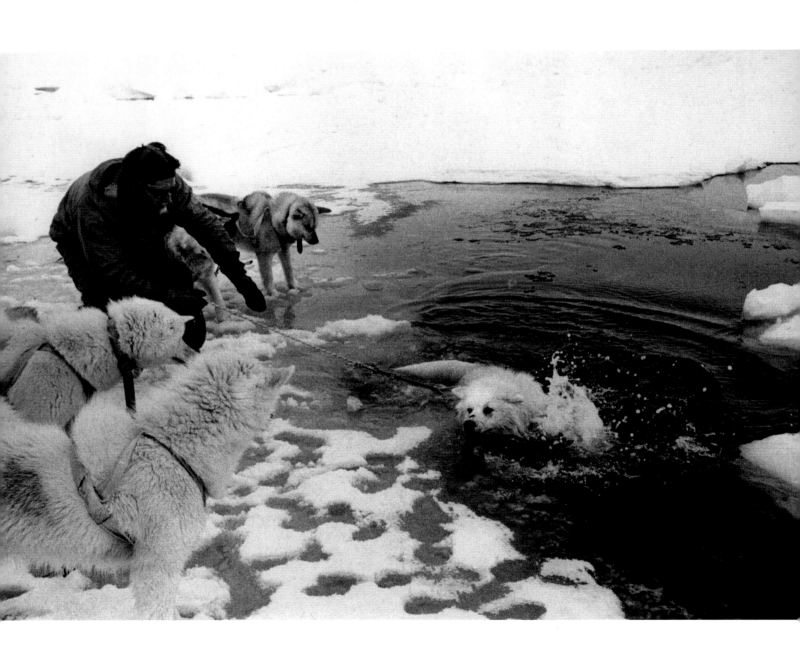

ABOVE Ken pulls his lead dog Bubbles from the water after it had fallen through the ice. Huskies are strong swimmers, but a loaded sledge sinking could easily drag a whole team under.

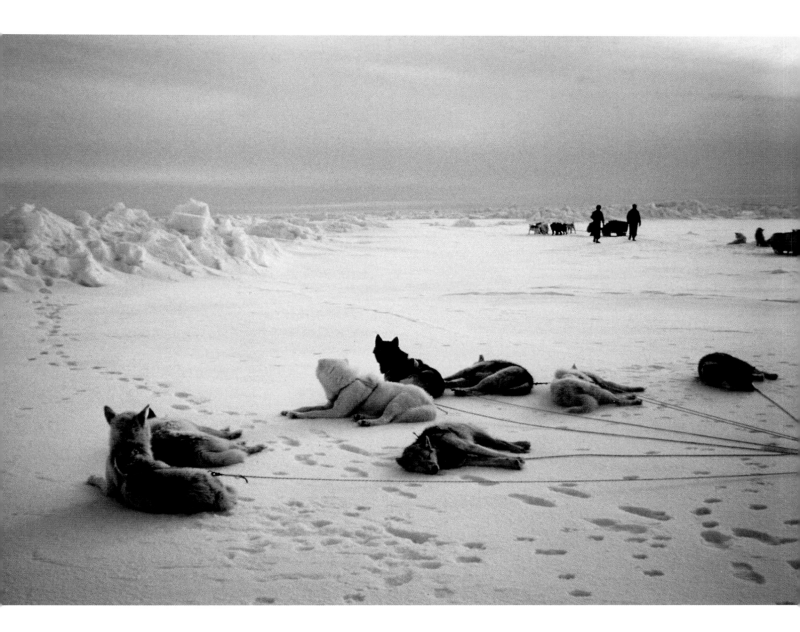

ABOVE From March into April the mists rolled in. The sun shone without warmth. Day and night fused together. We were approaching a point on the Earth's surface where all the lines of longitude converge, but it's a confusing and empty place. The ice is always on the move. Reaching the Pole is like trying to step on the shadow of a bird hovering overhead.

FOLLOWING The North Pole, 6 April 1969: we are the first British men there, and the first to reach it over the ice from Alaska. Others had got there, by plane or submarine, but no one had gone the whole way across the Arctic Ocean. There was no shouting for joy or celebration. We are cold and the job is only half done. Now comes the last leg of the journey – the mad dash for Spitsbergen.

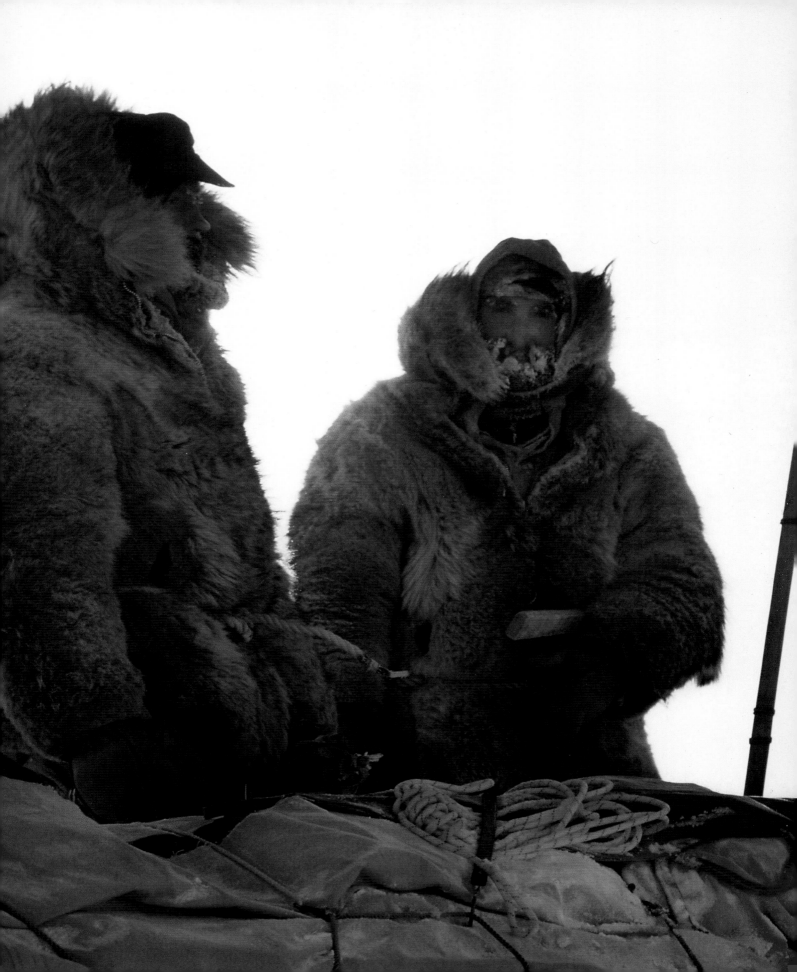

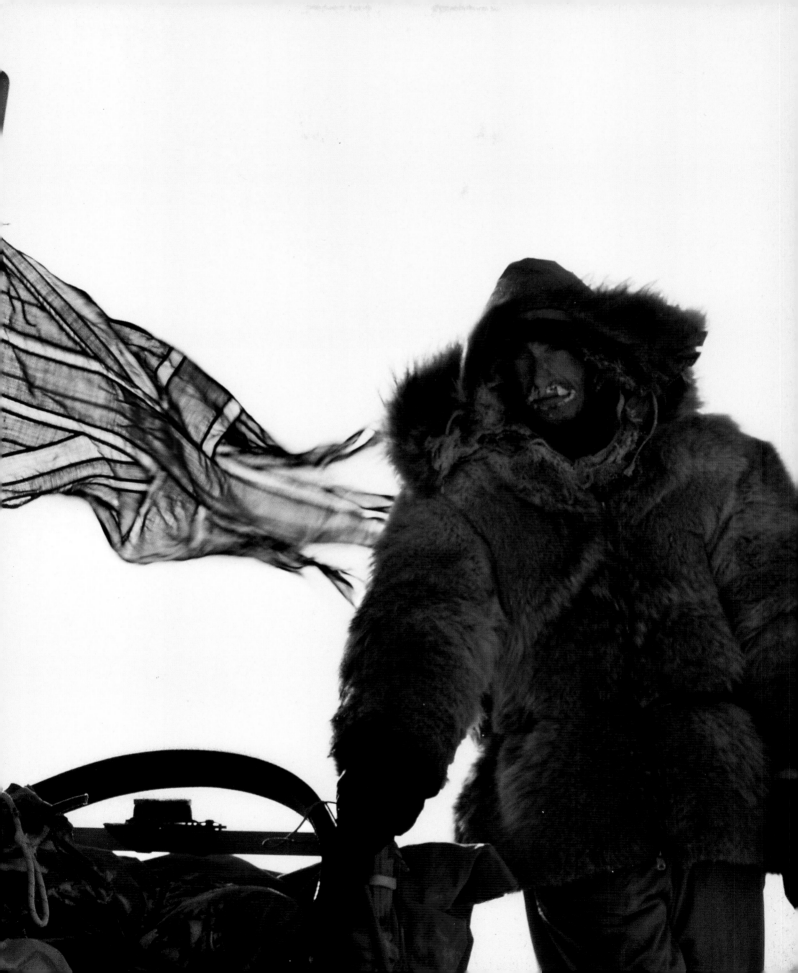

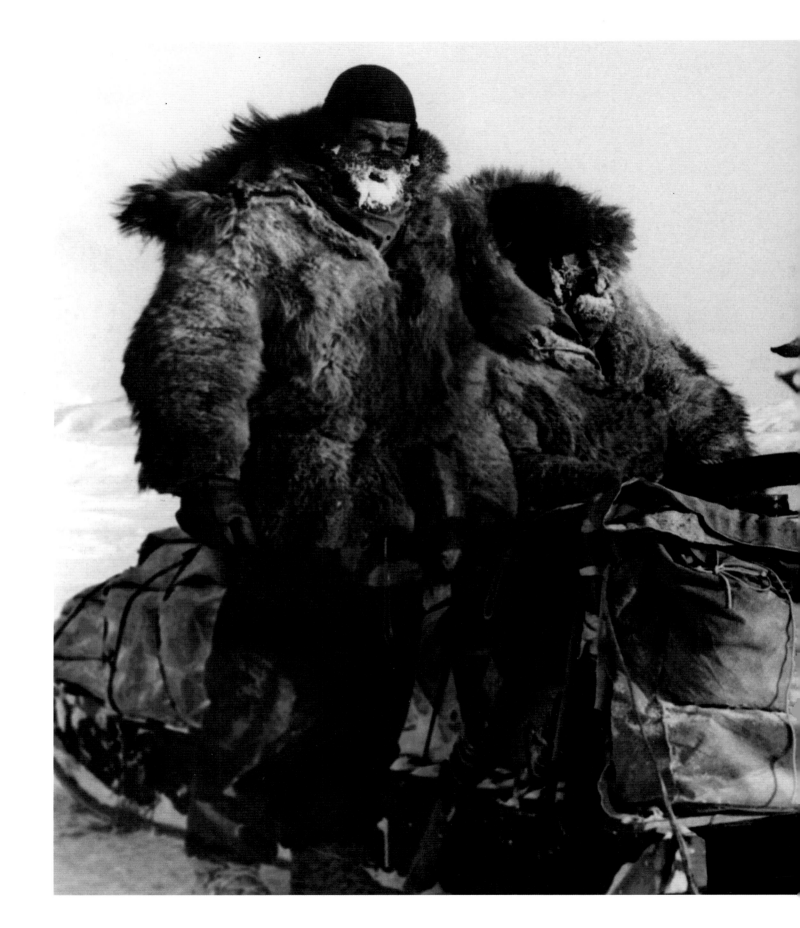

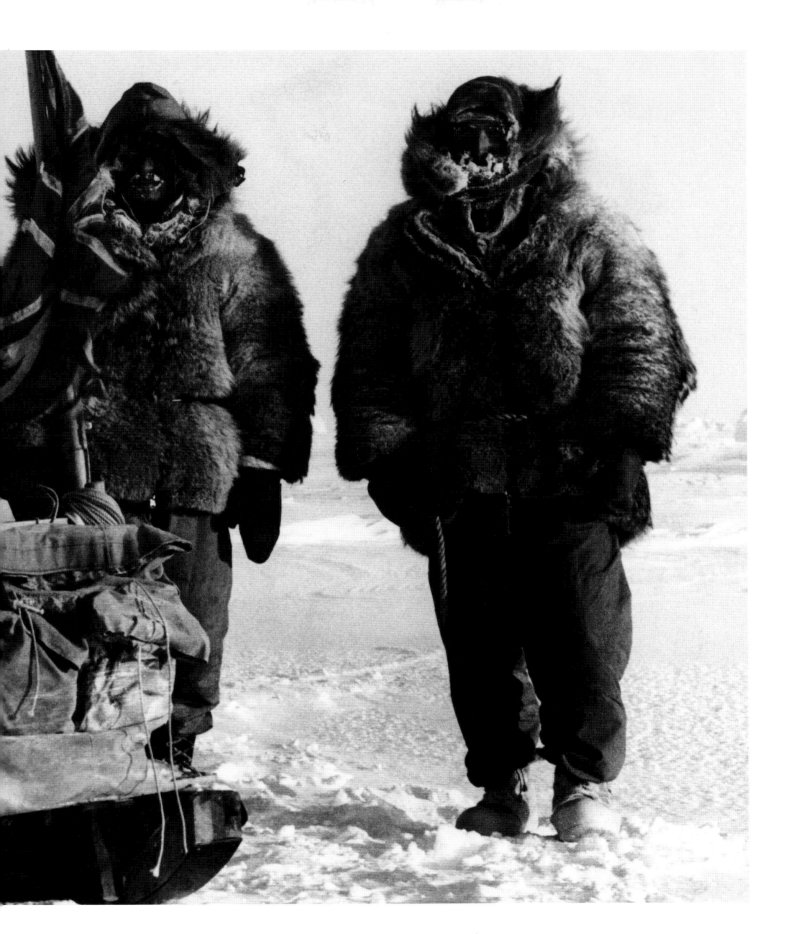

PREVIOUS Even as we stood at the North Pole it was drifting away. Using the timing device on my Nikon F2, I took 36 pictures using each exposure setting in the hope that at least one would come out. We are just four tired men arranged in a line – myself, Fritz, Allan, Ken – trying not to look too exhausted. Only by forced marches and travelling for over 15 hours each day would we make Spitsbergen before the summer melt.

LEFT The next month was one of constant anxiety, broken floes, effort and fatigue. Here Allan and Ken are climbing a ridge for a view ahead, scouting for bears. As we waded through slush and meltwater up to our knees, and hacked our way through some of the most chaotic ice we had ever seen, the bears harassed us. Seldom was such a goal more attractive than solid land, still some 700 miles away.

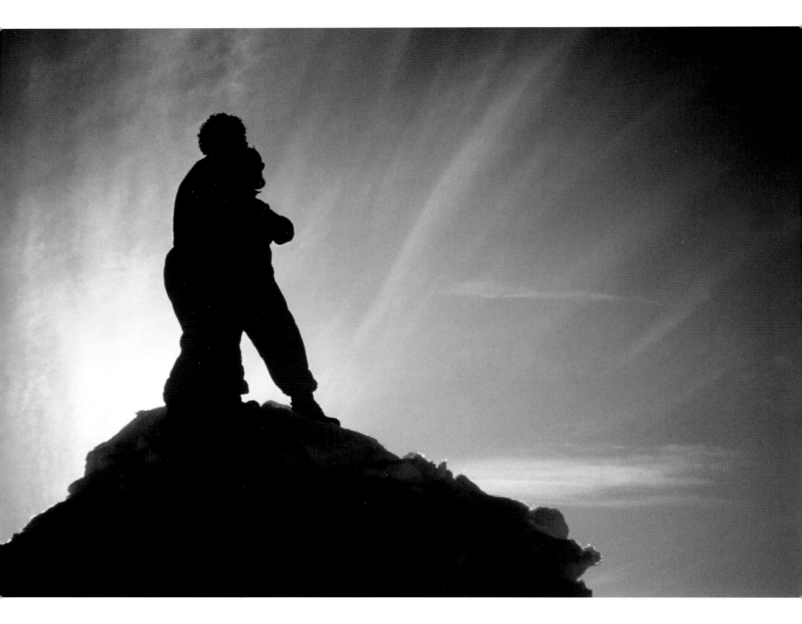

ABOVE One evening I climbed a large hummock of ice and
stuck my harpoon in the summit. Steadying my rifle against
it I took aim at the cloud base directly ahead: through the
telescopic sight I suddenly saw land climbing out of the
horizon. It was a hostile looking grey and white coast, but it
was a joyous moment.

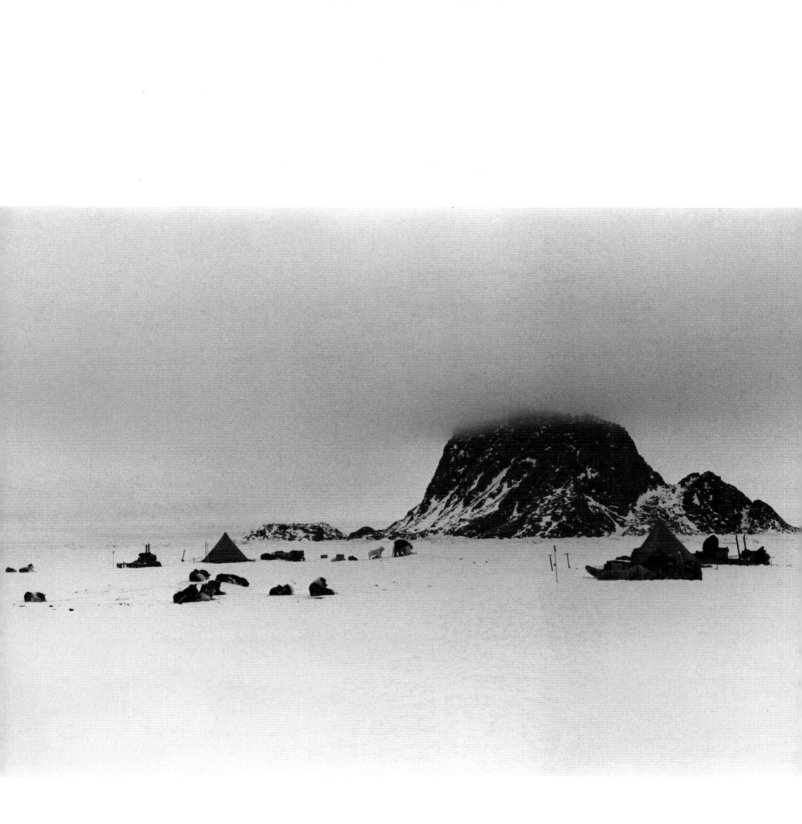

ABOVE Our camp at Vesle Tavleøya – 'Little Blackboard Island' – on 29 May 1969. First landfall was made here by scrambling ashore: Allan and Ken hopped across the final few floes. But we were in a very dangerous place and the sea rushed in as they hurried back. I was delighted when the mountain was named Herbertfjellet by the Norwegian Polar Institute in 1979. At the time we were thinking of the 100 miles of broken ice that still lay between us and the ship.

FOLLOWING As I reach HMS *Endurance* at last, Captain Peter Buchanan greeted me with a handshake on the ice. His first words were to apologize for not bringing any champagne with him. He did also have a message of congratulation from my father. That meant the world to me.

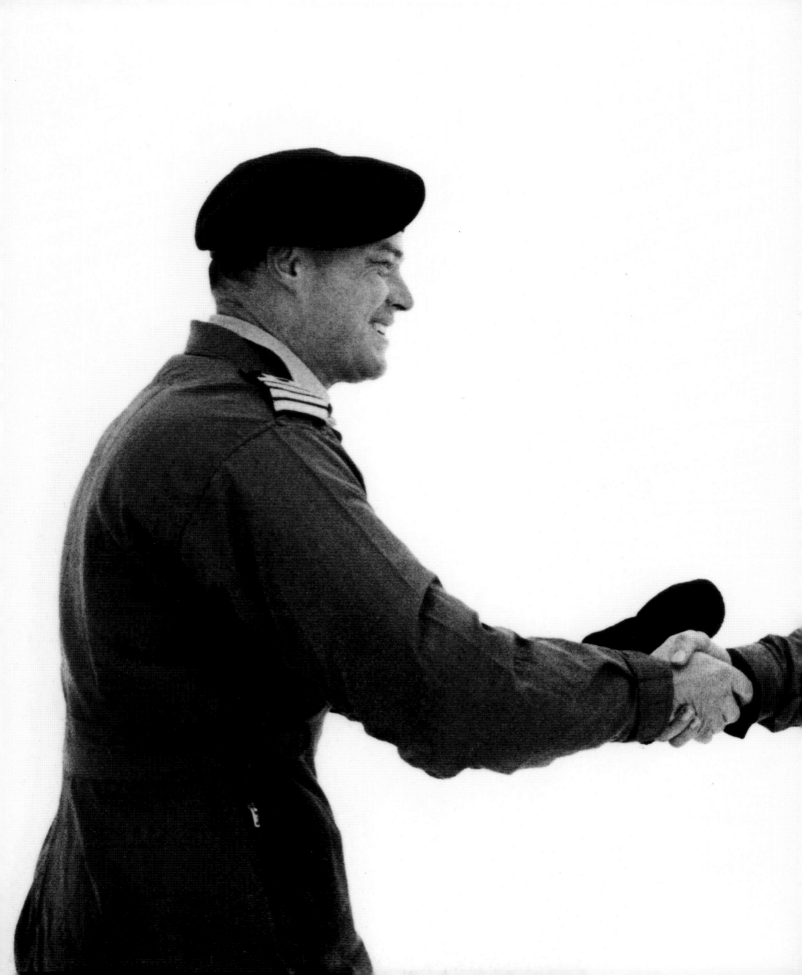

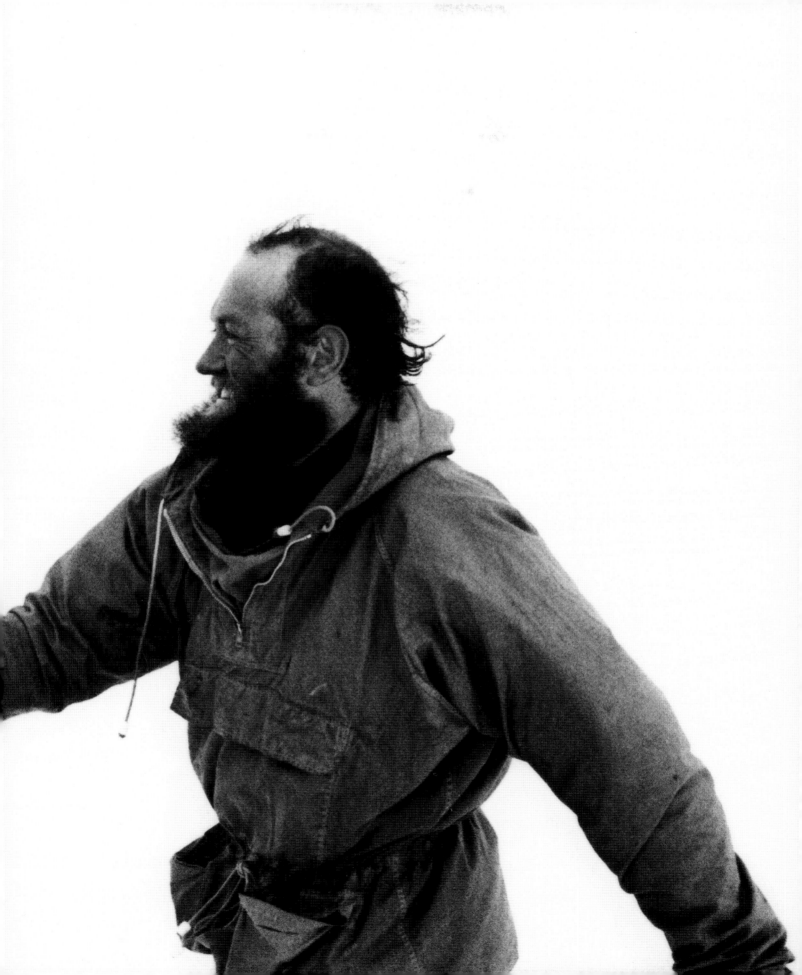

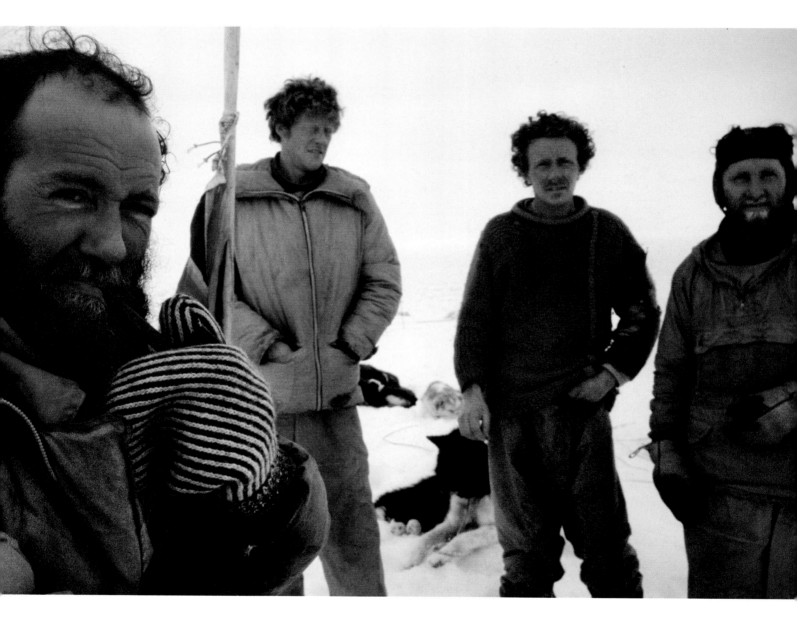

ABOVE AND RIGHT By the time we made our rendezvous with *Endurance* we had covered 3,720 route miles and had been on the ice a total of 476 days. It was the longest sustained sledge journey in the history of polar exploration. After my companions were ferried to the ship by helicopter I was alone with my dog team on the ice. I sat in peace until the helicopter returned and I was swallowed up by noise.

And that's how it ended. In a week's time we were back in England, in ironed shirts and polished shoes, speaking to the world's press. As for the huskies, two teams stayed on Spitsbergen and the others went to a ski resort in Norway where they formed an ambulance sled unit. I brought two dogs home – Apple and Nell – and after winning awards at Crufts they were given to the Husky Club of Great Britain.

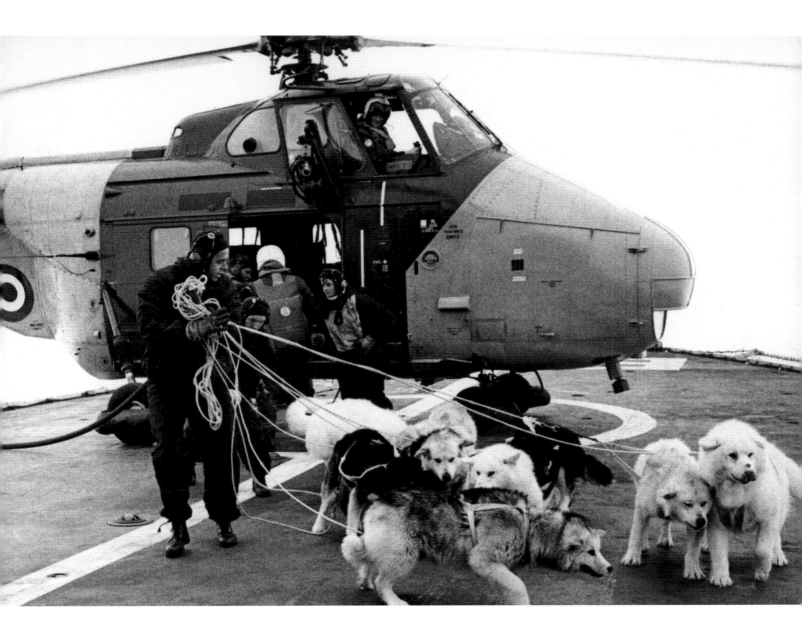

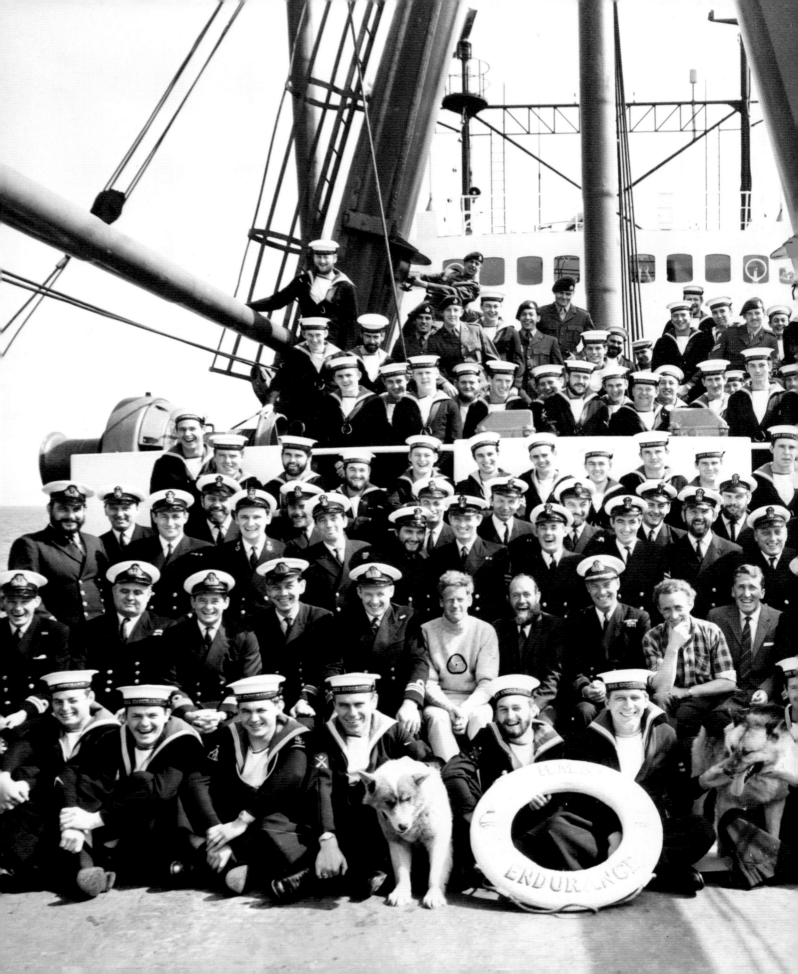

LEFT You can find us among the rows of smart naval men, the only ones not wearing hats. Later that night the crew laid on a special celebration – watching the Hollywood film *Custer of the West*. This was the last of the old-style pioneering journeys, and as it ended the eyes of the world were focused on an another event, one of far greater historical significance: the first landing on the moon.

LEFT I proposed to Marie in the car park at Heathrow Airport and we were married just three days later, on Christmas Eve 1969, at Chelsea Registry Office, my bride looking stunning in an Alaskan-fur parka and mini skirt. A few years later, I took Marie and our new daughter Kari up to Northwest Greenland and introduced them to the polar world that had become such a part of my life, a part of my soul in fact.

ABOVE Many years later, I was surprised by Eamonn Andrews for *This Is Your Life*. Our dear friends John Alderton and Pauline Collins were there, as were old sledge-mates like Allan and Fritz, Geoff Renner and Peter Otway, who had been flown in from New Zealand. Sir John Hunt, Sir Robin Knox-Johnston and Sir Chris Bonington also added to the event, but I have to admit this moment of showbiz was utterly bizarre.

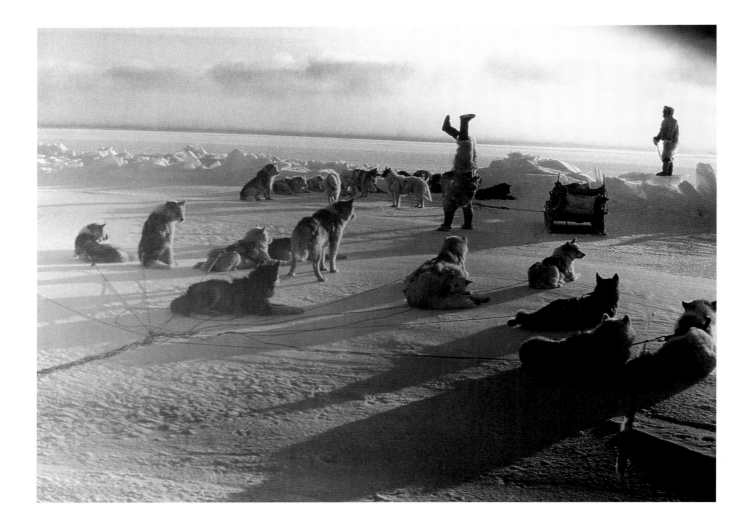

ABOVE While his travelling companion scans the frozen sea for seal, a young hunter celebrates the return of the sun with a handstand. I joined my Inuit friends on many spring hunting trips like this in Greenland and they were always tremendous experiences.

RIGHT I returned to the North Pole in 1987 for filming. We found a Japanese team there with a motorbike. In 1991 I went again, this time on the Russian icebreaker *Sovetsky Soyuz*, and we made the first surface vessel crossing of the Arctic Ocean, from Murmansk to the Bering Strait, smashing through the ice at a steady 15 miles an hour. When we'd travelled with dogs it was often no more than 15 miles a day. At the Pole what did the millionaire passengers do? They celebrated with a fancy-dress party on the ice.

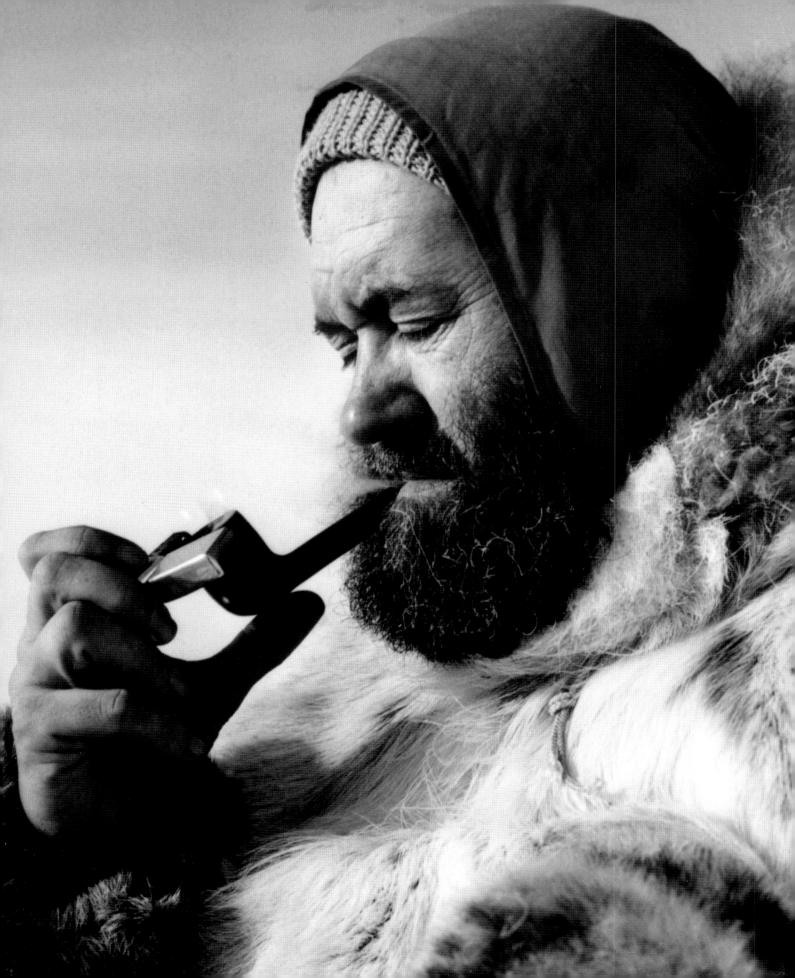

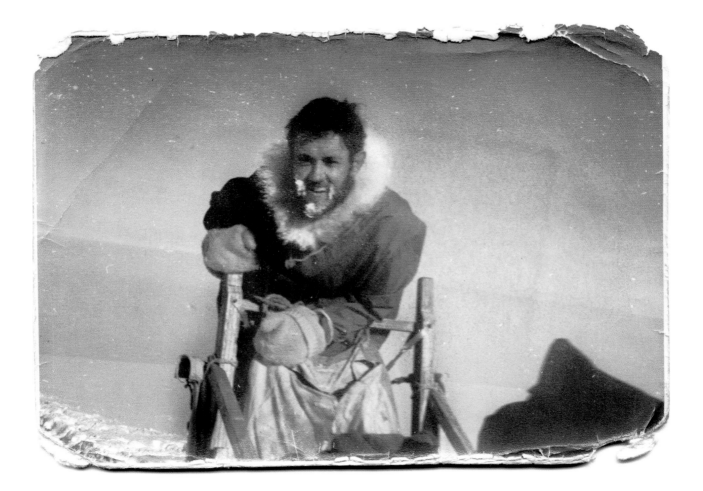

4 | REFLECTIONS

All men dream: but not equally. Those who dream by night in the dusty recesses of their minds wake in the day to find that it was vanity: but the dreamers of the day are dangerous men, for they may act their dream with open eyes, to make it possible.

T. E. Lawrence, 1922

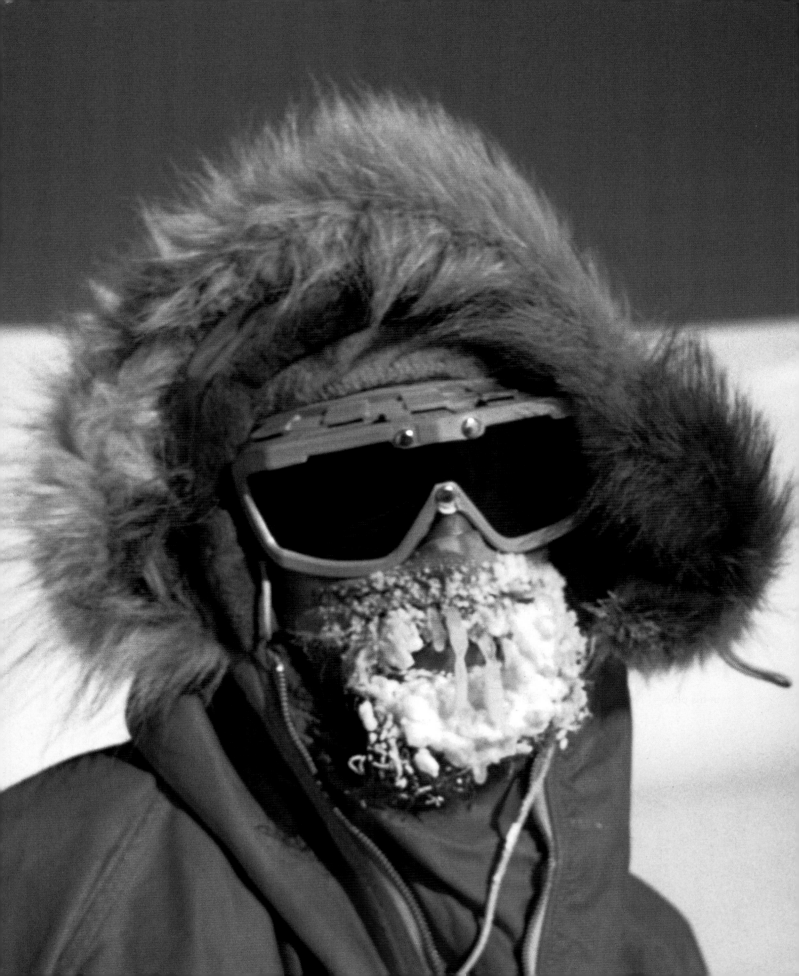

AFTER AMUNDSEN

PETER OTWAY

The arrival at Scott Base in Antarctica of twelve snarling, terrified huskies in their aluminium kennels was the first positive sign that Wally was truly on his way. For weeks I had read newspaper reports of how this highly experienced Antarctic explorer had been scouring isolated Greenland villages to buy huskies to beef up New Zealand's Scott Base teams with a bit of 'new blood'. Sure enough, several days later the man himself slipped into base, almost unnoticed. For me, as a recently qualified land surveyor and keen skier assigned to work with Wally for the next two years, this was to be the start of a lifelong friendship with a truly inspirational leader of men.

In our first three-month summer field season we worked in separate teams in the wilderness, several hundred miles to the south. Later, we were essentially a two-man unit among eleven scientists and maintenance men at our base. We spent two gruelling months on the sea ice in plunging autumn temperatures, chainsawing our way through about 25 tons of frozen mutton and 60 seals for our dogs tethered there, then raising their pups through the winter, preparing the field gear, and caring for and training the dog teams.

Throughout that sunless winter Wally entertained us all with his thrilling but often hilarious adventures around the world, particularly with his 'hairy-arsed' companions sledging through blizzards across the Antarctic Peninsula. As we worked together in our sledge room and cosy survey office to the sounds of Wally's classical music tapes – and in aromatic clouds of smoke from his pipe – I became caught up in his dreams and plans for pioneering expeditions in the old-fashioned style. Wally was an unabashed romantic in the mould of his hero, Shackleton, with a contempt for the ordinary and a particular distaste for officialdom. Dominating all our actions, though, was the urgency to complete our preparations in time for the coming season – and what an amazing season it would be.

Our four-man team, the 'NZ Southern Party 1961/62', was granted by the New Zealand government the great privilege of undertaking a survey and geological reconnaissance of the region made famous by Amundsen and Scott half a century earlier. This was the 'Gateway to the Pole', a land where heroes had been created. They hauled their sledges up the mighty glaciers cutting through the Transantarctic Mountains in their quest to be first to the South Pole in 1911. Nearly twenty years later, Admiral Byrd became the first aviator to reach the Pole, flying through a gap in the same mountains. And now we had the chance to trace their routes for ourselves.

Our task was to explore and to return with a map. A noble pursuit, but easier said than done. We'd journey through the Queen Maud Range from the Beardmore Glacier and hoped to reach the Axel Heiberg Glacier 200 miles to the east. Apart from these two glaciers the terrain was unexplored, comprising the bleak Plateau, majestic mountains, dry deserts and a multitude of glaciers cascading down to the Ross Ice Shelf. Our team, with Wally as leader and myself as surveyor, included a talented and enthusiastic young geologist, Vic McGregor, and an experienced mountain guide, Kevin Pain, as field assistant. This would be a mission into historic but virtually unknown territory.

In early November 1961 we watched our drop-off plane blast off from the Polar Plateau in a billowing cloud of snow and a bitterly cold minus 32°C wind. The old US Navy Dakota DC3 finally disappeared from view, leaving us utterly alone on the edge of an endless plain of wind-driven snow. We picketed our eighteen dogs on their wire spans and pitched our two tents: Camp 1. Our challenge had begun.

LEFT Surveyor Peter Otway tries to smile for the camera after eight hours at a theodolite on the summit of Mount Fridtjof Nansen in 1962. His 'dedication to duty was truly impressive', Wally recorded in his journal that night. Peter and Wally became lifelong friends.

PREVIOUS This is the earliest photograph of Wally sledging. It is Antarctica in 1956. Here he learnt the art of polar travel, navigating by the stars and mapping mountain ranges. He was just 21 years old.

For nearly three months we followed Wally's carefully formulated plan, skirting around the edge of the Plateau and systematically establishing 20 survey stations on prominent mountain tops, many over 11,000 ft in elevation. Sledging between stations, we relayed up to 1,100 lb of gear, food, fuel and the growing pile of geological specimens. It was often tough going over the cold, gritty snow or hard, knee-high sastrugi, sometimes blindly crawling in miserable whiteout conditions. And how we admired the indomitable spirit of Shackleton's and Scott's teams manhauling their sledges under the same conditions, with no dogs. It was during these testing times that Wally's natural leadership came to the fore. No matter what the setback, he always found a solution. That was his genius I suppose: even on the darkest day Wally could raise your spirits from rock bottom to the summit of enthusiasm. It was truly inspiring to travel with him.

Our survey stations brought yet another challenge: climbs of up to 4,500 ft with heavy loads. This was followed by about five hours of painstaking observations: fiddly, precise horizontal and vertical angles to at least 20 selected points, with a photo-theodolite panorama to triangulate minor features and take astronomical observations for location and azimuth – and all in sub-zero temperatures. This was my personal challenge, but I felt even more sorry for the poor booker, Wally or Kevin – sometimes both – with the boring task of recording the numbers I shouted out against the wind or trying to sketch and label the 360-degree panorama and identify the observed features. We would have to stop frequently to jump around clapping hands to restore circulation to frozen limbs, fingers and faces, muttering (on occasion with mild profanities) about this being the coldest job on earth – and worse.

Meanwhile, geologist Vic would be working on the snow-free ground of the mountaintop systematically identifying and collecting rock specimens, recording their bedding and location and searching for fossils – an operation that hit the jackpot at only our second station when he discovered the first ever Triassic fossils in Antarctica. These consisted of many well-preserved ferns and conifers in shales of the Beacon group and an impressive coal seam – convincing evidence of a bygone semi-tropical climate, but hard to imagine now. Finally, all would join in building a high cairn to mark the station position before starting the long trudge back down to camp. There we would feed the dogs, make a daily radio connection with Scott Base, tap out a message in Morse code, wriggle into our double sleeping bags as the dogs had their evening 'howlo' and prepare a dinner of hot soup and meat-bar stew. Then diary writing, bedtime reading, and falling asleep to the sound of the flapping tent and hissing snow with hoar frost from our frozen breath raining down from the walls.

In compensation, many of the views from the high stations – each one on a virgin peak – were truly magnificent, especially looking out over the mighty 130-mile long Beardmore Glacier, Shackleton's and Scott's notoriously difficult pathway to the Pole. As we stood beside our puffing dogs on the 11,750-ft snow summit we named Husky Dome in recognition of the highest point reached by dogs in Antarctica, we had our first sweeping view over mountains and glaciers down to the ice shelf. Our most extreme experience of the season was the 17-hour marathon climb and survey of Mount Fridtjof Nansen overlooking the Axel Heiberg, establishing not one but four linked survey stations in very trying conditions. At an altitude of 13,350 ft, this became the highest mountain then climbed in Antarctica,

ABOVE RIGHT Norwegian explorers Roald Amundsen and Helmer Hanssen took a number of measurements to confirm their position in the vicinity of the South Pole from 14 to 17 December 1911. Here, they pose as if taking observations with a sextant and artificial horizon.

BELOW RIGHT On the summit of Mount Fridtjof Nansen, the highest previously unclimbed peak in Antarctica, 16 January 1962. Peter is at the theodolite and Wally is huddled over the notebook to record Peter's shouted readings. 'It was not a day to idle in the sunshine sketching panoramas of the mountains that lay before us', Wally remembered. It was the coldest survey station of the whole summer: minus 33°C.

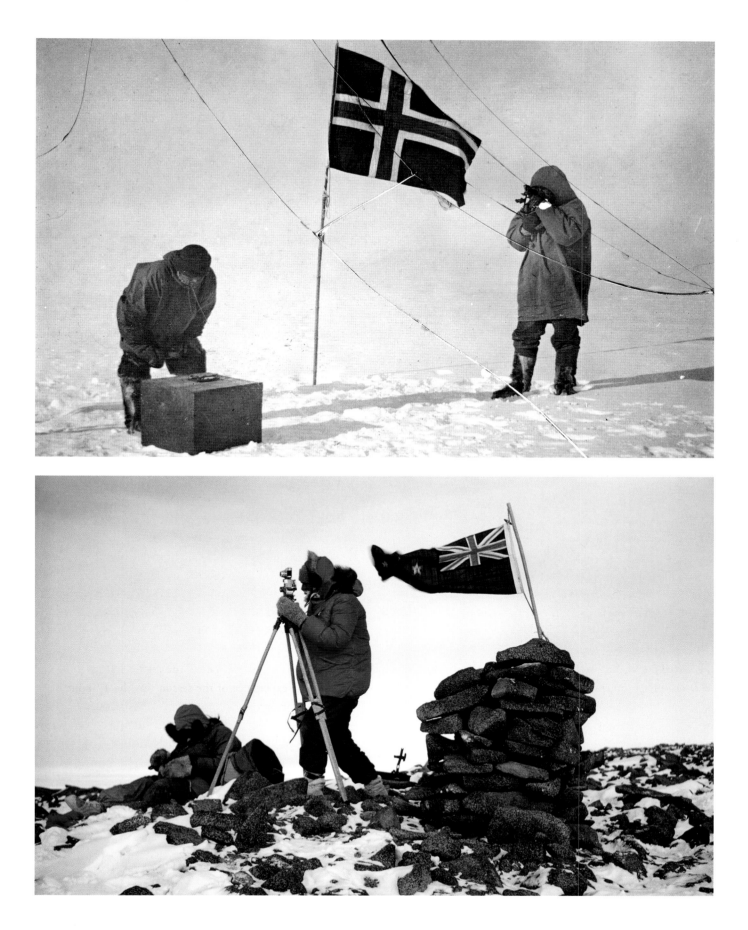

but with a minus 45°C wind chill and in our state of exhaustion, that seemed a very dubious reward at the time.

Following the sudden onset of a five-day Christmas blizzard, the bad weather continued with whiteouts on 33 of the remaining 43 days on the Plateau. But we struggled on. What might have been a frustrating time was actually a series of minor celebrations: Shackleton's 'Furthest South'; the fiftieth anniversary of Amundsen attaining the Pole; and Scott's arrival at the desolate spot about five weeks later. Each anniversary demanded a party so, at Wally's invitation, Kevin and I would crowd into his tent with Vic, whereupon Wally magically produced a small bottle of whisky and a few luxury items he had craftily stowed away, and we would all toast our hero of the day. Another little touch of Wally's was flying his homemade flag from his sledge on the appropriate day – Norwegian or Union Jack. Through Wally we relived the history, with a sense of reverence, of the very region we were surveying for the first time.

Wally's grand finale was still to come. As the season progressed our thoughts turned increasingly to the problem of finding a route off the Plateau for a low altitude pick-up, as it was clear from the start that the old DC3 would probably fail to take off fully laden at a higher level. Wally's original plan, backed by veteran explorer Sir Vivian Fuchs, was to dash the 300 miles to the US science station at the South Pole and hitch a ride in an empty Hercules transport plane back to base, but this was rejected by the American pilots as being too risky. Undaunted, Wally then had a copy of Amundsen's book *The South Pole* airdropped, and, after a careful study, he requested permission to descend the Axel Heiberg Glacier. To his consternation, permission was not granted until six weeks later, the very day we had completed the survey. By this time Wally

had actually descended the glacier on skis, flagging a safe route through the daunting icefalls. He then spent innumerable hours on the radio, debating in Morse code, trying to convince the authorities that he had actually done so and lived to tell the tale.

We finally began the 9,000-ft descent together on 2 February 1962, and almost at once we were bogged down in the incredibly soft snow. This proved a blessing in disguise, slowing our sledges as the dogs raced down the series of steep terraces and weaved their way between the numerous crevasses. As avalanches roared off Mount Fridtjof Nansen, we rode our luck and willed our dogs onwards. Wally's flagged route saw us safely down this great river of contorted ice and we reached the bottom three days later. Amazingly, photographs taken by Amundsen from his campsites matched our views exactly, the only plausible areas of relative safety in a sea of crevasses. Even Amundsen, not known for exaggeration, had exclaimed: 'The wilderness of the landscape is not to be described: chasm after chasm, crevasse after crevasse, with great blocks of ice scattered promiscuously about, gave one the impression that here nature was too powerful for us.' But like our hero, we had struggled on and made it.

Clear of the bottom icefall, we now had a relatively easy downhill run on firm snow, dodging the large, regular crevasses and covering the last 10 miles to the foot of the glacier. After a prolonged radio blackout, Wally was able to report our safe descent – to the great relief of all. After almost 100 days our mission was at an end and our dogs had done us proud. Two days later, at 8 p.m. on 8 February 1962, we were picked up by the old DC3, sledging from the runway on the sea ice into Scott Base just in time for breakfast.

Under Wally's leadership the team had exceeded its objectives, and without a serious mishap despite appalling conditions.

As a bonus, we had also scored a series of Antarctic firsts in the course of our work. And at a personal level, we had proved to ourselves, and each other, that we could survive and work in the harshest of environments. It seems ironic now that today's extreme athletes are constantly looking for new risks and contriving difficulties for themselves. We didn't need to seek out danger: every day was a challenge – and our morale could not have been higher. Being the first to retrace Amundsen's tracks exactly 50 years later enabled us to better appreciate the skill of this great explorer: a man of few words but possessed of prodigious determination. And Wally surely became his equal.

Only a few weeks later I was back in the warm green fields of New Zealand, with my sixteen months on the ice with Wally already an incredible, almost surreal, memory. Our map was finally published in 1964 in six sheets at a scale of 1:250,000 from the drafts we had painstakingly plotted. Covering almost 21,500 square miles, this was the largest area surveyed by any New Zealand team and we felt proud to have played our part in adding to the human knowledge of this incredible continent. Looking back, that season with Wally exploring in the footsteps of our heroes was one of the most rewarding experiences of my life. But for Wally, no doubt, the Polar Plateau and the Axel Heiberg were just a proving ground on his way to even greater challenges in the years ahead.

RIGHT The Americans airdropped a volume of Amundsen's *The South Pole* to Wally's survey team. Wally and his companions read passages to each other at night in their tent. The book was their talisman as they became the first men to rediscover and retrace Amundsen's route on the Axel Heiberg Glacier.

FEEL YOUR FEAR

DMITRY SHPARO

British explorer Wally Herbert was my hero when I was a young man and I still admire him hugely. I read about his pioneering journey across the Arctic Ocean in a Russian translation in 1972, and it became my main source of inspiration when I was planning my own expeditions. I took his book everywhere with me as I dreamed of my own adventure – to become the first man to ski to the North Pole. My book soon wore out and so I bought a second copy and again filled it with notes and underlinings. I was enthralled by his experiences.

Wally's achievements really helped in my own success on the ice. In 1979 I realized my dream by leading the first ski expedition to the North Pole from the De Long Archipelago off the coast of Russia, some 1,450 km over 76 days. After this major expedition I was eager for more and in 1988 I led the first ski crossing of the Arctic Ocean along the short route: from Russia to Canada, via the North Pole. I say short – it was still 2,000 km over 91 days, but it was short compared to Wally's journey on dog sleds along the greatest diameter of the polar basin. But I did feel now that I understood a little of his great achievement. We came from two very different countries: democratic Great Britain and the totalitarian Soviet Union, but something much more important united us – a message about the possibilities of a person, whether in the sphere of culture, science, sport or exploration at the ends of the earth. We shared the simple belief that it was possible to face your fears or go beyond what others had done before. We would explore something that no man had seen.

Wally Herbert fought for his plan for four years, and we struggled to get the permission of the Communist Party of the USSR for almost seven. When I stood on the rocks of Henrietta Island in 1979, ready to take my first step, I also experienced what Wally may have too as he pushed off the land at Point Barrow back in 1968. We were stepping into the unknown, not just into those white-blue beautiful ice spaces, but deep into the terrible black areas of the Arctic Ocean which have no exact definition, just one that comes close: *hell*. Our friends and the helicopter crew tried to smile and wish us well, but they all thought we would never return: just seven men on skis with giant backpacks, 52 kg each, about to walk to their deaths.

Even today, the ice is tough and the fear is the same. It is all very real, no matter how much technology may have made some things easier. In 1979 we refused to take the easy way by accepting a helicopter ride over that first stretch of treacherous ice. 'Come on', the pilot called, 'I will take you on board. It will take no more than 15 minutes.' But we seven men did not want to fly. The true measure of our expedition – from Land to the Pole – had to be achieved in the way we imagined, or all the years of effort and planning would have been wasted. We had to begin and complete our route on the terms we had set and take responsibility for ourselves. So we said no to the pilot and waited until we were alone. And then we made that first step. Two of us took a bath in the frozen waters that day. One of my team spent almost five minutes in and had to swim through the heaving grey slush. The temperature was minus 35°C. We lost two skis. But this was our start and now the northern horizon called us on.

When we finally got safely home after this expedition, I made my first trip to England. Why? Well, I was desperate to read the original diaries of Captain Scott and to talk to Wally. They were both explorers I admired, but Wally was a special man. Whereas Scott had suffered for every mile yet died in his tent, Wally was able to fight on through and return with all of his men. Wally's

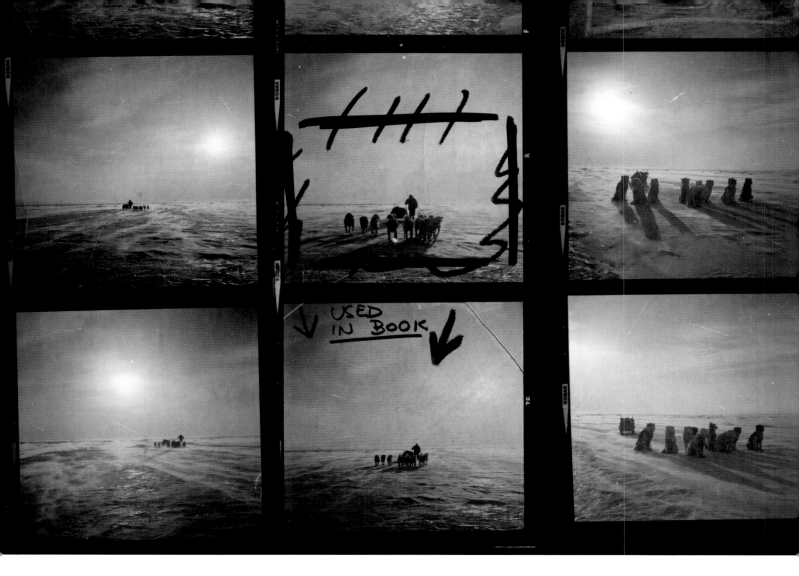

expedition became a true success when they made that landfall off Spitsbergen but, even more importantly, it was a real victory when all his polar companions came through to the end together.

In later years I was lucky to become friends with Fritz Koerner – that wonderful, lanky, freckled Canadian – and we also drank a little vodka with Allan Gill too. They were both, like Wally, fine men who took part in a truly great adventure and who understood what it is about the frozen ocean that is so attractive to people like me. They would have agreed with me also when I give this final piece of advice to anyone hoping to make an expedition across the ice: you must always *fear* the Arctic Ocean. This is not to say you must be scared, but rather that you must properly respect this environment. It is not only heavenly beautiful, not only so distant from civilization, not only geographically unique – but it is also inherently, mortally dangerous.

Each person who travels to the North Pole must be constantly aware of the entire surroundings. Feel your fear. Be honest with yourself and be sure to take your emergency beacon. If you're not willing to die out there, you must always think about how you're going to get home.

ABOVE A contact sheet of medium-format film from Wally's Arctic training expedition in 1967. It was a harrowing experience but, as Wally said, 'an easy journey would have taught us nothing'. During the crossing itself, temperatures in winter were frequently minus 45°C or below. Exposed flesh would freeze within seconds; even the smallest mistake could prove fatal.

FINDING FOCUS

BØRGE OUSLAND

Almost thirty years ago, I remember first reading about Wally Herbert. His achievement caught me instantly and I knew that I wanted to experience the Arctic Ocean too. I had then never stood on pack ice, yet began planning an unsupported ski expedition to the North Pole. Everyone has to start somewhere. Even the greatest explorers, like Wally and my hero Nansen, were novices at the beginning. My head was filled with questions. What was it like, this ever-shifting ice? Would I survive? Reading accounts of Wally's expedition frightened me, but it also helped me to prepare and I couldn't wait to go and try it for myself.

Two North Pole expeditions later, I really understood the scale of Wally's efforts. It was 2001, and I set out on one of my most challenging expeditions – a solo crossing of the Arctic Ocean. I would try a route from the Russian side to Canada. It became a journey as much for the mind as for the body, naturally, where the daily struggle constantly shifted between survival and meditation.

Often when I leant on my sticks and stared down at the ice, I discovered a world that is easy to overlook: all the tiny pieces of accidental information created by wind, ice and light. A gaze that wanders over the horizon searching for a navigable route often sees only the big picture. Dramatic, beautiful and imposing that picture may be, but the little things have value too. Searching for the minute within the vast was a challenge that gave me much unexpected joy. The trip wasn't merely a certain number of kilometres and days, I was in fact moving through one huge exhibition of art.

On the Arctic Ocean there is something happening every moment. Each pressure ridge has its own shape, nothing is the same, there is variation right down to the smallest snow crystal.

But it was easy to fail to notice this during the day's battle with the sledge and the ice. The painter Jacob Weidemann has expressed it well: 'The glimpse of a wing in the sun, dry warm air, the scent of the whole living earth, all in my garden. To look, to look is what's difficult, that's the place you'll miss if you cannot manage it.'

I forced myself not to miss it. Finding nature's art brought profit and happiness. Penetrating the great whiteness, delving down into the details, helped me to endure the toil; it saved me from giving in to the feeling of powerlessness every time I was stuck fast in enormous deserts of pack ice. At times like those I would focus intensely. Without others to lean on, once I dared to open up, I got closer to myself and saw the ice not simply as an enemy. Fear was the real foe, fear of the ice, fear of being alone.

The pack ice was so bad in 2001 that any other outlook would have caused me to give up. I had to remain positive. The ice was densely packed over vast areas, heaps of blocks devoid of any pattern or direction. These must have been formed when the ice was new; they weren't especially big, but they were very difficult to cross. The loose snow had built up and the sledge got stuck the entire time. I was doing approximately 2 km less per day in the same area compared with my North Pole expedition in 1994. It was supremely heavy going at best, and it got even slower when I had to pick my way through ice-labyrinths like these.

Sometimes I was lucky and could follow frozen leads. Like motorways, they cut through the ice, and although they seldom headed due north, it was almost always worth taking them. Once the leads altered course, or closed up, the fun was over and I had to head into the pack ice again. I would travel 150 m for each 100 m of northerly travel. To search for a route I'd leave the sledge and climb the nearest pressure ridge to survey the

LEFT It was 'The longest, loneliest and coldest trek ever undertaken', ran the caption in *The Hornet* comic in this wonderful retelling. The *Illustrated London News* was also full of praise: 'That the spirit of adventure is still not dead, even in these seen-it-all done-it-all 60s, was proved this year by four men who together shared one of the classic explorations of all time.... It was a great feat of endurance, both physical and mental, a journey of sheer dogged courage.'

scene; if the terrain was difficult I'd have to stamp a path first. Even if the distance travelled was longer, the bonus was energy saved and less wear to both body and equipment.

As I moved off to complete the final degree of latitude to the North Pole, the ice began to pack violently and I witnessed the birth of the giants, seeing the way the really large pressure ridges were formed. The ice was around 2 m thick up here, and incalculably huge forces were working on a front several kilometres long. Shock waves came and went, sometimes in one place and sometimes in another. Blocks the size of cars reared up. The crushed ice came on like a wave, sometimes 5 or 6 m high.

I left the sledge at a safe distance and went over to take a look. The only way I can describe the sound of such packing is that it was like the noise from the engine room of a super-tanker mixed with the screeches of innumerable polystyrene blocks rubbing against each other. In between there were loud reports as cracks formed in the floe I was standing on. Water spewed out of the fissures and small lakes formed where the floe was pressed down under the weight of tons of ice. Blue-green ice dripped with seawater, frost mist rose into the air and gathered in a fine layer on my anorak. There was the smell of sea and brine and the air quivered with discharged energy.

To experience something like this is like watching an explosion in slow motion. In a seething, destructive demonstration of its power, nature had once again demonstrated who was boss. Fresh pack ice stood like glistening rows of teeth to the northeast, yet on the other side, my side, it was still untouched. As the zone went right across my line of travel, I had to wait patiently until it stopped. After an hour only a faint grumbling remained and I went to find a route. Great ice blocks formed natural bridges, but I had to be extremely careful. If I fell into one of those crevices I'd have no chance at all.

The ice could begin to shatter again at any moment and I had no wish to be caught in a trap like that. I'd experienced this before, back in 1994. I was crossing a new pressure ridge of large, coarse ice and just as I reached the middle it suddenly started to erupt. The sledge wedged itself between the ice blocks and water rushed up out of gaping holes. Both the ice and I were just about to be forced under. I had to get out, but what about the sledge? It contained every bit of my equipment and if I lost it I'd have no chance of success. As soon as I realized this I suddenly summoned up unplumbed power reserves. I hoisted the sledge up on to one of the blocks, and from there manoeuvred it forwards as the ice convulsed beneath my feet. I managed to get to safety, but only by a whisker and I was shaking for a long time afterwards. I had to focus my thoughts and move on. That's all you can do.

This time, again, I was doing it alone. I put my skis on the sledge and hauled it over the point the pressure ridges were at their lowest. Thin ice had already begun to form on the open water in between the ice blocks, and I got through without the slightest stirring. Once on the other side I began to ski fast and pull hard to make up for lost time. The ice was rough, with old, weathered pressure ridges and large drifts of snow which lay like boats keeled over where the wind had died on the leeward side. The sledge was light enough for me to make good speed, but conditions were much worse than normal this far north. The ice had put me behind schedule, and I caught myself wondering if I would make it before my food ran out. That's the nature of the polar ocean, always something to worry about; you just have to let it go.

POLAR ATTRACTION

VICTOR BOYARSKY

What is it? What does this magic point mean? The North Pole does not appear on most maps, but it is used by everyone in their modern lives, driving in their cars, finding their way to new places, or meeting friends with their heads buried in their mobile phones. Maybe a few might remember the North Pole from geography lessons in school, but surely the majority will never think about the Pole in their lives. Some may not even know the difference between North and South, and why should they? But for a few people, myself included, the Poles have become an integral part of their nature, their heart and soul. They are inescapable.

My first time at the North Pole was April 1978 when I was a polar scientist working at the Soviet drifting station 'NP-23', investigating the sea ice and ocean currents. The ice floe on which we set up our station drifted towards the North Pole. When we were just 100 miles away, we simply could not miss such a chance and pointed our biplane towards the top of the world. According to our simple navigation we landed quite close to the Pole and spent about an hour there, taking photographs and having fun under a blue sky. The sun was dazzling, the cold fresh air filled our lungs. Now, nearly forty years later, I have been to the North Pole more than fifty times, perhaps more times than any man alive. I still see this picture in my head like it was yesterday.

But why? What is special about this invisible point, no different perhaps from millions of others on the surrounding white surfaces of the sea ice, with its monstrous pressure ridges and the deep black scars of open leads? My answer, based on multiyear experience, is 'NOTHING!' Of course there are no marks, monuments, buildings or huts on this sacred place, nothing to signal that it is the fabled North Pole. Even at this precise spot you are only ever there for perhaps no more than a dozen seconds, as the winds and currents keep the ice always moving.

The most tricky thing about reaching the North Pole now for many a determined modern adventurer, with their expensive GPS equipment, is actually fixing the point at 90° North for long enough to take a photo. Wally Herbert was right when he described it like 'trying to step on the shadow of a bird flying overhead'. But this is also why reaching this spot is still a satisfying quest. Every adventurer has a unique chance to discover their own North Pole on the sea ice, where for certain no one has ever stood before. In fact, the whole of the Arctic Ocean is like this. This is why the North Pole is still an appealing blank. The nothing is what makes it so special. At the South Pole the Americans have built a huge permanent scientific station, which hums with diesel fumes and electricity generators. There is no place there anymore for romantic dreams.

But at the North Pole we can still take a pair of skis, or a dog team, and journey through bitter cold, wind and unpredictable sea ice, just to reach something almost virtual, existing on the displays of our GPS for only the blink of the eye. Men like Wally Herbert were the pioneers – we all just follow them – so the North Pole must now be inside us. It is a deeply personal thing. Only that personal urge can create the motivation you need to summon all your strength to achieve something that seems so unnecessary. For many people this will be the hardest thing they ever face. And for most, the horrors soon subside and it becomes the happiest time of their life.

Until twenty years ago, the North Pole was still untouchable for all but the very toughest of travellers. In 1990, when the first commercial cruise there on a nuclear icebreaker took

place, a new era in the history of the North Pole began. Perhaps it was the beginning of the end; or rather the beginning of a new chapter for a new type of person. In 1992, I was one of the organizers of the first commercial flight to the North Pole with helicopters, and since 1993 to the present day we have organized a temporary ice base and airstrip on drifting ice with the exotic name 'Barneo'. Every April, I wave goodbye to more than 250 people heading north from this floating base close to the Pole. Their dreams are now just over 60 miles or 100 km away.

Some of them are skiers, who choose to travel to the Pole varying distances from their warm tents. Others decide to fly direct in one of our helicopters. I have now led 25 trips across the ice to the Pole and it is still a hugely difficult proposition for some. So many times, big strong men after just a couple days will sit on the ice and cry like a child, unable to continue, and we have to take them back to the base. Others, perhaps more motivated women, will just keep on going, and – though crying in their tent at night – refuse to give up. So, the North Pole demands motivation, even today when we might think it is easy. I can only imagine what it must have been like for Wally Herbert and his team almost 50 years ago, alone on the ice, making the longest journey possible and doing it for the very first time. These men were not tourists. They were the real explorers.

RIGHT While America was planning to put astronauts on the moon, four men pioneered a route across the top of the world, as shown in this original photo-negative print of their journey. No polar explorers before or since have spent several months at that latitude drifting through the polar night, constantly in danger.

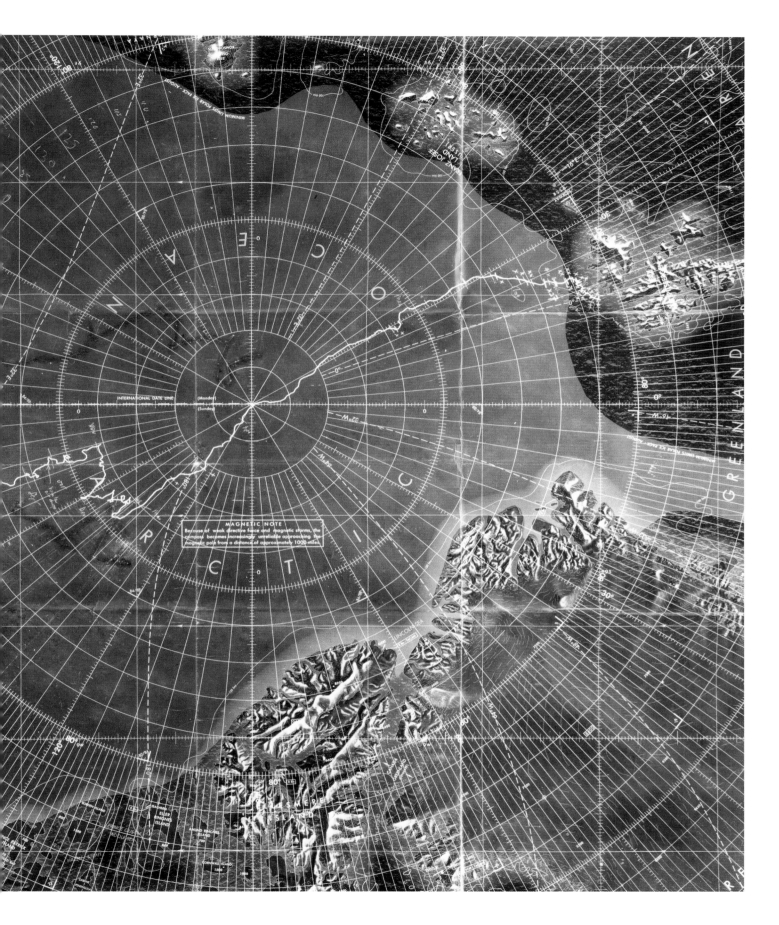

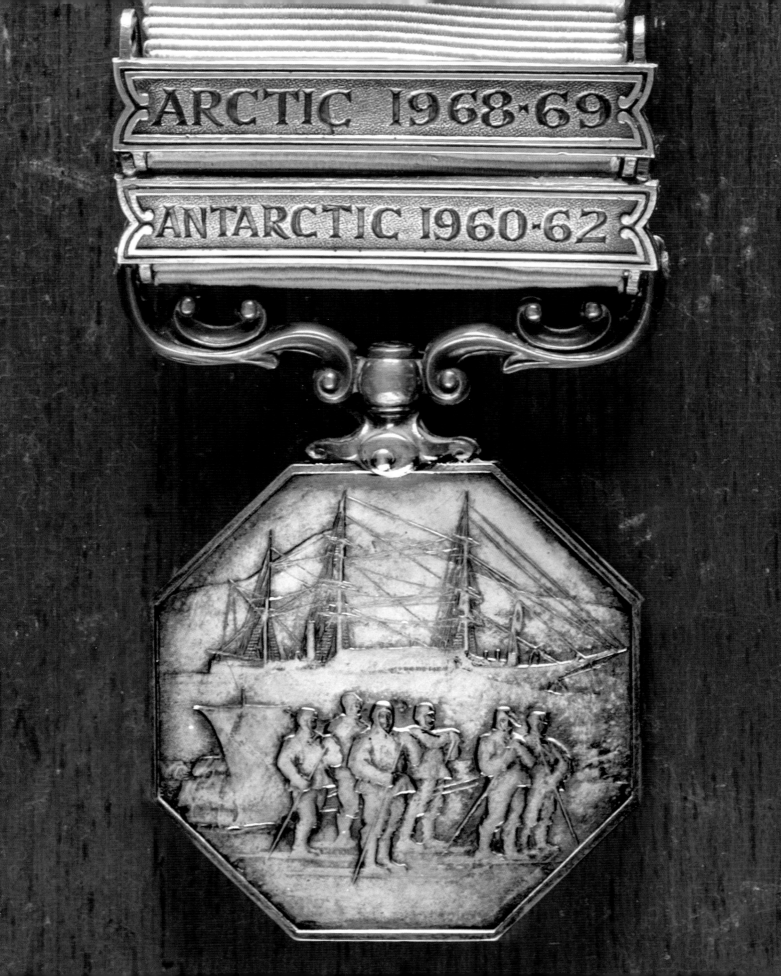

DEGREES OF UNCERTAINTY

SIR RANULPH FIENNES

Suffering seems to have been a regular feature of my expedition life. You plan very definitely not to take unnecessary risks, but on the ice dangers are everywhere. You have to turn setbacks into positives. Whenever our team has had a serious problem, or even lost a digit or two, we review what happened and why. Some people call these inevitable things 'bad planning' or 'foolish mistakes'. But that is nonsense.

You have to remember that if you're doing something that hasn't actually been done before, then you're in a state of *unknownness*. Nobody's done it; though some experts might have tried. Are we sure that humans can actually do it? You have a degree of uncertainty about everything, which means how the hell could you have planned it differently if you didn't have previous knowledge to inform your plans?

My appreciation and respect for the explorers of old is a natural sequitur to my own experiences. A degree of uncertainty is what makes an expedition all the more interesting. To step into the unknown, to break the barriers of possibility is what Wally and his men did with their crossing of the Arctic Ocean. They went where nobody had gone before. Anyone who now tries to follow has the safety net of knowledge that it *can* be done. It's much harder to be the pioneer.

Wally Herbert stands head and shoulders above others. His frequent successes in perilous situations are all the more remarkable when you realize he managed to avoid lethal disasters along the way. Desert explorer Wilfred Thesiger is another whose journeys I find heroic and, like Wally, he was the consummate professional – highly skilled and rarely in trouble. Success is a moveable target and achievement is largely in the eye of the beholder. Yet, some things are just awesome whichever way you look at them. Crossing the Arctic Ocean for the first time is one of these things.

What makes someone great? Wally's ability was of a different order of magnitude. He was a modest man, a kind soul, a supremely talented artist, a gentleman, but he was no pushover. On the contrary, a tougher man you'd never meet. His knowledge was earned through hard experience. He began with surveying in Antarctica, exploring virgin glaciers and mapping vast mountain chains. He became a master in handling dog teams and in surviving out on the ice. He later lived and travelled with the finest Inuit hunters and learned their craft, and they respected him too. He became one of them, a traveller, a companion, an equal among great men, and then a formidable leader.

I admire men and women who have the courage to act out their inner dreams. As a leader Wally encouraged his companions to join his dream, to take on the quest as their own. But as leader, the buck stops with you. Your teammates are essential, but the pressures of responsibility are yours alone. A wrong decision can jeopardize all your lives, and your men depend upon you to bring them home. The vision for an expedition might be a blessing and a curse, particularly if you don't prove up to the task as a leader, but to the victor rightly belong the spoils.

Wally was knighted as an 'Icon' in the Millennium Honours list. After his monumental efforts in the Arctic, it was an honour that many of us felt was long overdue. I joined Wally and his family that day and was delighted to witness our country's official recognition of his success. I know it was something that meant a great deal to him. He died in 2007, our greatest polar traveller since Shackleton and Scott.

In the newspapers of 1969, Wally's Trans-Arctic crossing was sometimes likened to a 'horizontal Everest'. The difficulties are certainly comparable, yet having climbed that mountain I can say that the Arctic is a *much* harder proposition. The first ascent

LEFT Wally Herbert was knighted in 2000 as an 'Icon of the Millennium'. He has a mountain range and a plateau in the Antarctic, and the most northerly mountain in Spitsbergen named in his honour. He was also awarded the Founder's Gold Medal of the RGS. His Polar Medal carries two bars, for the Arctic crossing and for his cartographic work in Antarctica.

of Everest in 1953 took just three months, compared to Wally's sixteen months of committed endeavour. Add in the inhuman temperatures, the long periods of total darkness, and, don't forget, the bears that can hunt you down and eat you, day or night, and it makes the present-day assaults of Everest look like a camping trip.

<div align="center">❧</div>

The world of exploration has now changed beyond all recognition. On my first polar expeditions, the communications equipment was all high-frequency and about two-thirds of the time you could only make contact through Morse code. My base commander and radio operator in those days was my wife Ginny. She got all the gear together, trained other people and serviced and repaired the equipment. She was essential to our success. That human link with home was a crucial difference with the old expeditions, but what we were doing still wasn't easy, particularly so if you compare it to the technology available today.

Back then you'd arrive at your camp at the end of the day; the person first into the tent would sort things out, get the coffee on the boil and would immediately put the radio battery up in the roof of the shelter for two hours to start warming it up. The other person – who would probably be the communicator and navigator – would be outside getting slowly colder and colder, because he'd be working out what direction to set the radio equipment facing. Remember, there was no GPS until the early 1990s, because there were no satellites going over the Poles at that time. He would be positioning two ski sticks in the snow about twenty yards apart, before stringing up antenna wire between them. The aim was for the wire to be horizontally facing the direction of where we thought Ginny was, several thousand miles away.

After that, you'd look in the *Ionospheric Prediction* book to get the best frequency to use to bounce the message off the ionosphere to her. From the middle of the antenna wire you'd have a line coming through the tent door and into the radio set, which would only work once you'd warmed it up. Somebody would have a device round their knee that was whirred round and round to act as a battery charger, because in those days there were no solar chargers. Or you'd tap away in Morse for hours on end.

In one sentence I can tell you what you now do instead of the ski stick method: you go into the tent, you take your sat phone out of your pocket, you drink your cup of tea, ring a number and tell them exactly what you want to say. Likewise with navigation, you do not spend an hour trying with a sextant to find the altitude of the sun or a star and then a further half an hour with *Sight Reduction Tables* and a *Nautical Almanac* attempting mathematically to work out your position. You have another cup of tea, press another button on your GPS, and it tells you precisely where you're standing.

In terms of uncertainty, and difficulty, the differences between now and Wally's era are huge. His generation of Antarctic men were pioneering surveyors. They navigated by the sun and stars. They did not set out to break records or become famous. And why would they have wanted to anyway? They were exploring virgin territory. They came home with discoveries. They made maps.

Historic achievements like Wally's are incomparable. They stand out from the rest. In setting his sights on the Arctic Ocean he chose the ultimate test. It was the journey never imagined, never attempted, and it is unlikely ever to be repeated. They don't make men like Wally anymore.

RIGHT Norwegian explorer Fridtjof Nansen was the first to conduct detailed scientific observations on the Arctic Ocean. He intentionally let his ship *Fram* get stuck in the ice north of the Russian coast and it served as a laboratory and base for three years while it drifted. It is July 1894 and Nansen is taking water temperatures. This expedition, like Wally's, was the perfect balance between adventure and science.

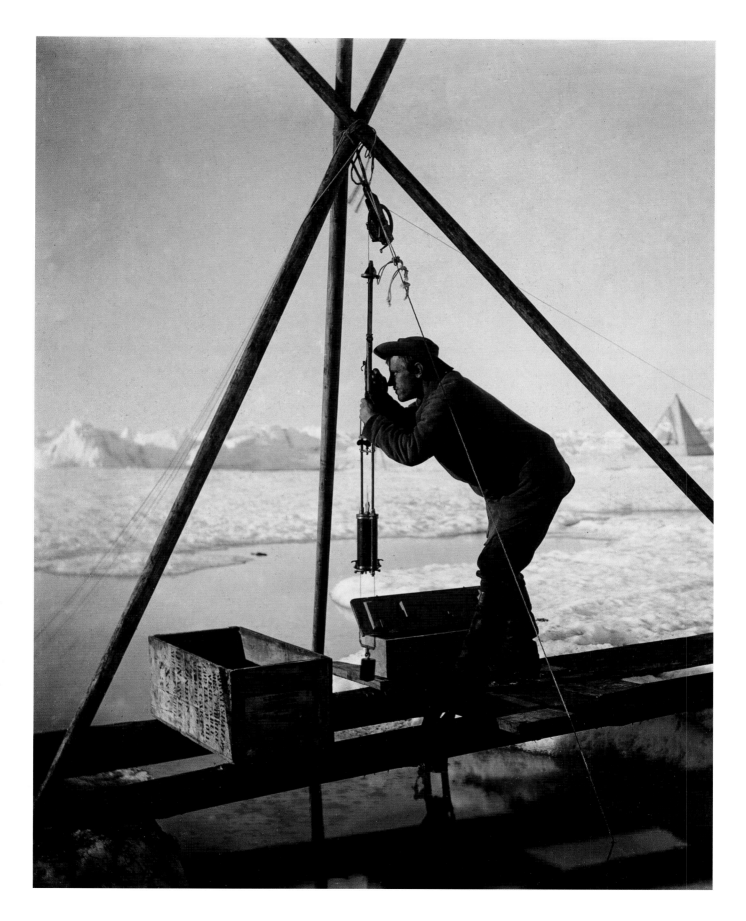

DELICIOUS DISCOMFORT

MARTIN HARTLEY

'There are moments out there', Wally Herbert once said, 'when you're so exhausted you become almost detached from yourself. You go through a sort of *discomfort barrier* and from that point on it is almost delicious.' During his epic Arctic Ocean journey he covered more than 3,620 miles; that's 140 marathons back to back. Talk about breaking through your discomfort barrier!

If there was any man on earth who could speak with authority about travelling on the Arctic Ocean, it was Wally. He was the last of the real explorers. The Arctic Ocean is truly unique: it's not really like a frozen lake – even Siberia's frigid Lake Baikal is easy in comparison – or a snow-covered glacier or mountain plateau. Its closest relative might be a desert, at least in a psychological sense, but that alone is not enough to describe life on the surface. You have to try it to know.

Having spent a fair amount of time on expeditions, I now understand what Wally meant when he spoke of the 'discomfort barrier'. If you want to really embrace the beauty of the Arctic Ocean you have to go beyond the horror to find a happy place. If you cannot break through this barrier then your journey will be a short one. When you push on further, the intense struggle actually becomes hugely enjoyable. It is only by enduring this sort of pain and anxiety that I really feel that I've achieved something worthwhile in an adventure sense. It is good to face the possibility of death sometimes. It makes you more aware of how wonderful life is.

To travel on the Arctic Ocean is to learn to live with pain at every step. For me, if one word encompasses the Arctic Ocean possibly more than any other it is 'brutal'. It is true. Long Arctic Ocean expeditions are brutal: the pain is physical and very real.

As a photographer the challenges increase. Cold is invisible; you cannot photograph it, but you can photograph its effect on people. I would argue that pioneering mountaineering expeditions have a kind of short-lived pain, rather like stubbing a toe on a rock. Polar journeys by comparison are more like living with a protracted, debilitating condition. The mental, emotional and physical suffering is unrelenting. There are moments of happiness and beauty too, but these are usually followed by yet more pain.

This being said, the physical stuff is straightforward to deal with – it is manageable. The real Achilles Heel of a big polar expedition is a weak mind. Arctic Ocean travel is committing mentally and physically. An easy retreat from a bad situation is unlikely as you need good weather and perfect ice conditions to effect a quick escape, and those two key factors rarely coincide. Intense cold is not something I fear on an expedition. In fact, it's the lack of cold that is more of a problem. Once the season warms up you get humidity and fog; fog that stays for weeks, fog so thick you might as well be living inside a glass of milk.

These bizarrely blank surroundings can sap your soul. Later on the fog lifts, accompanied by warm temperatures and open water. 'Warm' in the Arctic is anything above minus 25°C. Warm brings as many problems as cold. In fact, warm is bad news for polar travel, as it means low pressure systems, high winds, snowdrifts, heavy snow, poor visibility, wet clothes, wet tent, low morale. Once warm temperatures arrive the pleasure of the Arctic – the delicious discomfort that Wally talked about – actually disappears and the warmer weather just makes for a very unpleasant time out on the melting ice. It is best when it is *extremely* cold.

ↄ৶

LEFT Wally's tattered Union Jack, the first to fly at the North Pole. As Wally recalled: 'We did not plant our flag at the Pole in 1969 and leave it there. Our greater aim was to get it all the way across the Arctic Ocean. The ice is moving all the time at the Pole and if we had left it there it would have simply floated away.'

Polar travel today allows a glimpse of what life might have been like for legends such as Wally, Captain Scott, Shackleton, Amundsen and Nansen. Yet a glimpse is all it can be, nothing more. All my journeys in both the Arctic and Antarctica have been incredibly rich adventures in a personal sense, but this is not exploration. All modern expeditions now are not the committed journeys they once were. And, certainly, it is not true exploration to discover 'new human boundaries' or to be the fastest to the Pole. Athletics like this is best left for Olympians who truly do test nerve and sinew for a purpose.

It's human nature to want to be the first to do something, but just because you're first doesn't necessarily make it all that worthwhile. With polar people, it's getting very difficult. For mountain climbers there are still unnamed and unclimbed peaks and terrifying sheer granite faces that nobody's yet dared. So for them there doesn't appear to be any artificiality about what they're achieving. But with polar adventures nowadays, it's very easy for a cynic to say 'well they're just doing it for the sake of doing it and calling it a record because they want sponsorship'. That's why it's so important to distinguish the meaningful firsts.

I'm not willing to define myself as an explorer. Nor should any self-respecting adventurer today. To do so is to capitalize on, and yet devalue, the hard work of Wally and his fellow explorers who made real discoveries. Many modern travellers stand on the shoulders of giants without acknowledging this support, and this is surely a fast route to get your head in the clouds. The contemporary adventure world is awash with the word explorer, it levers cash from sponsors and pumps up individual egos. But genuinely to earn the right to the title of 'explorer' is almost impossible these days. I save my energy by doing some honourable adventuring, as it is the next best thing.

Crossing Antarctica during the polar winter is perhaps the only great journey still to be achieved. Whoever does that first will have their record. But then, in time, a new generation will feel compelled to try it on skis, or with kites, or roar across in new fuel-efficient trucks. Eventually, people will be trying every possible variation, and some will pay to be guided there as a tourist, tweeting and taking 'selfies' all the way, or merely sledging the last few miles, and so on.

Others will try faster or boast of longer journeys, anything to claim the label of originality. You can complete a long journey simply by going round and round in circles or repeating your route there and back, there and back, to and fro from your food depot. As some have done. It's the 'long-haul' syndrome. Why would you do that unless you had a destination at the end of it? Sheer distance covered doesn't make your camping ramble any more inspiring than a shorter trip. An innovative journey is what's needed, a goal from one point to the other, like climbing the perfect line on a mountain face. There is elegance in the direct route.

So, it's not what you do, but *how* you do it. And, you have to be willing to risk everything in the pursuit of an idea. I know this was at the heart of what Wally did. It is frustrating when modern polar efforts grab the headlines, while genuine exploration firsts are forgotten. The major advantage we all now have when travelling on the Arctic Ocean to the Pole is knowing that it can be done. That is why Wally's journey was pioneering. I also know that the pain is just a phase and it will pass quickly, and whatever journey I take across the ice it will *never* be as long as Wally's. That provides me with a little comfort when the going gets tough.

RIGHT Images from a modern Arctic Ocean expedition in 2014: photographer Martin Hartley was able to share them online via satellite. He shoots professionally on Nikon, but it is remarkable now what can also be created on iPhone, as long as you can keep it – and yourself – from freezing.

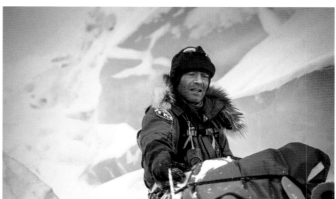

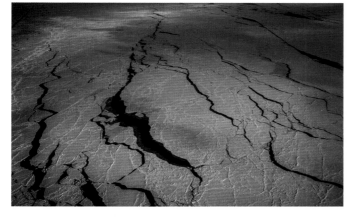

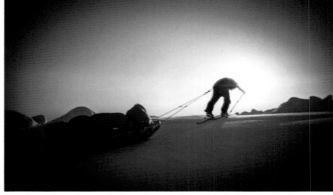

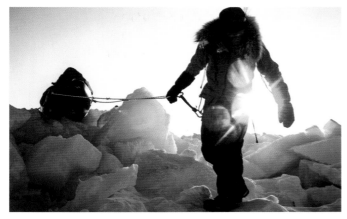

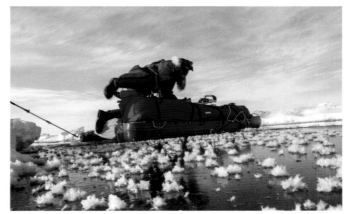

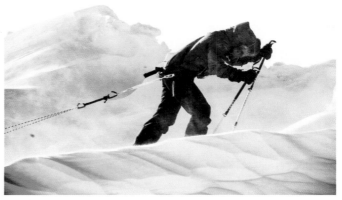

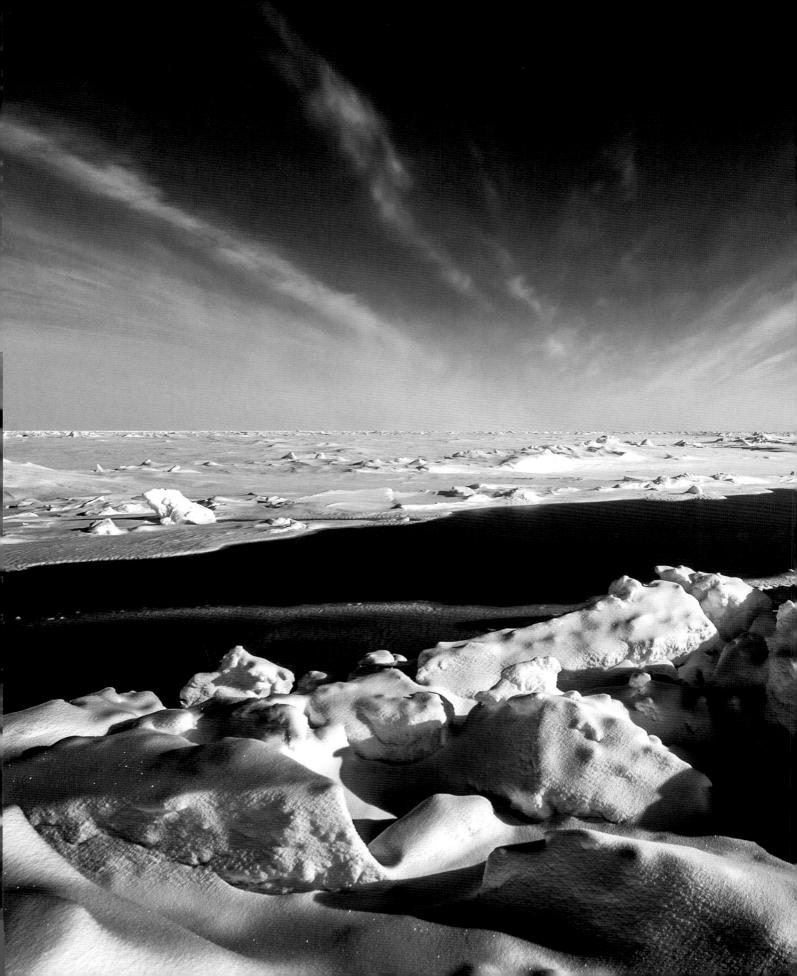

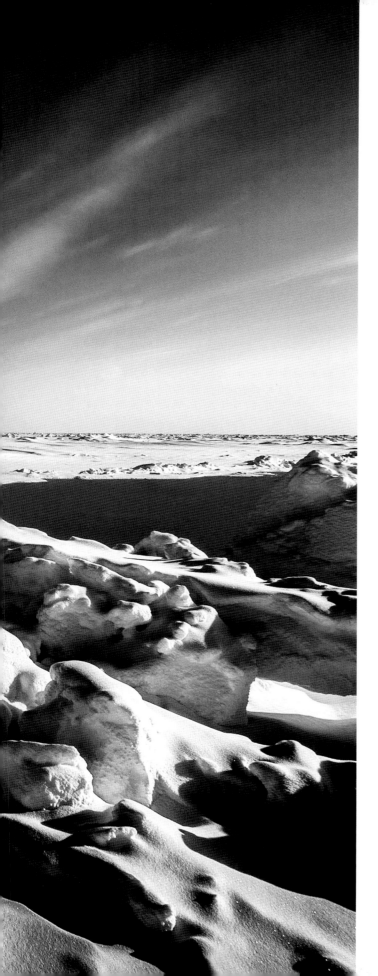

WONDROUS COLD

CECILIE SKOG

The North Pole has given me so much. Some say it's a hostile place and they can't understand why anyone would want to go there – they have no reason to think otherwise I suppose. Many adventurers now make careers about how difficult it all is; and it is true, the Arctic Ocean is one of the most dangerous places on our Earth. But, for me, it's a place that I'll always think of with deep happiness.

I had been told that trying to ski on the Arctic Ocean would be the worst journey in the world. But we could fly home from the North Pole; what a luxury compared to the men of old, the pioneers like Wally Herbert. This is still a frightening and deadly serious place, but I would also learn that it's the most beautiful place too. Wally understood this. He loved the Arctic Ocean. That is why he kept going back there. It was the place he felt most alive, most happy. I can understand this feeling. Colour is everywhere, not just endless white. It is bright blue, blue grey, white and blue again. And in between is deep red sun, sometimes bobbing on the horizon, with low, splashing rays that ignite the sky ablaze. And the colour rubs off on the pack ice and paints the scene in warm pink. Why would I not want to take a ski holiday in a world like this?

This may sound strange, but since I was a little girl I always wanted to be Pippi Longstocking. With her strength, courage and kindness, she was my role model. I especially liked her determination: 'I've never tried that before, so I'm sure I can do it!' I think this has been a driving force in my life. It's important to give anything a go. I had been on many climbing expeditions, and had even walked to the South Pole, but I'd never set foot on the Arctic Ocean. People said I wouldn't be tough enough, but that only made me want to do it even more. And so, to the North Pole I went.

LEFT The polar pack is roughly 5 million square miles of ice in a constant state of movement. Winds and currents churn the ice around, fracturing it, pressuring it into walls, or pulverising it into belts of mush. It is an incredibly challenging yet beautiful environment.

Here are glimpses of that time in 2006. Rolf and I have two sleds each. We move north with one at a time, forwards, then back, and forwards again with the other. We go three times the distance the GPS shows us each evening. Actually, it's much more, as we are rarely able to go straight north. Drifting south during the night, we wake to find we are back where we had been the day before. We force ourselves out of our sleeping bags to try harder and harder each day.

Clambering over pack ice, we gradually inch our way north. We balance on the slippery ice blocks, which are in constant motion. We jump, and crawl on all fours, climbing through holes, and all the time with our sleds in tow. The days are short so early in the year, the beginning of March, and we are at 83°N. But the sun yawns and stretches and climbs steadily slightly higher in the sky, remaining forty minutes longer each day. It warms my cheeks. There is a full moon in the same sky as the sun, and I look up and try to store away all these beautiful pictures in my head.

Drift ice has led us south again, one night as much as 9 km while we sleep. Mornings are not long; we will not sit there and float back more. I tie my boots hard, bend my neck. Ice can try to take you where it wants, but we're here to go against the flow. We're out on the ice choosing a different way of life. We strive each day, our heads full of thoughts. Or, sometimes, full of nothing and the days merge into each other. Suddenly we encounter a few miles of open, black sea. We must find a point that is narrow enough for crossing. We climb up the ridges to probe. We put on our dry suits to swim 60 m, the full length of the only rope we have. We can't safely cross open water that is any wider. Whoever is in the lead swims across first, we hook the sledges together, and the other follows on.

By 2 April we have been on the move for a month and the sun is in our sky throughout the day. It is no longer possible to separate the days from each other. The temperature is kinder and with the change in the weather comes more open water. Below us, the black ocean, 4 degrees cold and 4,000 m deep. Jump around, jump in, jump over? Some of the gaps are so narrow that we can put sleds in them, they make a bridge and we crawl over and pull our sleds across. If they are wide and open, we have to swim. We swim more and more. We are tougher now. We worry less. Sometimes there is not a cloud in the sky. Days like this are heaven when you have to swim through the ice. Throughout the trip we cross together hundreds of stretches of open water. Our speeds increase; we're no longer fighting the drift. Having struggled for sixteen days to cover the first degree, we spend a week from 86° to 87° latitude.

Now it is four days before we reach the Pole; the north wind is up and it snows hard. Rolf shouts out from behind that I should wait. I'm a little annoyed at stopping as I'm getting cold. He comes to me without his sled. Something is strange. He looks serious and a bit scared, but he skis right up to me, stops, then gives me a kiss. I'm about to say something, but he interrupts: 'You have been my girlfriend for more than three years, and I want us to be together when we get old. I love you', says Rolf, taking hold of both my hands and going down on his knees – on skis. I draw breath, as he asks me to marry him.

My boyfriend has red rosy cheeks and tears in his glacier blue eyes. As my tears flow, some of them freeze. I have hoped for this moment so many times, but I'm not at all prepared, especially not here, floating on the Arctic Ocean. 'Yes, of course I will!' Rolf takes off one mitten and one of mine and hands me a ring. It is the finest piece in the world; a ring he had secretly

woven together using wire from our repair set. We hug each other and cry a little – two happy souls drifting on a little piece of ice.

On the last day towards the North Pole, Rolf hands me the Norwegian flag, which has been lying on his sled since the morning. I ski with the flag in my right hand the last distance. Red and blue in contrast to all the white. I am silent. Happy, proud and touched, after 48 days and 22 hours on the ice. Tears are flowing again; our cheers from earlier in the day have subsided. We are on top of the world and with a flag waving to the south.

After the trip, we already had new dreams and plans. Rolf and I married soon after the North Pole and we explored more of the world together. But this pure happiness would not last. Rolf died in 2008 during an avalanche that killed eleven people on K2. I was coming down the mountain with him and was just 20 m away when the snow hit. I saw him swept off the mountain into the void. How could I go home, what was I going home to? Rolf was my home and I had to leave him there.

It took me time to find life again. It started on the coast in Norway, on the edge of the ocean. It was easier to breathe on the beach. I had the horizon, the air, the sky. Slowly I regained strength and developed new dreams. Rolf taught me that dreams are precious. So I asked two girlfriends if they wanted to cross Greenland with me. They both said yes. Suddenly I had found people with whom I could share my dreams once more. It helped me to come back to life.

On my girls' trip, an American climber and adventurer Ryan Waters joined us. We had met him in the Himalaya when I was a guide and he was welcome to come with us. After Greenland, I felt more alive and wanted to keep skiing. I asked Ryan to cross Antarctica with me. It was a journey that took 71 days, from 13 November 2009 to 21 January 2010. We packed 78 kg of food for 78 days and actually gave ourselves time to enjoy the 1,800-km march.

The following year I returned to the North Pole in mid-summer. This time I went with fellow Norwegian Rune Gjeldnes using skis and folding canoes. Well, we didn't get very far. Often there was too little water to paddle and too much water to ski. I experienced something on this trip that I'd learnt many times before: it is not the most important thing to reach the goal, but to go outside, to try your best and have fun. The North Pole has taught me that. It is something I take with me everywhere I go.

I have a boat in the Mediterranean and enjoy learning something new from scratch. If I've not tried something before, for me it's important to have a go. How else do I know? Sailing is a bit like skiing, the vastness, the sky, the freedom. Some people go into the wilderness to struggle and to overcome, some to find themselves, or to escape from the everyday. Perhaps some go to cure heartache, or just to find some silence. I can't forget the pink ice and the wondrous cold. I escaped to the North Pole and found memories I will cherish for life.

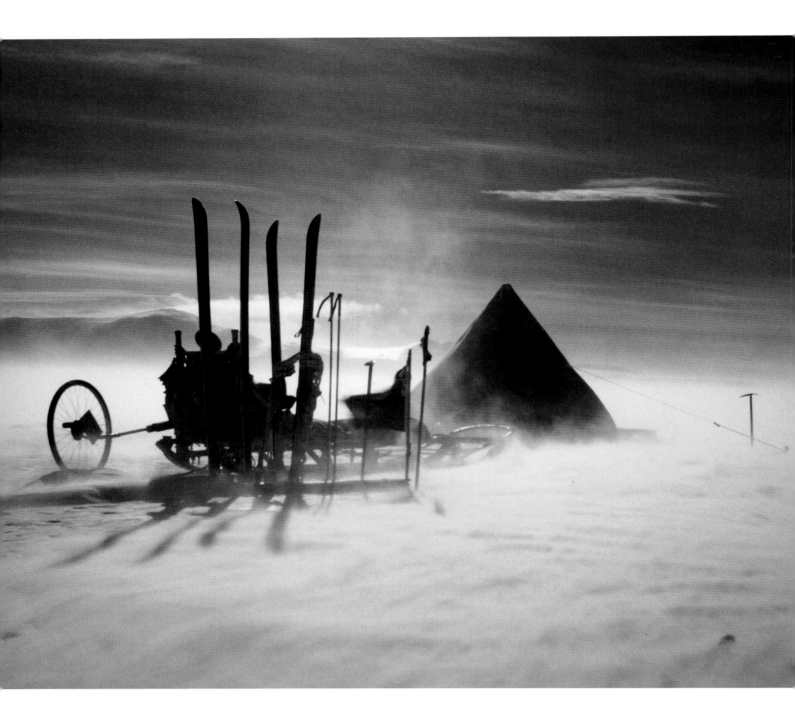

THE HARD WAY

ERLING KAGGE

The struggle often lies between the ears, not just in the feet. There's always a little voice inside my head that tells me to take the easiest alternative. To put off making a difficult phone call, perhaps avoid a tough job or tricky situation, to opt for the path of least resistance. It is tempting to want to fly to the top of Everest instead of climbing, or reach any goal by an easier route. When reading about Wally Herbert and his expeditions as a pioneer I'm reminded that it's meaningless to live with a 'make-it-easy-for-yourself' attitude. Wally did the opposite and chose the most difficult options. He had the courage to do things the hard way.

Walking to the North Pole was not enough for Wally. He and his men preferred to walk the longest way possible. He understood better than most that 'the unexamined life is not worth living'. I deeply admire him for that. He was leading his own life as an explorer, artist and thinker, actively taking responsibility for himself. We have to be willing to take up more burdens in order to be free. I admire Wally for many other things too – for his romantic attitude, for his standing up for those he believed in, for giving his committee sitting in comfort in London hell, for his lifelong desire to discover his true inner self. As many wise men have claimed: 'he who has something to live for, can stand almost anything'. No one showed this better by example than Wally Herbert.

Being an explorer today is obviously very different from what it was like in the past for legendary pioneers such as Roald Amundsen, Ernest Shackleton and Wally. They were the first – they struggled to reach the Poles. Today we stand on their shoulders. Yet, a polar expedition can be reduced to the most simple of things: it's still about surviving the night and then putting one leg in front of the other. The true challenge lies in

daring to do it at all, not least bothering to do it for 3,720 tough miles, for some 470 days, like Wally did.

When I'm asked what the hardest thing is out there in the wilderness, I'm never in any doubt as to my answer: getting up in the morning. There's something unspeakably tempting about remaining in your sleeping bag when it's 50 below, as it was at times on my own way to the North Pole. To save on weight we had neither sufficient fuel to warm up the tent nor extra underwear, so for the 63 days the expedition lasted I didn't undress a single time. On that journey there was no shortage of reasons to remain in a sleeping bag: cold, wild weather, illness, tiredness and injury.

Of course getting up can be painful, but what's even worse is lying there dreading doing so. Because the greatest danger – as in life – is putting things off. And I must get up, or I will die. It's simply a question of whether I put it off for five minutes or five hours. Most things are easy thereafter. All that I am dreading – frostbite, blisters, exhaustion – are, as a rule, never so bad once I've got going. Countless times I've been in my tent or on a boat listening to wild weather outside, dreading getting up and creeping out. It took many years before I ceased to be surprised that the wind was seldom as bad outside as it sounded when I was lying listening to it tugging at the flysheet of the tent or in the rigging. On expeditions, as in many things, the first step is always the hardest.

❧

We are all *born* explorers. You, me and everybody else. When I look at my three daughters, they are wondering what's hidden behind the next hill, and they started to climb chairs, stairs and

LEFT In 1961 in Antarctica Wally's team was caught in a blizzard on the edge of the Polar Plateau. On 3 February the weather cleared and he was able to set up a survey station to complete his map and take this photo. Several months later, working up his field notes at Scott Base, he realized that they had camped, by coincidence, at precisely the same place as Scott, Wilson and Shackleton – their 'Farthest South' of 30 December 1902.

the like before they learnt how to walk. My challenge as a father is to make sure they do not stop wondering about what lies beyond their horizon. Because to be an explorer is not something you become, it is something you are from birth. To venture outdoors is a natural state of mind. But if you are not very careful, in your daily life you will lose this curiosity early on. Years of school, parents' expectations and society's various demands slowly grind your original spirit down and eventually you begin to behave in a civilized manner.

Adam and Eve left paradise because it was dull. They had to choose between the ultimate happy life in easy circumstances on the one hand, or the pursuit of knowledge on the other, with challenges that would bring not only happiness but also unhappiness on the way. They were the first two explorers in history. 'In paradise all dreams are made real. Everything is perfect – too perfect', a friend of mine commented. And my guess is that this is also one of the reasons why many people still dream about leaving the easy life to head into the icy wastes and suffer a little.

The most common question put to an explorer is: 'Why?' Why choose to wake up to a temperature of minus 54°C on the pack ice near the North Pole, why ski to the South Pole in total solitude, or why not climb a mountain next to Mount Everest? 'Because it is there' is obviously the preferred reply, borrowed from George Mallory, and it is a useful one because it suggests that there is actually very little we *have* to do in life. I believe most people primarily travel to the Poles for everything that is not there, and to a lesser degree for what's there. The lack of heat and other people, few disturbances, little shelter from the weather, hardly any safety nets if something were to go wrong. The minimalistic environment becomes a part of the enriched feeling of using your potential, being present in your own life and reaching for something that is beyond yourself – and eventually to feel happy.

If most people could do it, you would have to find somewhere else to travel to. And Mallory's reply is more honest than the frequent reasons repeated by people skiing to the South or North Pole today: to raise money for charity or scientific research, peace, to celebrate old heroes like Scott and Amundsen, to protect the environment or vulnerable cultures, and a love for the natural world. It may all be true, but adventurers tend to forget their other reasons: egocentricity, a need for attention and recognition, revenge, nationalism and money. I admit to feeling some of these things.

There is, however, one element that is even more important, and seldom mentioned: *to explore is a love affair*. And a very intense one. As soon as the idea of becoming the first human to ski to the South Pole alone appeared between my ears I made the decision to do it, and stopped thinking about anything else. It is an absurd thing to do, but love makes you blind. I fell in love with skiing into a white nothingness with everything I needed for the whole expedition on my sledge.

ↄ

There were always people standing on the beach to greet legendary discoverers such as Christopher Columbus, Captain Cook, Ferdinand Magellan and Leif Eriksson when they 'discovered' new places. These classic journeys of discovery – more accurately journeys of *re*discovery, as most such journeys actually are – have to do with travelling as far as possible from where you start,

responding to a difficult goal that you have set yourself. Across, beyond and perhaps above. To uncover something that can be described as a white spot on the map, real or imagined.

The good news now is that a small adventure contains many of the same elements and richness of experience as any big expedition. The joy to be found in making the decision to reach for something beyond oneself enriches not only your own life, but the lives of those you care for. A day away from home, a night in the forest, a weekend in the mountains or sailing with friends can be the start of a very special journey. The long expeditions have taught me to appreciate the smaller adventures more. The stillness in the wilderness is profound. At home there's always a radio on, a phone ringing or a car passing by. All in all there are so many sounds that I barely hear them. But on the ice I became so drawn into my environment, so much a part of it, that stillness became part of me, something I could listen to.

Nature gave Wally a great deal. Not the type of information we acquire in school – facts, ideas and theories that change generation by generation – but the kind of knowledge that can last you a lifetime. On the ice you are a part of nature and connected with everything around you. You are simply, completely aware of every moment there and at that time. Past and future are irrelevant. I try to remember that feeling in my life at home, where I can tend to neglect the immediate in preference for what is to come. I believe that being so present in one's own life in such an intense way taught Wally not to take life for granted. And hopefully it also taught him to be happy to exist.

Now and again I dream about life on the ice, because I'm in no doubt whatsoever that life out there in all its simplicity was uncommonly rewarding. I felt I had everything I needed, and that I was the richest man in the world. The hugeness of the landscape and the colours of the Arctic Ocean ice would make anyone travelling there happy. I've learnt that blue is the colour of poetry, white of purity, red of passion and green of hope. But out on the ice such a classification doesn't seem natural. What colours symbolize is up to you. After some weeks all of them stand for poetry, purity, love and hope. The following day, red, blue and white can stand for storm and frost, or for terrible dangers too.

It can feel unpleasant and risky to change your own world, experience nature and spend less time in civilization. But perhaps it's even more risky to do nothing; even more perilous a thing *not* to try to discover how good life can be away from town. What you will regret in times to come are the chances you didn't take, the initiative you didn't show, what you didn't do. If you say it's impossible and I say it's possible, we're probably both right.

When I've felt my own smallness in relation to nature, I've often also felt an inner greatness. I've gone through terror and happiness, known relief and disappointment, beauty and pain, sensed closeness to the elements, given of myself and received, had the joy of physical exertion, and been strengthened in the view that there are still challenges and dreams worth giving one's all for. I don't recommend you to do what I have done, even though I know that it may be within your power. It is not up to me to advise anyone to follow in an explorer's footsteps, but I strongly recommend everyone to search for their own North Pole. It is never easy, but going the hard way usually gives the greatest reward. In all, this message is simple: you can't make any dreams real if you always stay in your sleeping bag.

ULTIMA THULE

GEOFF RENNER

Wally and I were friends for more than forty years and I had the good fortune of travelling with him to the high latitudes in both hemispheres. We first met in the summer of 1967. I was employed by the British Antarctic Survey to assess field data collected during an eighteenth-month tour to the Antarctic Peninsula, where Wally began his remarkable polar career. With only a few months remaining until he left for Point Barrow, Alaska, for the start of the British Trans-Arctic Expedition, he talked about the preparations and challenges facing his four-man team.

Their successful crossing of the Arctic Ocean along its major axis was a pioneering feat, hugely respected in the circles of exploration and discovery – and one not yet repeated. In the two hectic years following this North Pole triumph, Wally wrote and lectured about it, became a husband to Marie, a father to Kari, and was already making plans for his next expedition: to revisit the Far North for an extended stay among its indigenous peoples. On this occasion he chose to take his new family too. Wally wished to record in words, brush strokes and film the Inuit way of life, through all seasons of the year. For Marie, a polar newcomer, the challenges were huge, not least to become accepted as part of the community and look after a daughter not yet one year old. 'Ultima Thule' was the name chosen for the family adventure to Northwest Greenland. They stayed for almost eighteen months, living with the Polar Eskimos at a tiny settlement called Qeqertarsuaq, also known, coincidentally, as Herbert Island.

Wally invited me to come north for a few months and to join him on a lengthy dog-sledge journey to observe and document the spring hunting of polar bear, walrus and seal. We were to travel with Wally's close friends Avatak and Peter Peary, the Inuit grandson of Robert Peary, both exceptional hunters. But first, I needed to reach the tiny settlement itself. Arriving at Thule air base from Copenhagen, I was met by Wally and Marie with their team of sixteen huskies. Ahead lay a 70-mile route across sea ice, snowfield and glacier. Not far into the journey we found ourselves cramped and confined beneath a makeshift tent enduring a storm that had been accurately forecast, though not in its ferocity or speed of approach. Wind speeds up to 170 knots were measured at the air base. The pitch was far from perfect. Upwind the guy lines were secured on to the overturned sledge; downwind they looped snug belays tunnelled into the hard sea ice. An Inuit harpoon raised an untidy pyramid of the tent's fabric, providing space enough to breathe but little else. Inside, we three figures lay semi-prone; darkness had stolen the light and conversations had surrendered to the wind's voice. Driving snow hammered against the shelter and spindrift invaded within.

By dawn the icescape was emptied of its aggression. The clear air was frosted calm, the visibility sharp; the skies heralded a clear blue and the ice had thankfully remained fast. As we emerged, we stretched stiffened limbs and dusted the fine snow from our furs. Our team of huskies emerged from beneath drifted snow, shook themselves then clamoured for our attention. With the sledge loaded and lashed, the dogs were harnessed and encouraged by a gentle cast of the whip. Ahead of the fan trace lay a punishing terrain with the added urgency of reuniting with baby Kari, who was in the temporary care of Maria and Avatak, their Inuit neighbours.

This was my welcome into the Arctic world of Wally and Marie. For Wally that journey was but one of an archive; for Marie, it was a memorable introduction to demanding polar

RIGHT When Wally decided to take his family to live in Greenland many companies offered their support. Here baby Kari appears in a publicity shot for Heinz, with half a ton of baby food to last her through the polar winter. The Inuit children rather liked it, but Kari preferred the local diet of raw fish, seal and walrus.

travel and the first of many adventures they would share. For the waiting Kari it was another opportunity to learn a few more words of Inuktun and further astonish and confuse her parents with her native vocabulary. For me, it was the first time I came fully to appreciate just how at one Wally was with the environment of the Polar North – by adapting to it, not fighting it, he thrived there. This was quickly apparent in his dog-driving skills, very different from those perfected for Antarctic surveys, now transformed and mastered for Arctic survival.

Spring was moving towards summer by the time I had to leave. The fast ice had relaxed its grip on those overwintering icebergs near the village, and they drifted south. Likewise, the residents of the settlement and its guests moved to summer camp for a more relaxing season of living, learning and laughter. No matter the season or circumstance, Wally's admiration for the Inuit hunters was reciprocated, for they too recognized his aptitude in their world. Few from abroad who reach out to those testing latitudes attain that credit.

In time, each of the family would come to publish recollections of those privileged times: *Eskimos* by Wally, *The Snow People* by Marie and, three decades later, *The Explorer's Daughter* by Kari. For my own part, I felt very fortunate in being able to share in what was such a special time in their lives.

In later years, Wally and I frequently sailed together to Antarctica, mostly on the expedition cruise ships *Explorer* and *World Discoverer*. I remember him on South Georgia, the mountainous snow-capped island, a sublime place that is home to over three million seals, half a million king penguins and the wandering albatross. Wally, ever the self-confessed non-birder, always referred to that bird light-heartedly as 'Albert Ross'. It is also the island associated of course with Sir Ernest Shackleton.

At Grytviken, on the island's more sheltered northern coast, Shackleton is buried in the small whalers' cemetery. His headstone is hewn from grey Scottish granite and faces South. On a blue-sky morning of 26 January 1996, 80 or so passengers and staff were there, recently landed from the *Explorer* at anchor in the bay. Wally had been invited to lead us ashore and pay tribute to Sir Ernest. I remember his words clearly: 'Shackleton was an inspired man, a leader of men, the man who never lost a man. He was an Explorer. He was an Explorer's Explorer. But greater by far than all of his human qualities was the SPIRIT of the man.' That spirit, Wally believed, epitomized and inspired all those early explorers during what many refer to as the Heroic Age; whatever their nationality or quest, these men were united in their willingness to act on their dreams and pursue their goals. They were drawn to the ice by an urge to experience more. Wally could understand why.

When I think of Wally back at home, I immediately see the family sharing winter evenings together in Devon or in Scotland, usually around a table decked with candles and a bottle or two of vintage Beaujolais. A log fire adds to the warmth and Wally's mischievous humour sets the mood. Depending on the number of guests, dining chairs might comprise stacked sledging boxes, keepsakes from his North Pole crossing. We'd share stories into the small hours.

Thirty-five years after the Trans-Arctic Expedition reached the North Pole I set foot at exactly 90°N – according to my GPS. Times had changed since 6 April 1969 when Wally and his team had determined that absolute spot with theodolite and sextant, all the while moving on the skin of a crystalline ocean. Their arrival in 1969 had been hard won after months of exacting sledging; mine followed a few comfortable days lecturing

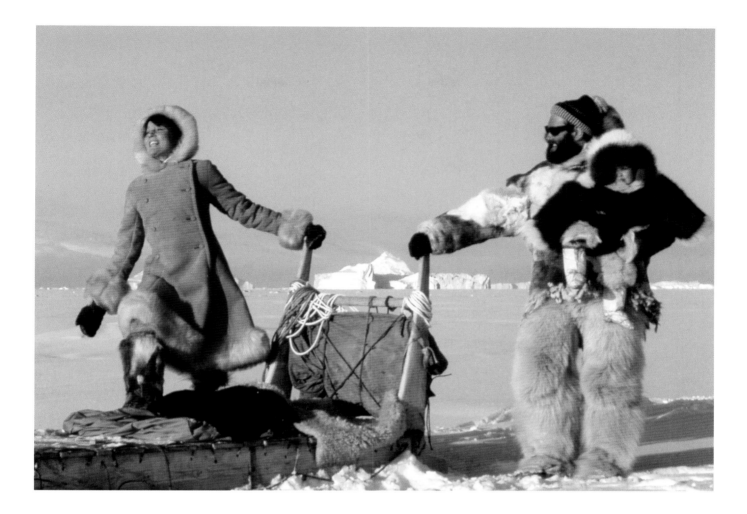

aboard a powerful Russian nuclear icebreaker. As the passengers and crew disembarked on to the ice to rejoice in their own attainment, I withdrew to a nearby ice floe in the lee of a pressure ridge. During the Trans-Arctic Expedition I had been flown to Point Barrow as a possible replacement for one of the team when injury had threatened his evacuation. Happily he recovered and the party continued as it had started. Now, in quiet isolation, I could visualize Wally, Allan, Fritz and Ken arriving in different times and circumstances. I celebrated their supreme achievement with them, and for them, in the privacy of my own mind.

My final memory of Wally is a simple one. He is standing with Marie on the doorstep of their Scottish croft looking over the mist-blanketed meadows stretching to the Highlands beyond. For others, of course, he will be remembered for his contributions to polar exploration, or his cartography, scholarship, art and the wise counsel he generously gave to those seeking out their own adventures. The pleasure of being a friend was also to see him as a devoted family man: husband to Marie and father to daughters Kari and Pascale. Love, support, joy and memory bonded them in what was his life's tough calling as a true explorer. They understood his motivation, appreciated his achievements and dwelt in his compassion. Friends, acquaintances and family alike, we all still admire the SPIRIT of the man.

ABOVE The joy of being in the Arctic together as a family: Marie, Wally and Kari are sledging on the sea ice in Greenland in early spring 1972.

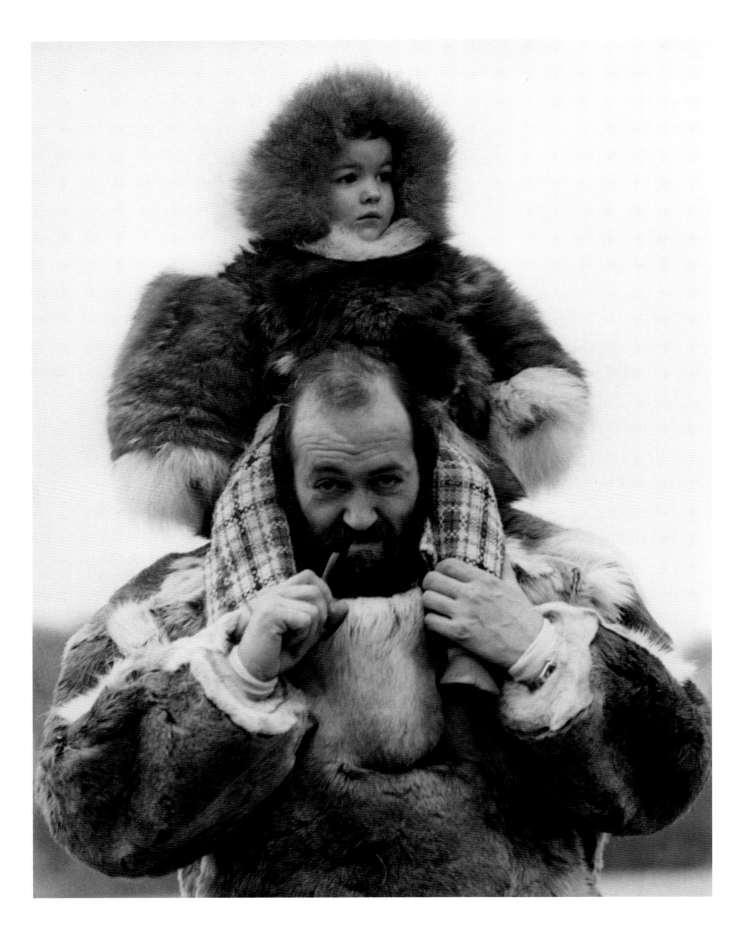

MY FATHER

KARI HERBERT

When I was just ten months old my father took my mother and me to the wilds of Greenland. We were to live with an indigenous tribe of hunters known as the Polar Eskimos, or *Inughuit*, with whom he had travelled when training for the Trans-Arctic Expedition in 1967. Throughout his life my father had been drawn to those places on the planet that seemed beyond reach, and the Arctic and the Inughuit held for him a particular fascination. There was no doubt in his mind that we should go too.

Our destination was Qeqertarsuaq, a tiny island off Greenland's northwest coast, which supported one of the last hunting villages. It was a subsistence community on the fringes of civilization; there was no electricity or running water – ice from freshwater icebergs was melted for daily use – and an entire family would sleep on a single wooden platform covered in skins and pelts. They were utterly in tune with their environment and wholly respectful of the animals they shared it with.

The little red hut which was to be our home had only ever been used as a shelter for visiting hunters. Outside, huskies lay sprawled among bleached bones and boulders and on the roof were the rotting remains of walrus and whale. Inside, the walls were stained with old blood and grime, the windows were cracked, and the smell of decaying meat was overwhelming. 'We had to paint it immediately,' Dad would smile years later, 'so it would seal in the smell.'

My father was in his element in the polar wilds. The Inughuit hunters sensed it and they put his skills to the test. He passed. So much so, that when my mother and father were caught in a terrible storm returning from Thule airbase on one occasion, the hunters refused to go in search of them. They told their wives it would be an insult to help someone of his experience. There is huge fondness for the memory of my father, whose name they pronounced 'Ooaalee', among those Inughuit who knew him. Still the hunters laugh at the stories he told when sharing a brew on a hunting trip; they reminisce about his understanding of their traditional culture, and say with pride how he drove dogs like a true Inuk.

That time in Greenland was the greatest gift my parents could have given me. The villagers became our friends, our family. The first words I spoke were in their language, I took my first steps on the polar tundra and, for that magical time, I was part of their tribe. We lived with them for nearly two years, and could have stayed longer, but my parents were worried I was becoming too wild, and that returning to Britain would be too much of a culture shock.

Back in England we had a regular stream of visitors to our new home – old sledging companions and eminent polar scientists, as well as ambitious young adventurers hungry for advice. By

LEFT Kari was just ten months old when her father first took the family to Northwest Greenland. They spent the winter of 1971 in an isolated hunter's hut. Her first words were in Inuktun and her first steps were taken on the polar tundra.

the fire they and my father would swap stories late into the night, and each visitor would leave well fed and inspired.

It was only later in life that I realized our experiences as a family were often far from 'normal'. Fox-fur clothing and seal-skin boots were nestled among the packets of peas and ice cream in our freezer; narwhal tusks framed the fireplace and polar books covered every wall; my father's North Pole sledge lay for years in our front garden before it made its way to a museum; on my bedroom ceiling he had painstakingly stuck all the major constellations of the northern sky in glow stars – whenever he was away on his journeys I stared at that ceiling knowing that Dad would be looking up at those same tiny patterns of light to find his way home.

On 12 June 2007 my father passed away. Though he had been ill for some time, the sudden loss was devastating. I felt uprooted, bewildered and strangely unprotected. Some of the sparkle of life was gone. The night he died I dreamed he was on a dog sledge, racing up and over a rainbow to his next great adventure. I woke up in tears, my arm sore from waving goodbye.

In this book are a host of stories, images and recollections that build a picture of an extraordinary polar traveller; a pioneer, a man with a vision; a hero. To many people their father is a hero, and yes of course he was mine, but more important than that, he was a kind spirit and my own very loving Dad.

My mother and father always joked that my sister Pascale and I had chosen them to be our parents. If this is true, then I chose extremely well. My mother's wisdom, energy and empathy continue to be an inspiration to me. Her sweetheart, my Dad, was an instinctive explorer and a gifted writer and artist; he was a warm and generous family man and a wonderfully funny story-teller. You couldn't have found a more loyal friend too. 'The thing about Wally,' his sister Kath said to me after he died, 'was that he lifted something up in you.' She was absolutely right. I am immensely proud of these qualities in him.

I am surrounded by things that remind me of my father. On my writing desk is a photograph of the two of us in our hut in Greenland – Dad wearing his 'Eskimo' anorak, a big beard and a big smile, with me in his arms. Beside this picture is an assortment of tupilaks, small carvings that my father had been given by his friends in the North. Every time my daughter Nell and I see a rainbow, we say 'hello' to Grandpa. Huw and I are looking forward to taking her to the Arctic this year to dance on the sea ice, ride a dog sledge and listen to our Inughuit family share some stories about 'Ooaalee'. In time, Nell will learn just what a special person her Grandpa was.

RIGHT Not yet two years old, Kari plays in a hut in Etah in the far north of Greenland. It was here that explorer Robert Peary overwintered before trying for the Pole in 1909. The tiny settlement is now abandoned, though Inuit still travel here to hunt walrus and polar bear.

FOLLOWING Original colour prints from Wally's early expeditions in Antarctica, which included overwintering twice in a hut at Hope Bay and then leading the first crossing of the Peninsula in 1957.

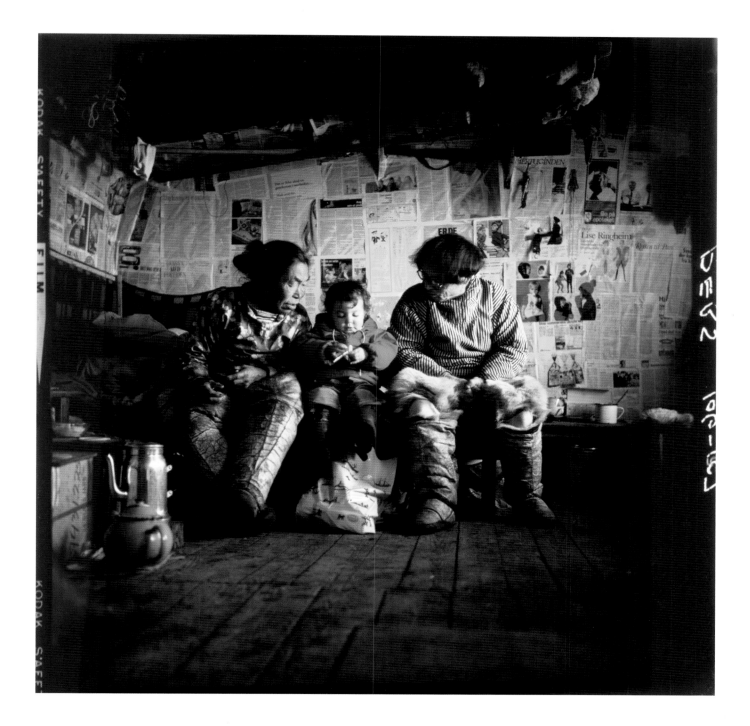

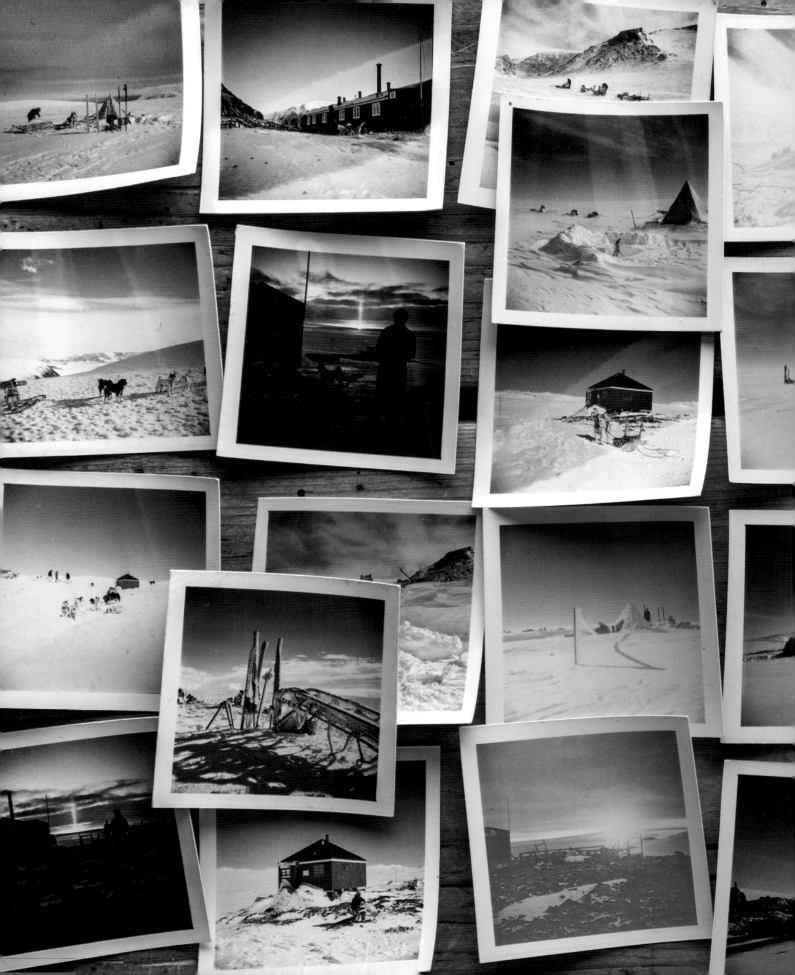

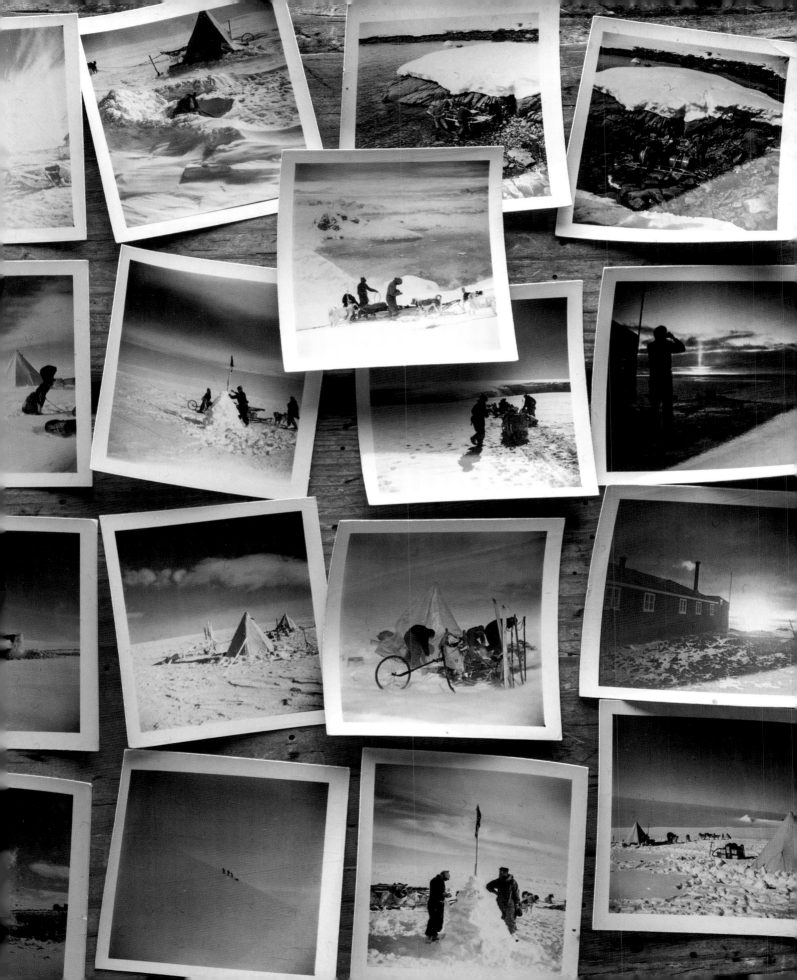

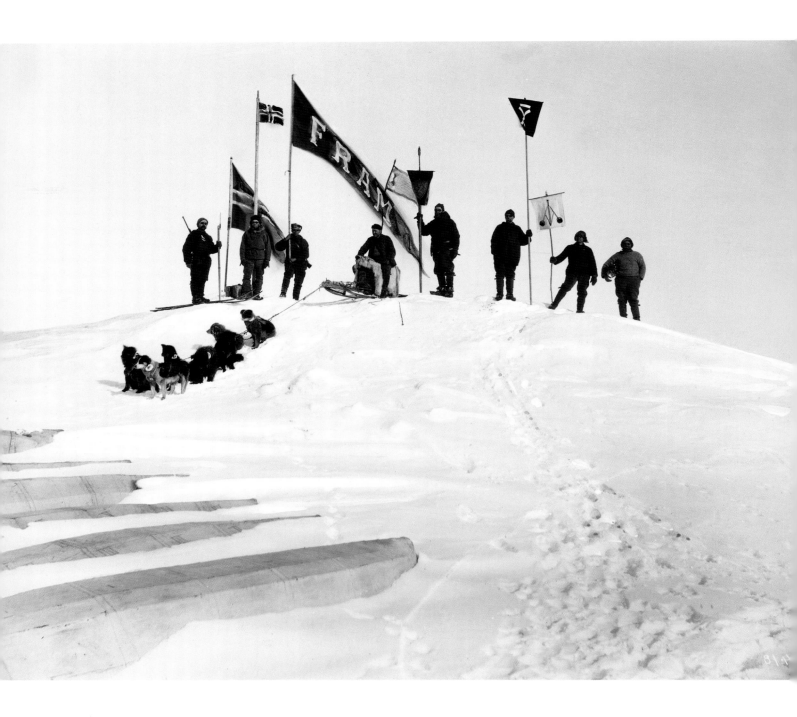

ABOVE The crew of *Fram* parade with flags and banners as they continue their long drift locked in the ice of the Arctic Ocean, 17 May 1895. Their leader, Fridtjof Nansen, has left the ship to push north for the Pole. Nansen's willingness to defy conventional wisdom and take on a challenge that many thought impossible was an inspiration to Wally. Nansen defined the *difficult* as that which can be done at once, and the *impossible* as that which may take a little longer.

A NORTH POLE CHRONOLOGY

A TIMELINE OF NORTH POLE FIRSTS, MAJOR (AND MINOR) MILESTONES, TRAGEDIES AND TRIUMPHS

1773 Constantine Phipps commands the first British naval voyage of discovery towards the North Pole. His orders are to take the ships *Racehorse* and *Carcass* beyond Spitsbergen. They reach a farthest north of 80°48'N on 27 July, though spend much of their voyage locked in the ice and are lucky to escape before winter. It was on this expedition that the young Horatio Nelson is said to have fought with a huge polar bear. They exceed the record of 80°28'N established by the Russian Vasily Chichagov in 1766 and their record is not surpassed until the whaler William Scoresby reaches 81°30'N in 1806.

1778 James Cook's last voyage, in command of *Resolution* and *Discovery*, explores the coast of Alaska and northeast Siberia. The ice in the Bering Strait proves to be impassable.

1818 A British naval expedition under David Buchan in *Dorothea* and John Franklin in command of *Trent* aims to find a passage from Spitsbergen by way of the North Pole to the Bering Strait. Their progress is halted by storms and an impenetrable barrier of ice at 80°17'N.

1820–23 Ferdinand von Wrangel explores the Siberian coast with dog sledges and sights the island now named after him.

1827 William Parry in command of *Hecla* is ordered by the Admiralty to attempt the North Pole from Spitsbergen using boats fitted with sledge runners. Progress is piecemeal: the southward drift of the ice proves more rapid than they can haul themselves north, but they achieve a new record of 82°40'N that will stand for nearly fifty years.

1829–33 John Ross leads a privately funded Northwest Passage expedition on *Victory*. Ross's nephew, James Clark Ross, sledges up the Boothia Peninsula to become the first to reach the North Magnetic Pole, on 1 June 1831. *Victory* is caught in the ice and abandoned and the crews are lucky to be rescued by a whaler. For the British public, confused between the North Pole and the North Magnetic Pole, this is seen as a definitive achievement. Ross does little to correct the misunderstanding.

1845 Sir John Franklin's *Erebus* and *Terror* disappear without a trace, attempting to navigate a Northwest Passage. Many expeditions are sent in search of the missing party and these rescue missions resurrect the quest for the North Pole.

1852 Searching for Franklin, Edward Inglefield discovers Smith Sound running up the coast of northern Greenland. This is the opening that encourages many other expeditions to go north in his wake.

1853–55 Elisha Kent Kane commands a US expedition on *Advance* up Smith Sound. He survives mutiny, the loss of his ship and a difficult boat journey back to safety, announcing that he has found an 'Open Polar Sea'.

1860–61 Isaac Israel Hayes with *United States* sails up Smith Sound. He too sees clear water, which he mistakes for an open sea all the way to the Pole.

1869–70 Germany mounts an expedition under Carl Koldewey with *Germania* and *Hansa*. Sledges explore the east coast of Greenland, reaching 77°01'N.

1871–73 The American Charles Francis Hall attains 82°11'N via Smith Sound aboard the *Polaris*. The expedition falls apart after Hall's death and the ship is wrecked. Half the crew drift south on an ice floe until they are rescued almost six months later.

1872–74 Karl Weyprecht and Julius Payer of Austria-Hungary believe a Gulf Stream might create a 'thermometric gateway' to the Pole. Their ship *Tegetthoff* is trapped in the ice and they drift north to discover a group of islands which they name Franz Josef Land. With scurvy debilitating the crews, they abandon ship and drag their boats south to open water.

1875–76 George Strong Nares leads a British naval expedition with *Alert* and *Discovery* through Smith Sound. Sledge teams man-haul along the northern coasts of Greenland and Ellesmere Island to 83°20'N.

1878–79 Swedish Baron Adolf Erik Nordenskiöld on *Vega* successfully traverses a Northeast Passage.

1879–82 George De Long of the US Navy navigates the Bering Strait with *Jeannette* in search of currents to the Pole. Drifting in the frozen Arctic Ocean, the ship eventually sinks. Twelve men, including De Long, perish in the Lena Delta.

1881–84 The First International Polar Year. American Adolphus Greely sets up a post at Fort Conger on Ellesmere. One of his lieutenants reaches 83°23'N, beating the Nares record by 4 miles. When supplies fail to arrive, Greely evacuates his men overland. By the time they are rescued only six of the 24-strong team are alive; some have resorted to cannibalism to survive.

1888 Fridtjof Nansen of Norway makes the first crossing of Greenland's inland ice sheet from east to west.

1893–96 Nansen sails *Fram* into the polar pack, hoping that it will drift with the ice from Siberia to the Atlantic. Nansen and Hjalmar Johansen leave the ship to try skiing to the North Pole. They reach a record farthest north of 86°12'N before retreating to Franz Josef Land. They are rescued by British explorer Frederick Jackson, who has also made an attempt on the Pole, but manages to sledge no further than the northern islands.

1897 Salomon Andrée, a Swede, flies in the *Eagle* balloon. At 82°93'N he is driven down by bad weather and tries to cross the ice back to Spitsbergen. His remains are discovered on a small island in 1930. This is the first landing of sorts on the pack ice, but he is nowhere near the Pole.

1898–1902 Norwegian Otto Sverdrup spends several winters on the coast of Ellesmere in *Fram* and explores the western extent of the archipelago. American Robert Peary also has numerous northern adventures. From Ellesmere he travels over the sea ice to 84°17'N in his first attempt to reach the Pole.

1899 American journalist Walter Wellman tries to sledge to the Pole from Franz Josef Land, but is brought home a near-cripple having not made much distance north of the islands.

1899–1900 The Italian Duke of Abruzzi winters on Rudolf Island. His second-in-command, Umberto Cagni, reaches a new northerly record of 86°34'N, surpassing Nansen's farthest north.

1901–02 With the support of US industrialist William Ziegler, Evelyn Baldwin tries to reach the Pole from Franz Josef Land using dogs and ponies.

1903–05 Norwegian Roald Amundsen completes a Northwest Passage aboard *Gjoa*.

1905–06 Peary sledges across the sea ice from Ellesmere, reaching 87°06'N, though his readings are criticized. Danish explorer Ludvig Mylius-Erichsen travels along the northeast coast of Greenland and also finds serious errors in Peary's maps.

1906 Wellman tries again, this time by airship from Spitsbergen; engine failure prevents him from taking off. He returns in 1907 with a more reliable airship, but it crashes on a glacier; in another attempt in 1909 he flies a few miles north before being forced back – the airship later blows up.

1908 American Frederick Cook travels through the Arctic west of Ellesmere and declares that he has reached the Pole on 21 April. Initially lauded, he is soon shown to be a fraud.

1909 Peary sledges to the Pole from Greenland and on 6 April raises his flag close to 90°N. He returns to America to a hero's welcome. Unlike Cook, his claims are upheld during his lifetime. His readings are later proved to be false.

1913–14 An expedition by Russian surveyor Georgy Sedov aboard *Foka* manages to survey some parts of Novaya Zemlya and Franz Josef Land, but Sedov dies during a sledge journey.

1913–15 Russian mariner Boris Vilkitsky makes the first east–west crossing of the Northeast Passage with *Taymyr* and *Vaygach*.

1921–24 Danish explorer Knud Rasmussen makes an epic trek with dog sledges from Greenland to Siberia, completing a Northwest Passage and conducting wide-ranging ethnographic work.

1925 Amundsen and sponsor Lincoln Ellsworth leave Spitsbergen in two Dornier flying boats. They reach 88°N before engine failure forces them down. After two weeks of repairs, they just manage to escape. These are the first aircraft to land on the ice.

1926 Americans Richard Byrd and Floyd Bennett, pilot, fly to the Pole from Spitsbergen on 9 May in the Fokker trimotor *Josephine Ford*. Over the following years their claims to have reached it are called into doubt. A few days later,

Amundsen, Ellsworth and Italian pilot Umberto Nobile cross the Arctic Ocean from Spitsbergen to Alaska on the semi-rigid airship *Norge*, passing 90°N overhead on 12 May and flying nonstop. They are the first people, without doubt, to see the North Pole.

1928 Australian Hubert Wilkins and pilot Carl Ben Eielson fly from Point Barrow, Alaska, to Spitsbergen by plane in a 20-hour flight. They touch down along the way at Grant Land on Ellesmere. Nobile again flies over the North Pole in the airship *Italia*, but crashes on the return to Spitsbergen. He narrowly escapes with his life.

1937 Under the leadership of Ivan Papanin a Russian expedition is landed about 20 miles from the North Pole by aircraft on 21 May. Establishing a scientific station, they float for eight months before being picked up off the east coast of Greenland after a drift of 1,324 miles. They are evacuated by the icebreakers *Taimyr* and *Murman*.

1941 Russian aviator Ivan Cherevichnyy flies to the 'Pole of Inaccessibility', the most remote point in the Arctic Ocean.

1948 On the instructions of Stalin, a team of 24 Soviet scientists led by Aleksandr Kuznetsov are flown north for scientific and strategic purposes. Cherevichnyy lands them at the North Pole on 23 April for the first time in history. He is made a 'Hero of the Soviet Union' for his efforts. They are the first people undisputedly to stand at the Pole. From this point onwards the Soviets establish regular drifting research stations on the Arctic ice pack.

1952–60 America establishes a research station, T-3, on a large tabular iceberg they name 'Fletcher's Ice Island', which drifts for eight years in the Arctic Ocean. The base includes huts, a power plant and a runway for wheeled aircraft. Before the era of satellites, T-3 is a valuable strategic site for atmospheric measurement.

1958 American nuclear-powered submarine *Nautilus* commanded by William Anderson crosses the Arctic Ocean without surfacing, reaching the Pole on 3 August. The following year American submarine *Skate* breaks through the ice and surfaces at the North Pole on 17 March.

1962 Soviet submarine *Leninski Komsomolets* reaches the North Pole. As the centre of the populated hemisphere – separating the Eurasian landmass from North America – the Arctic Ocean attracts huge strategic and geopolitical interest.

1968 American Ralph Plaisted travels close to the North Pole on a snowmobile, though he uses aircraft to cross sections of open water and his claims are later disputed.

1968–69 British explorer Wally Herbert leads the first surface crossing of the Arctic Ocean, from Alaska to Spitsbergen. They are on the sea ice for 476 days in total, sledging over 3,700 miles. They reach the North Pole on 6 April 1969. If Peary's claims are false, as most now believe, Herbert and his team are also the first men in history to reach the Pole by surface travel.

1970 Count Monzino, Italian millionaire, reaches the North Pole on 19 May. His five-man team is supported by 13 Inuit hunters and 150 huskies. The following year British submarine *Dreadnought* also reaches the North Pole.

1977 The first surface ship to reach the North Pole is the nuclear-powered Soviet icebreaker *Arktika*, commanded by Yuriy Kuchiyev, arriving on 17 August.

1978 Japanese adventurer Naomi Uemura completes a solo journey to the North Pole from Cape Columbia, the northernmost point of Canada, by sledge with 17 dogs.

1979 Dmitry Shparo and six Soviet companions reach the Pole after a march of 930 miles without dogs or sleds. They are the first to reach the Pole on skis.

1979–82 Sir Ranulph Fiennes leads the Transglobe Expedition, the first circumpolar journey round Earth.

1985 Sir Ed Hillary and lunar astronaut Neil Armstrong join a trip to fly to the North Pole. Once there they open a bottle of champagne, which freezes solid before two glasses can be poured. With this easy trip, Hillary effectively becomes the first person to stand at both Poles – he journeyed to the South Pole by tractor in 1958 – as well as on the summit of Everest.

1986 American Will Steger leads an international expedition with 21 dogs, the first to reach the Pole without resupply. Ann Bancroft, also American, becomes the first woman to trek there. Frenchman Jean-Louis Étienne reaches the North Pole solo.

1987 Wally Herbert returns to the North Pole, flying from Ellesmere in a Twin Otter while making a film. A Japanese expedition arrives there too, with Shinji Kazama riding a motorbike and two Inuit snowmobile drivers in support. The trend for adventurous polar stunts continues to this day.

1988 In the first crossing of the Arctic Ocean from Siberia to Ellesmere, a team of nine Soviets and four Canadians is led by Dmitry Shparo. Canadian Richard Weber also becomes the first man to reach the Pole from both sides of the Arctic.

1990 On 4 May Børge Ousland and Erling Kagge from Norway arrive at the North Pole on skis after a journey lasting 58 days. They are the first people to reach the Pole without resupply and without dogs. To travel 'unsupported' and in this way is now the new benchmark for competing adventurers, though most are flown home from the Pole itself.

1991 Nuclear-powered icebreaker *Sovetsky Soyuz* is the first ship with passengers to reach the Pole. By 1998 she had made another six voyages there. Herbert is invited as a special guest on the voyage, which also makes the first surface vessel crossing of the Arctic Ocean, from Murmansk to the Bering Strait.

1993 Weber and Russian Mikhail Malakhov lead the first commercial North Pole expedition. Today companies take more than 100 people trekking to the Pole each year. Men and women of many nationalities are now able to have their own personal triumphs.

1994 Ousland becomes the first person to walk solo and unsupported to the North Pole.

1995 Weber and Malakhov become the first to reach the Pole and return to Canada with no outside help, no dogs, planes or resupply, after a journey of 960 miles in 108 days.

2000 Norwegians Rune Gjeldnes and Torry Larsen make the first unsupported ski crossing of the Arctic Ocean, travelling over 1,000 miles from Russia to Canada in 109 days, reaching the Pole on 29 April. The British adventurer David Hempleman-Adams makes the first hot-air balloon flight to the North Pole. There has not, as yet, been a solo unsupported ski crossing of the Arctic Ocean. This would be a great journey.

2002 Victor Boyarsky is the leader of 'Barneo', the Russian drifting station at 89°N, which is now an annual fixture for polar trekkers. Regular helicopter flights are established. He has led more than 25 expeditions to the North Pole.

2006 Ousland and South African-born Mike Horn make the journey from Russia in the polar winter, reaching the Pole on 23 March. Later, Weber and Conrad Dickinson from Britain become the first to reach the Pole just using snowshoes and, on 16 April, Albert II, Prince of Monaco, becomes the first reigning monarch to reach it. Cecilie Skog of Norway is the first woman to achieve the 'Grand Slam' of the Seven Summits and the North and South Poles.

2007 Russian oceanographer Artur Chilingarov is leader of the *Arktika* expedition that on 2 August descends in two *Mir* submersibles some 13,980 ft below the ice of the North Pole in order to plant a titanium flag on the seabed. They also collect soil samples from the Lomonosov Ridge to strengthen geopolitical claims to the Pole.

2013 The Olympic torch is carried to the North Pole on nuclear-powered *50 Years of Victory*, as part of the torch relay for the 2014 Sochi Winter Games. The icebreaker left Russia's Arctic port of Murmansk and made the journey in about 91 hours, the quickest voyage ever. By 2015, Quark Expeditions, who operate the ship, will have taken almost 1,800 passengers from all over the world there. Vasily Yelagin leads a team that drives 'Yemelya' amphibious trucks from Siberia to the Pole. What will come next?

FOLLOWING Contact sheet of shots made for an equipment sponsor during Wally's expedition to Greenland in 1971–72. Wally lived and travelled with Inuit hunters to make a film of their vanishing ways of life.

BIOGRAPHIES

AUTHORS

SIR WALLY HERBERT was a pioneering explorer and an award-winning writer and artist. During the course of his polar career, Sir Wally travelled with dog teams and open boats well over 25,000 miles – more than half of that distance through previously unexplored areas. During his five years in the Antarctic he mapped on foot some 45,000 square miles of new country and he later lived among the Greenland Inuit of the High Arctic with his wife and young daughter. He is most famously remembered as the leader of the first expedition to cross the Arctic Ocean from Alaska to Spitsbergen via the North Pole. He completed his memoirs *The Polar World*, and was working on this book when he passed away in 2007.

DR HUW LEWIS-JONES is a historian of exploration with a PhD from the University of Cambridge. He travels in the Arctic and Antarctica each year working as a polar guide. Huw was Curator at the Scott Polar Research Institute, Cambridge, and the National Maritime Museum, London, and is now an award-winning author, who writes and lectures widely about adventure and the visual arts. His books include *Arctic, Ocean Portraits, In Search of the South Pole, The Lifeboat, The Crossing of Antarctica, Mountain Heroes* – Adventure Book of the Year at the World ITB Awards in Germany – and *The Conquest of Everest*, which won the History Award at the Banff Festival. He lives in Cornwall.

OUR CONTRIBUTORS

VICTOR BOYARSKY began his polar career studying glaciers and sea ice with remote-sounding radar systems, participating in ten Antarctic and Arctic scientific expeditions. In 1988 he was a member of an international team that crossed Greenland from south to north, and the following year he joined the Trans-Antarctica expedition which crossed the continent via the South Pole by the longest way, some 6,500 km (4,000 miles) on skis and dog sleds. In 1995 he was co-leader of an international expedition that crossed the Arctic Ocean from Siberia to Canada. Since 2002, this polar veteran has been expedition leader for the International project 'Barneo', providing logistics for all manner of Arctic activities, having led some 25 skiing expeditions to North Pole itself. Since 1998 he has also been Director of the Russian State Arctic and Antarctic Museum in St Petersburg.

SIR RANULPH FIENNES is described as 'the world's greatest living explorer' by the *Guinness Book of Records*, and his achievements prove this is no exaggeration. He was the first person to reach both Poles by surface travel and to cross the Antarctic continent unsupported. He is the only person yet to have been awarded two clasps to the Polar Medal for both the Antarctic and the Arctic regions. Fiennes has led over thirty expeditions, including the first polar circumnavigation of the Earth, and in May 2009 he successfully reached the summit of Mount Everest. His ongoing dream is to make the first crossing of Antarctica in winter, the so-called 'coldest journey'.

MARTIN HARTLEY is one of the world's leading expedition photographers. He was nominated as *TIME* magazine 'Hero of the Environment' in 2009 for his work in documenting the Arctic Ocean sea ice cover with the Catlin Arctic Survey. His adventure and travel photography has been published in leading newspapers and magazines, including *National Geographic* and *The Times*. He lives in Bristol, though rarely has a chance to be at home. He has now worked in the polar regions on some fifty different assignments and has completed four major North Pole expeditions of his own.

KARI HERBERT is the daughter of Sir Wally Herbert. She is a writer and photographer and her work has been published widely in newspapers and magazines, including the *Independent, Sunday Times, Guardian, Observer, Geographical* and *Traveller*, among many others. Her first book, *The Explorer's Daughter*, was aired as Book of the Week on BBC Radio 4 and was published in numerous languages. Her latest books include *In Search of the South Pole* and *Heart of the Hero*.

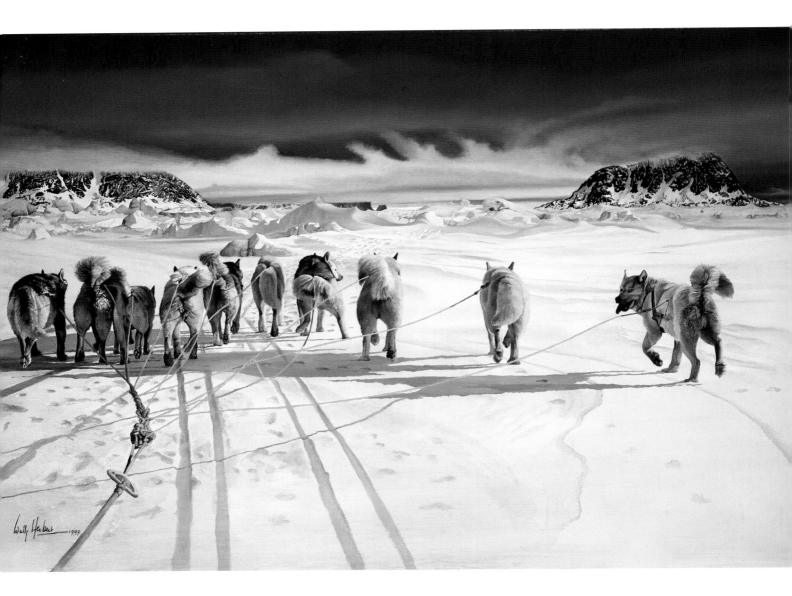

ABOVE One of Wally's wonderful paintings, completed in later life, of his view as he approached landfall on the Arctic crossing. He had climbed a pressure ridge earlier that day and through his rifle's telescopic sight glimpsed mountains rising from the ice.

PAGE 237 In Wally's own words: 'Our Arctic journey was full of danger from the very first day. Could I admit to the fear I felt? Were my companions feeling it too? ... All I know is that without fear a challenge has no cutting edge.... I owe so much to those fine men who endured with me the hardships of that journey – Allan, Fritz, Ken, and Freddie on the radio. Though a harrowing experience at times, it was without a doubt the most rewarding adventure of my life.'

ERLING KAGGE is the first in history to walk alone to the South Pole, and the first to have skied to the North Pole, the South Pole and climbed the 'Third Pole', the summit of Everest. He has sailed across the Atlantic, around Cape Horn, to the Antarctic and the Galapagos Islands. Most recently Kagge crossed New York City via its train, subway, water and sewage tunnels, living underground and only coming to the surface to change tunnels. Kagge has a law degree from the University of Oslo and has studied philosophy at the University of Cambridge.

PETER OTWAY is a New Zealand surveyor and volcanologist who was awarded the Polar Medal after four seasons mapping large tracts of virgin terrain in Antarctica. This included over-wintering and sledging with Wally Herbert, and making the first descent of the Axel Heiberg Glacier after Amundsen, exactly 50 years later. After surveys in the Libyan Sahara and Iran's Zagros Mountains he spent most of his career in the NZ Geological Survey engaged in tectonic research and volcano surveillance, with frequent surveys on high mountains and erupting volcanoes, including four seasons on the crater rim of Antarctica's Mount Erebus. He continues to give lectures in New Zealand and on Antarctic expedition ships on volcanoes and climate change.

BØRGE OUSLAND is a renowned explorer, writer and film-maker, now arguably the world's leading polar traveller. Something of a national hero in Norway, he is widely admired not only for his exploration achievements but also for the core values he pro-motes: humility, meticulous planning, self-reliance and a sincere appreciation of the natural world. He made the first unsupported trek to the North Pole in 1990, doing it again solo and unsup-ported in 1994 in just 52 days. In 1997 he completed the first unsupported solo crossing of Antarctica, an epic journey of 2,845 km (1,768 miles) in 64 days, experiencing temperatures as low as minus 56°C. In 2001 Ousland made the first solo crossing of the Arctic Ocean, from Siberia to Canada via the North Pole and in 2006 he reached the North Pole again, with fellow epic adven-turer Mike Horn, this time becoming the first to dare the trek solely in the 24-hour darkness and intense cold of the polar night.

GEOFF RENNER was chosen as the reserve member of the Trans-Arctic Expedition in 1968, and having become a close friend of Wally's in later life, travelled extensively with him in the polar regions. He spent many seasons in Antarctica participating in oversnow and airborne geophysical investigations. For this he was the recipient of the Polar Medal and an Antarctic place name. Renner has also travelled in remote hot deserts including the first west–east traverse of the Sahara. This was as scientific co-ordinator – under the auspices of the Royal Society – on the Joint Services Expedition crossing from Senegal to the Red Sea.

DR DMITRY SHPARO is a legendary Russian explorer, with a PhD in mathematics and over four decades of remote expedition experience. In 1979 he was the leader of the first ski expedition from land to the North Pole and in 1988 he was leader of a Soviet-Canadian expedition that completed the first traverse of the Arctic Ocean from Russia via the North Pole to Canada. Currently Shparo is Director of the Adventure Club in Russia, which since 1991 has been leading a sport rehabilitation pro-gramme for people with disabilities and developing adventurous activities for children and teenagers. He was awarded the Order of Lenin, the highest honour in the USSR, for his achievements, as well as other awards including diplomas from the *Guinness Book of Records* and the prestigious UNESCO 'Fair Play' award.

CECILIE SKOG is a Norwegian nurse who has become one of the leading adventurers of her generation. Since summiting Everest in 2004 she has followed her dreams of working in the outdoors and became the first woman to achieve the 'Grand Slam', climbing the Seven Summits and making ski expeditions from the coast to the North and South Poles. In 2010, with Ryan Waters, Skog completed an unsupported crossing of Antarctica, travelling more than 1,800 km (1,120 miles) in 71 days. In 2011 she attempted the North Pole again, with celebrated Norwegian adventurer Rune Gjeldnes, using skis and folding canoes. Skog has now climbed five of the world's 8,000-m peaks – Cho Oyu, Everest, K2, Manaslu and, most recently, Lhotse – and she has crossed the Greenland ice sheet five times.

As our knowledge of this planet grows, so it seems to shrink in size, and when we saw the pictures of it taken from the moon it became almost insignificant. Yet it has always been the same size to men, and its mountains and deserts, oceans and ice caps still pose the same problems and challenges to men with a feeling for adventure and discovery. The first surface crossing of the Arctic Ocean was the longest sustained journey in the history of polar exploration. It is an achievement which ranks among the greatest triumphs of human skill and endurance.

The Duke of Edinburgh, 1971

And of what value was this journey? It is as well for those who ask such a question that there are others who feel the answer and never need to ask.

Sir Wally Herbert, 1969

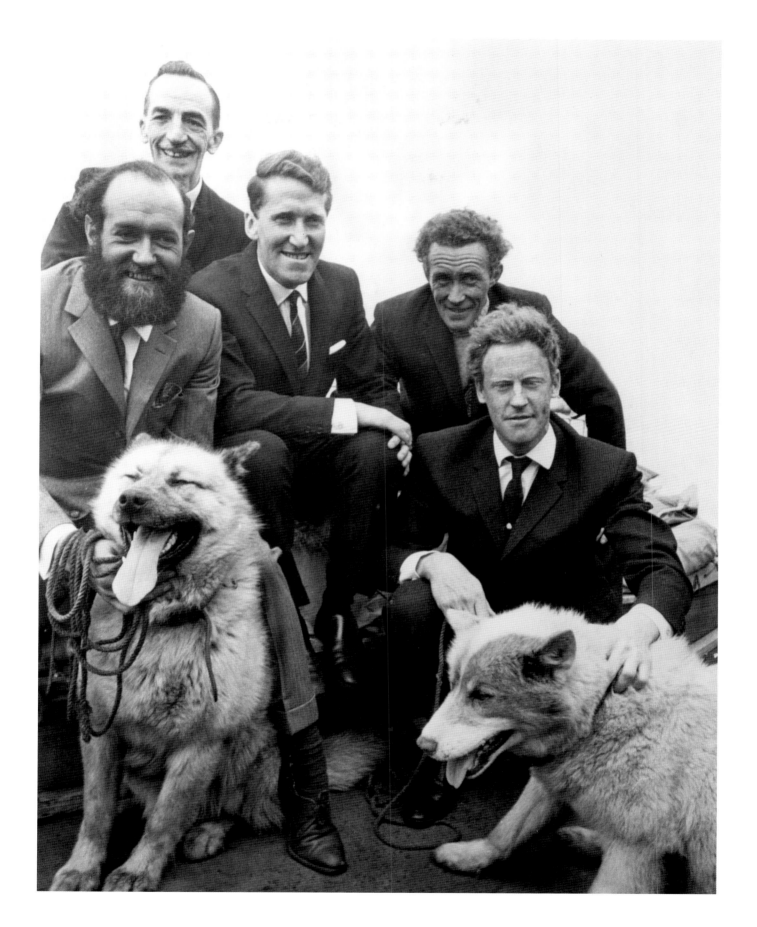

FURTHER READING

Anderson, William R., *Nautilus 90 North* (Cleveland: World Pub. Co.; London: Hodder & Stoughton, 1959)

Armstrong, Terence, *The Russians in the Arctic* (London: Methuen; Fairlawn, NJ: Essential Books, 1958)

Berton, Pierre, *The Arctic Grail* (London: Viking, 1988)

Brandt, Anthony, *The Man Who Ate His Boots* (New York: Alfred A. Knopf, 2010)

— *The North Pole: A Narrative History* (Washington: National Geographic, 2005)

Capelotti, Pete, *By Airship to the North Pole* (New Brunswick and London: Rutgers University Press, 1999)

Debenham, Frank, *Discovery and Exploration* (London: Hamlyn, 1960)

Delgado, James, *Across the Top of the World* (London: British Museum; New York: Checkmark Books, 1999)

Dolan, Edward, *White Battleground: The Conquest of the Arctic* (New York: Dodd, 1961)

Emmerson, Charles, *The Future History of the Arctic* (London: Bodley Head; New York: PublicAffairs, 2010)

Fiennes, Ranulph, *Cold* (London: Simon & Schuster, 2013)

— *Mad, Bad and Dangerous to Know* (London: Hodder & Stoughton, 2007)

— *To the Ends of the Earth* (London: Hodder & Stoughton, 1983)

— *Hell on Ice* (London: Hodder & Stoughton, 1979)

— 'Brave Spirits' in Lewis-Jones, Huw and Lowe, George, *The Crossing of Antarctica* (London and New York: Thames & Hudson, 2014)

— 'This Endless Horizon' in Herbert, Kari and Lewis-Jones, Huw, *In Search of the South Pole* (London: Conway, 2011)

Fleming, Fergus, *Ninety Degrees North* (London: Granta; New York: Grove, 2001)

— *Barrow's Boys* (London: Granta, 1998; New York: Atlantic Monthly Press, 2000)

Hadow, Pen, *Solo: The North Pole Alone and Unsupported* (London and New York: Michael Joseph 2004)

Hempleman-Adams, David, *At the Mercy of the Winds* (London: Bantam, 2001)

Henderson, Bruce, *True North: Peary, Cook, and the Race to the North Pole* (New York: W. W. Norton, 2005)

Herbert, Kari, *Heart of the Hero* (Glasgow: Saraband, 2013)

— *The Explorer's Daughter* (London: Penguin, 2004)

Herbert, Kari and Lewis-Jones, Huw, *In Search of the South Pole* (London: Conway, 2011)

Herbert, Marie, *The Snow People* (New York: Putnam, 1973)

Herbert, Wally, *The Polar World* (London: Polarworld, 2007)

— *The Noose of Laurels: The Discovery of the North Pole* (London: Hodder & Stoughton; New York: Athenaeum, 1989)

— *Hunters of the Polar North* (New York: Time-Life Books, 1981)

— *Eskimos* (London: Collins, 1976)

— *Polar Deserts* (London: Collins; New York: F. Watts, 1971)

— *Across the Top of the World* (London: Longmans, 1969)

— *A World of Men: Exploration in Antarctica* (London: Eyre & Spottiswoode; New York: Putnam, 1968)

Holland, Clive (ed.), *Farthest North: Endurance and Adventure in the Quest for a North Pole* (London: Robinson; New York: Caroll & Graf, 1999)

— *Arctic Exploration and Development* (London and New York: Garland, 1994)

Huntford, Roland, *Nansen: The Explorer as Hero* (London: Duckworth, 1997)

Kagge, Erling, *Philosophy for Polar Explorers* (London: Pushkin, 2005)

— *Alene til Sydpolen* [*Alone to the South Pole*] (Oslo: Cappelen, 1993)

— *Nordpolen: Det Siste Kappløpet* [*The North Pole: The Last Race*] (Oslo: J.W. Cappelens, 1990)

Kirwan, Laurence, *The White Road* (London: Hollis & Carter; New York: W. W. Norton, 1959)

Lewis-Jones, Huw, *Arctic with Bruce Parry* (London: Conway, 2011)

— *Face to Face: Polar Portraits* (London: Conway and Polarworld, 2009)

Lewis-Jones, Huw and Lowe, George, *The Crossing of Antarctica: Original Photographs from the Epic Journey that Fulfilled Shackleton's Dream* (London and New York: Thames & Hudson, 2014)

— *The Conquest of Everest: Original Photographs from the Legendary First Ascent* (London and New York: Thames & Hudson, 2013)

Lopez, Barry, *Arctic Dreams* (New York: Scribner, 1986)

McCannon, John, *Red Arctic* (New York and Oxford: Oxford University Press, 1998)

McGhee, Robert, *The Last Imaginary Place* (Oxford and New York: Oxford University Press, 2006)

Malaurie, Jean, *Ultima Thule: Explorers and Natives of the Polar North* (New York: W. W. Norton, 2003)

— *Last Kings of Thule* (London: Allen & Unwin; New York: Crowell, 1956)

Mills, William, *Exploring Polar Frontiers: A Historical Encyclopedia* (Santa Barbara: ABC-CLIO, 2003)

Mirsky, Jeannette, *To the Arctic! The Story of Northern Exploration* (London: Hamilton; New York: Viking, 1934)

Nansen, Fridtjof, *Farthest North* (London: George Newnes; New York: Harper, 1898)

— *The First Crossing of Greenland* (London and New York: Longmans, 1892)

— 'Introduction' in Amundsen, Roald, *The South Pole* (London: John Murray, 1912)

Naylor, Simon and Ryan, James R. (eds), *New Spaces of Exploration: Geographies of Discovery in the Twentieth Century* (London: I. B. Tauris, 2010)

Neatby, Leslie, *Conquest of the Last Frontier* (Athens: Ohio University Press, 1966)

Nobile, Umberto, *My Polar Flights* (London: Muller; New York: Putnam, 1961)

Nuttall, Mark and Callaghan, Terry V. (eds), *The Arctic: Environment, People, Policy* (Amsterdam: Harwood Academic, 2000)

Ousland, Børge, *Alone Across Antarctica* (Oslo: Boksenteret, 1997)

— *Alone to the North Pole* (Oslo: J.W. Cappelens, 1994)

Pala, Christopher, *The Oddest Place on Earth: Rediscovering the North Pole* (San Jose: Writer's Showcase, 2002)

Papanin, Ivan, *Life on an Icefloe* (London: Hutchinson, 1947)

Peary, Robert, *The North Pole* (New York: F. A. Stokes; London: Hodder and Stoughton, 1910)

Potter, Russell, *Arctic Spectacles: The Frozen North in Visual Culture* (Seattle: University of Washington Press, 2007)

Rasky, Frank, *The North Pole or Bust* (Toronto and London: McGraw-Hill, 1977)

Rawlins, Dennis, *Peary at the North Pole: Fact or Ficton?* (Washington: R. B. Luce, 1973)

Riffenburgh, Beau, *The Myth of the Explorer: The Press, Sensationalism and Geographical Discovery* (London: Belhaven, 1993)

Ross, Maurice, *Polar Pioneers* (Montreal: McGill-Queens University Press, 1994)

Ryan, James, *Photography and Exploration* (London: Reaktion, 2013)

Sale, Richard, *The Scramble for the Arctic* (London: Frances Lincoln, 2010)

Savours, Ann, *The Search for the North West Passage* (London: Chatham, 1999)

Shackleton, Edward, *Nansen: The Explorer* (London: Witherby, 1959)

Skog, Cecilie, *Den Himmel Berühren* [*Touch the Sky*] (Munich: Malik, 2009)

Weber, Richard and Malakhov, Mikhail, *Polar Attack: From Canada to the North Pole, and Back* (Toronto: McClelland & Stewart, 1996)

Williams, Glyn, *Arctic Labyrinth* (London: Allen Lane, 2009)

INDEX

Page numbers in *italics* refer to captions to illustrations

Across the Top of the World (BBC) *6*

airdrops, use of 91, *95*, 95–96, 97–99, 101, *118*, *136*, 147, 151, 152

airplanes/air support 50, *76*, 189, 192, 199; *see also* airdrops, use of

Alaska 27, 42, 87, 91; *see also* Point Barrow

Amundsen, Roald 23, 48, *77*, 189, *190*, 192, 193; *South Pole, The* 48, 192, *193*

Anders, Bill 17, *17*

Antarctica, expeditions to 18, 22, *37*, 41, *41*, 45, 158, 213, *224*; *see also* Herbert, Sir Wally; South Pole

Apollo space missions 11, 17, *17*

Arctic, the, expeditions to 22, 27, 197–98, 200, 207–08, *208*, 215, 216; *see also* North Pole; Trans-Arctic expedition

Arctic Ocean *6*, 22, 27, 29, 87, 194, 195, 197, 199, *204*, 207, 211; maps/charts of 30, 42, 87, 89, *93*, 95

Arctic Research Laboratory 91, 95–96, 102, *118*

Avatak 218

Axel Heiberg Glacier 47–50, *77*, *80*, 189, *190*, 192, 193; Amundsen's ascent route 48–49, 50, *77*

Bae, Rolf 212–13

Barne Glacier *67*

'Barneo' 200

Beardmore Glacier 50, *71*, *77*, 189, 190

bears *see* polar bears

Beck, Bill 96

Borman, Frank 17

Boyarksy, Victor 199–200, 232

Buchanan, Captain Peter *175*

Byrd Glacier *76*

Byrd, Admiral *76*, 189

cameras *22*, 155, *173*

Canadian Air Force 91, 101–02, *136*, 147, 151

Carse, Duncan 44

Church, Freddie *6*, 91, 100, 101, *122*, 146, 148, 149, 151, 153, 156, *234*

Clifford, Sir Miles 88

climate change 22, 89, *130*, 190

clothing 29–30, 90, 102, *106*, *124*, 146, 224

Commonwealth Trans-Antarctic Expedition 45

cooking 103, *132*, 146

Dickerson, Dick 96

dog teams *6*, 28, 47, *57*, *63*, *64*, *80*, 95, 97, *110*, 157, 220; looking after/training *70*, 90, *132*, 189

Duce Bay 45–46

Edinburgh, Duke of *see* Philip, Prince, Duke of Edinburgh

Elizabeth II, Queen of Great Britain 149–50, 151

Ellesmere Island *87*, 89

Endurance, HMS 91, 155, 156, 157, *159*, *175*, *178*, *181*

Engelstad, Mount *77*

equipment 91, 145, *231*; navigational 103, *141*, 199, 204, 212, 220; photographic/filming *22*, 155, *173*; scientific 99, *130*; for surveying *74*, 190; *see also* dogs/dog teams; radio equipment/communication; sledges/sledging

Etah 90, *224*

Everest, Mount 18, 22, 156, 203–04, 215, 216

Fiennes, Sir Ranulph 27–37, 203–04, 232; Arctic expedition 29–33

Fleming, Launcelot, Bishop of Norwich 91

food rations/supplies 46, *54*, *60*, *74*, 103, 146

fossils 21, 50, 190

Fram 152, *204*, *228*

Fridtjof Nansen, Mount *6*, 47, 48, *189*, 190, *190*, 192

Fuchs, Sir Vivian 'Bunny' 90, 192

geological specimens *23*, 47, 50, 190; *see also* fossils; scientific research

Gill, Allan *6*, 88, 91, 99, *122*, *124*, *133*, 150, 151, 153, 156, *159*, *160*, *167*, *173*, 195; and dog teams/sledging 89, *110*, *114*, 158; injury and recovery 100–01, 102, 103, 145, 146, 147

Gjeldnes, Rune 213

global warming *see* climate change

GPS equipment 199, 204, 212, 220

Greenland 42, 158, 213; Herbert family life in *183*, *184*, 218–19, *218*, *219*, 223, 231; huskies from *6*, *64*, 91, 151, 189; training expedition to 89–90; *see also* Inuit; *and individual placenames*

Grytviken 220

Gurney, Norman 44

Hanssen, Helmer *190*

Hartley, Martin 30, 207–08, *208*, 232

Hedges, Ken *6*, 91, 97, *114*, 148, 156, 158, *159*, *166*, *167*, *173*; medical role of 99, 100, 146

Herbert Island 218

Herbert, Kari *183*, 218, *218*, 220, *221*, 223–24, *223*, *224*, 232

Herbert, Marie *183*, 218–20, *221*, 223, 224

Herbert, Sir Wally *6*, 18, 27–28, 33–4, *37*, *46*, *106*, *141*, 215, 232, *234*, 236; expeditions to Antarctica 21, *37*, *41*, 45–47, *45*, 47–50, *52*, *54*, *57*, 60, *61*, *63*, *67*, *70*, *71*, *74*, *75*, *76*, *77*, *80*, *82*, 158, 189–93, *190*, 203, 215, *224*; army career 43; as artist/painter 18, *32*, *37*, 158, *234*; childhood 42–43; expedition planning/inspiration 42, 87–89, *87*; and film/

photography *6*, *18*, *22*, *32*, *184*, *231*; journals *37*, 145, *189*; knighthood 203; as lecturer/guide 18, 158, 159; living in Greenland *183*, *184*, 218–19, *218*, *219*, *221*, 223, *223*; Polar Medal *203*; as surveyor and mapmaker 41, 42, 43, 47, 50, *54*, *57*, *71*, 189, 190, *190*, 193; *see also* 'Operation Husky'; Trans-Arctic expedition

Herbertfjellet *175*

Hope Bay *2*, 45, *52*; base hut at 45, *46*, *54*, *57*, *224*

Hornet, The *197*

huskies *6*, *64*, *67*, *70*, 91, 148, 151, *166*, *178*, 189, 218; *see also* dog teams

Ibsen, Henrik *15*

Inughuit, the 223, 224, *224*; *see also* Inuit

Inuit, the *6*, *64*, 89, 90, 92, 95, 96, *106*, *184*, 203, 218, 220, *231*; *see also* Inughuit

Inuktun language 220, *223*

John Biscoe 45, 47, *63*

Kagge, Erling 215–17, 235

Kaungnak 89

Koerner, Roy 'Fritz' *6*, 88, 91, 95, 100, 102, 103, 146, 147, 153, 155, 156, *159*, *160*, *167*, 195; scientific work of 89, 99, *128*, *130*, *133*, *136*, 158

Lawrence, T. E. 187

Lewis-Jones, Huw 17–23, 37, 232

Lovell, Jim 17

Lowe, George 18

McGregor, Vic 49, *82*, 189, 190, 192

McMurdo Sound 47

Mallory, George 216

mapmaking and cartography 42, 43, 46, 50, *54*, *57*, *71*, 189, 193, *200*; *see also* navigation; surveying

'Meltville' 99, *128*, *132*

moon, the 17, *17*

Moskushamn 41, 157

Nansen, Fridtjof *6*, 42, 85, 89, 152, 157, 197, *204*, *228*; *see also* Fridtjof Nansen, Mount

Nares, George 88

navigation: traditional methods of 21, 103, *140*, *141*, 145, 150, *163*, *189*, 204; using GPS 199, 204, 212, 220

New Zealand Antarctic Expedition 41

North Pole, the *6*, 21, 150–1, *167*, *207*; commercial travel/cruises to 158, *184*, 199–200, 220–21; expeditions to 22, 27, 29–33, 34, 42, 87, 194, 195–96, 197–98, 199, 200, 207–08, *208*, 211–13, 215, 216, 220

ILLUSTRATION CREDITS

© **2015 The Wally Herbert Collection:** endpapers, 2–3, 4, 7, 8–9, 10–11, 14, 26, 32, 35, 38, 40, 45, 48, 51, 52, 53, 54, 55, 56–57, 58, 59, 60, 61, 62–63, 64–65, 72–73, 74, 75, 76, 77, 80, 82–83, 84, 86, 93, 94, 98, 104–05, 106, 107, 108, 109, 110–11, 112, 113, 114–15, 116, 117, 118, 119, 120–21, 122, 123, 124, 125, 126, 127, 128–29, 130, 131, 132, 133, 134, 135, 136, 137, 138–39, 140, 141, 142, 144, 148–49, 154, 159, 160, 161, 162, 163, 164–65, 166, 167, 168–69, 170–71, 172–73, 174, 175, 176–77, 178, 179, 180–81, 182, 183, 184, 185, 188, 195, 196, 200–01, 214, 219, 221, 222, 225, 233, 234, 237.

Object Photography by Martin Hartley: 12, 19, 20, 23, 24–25, 36, 186, 193, 202, 206, 226–27.
The Hornet ® © DC Thomson & Co. Ltd. 2014. Used By Kind Permission of DC Thomson & Co. Ltd: 196.
NASA / Bill Anders: 16.
Martin Hartley: 31, 209, 210–11.
The Peter Otway Collection: 66, 67, 68–69, 70–71, 78–79, 81, 191b.
National Library of Norway: 191a, 205, 228.

ACKNOWLEDGMENTS

This book forms the final part of a historic trilogy of great twentieth-century explorations. Our success with George Lowe's *The Conquest of Everest* and *The Crossing of Antarctica* enabled us to fulfil a long-held ambition with this material: to do justice to the incredible life of Sir Wally Herbert. His pioneering journeys earn him a place alongside the likes of Scott, Amundsen, Shackleton and Nansen. These were the polar explorers he also greatly admired.

Wally's wife, Lady Marie Herbert, blessed this project with her energies and wisdom. As is always the case, I couldn't have created a book without a supremely generous and talented team. Thanks to my old mate polar photographer Martin Hartley, the sublime Liz House, Charlie Hey and Craig Farley at the Photography Centre at the University College Falmouth, and a cohort of Arctic veterans whose experience and insights have added greatly to this work. The team at Thames & Hudson in London led by Colin Ridler again provided their expertise to help me make this special book a reality.

I should like to remember once more the tremendous Wally Herbert: explorer, author, photographer, artist, father, friend, and now a grandfather too. But most important of all, my thanks and love to Kari and our daughter Nell. I'm sorry I missed another Cornish summer. Let's go back to the Arctic together very soon.